Modigliani

Also by William Fifield

I Wed Thee Till Sunday
The Devil's Marchioness
The Sign of Taurus
Matadora
Encyclopedia of the Wines of the World (co-author)
The Sherry Royalty
Entretiens Avec Jean Cocteau
Jean Cocteau

MODIGLIANI

by
William Fifield

WILLIAM MORROW AND COMPANY, INC.
NEW YORK 1976

Printed in the United States of America.

1 2 3 4 5 80 79 78 77 76

Library of Congress Cataloging in Publication Data

Fifield, William (date)
 Modigliani.

 Includes index.
 1. Modigliani, Amedeo, 1884-1920.
ND623.M67F53 759.5 [B] 75-41362
ISBN 0-688-03039-4

For James Landis

Contents

Author's Note

This book has been made from living witnesses. The story of Modigliani has been falsified, and now from book to book is handed down, ever more warped. "The Modigliani family itself responded to, to some extent created, 'Modigliani,'" Jeanne, his daughter, told me in 1973. By "Modigliani" she meant the false Modigliani, the inconsistent Modigliani, incomprehensible because not penetrated deeply enough—to the stung, tormented, unbelieving Sephardic Jewish soul where it all came together. The Modigliani "not Jewish at all but very Italian." "They re-created him in terms of how they saw things"—how true this is of witnesses! "Thus," she went on on that March day in Paris, "the family acknowledged his drug addiction because they too venerated Baudelaire and Verlaine, but they minimized his drinking because they themselves were light drinkers. And they instinctively converted his sacred madness into the frenzy of genius, because it was present in practically all the Garsin, and thus something too close to home to be faced. So that the fictional Modigliani existed in Tuscany too, in the Modigliani-Garsin home—and such research as went to the supposedly unimpeachable source put down its root in half-invention."

Yet as late as 1973–1974 people were still alive who had known Modigliani, been painted by him, and, taken by the right handle, as it might be put, would speak out the truth. The motive—crass commercial exploitation—for the first original fakings of the true life had disappeared. His sister-in-law, for example, was alive in Rome. Lunia Czechowska was alive in Nice, holding locked within her as though in a Persian casket the key to the secret of Modi-

gliani's last, unfathomed love in that hot summer of 1919, last of his life, and to the impenetrable mystery, so said, of Jeanne Hébuterne's suicide two days after his sordid death. Upon her outside, in her physical appearance, Lunia held part of the secret—elegant, svelte, physically attractive and, to the eye, not sixty (it was 1974, her eightieth year). What she must have been in 1919 when she was twenty-three! When I came in Natali was painting. A thrill ran through me. It was the exact posture—blue apron, beret, stooped to the easel—in which Modigliani had surprised him in July, 1912. And a half century rushed back and we were in 1912, in July, in Livorno, in the Piazza Giovanni Maria Lavagna, and Modigliani was home from Paris, sick, his head "shaven."

It is true that the disparity of original witness, laid side by side, seems to carry you further into confusion, but this is only at the first and you see that it is the nature of the thing, and finally all converges, as truth does, into the complex whole which is the portrait of a man. *Modigliani* could not have been written—there would have been no point—without the generous aid of those consulted; it owes its existence to them. Thirteen—all, I believe, who were then alive—were painted or drawn by Modigliani; the role each played in the life may appear in the narrative to follow. Something more than thanks, if they are living, or else veneration to their shades, in more than one case immortal, is due those who told me of "their" Modigliani—Picasso, Diego Rivera, Cocteau, Braque, Jeanne Modigliani (daughter of Modigliani), Vera Modigliani, Adriana Modigliani, Jean Kisling, Laure Ortiz de Zárate, Waclaw Zawadowski, Roger Wild, Germaine Labaye (Haricot Rouge), Mme André Hébuterne, Mme Foujita, Mme Gilani Abdul-Wahab, Germaine Survage, Simon Mondzain, Lunia Czechowska, Hanka Zborowska, Paulette Jourdain, Pinchus Krémègne, Renato Natali, Thora Klinckowström.

How but through a broken heart
may Lord Christ enter in?
—Oscar Wilde

Modigliani

Dream and Flaw

Two Aspects of Modigliani

Anna Akhmatova, born 1889, a successful poet of love. Her eyes, her fringe, her enigmatic silences, her shawls initiated and set styles. A radiant character engulfed in shadows. She could read dreams.

"We communicate," he said. We sat on the benches of the Luxembourg. In 1911 he lived in Impasse Falguière. He seemed enclosed in a ring of solitude. Never mentioned the name of a friend, never joked. Never spoke of past loves, never mundane things. He was nobly courteous; he worked at sculpture in the courtyard adjoining the atelier. He invited me to the Salon des Indépendants in 1911 but when I appeared he didn't approach me. He took me to the Egyptian Department of the Louvre—he dreamed only of Egypt, "all the rest was of no importance." He drew my head in the manner of the dynastic queens of Egypt. He was entirely conquered by what he called "the grand art." He took me to see Paris—night, *clair de lune*. Before the Venus de Milo he turned—"women of a beauty worthy of painting or sculpting seem heavily dressed in their clothes." He had a huge black very old umbrella, we sat under it in the Luxembourg in the warm summer rains of Paris. We recited Verlaine in chorus. He was that rarity, a painter who knew and loved poetry. I found his studio door locked, I threw roses through the window idly. "How did you get in? The door was locked." "I didn't." "But the roses were so beautifully placed—arranged on the bed."

He liked to wander at night in Paris—I'd hear his step in the

15

sleeping street, look through the blinds, see his shadow which slowed in passing my window. He saw things differently from the others—Cubism remained strange to him. "I am another of Picasso's victims," he said. Everything in fashion, called fashionable, he did not notice. We talked of poetry. He said he was twenty-four (he was twenty-seven). He was interested in aviators, they whirled around the Eiffel Tower, but he met them. They are *sportsmen*, he said. What did he seek? A friend came to Russia who had heard of him: "An alcoholic monster."

Laure (or Laura, or Lo) Garsin, Modigliani's maternal aunt:

In August 1911, more worried than ever, I decided that I must tear him away from his Parisian setting and arrange for him to lead a healthy, quiet life in the country. Recha Rothschild was on vacation in Normandy. I asked her for the address of a pension or small apartment where we could pass the autumn at the seashore. Recha, always helpful and capable, found me a little villa free (and pretty into the bargain) at Yport, a small village in Seine-Inférieure. I cannot remember what excuse he gave for not leaving Paris with me. I only remember that when he did join me at Yport in the beginning of September he had already been given his traveling money three times. I knew perfectly well how he was spending it in Paris; he was buying paints and paying off debts, and up to that point I understood his behavior and approved of it. What I could neither understand nor approve was his arrival at the Villa André in an open carriage, soaking wet. With the little money left over from the third lot after he had paid his traveling expenses, he suddenly decided to treat himself to a trip to Fécamp. He had heard of the beauty of its beach, a few miles from Yport, and in spite of the downpour he wanted to have a sight of it without wasting any time. You will understand what a weight his amazing folly placed on my shoulders. I felt that I had made an enormous mistake in bringing to such a damp climate an invalid who calmly exposed himself to all weathers. I was haunted by the terrifying idea that I would find myself with no means of heating the house, with no means of avoiding a return of his illness, in a village where I knew no one except the peasant woman whom I had taken on as maid-of-all-work. No, it was absolutely impossible to do anything to

help him! We left Yport—he thought because of a whim of mine—
without, so far as I can remember, having spent even a week
together.

For Eugenia Garsin, the summer of 1898 was crucial. In May
her oldest son, Giuseppe Emanuele Modigliani, was taken in Pia-
cenza as an anarchist. He was arraigned in Florence and on July
14 sentenced to six months in the Domenicani Prison of Livorno.
Now he was near home at least! She took his part in it, as she did
that of her children in everything, somewhat too forcefully, and
the last thin thread to the Modigliani was snapped. She was a
Modigliani by bed and rule, though she tended to think of herself
as Garsin. She had filled the house up with Garsin (Jeanne, her
granddaughter, Modigliani's daughter, tells me the name is He-
brew, and its plural is Garsin)—her sister Laure, her sister Gabri-
ella, who will fling herself headfirst down a stairwell in Rome in
1915, their father Isaac, son of old José the Blind Patriarch and
apple of his shut eye, and of course the four half-Modigliani her
husband Flaminio has got on her.

Giuseppe Emanuele, called Menè, was no more anarchist than
you are—that honor being reserved for his baby brother, Amedeo,
who two days before the sentencing by the Florence Tribunal
turned fifteen. But Menè's Socialist agitation sufficed in the Italy of
that day. The year before, King Humbert's life had been attempted
by anarchists; and he would be assassinated two years hence by the
anarchist Bresci. The ferment of Garibaldi was in Italy, the French
Revolution, Marx, and, at another level, that of Nietzsche, Baude-
laire, Alfred de Musset, and *The Sorrows of Young Werther* of
Goethe, seductive invitation to suicide as high esthetic accomplish-
ment sweeping through the young of Europe like a wind of hari-
kari. Henri Bergson had begun to write in Paris.

Villon, the robber poet and hangman's friend of old medieval
Paris, was returning to fashion in these days, and Modigliani,
youngest of Eugenia's brood, could read him in the original—as,
with dubious effect, he could read Bergson. Bergson had published
Matter and Memory two years before, and Laure had borne the
French text home like a captured eagle. They must have been the

first family in Livorno to have read it. But then they were different from everybody else—and knew it. Eugenia said, when she was asked, and when she wasn't, that solitariness was their metal—that and contempt for money. She meant the Garsin, of course.

They were French. To the confusion of biography, old Giuseppe Garsin, born in Livorno, went to France, taking with him Isaac, his son, born also in Livorno, and there, in 1849, Isaac married, getting eventually on his cousin Regina Garsin (marrying cousins was a hallmark of both the Modigliani and Garsin families), seven children. And when one of these, Eugenia, chooses to go back to Livorno to marry, biography does not take her away from Livorno at all—and solves the problem of Modigliani's French (Lunia Czechowska tells me he spoke French better than Italian, which by 1917 when he fell in love with her might have been true) by, in one illustrious instance, having him perfect it from Beatrice Hastings!—the South African poet, feminist, discoverer and girl friend of Katherine Mansfield, with whom he lived two years of sex, drugs and mayhem—and whom he once threw bodily through a window. (She had the habit of cutting a notch in her bedpost for each new man she had.)

His mother Eugenia was French, and spoke French, English and Italian. Her father, Isaac, who came to Livorno to live with them in 1886, when Modigliani was two, was a Mediterranean man, strangely neurasthenic. He spoke Spanish, French, Italian and Greek as if they were birthright languages, and Arabic and English too. Aunt Laure, who from time to time severed herself from human life, cut herself off from humans, and was in and out of institutions for persecution mania often enough by 1915—the year Modigliani's aunt Gabriella killed herself by throwing herself down a stairs in Rome—performed the remarkable feat of remaining clear in intellect and writing with indifferent perfection in French, Italian and English until her death at one hundred. She published too, and Modigliani collaborated with her in 1909. She had the idea, and it filled her with terror, that the famous literary men of her time were going to come to Livorno to rape her. But they never did.

Among these people, Modigliani grew up. He knew French as soon as he knew Italian; when he read Baudelaire, Villon, Bergson and the writers of decadence—he read them in the original. He did not know English. (I have checked with many who knew him and none remembers him speaking English; Lunia Czechowska, Jeanne Modigliani and Waclaw Zawadowski said he did not speak English.) It is odd because his life was starred with English contacts, from Nina Hamnett to Arnold Bennett, the then celebrated English novelist who was really his first important buyer, buying *Lunia Czechowska* when Modigliani was less than a year from death. And odd because it would seem he would have had ample occasion to learn it. Grandfather Isaac knew it well enough to transact business in it, though eventually his high disdain—and something stranger—caused him to fail. And Isaac's daughters, Laure and Eugenia, knew it well enough to write and publish in it, which they both did. Modigliani had a good mind, was very proud of his small self—willful. Even today Renato Natali remembers him, when they were both fourteen, saying you could learn nothing at school, for what could they teach you? He felt the same at Micheli's Art School. He did not deign to be in accord with Micheli's ideas. So perhaps he did not learn English because he did not want to. Ossip Zadkine, the Russian sculptor, had to be his English intermediary with Nina Hamnett. Perhaps with Aleister Crowley, the Satanist, who was mixed into this black pot of things? Beatrice Hastings, his mistress for two years, said Modigliani had psychic powers—as who has heeded?

There was a peculiar detail transmitted to me by Natali. The day before foul weather, Natali said, Modigliani was sarcastic, offensive, but when Pluvius broke he became soft as rainwater. And apparently this was true from the earliest years.

The Modigliani lived at 4 Via delle Ville, today 38 Via Leonardo Cambini, erroneously put in all histories and catalogues of Modigliani exhibitions as number 10. There is a plaque over the door, and it commemorates the fact that Giuseppe Emanuele Modigliani lived there. Number 10 is a small two-story house far less manorial than the house in Via Roma where Modigliani was born.

It corroborates that, not long after the painter's birth in 1884, the family, having come down in the world, had to move to humbler quarters. But it was the present 38 to which they moved, not 10; and 38 Via Leonardo Cambini is so like 38 Via Roma as to double it.

The Via Roma house belonged to Emanuele Modigliani, father of Flaminio, grandfather of the four children—Menè, the first born; Margherita, who came along three years later; Umberto, the pariah; and Amedeo. Giuseppe Emanuele (Menè) was named after both sides, his great-grandfather Giuseppe Garsin and his grandfather Emanuele Modigliani, whose house it was. But a dozen years later when "the baby" arrived he was called Amedeo Clemente, after Uncle Amedeo Garsin in Marseille and Clementine Garsin, the only sister who stayed in Marseille, and became the mainstay of the family there. Something had perhaps already then happened in the family; something that may have influenced a peculiar and indeed curious and original conduct with women down the long length of a brief life. His names were Garsin; no Modigliani baptismal name.

The Garsin lived at No. 21 rue Bonaparte in Marseille, a palatial upper-middle-class house and almost more, which had a large flower-hedged and lawn-furnitured back garden, in which the Garsin would congregate in their leg-o'-mutton sleeves, high celluloid stiff collars, little white frocks or Lord Fauntleroy pants, for the family festivals, a sort of "Fourth of July" of a bygone day, lost—through which old José groped, and no one would have dared say him nay. He was the Father.

Eugenia was born into this in 1855. She had an English nurse, a stern, unforgiving Presbyterian creature. She went to a Roman Catholic school in French. She lived among Jews who spoke Italian, and very little Hebrew. They were orthodox in nothing. Eugenia must have been, from the first, cut loose—left, as proved out, with an urge to faith and nothing which could possibly be believed in. Faced with the alternatives of sink or swim, she swam. She was practically the only one in her family who did.

It is a curious thing that the partners of marital discord, who will hardly even speak to each other, which was the case of Fla-

minio and Eugenia by this time, nevertheless copulate. They did, and Amedeo is the proof of it. And probably Umberto. Giuseppe Emanuele and Margherita came earlier—Menè in the October of the very year they were married, 1872, so that it may be supposed they were quick. Do we know why love matches go astray? Here we have evidence in Jeanne's, a child's, eyes, of something before she was eight, for that was the age she was when her grandmother died—and her grandfather a year later. The eyes of a child may misconstrue, but they see a lot.

After her father's terrible death, and her mother, Jeanne Hébuterne, threw herself from a fifth-story window onto the paving two mornings later, Jeanne—I shall commence to call her Giovanna, as her father did, to avoid confusion with her mother—Giovanna was adopted into the Modigliani family by Margherita, Modigliani's sister, not in Livorno as you may well read in every text but in Florence, in Via Giambologna. The Modigliani family had already moved to Florence before Modigliani died. So Giovanna (born Jeanne Hébuterne, for she had no legal father; legalized to Modigliani, not because she was Modigliani's daughter but because Margherita adopted her) saw.

She was in the hallway. "The Modigliani always left their doors open," she told me. "I don't know why. Grandfather and grandmother slept as far apart as they could in the house, but he *did* have a bedroom in the house. The biographers of my father who have killed him off—or divorced them!—they were not Catholics but we lived in *Italy*—did so because of his invisibility in the Modigliani story. But he was there all right, simply effaced, till he died in 1928. One day I was in the hallway"—this is verbatim, noted down in Paris in March, 1973, when Giovanna (Mme Jeanne Modigliani-Nechtschein) was fifty-four—"there is something wrong in the blood of the Garsin—too many suicides, too many neurotics. The Garsin is a mad family. Eugenia was a wonderful woman—extraordinary accomplishment, the school, for her period —wonderful to everyone but Flaminio. He had no sense of business, was not particularly capable, but he kept on going to his business and lived in the house, though he was effaced. His could not have

been a pleasant life, but he made no effort. He was a noodle." She took an inverted, tormented pride in the neurosis of the family, as one might in haemophilia, for she believes it has descended to her, and to her daughter. In Eugenia's rose, brass-hasped photo album she showed me—"here is ———, suicide. This is the English one"—Evaristo, Eugenia's oldest brother, had carried the line into England—"the boy who killed himself in England. There are more suicides in the family than are admitted in the family—Amedeo Garsin, after whom my father was named, may be one. It is not sure he died of TB. The marriage went amiss for sexual reasons, according to close observers within the family. There could have been no other explanation. Was it not almost inevitable? Playing with dolls and then, when my grandmother was only fifteen, a man she scarcely knows appears. They had rooms as far apart as the house permitted. For some reason, however, the Modigliani-Garsin always left every door open. One day—" She broke off; resumed with something like compulsion. "Menè alone was stable. Margherita suffered from persecution complex. Umberto, when not very old, asserted that progress was outstripping all his achievements in engineering and stated that it would be futile to go on. Whereupon he stopped all professional work, cut all social ties, locked himself away in his studio. Later he began to frequent the *bas-fond* of Milan. One day something went wrong with him; he went to Switzerland for his health; and he died. You might say it was a sort of involuntary self-destruction. It was that way with nearly all of them. One day I was standing in the hall and I happened to see Eugenia putting her husband's nightshirt away in a drawer. She held it from her at arm's *length*. I don't suppose I understood then, but I am a married woman now and now I do." (She calls M. Nechtschein *ma femme*.)

And it may have been the death of Emanuele Modigliani, the grandfather—after all, it was *his* house—that caused the Modigliani to move away from 38 Via Roma, the great archaic painter's birthplace, to 4 Via delle Ville. That would be the first house Modigliani remembered; there, probably, is where he seduced the housemaid. (Flaminio was pleased.)

The Modigliani moved to Piazza Magenta 3—documentary

evidence exists showing they were there by 1903—and then to Via
Giuseppe Verdi. The Valdese Church is there; a square statement
in brick of religiosity, looking like a reformatory. It was there, and
in its shade, bastioned by it from the sea, the Modigliani lived,
under the rule of Eugenia, a beaked woman, a lisp of hair on her
upper lip. Piazza Magenta is noble, perhaps the largest and most
refined residential square in Livorno. Neither the Via delle Ville
house nor that on Piazza Magenta was a modest abode. Those who
make the "crash" of the Modigliani accountable for a subsequent
peculiar vainglory in painting, err. They came down, but not with
a bump.

Modigliani cannot have lived much at Piazza Magenta. In
1901 he was at Capri, and Rome (with a significance until now
missed even within the family). In 1902 he was in art school in
Florence; in 1903 in art school in Venice. He did come home, to
Via Giuseppe Verdi, in 1909 and in 1912. Natali claims he saw him
in Livorno in 1916, and two drawings bear the possibility out, one
dated "Livorno 1916," the other of "Cypresses in front of the Sta-
tion Livorno 1916." But we shall see what can be made of Modi-
gliani's datings and inscriptions, and here the second inscription
could mean cypresses in front of Livorno Station drawn in 1916
but at another place—a simple comma in front of 1916 would see
to that, and Modigliani was never careful about such matters. If
he did return it had no effect on him, and so we will pass it over,
for surely we are not concerned with the occurrence of event but
what it has to say.

In and from the house at 4 Via delle Ville, Modigliani must
have lived the whole of his Livorno life, save in 1909 and 1912.
It contributed, perhaps irreversibly, to his formation. The conflu-
ence of two alien lines, the Modigliani and the Garsin. They were
the two mainstreams of Sephardic Jewry, sundered.

A loneliness characteristic of Modigliani began as early as
those Via delle Ville days. For all his friends who became artists
took to the provincial and rustic quality of Livorno, which was
then enclosed closer than now by the maremma, a tundra on
which white oxen sparsely grazed, as depicted by Fattori, their

common master, and Micheli, his imitator, their teacher. And only Modigliani—it was a matter of the blood—responded to the elegance of Pisa, Siena, Florence. Natali told me: "He was a Sienese painter of the thirteenth and fourteenth century at heart." At heart, but not at first.

His bent was venereal, almost from the beginning; of course this is not original in a young male. One must not write: the young Julius saw Rubicon written. And he stood amazed. . . . That is vertical biography, and biography should be written horizontally, as it is lived. We do not live on a pillar of assault upon the future, but upon a wide plain, half visible, chaotic, somewhat meaningless, and not particularly well sorted out. Romantics of Modigliani —legion—have, showing it inevitable in a lover of Dante (Beatrice —Beatrice Boralevi, Beatrice Hastings), made Beatrice Boralevi his first love. He had *no* love, and was to have but one. They have not read Menè's letter to his sister admonishing her ". . . if you could only forget your little Bice" (Bice was Beatrice Boralevi).

While Modigliani, I think, could not love women he loved Woman very much—his female nudes attest this. They are painted either before or after copulation. It is interesting to try to discover which. The model is looking at the painter, and a close look into her face will enable you to determine which. When Beatrice Hastings began to appear at the Café Rotonde, picturesquely got up as an English shepherdess holding a little basket suspended on a ribbon, Kisling wanted to paint her. Modigliani wouldn't permit it. Light is cast on what he thought to be true of painter and model. He said: "If a woman poses for you she gives herself to you." A door opened onto the nude painting sessions, always locked in the terrible last years; and we see what gave rose, ochre and peach sensations to art.

Menè's Letters

Menè has been writing to his family of the shortage of girls in the Apennine villages for the conscripts, of "collective flirts,"

"unisexual dancing," of himself dancing with a great blonde who would have been charming had she had the other eye; he is doing his military service and seems a lovable, idealistic child, though he is but two years from prison as a dangerous anarchist. Now he gives us some idea of life in the family by the following to his sister Margherita—Piticche, his pet name for her.

Last night I was lying with my face in the pillow when my emotions awoke and I felt as you often feel, you too, in one of those splendid states of spirit when the blood floods the brain with the vital juices of great ideas, in one of those states when, in the street, in the evening, you quicken your step, sing at the top of your voice, strike the walls—and in your camp bed you screw your head into the pillow to isolate yourself, to concentrate, to hypnotize yourself almost, in order more intensely to contemplate your great thoughts—last night I gave myself up to bestiality and the thought of Piticche fixed itself in my head, tenaciously.

Menè to Dedo, they are twenty-four and twelve:

Perhaps it is useless to try to make you understand. . . . As, if I am not mistaken, Dante says . . . he of Signor Rodolfo. . . .

He refers to their parents as their *genitori*, as he always does: "authors of their existence."

How many times when performing work I have felt myself a stranger! This morning my first clear thought on waking was: I too am the son of working people!

His mother has opened the school; and now a performance has been put on in the Bebé-Theatre, and it is in the press. He is mortified in the depths of his Sephardic heart. He has mixed feelings about his mother's school (was he wrong?)—does she vaunt herself, seek applause, importance? It is unworthy of the family, and now is in the *Corriere Toscano!* But mama is *working.* And he wakes and thinks: "I too am the son of working people!"—and Dedo must understand this, impart it to the others, the discovery that they are children of working people. And he is to go to papa and mama and explain, and if they understand and agree he is to embrace them . . . "then think of all the rights given you by this discovery of being the son of workers!"

25

MODIGLIANI

1925, to mama (*mammicchia*)

Can it be Hebrew to be full of passion? But you can't turn back. And you must pay the tribute of the *chorchorim* in the purely animal sense.

But intellectually, nothing *chorchorim* about me!

How much Modigliani. I mean, Amadeo. *Chorchorim*—Hebrew for Jew. Sephardim corpuscles in the blood, but in the head—none.

"To know myself odious gorges me with pride" (April 4, 1926) —how far truer of Amedeo in Paris!

To mama (*mammicchia*, little mama)—he is forty-five and a member of the Chamber of Deputies.

> o listen! I am back from a solitary gallop over the hills under a sunset of violet clouds and gold sky. Galloping homeward I had the sensation of feeling well, put back new, and I thought: my old darling has perhaps molded me well. And to you I dedicated the throb of health, the agility of thought that mark such moments of full wellbeing, stung by the motion, the air, the beauty surrounding one. And I have thought it will make you happy to hear all this. I hope I'm not wrong and embrace you hard hard
>
> Menè

The very heart of the man is in that; it was within the much more contorted façade of Modigliani; and perhaps it derived from the despised Flaminio after all.

The word of the Garsin for embrace was *pascere,* to nourish. *Baci, baci, baci. Pasciti! Scrivete, scrivete, scrivete, cara, cara, cara.* (Kisses, kisses, kisses. I send you nourishment! Write, write, write, dear one, dear one, dear one.)

In his letters, obtained from his widow in 1973, Menè uses the language of the tribe in referring to money, *il malito*, the little bad thing—or simply "t," or he puts it into Arabic, *filussi*—the Unutterable Thing. He casts light by introducing Latin to Flaminio alone: with a formality not like him. To Flaminio, in the two letters that remain and are perhaps all there were, he does not use French, and one feels that probably Flaminio did not know

French, and that this was used kindly against him, isolating him the more. But, in general, in the letters Menè mixes French in with Italian, makes words by putting Italian endings onto French (a game with Dedo)—a smattering of Hebrew, Livorno slang, Judaico-Livorno words that exist nowhere else on earth.

"Socialism is the cheese on the maccaroni"—but, Menè writes, he becomes "politically unhygenic." *Tolstoianeggiando* by force, he finds good in it, for "living under a dictatorship is like prison . . . when you can do nothing more you relax and sleep better." Almost wearily he abandons the Tolstoyan mood and speaks out. This is at the Matteotti trial when his defense of the Socialist Giacomo Matteotti turns into an arraignment of Fascism brought into the dock.* It is a kind of relief for him.

3-4-1926, Naples, to *mammicchia*

> You will have read in the newspapers of the greeting the Fascists gave me. Now I am content and proud. The accounts exaggerate the bodily injury.

8-4-1926, (Menè's office is ransacked and everything smashed), Rome, to *mammicchia*

> Yes, the office was not in the orderly condition I keep it, but our noble persons are safe and sound.

"The humble masses alone can solve problems, never the individual"—and he is against individualists, such as are even found in the Socialist Party. But he writes from exile that he has gone up in the Eiffel Tower. The people below look like ants. Why are they purposelessly milling? To what end? What does it mean? You feel that he has an honest heart; he is a plain soul, as to the willing of it, but he has a blemish of the theatrical—which will flower in his brother in the Café Rotonde in Paris and in many a female heart and cause it that Modigliani be called "very Italian." The one *apt* flourish!

The Menè letters—from 1920 when Modigliani died and until Menè could no longer write to the family from exile, for it is too

* The murder of Giacomo Matteotti by Mussolini (in 1927) was the real beginning of the dictatorship.

dangerous for anyone to receive letters from him in Italy—are the best source for true information of the burial together at long last of the suicide lovers ("Finally they sleep together"—8 May 1925); the speculation and perhaps forging of Modigliani paintings, perhaps from the first hour; the first biographical falsifications (1922, to *mammacchia*—"disregard the *impressionism* of a *boulevardier* critic who in order to provide something fashionable writes . . ."). For contemporary letters cannot be revised with an eye to advantage, and we shall have recourse to them.

1926, from exile

> . . . about the fate of Aunt Lo. Think not of the legal responsibility, if the doctor doesn't give the guarantees hoped for, but about the moral responsibility if the woman does what can be imagined and abuses her mania of grandeur.

༜

Some of the names that assault you in present Livorno, with Piazza G. E. Modigliani and Via Amedeo Modigliani, the latter rather lost in the north part of the town—are Viale Fattori, Via Llewelyn Lloyd, Via Micheli, Via dei Macchiaioli—misspelled—Via Uberto Mondolfi. Modigliani entered Micheli's art school on August 1, 1898, in that crucial summer not three weeks after his brother was sentenced; Fattori was the master they all looked to, if they would, said to be the exemplar of *macchiaiuoli* painting, though that was qualified, at least by him; and Llewelyn Lloyd was a fellow student, a gaunt young man, half English.

Uberto Mondolfi was the young Modigliani's best friend, and the first thing Modigliani ever drew he drew in companionship with Uberto, so that the queer death's-head Pre-Raphaelite drawings on the backs of two harp-back wooden chairs, which still survive, are by one or the other of them and both together. But Uberto was seven years older, and in 1898, the critical year (how often this happened!), he turned from Dedo to Menè—he was almost exactly between them in age—and Socialism. He became eventually Socialist mayor of Livorno, which is why he has named after him a

long curving avenue going out past the beaches of Antignano and on toward Rome. He was ousted by Mussolini.

The first key person who appeared in the life who was not of the family was Uberto's father, Rodolfo Mondolfi—"the professor," as Menè called him with sarcasm. He had a good deal to answer for with the family. He was probably the most erudite man in Livorno. The idea of Eugenia's school was his, which Eugenia and Laure took to almost too readily. In 1884, in a manner subject to two different interpretations, the Modigliani had conditionally failed. In 1849, Emanuele, the grandfather, had come to Livorno. Among the Roman Modigliani the tradition is that he was a big spender, lived beyond his means. If Eugenia saw him differently, a straitlaced tyrant, the patriarch, orthodox in Jewry (a particular crime in the eyes of a Garsin), it was perhaps that when she was brought into the household she was sixteen and he was seventy-five. The fact that Crescenzo, head of the Roman Modigliani, saw fit to shift the youngest brother, Laudadio, over to Livorno only four years after Emanuele arrived there, would seem to bear the Modigliani version out—"the eye of the watcher." It may have been Emanuele, the grandfather, who commenced the failure, but of course Eugenia would not have it otherwise than that it was Flaminio.

The Modigliani in Rome were a very distinguished family, more distinguished even than the Garsin. The Sephardic Jews, the exiles from Spain, were, on the one hand, the lords of big business, and, on the other, the literary and philosophical Jews, much touched by their contact with the Arab in Spain. They had nothing to do with the Middle European Jews—the Soutine, Kisling, Lipchitz, Chagall, whom Modigliani was to meet in Paris—and without our knowing that he belonged to both Sephardic lines his life cannot be understood. When he was at his vilest, around 1911, his daughter explains it by saying—"but that was Arab, Sephardic Jew, Mediterranean, that bitter sarcasm." He was not a "Jewish" Jew at all; which is why most who knew him, themselves ordinarily north or central Europeans, say he had nothing Jewish about him. The Modigliani line belongs to the earlier Sephardic stage, having not yet come to think even big business contemptible, and the

Garsin to the latter, or idealistic stage. Modigliani did not know until 1901 that the Modigliani were great, and it affected him deeply. Eugenia may have known, or may not—it is hard to see how she could not have—but she said nothing about it, for the Modigliani in Rome had the great fault of exceeding the Garsin.

By 1849, Emanuele Modigliani thought he could buy a vineyard. His father, Abramvita, Modigliani's great-grandfather, had been one of five Jewish councilors to Napoleon to decide the fate of the Jews of Italy at the time of the Napoleonic invasion (turn of the nineteenth century); and Emanuele himself owned silver mines in Sardinia and forests there used for making charcoal. He had just done the papacy the favor of providing it copper; and felt that he was above the Justinian edict which forbade Jews to buy land. But he was ordered to cough the vineyard back up in twenty-four hours, and in his rage left Rome and went to Livorno. So, at any rate, legend has it, and not all legends of Modigliani should be rejected just because so many of them are palpably false (a truly dramatic life veiled behind a melodrama). From Emanuele's grandniece, ninety-seven, I was unable to find out if the vineyard story is true. In any case, the Roman Modigliani consider that Emanuele was probably fool enough to have done just some such thing.

It was not a foolish thing to go to Livorno as such. It was very sensible. The Medici had taken it over, when once they had become dukes of Tuscany, and set it up to rival Pisa—which had been the chief port till then. In order to attract trade, they had made it perhaps the freest city outside Holland for Jews. The Israelite Temple, just below which all the peregrinations of the Modigliani family can be found in a narrow triangle, was the largest synagogue in Italy. Rome itself was a free city to Jews, for it is a paradox that when the Catholic religion was driving the Jews out of Spain, Alexander VI, Borgia, was not in the least in agreement and there was great toleration in Rome within steps of the Church. Rome was free, but Livorno was freer.

By July 12, 1884, when Modigliani was born, Grandfather

Emanuele had died. By his management, or Flaminio's, the business had been brought low. In that July, Eugenia had everything in the house piled on her in childbed. For a law prevented bailiffs possessing anything on the bed of a mother with child. Eugenia soon saw that she could count on no one but herself; which she would probably have seen in any case.

She wrote a short story, and published it, and wondered if she might not become a novelist. Meanwhile Professor Mondolfi had given much to her self-confidence, eventually suggesting the school for young children of the bourgeoisie which was opened in the Modigliani home on Via delle Ville as a way of ameliorating the deteriorating financial position and showing that if one were not able to do it then another could, and which she could manage. Further, Mondolfi opened many avenues—Nostradamus, Dante. Mondolfi was a great Dante scholar, and Modigliani's knowledge of Dante (he often misquoted him, and sometimes simply made him up, Lunia Czechowska told me), which subsequently "amazed Paris for he could quote the entire *Divine Comedy* by heart," was come by in this way. Nostradamus, too. Modigliani was involved in occultism by 1903 in Venice, preface to Paris days with the incredible Moricand, and Crowley; but there was this tradition in the family. They were humanist, freethinking, theoretical, vastly read, and it is natural that such people are superstitious and turn to esoteric cults, for they cannot believe in what others do but nevertheless must believe in something.

The household gods were Moses Mendelssohn, Spinoza, Emerson and Uriel da Costa, and Mecca was Amsterdam. Emerson was Eugenia's particular pet, and there was a falling out here, for Laure much preferred Nietzsche. Could he not write better? Probably he could. Emerson, being Unitarian, particularly appealed to Eugenia, for the Unitarian passionately believes in a god who he says does not exist. Modigliani has been much maligned for being a fabulist (he was a fabulist) in saying he descended from Baruch Spinoza, who had no children. But did he say he descended from Baruch Spinoza or *the* Spinoza? There is no reason not to think his great-great-grandmother, Regina Spinoza, who married Solomon Garsin in Tunis, was of the philosopher's line. The possibility is he

did claim descent from Baruch Spinoza, for he liked to put the gloss on a thing. Biography has until now found him much at fault in boasting, in Paris, that he descended from rich bankers, for where were the rich bankers among the Garsin, of whom a full record was kept by Eugenia and uncovered by Giovanna in the 1950s? It might have occurred to someone to look among the Modigliani, and they would have found that Moses Modigliani, in the years around when Modigliani went to Rome, was one of the biggest bankers in Italy. But Eugenia didn't give space to the Modigliani.

Eugenia ghostwrote criticisms of Italian literature in English for an American who signed them and published them; she translated D'Annunzio.

Modigliani commenced to read D'Annunzio. His aunt gave him Kropotkin's *Memoirs*. He read Bergson, who was the perfect Sephardi, saying that the life force is everything and that if you can break from the mold you can create yourself. A man is the product of his heroic vitality, if only he can free himself from the materiality which is the gross social matrix—the Darwinian predetermination is a fraud, and God a queer fellow who, being inscrutable, does not count for much. Modigliani was fourteen.

He finished his preliminary schooling, then refused to go on. He was let enter Micheli's. He drew so incredibly well in 1898, presumably his first year, that it seems likely his art education in some manner preceded this. The School of Paris was to know three naturally genial artists: Picasso, Modigliani and Pascin—and they were all precocious. It is natural that gift should be precocious; for it is not learned, it is there. Modigliani, in his fourteenth year, drew as well as Picasso did in his, which was three years earlier: Picasso was born in 1881, Modigliani in 1884; and the chief difference between them from the point of view of technique was that Picasso was the son of an art teacher, so that he was always being saturated in the learning of art and proceeded very fast—"He is always ten years ahead of us," Modigliani was to say later at Parc Monceau. In fact, there is a letter of Eugenia's in 1899 which refutes her own statement that he began newly in the year before that.

Dedo has abandoned his studies completely and does nothing but paint, but he paints all day and every day—with a fervor and constancy that enchants and stupefies me. If he doesn't succeed this way it truly wouldn't be possible to do more. His teacher is very satisfied, and I—I can scarcely understand, for it seems that for having studied only three or four years he certainly paints not badly and he draws really splendidly.

This is the Livorno Museum copy, and I have not seen the original. Another copy, it is true, says "three or four *months*," but this seems downright impossible. The self-portrait in 1899, when he was fifteen, and the portrait of Micheli's son, done in the same year, are as accomplished as the youthful work of Picasso at the same age now to be seen in the Barcelona Museum.

He was the most literary painter of the age, and I think of any age. Even painters who were very good poets such as Michelangelo (Modigliani was a bad one) couldn't approach his *immersion*. It was family in part; but then he went on. He read Mallarmé, Ronsard. He read Carducci—high in tone, free in spirit, violently felt and in the mold of majestic form. He read Verlaine, the cheerful, heedless, childlike man, who ended his life in poverty in the Paris cafés and hospitals—notations of himself (be it Verlaine or Modigliani). He read Kropotkin, geographer, explorer, Socialist and anarchist. He read Bakunin: "A man obeys laws he himself feels, not any imposed on him by any authority." He read the heroic dynamism of Bergson. He read Leopardi, from a mother-dominated family, insignificant father, a patrician family down in the world . . . the morbid attractiveness of sickness. He read Baudelaire, Poe, Nietzsche, Dante, Lorrain, Villon. He read Rimbaud, Lautréamont (the poet of Surrealism—yet far in the future). His mother one day gave him a beautifully leather-bound volume of Oscar Wilde's *Ballad of Reading Gaol.* He read Shelley, who had sailed forth from Livorno to his death.

It was lamentable, for a life that began in the heartland of dream, that there had to be these tetherings—the romantic impulse, tethered—ending in hashish, absinthe, the "love" pits of discreditable women, fringed about by mangrove (the pubic hair)—

women disliked (while loved), and maimed and injured and abused, finally.

I think it worth translating the poem which was his favorite of them all. It is Baudelaire.

Often, as an amusement, the crewmen
Seize an albatross, flier of the vast seas,
Who, lazed companion of travel, follows
The ship spanning the bitter depths.

Placed on deck
The king of the blue, awkward and ashamed,
Lets its strong white wings
Drag like oars beside it.

The winged venturer, how uncouth and weak he is!
He, till now so beautiful, how ugly and comic he is!
One jabs his beak with a pipe,
Another, limping, mimes the crippled flier.

The poet is like that prince of the clouds
Who outflies the tempest and laughs at the archer;
Exiled aground amid jeers,
His great wings prevent his walking.

The family was cruel to Flaminio. To what degree with justice? It is important to know, for thus one measures Garsin. Much that Modigliani did in Paris was pure Garsin. The namegiver, Amedeo, made two fortunes and lost them—apparently because he regarded business as a kind of game of chance, in which the interest was in seeing which card would turn up. Isaac, the grandfather, also sported in business; with the consequence that he failed, but he didn't care much about this, and, having come to Livorno, spent much of his time walking with Dedo, clear out as far as Ardenza: where Margherita had begun to teach school. Isaac discoursed with him, then become twelve, on philosophy, especially Nietzsche, on whom he was expert. He was a good-looking middle-heighted man who seldom went to the Bourse, leaving that to others, but was adept at chess, and a seasoned debater in the club across from the

Caffè Bardi. One day at Ardenza he suddenly turned off the path, stepping aside into the furze of sea-bracken, and commenced to rage, breaking into unreasoned rage which seemed to have no provocation, or root in practical fact—a smooth-bearded man with silky muttonchop whiskers raving without cause, one pale, extraordinary eye, milk upon blue as the cataract had begun; but this did not surprise Margherita or Dedo for it was not considered unusual in him.

Perhaps in the blind blood was the origin of rages that puzzled everyone in Paris. Modigliani, later on, had something too of the exhibitionism of Laure; and who can know if he got it by heredity or emulation? He thought himself a wounded albatross, and he was; it is a paradox of his life that he released his art by self-destruction. It is important to know to what degree Flaminio was guilty, for this throws light on what it is to be Garsin. "He *was* nice," Giovanna told me, "but he was weak." Yet Laudadio, Emanuele's, the grandfather's, partner, had died in 1867 and everything had been left up to Grandfather Emanuele. Flaminio was then in his late twenties. Things were done differently in those days, and a son might not necessarily have overruled his father. Flaminio had a certain ruefulness, a wistfulness, in the face of life, and who knows if he got it from helplessness before the frivolities of the "hatefully too correct" Emanuele or at the spur of Eugenia? Emanuele lacked "the irony of the Garsin" in any case; it could be very high. In the mouth of a young, too-good-looking man in Paris, it could become sarcasm which dripped acid.

Modigliani employed, without a doubt, the endearing, beseeching smile with his mother, as later on he used it with woman after woman in Paris, to their destruction and his. Giovanna was fourteen months old when her parents died in the romantic aroma of suicide, but she lived in the family in Via Giambologna and knew well, as one does in the heart of a family, how it had been in the earlier day. The kind of superficial insight until now applied to Modigliani has considered his dependency on his mother a proof of sidetaking against his father; but it got him what he wanted. One feels Flaminio, if tolerated, might have done the same. Eu-

genia's red leather, hasped album which Giovanna, who owns it, may show you, reveals a strong, intelligent tribe, not looking very Jewish but looking Italian though they were French—"disequilibrated, unproductive, lacking social adaptability, but acutely intelligent" (Eugenia). Among them, a single photo of Flaminio, a Modigliani—he has something kindly about his mouth, the gentleness of the horse that has been beaten much and rendered sweet-spirited.

Giovanna thought that alcoholism is an hereditary ailment—but Modigliani was not alcoholic.

His daughter's sense that alcoholism is an hereditary flaw, a confession of the blood, which beats unseen, is natural. She is, herself, an alcoholic and has seen the inside of wards.*

I asked Natali, who went to school with him, what was the one distinct characteristic of Modigliani when he was a boy. "A sense of superiority," he said; "a strange sense of superiority. He did not find people of his category in Livorno, but he was right." It was strange but not unjustified—and at the same time he was a good companion.

Seen in her later photos, Margherita is distinctly masculine; when I asked Giovanna if her adoptive mother and Modigliani's sister was a lesbian she gave me a meaningful look. She has a marked tendency to attribute the explanation of things to erotic maldirection. Modigliani reflected something deep in the Garsin; that they should automatically be accorded special status. But the

* Self-destruction is not amusing; it may amuse others. But Modigliani dramatized it nevertheless. He brought on death, yet he did not, according to his friends, see it coming. He courted the unseen, dancing before Herod as Salome, head on the platter, but it was his own. Could he have in his nerves known? (He did not in his mind: Zavado, Lunia, Mondzain—all I have consulted still alive who were then closely present.) He had the kind of nerves which know what they do not know (not so unusual, perhaps only a lowering of the threshold of the barrier of the mind, of conscious awareness, tethered to the day, which tells us what we know, eliminating what we *know*). His demise, full of glint light, like swords flashing in gleeful desperation, and *deep* shadow, has, some time now, amused readers. But the stark face, so far as it may be chiseled free of the matrix supplied by men of the School of Paris, men of invention, is more unsettling, and in a crazy way glorious. Not dogged in dying, resolute, like Van Gogh—but more like Poe: a quality of the imagination, doubtless. He said to Survage in 1919, who wrote it down, "Alcohol is for the middle class evil. It is a vice. It is the Devil's beckon. But for us artists it is necessary." The fact is, alcohol was necessary to him. It was essential to his work method; eventually ineliminable from it.

innocent look surprised, in the unposed photos when he is not on guard against it, is Flaminio's. Modigliani disregarded Fattori's teaching received by means of Micheli as early as Capri; but Fattori's art influenced him all his life, Giovanna told me. And so it is. In Montparnasse, when it was the habit of the girls to go naked under a coat to the café, and when Kiki of Montparnasse went to Foujita naked under her coat, and then threw off her coat, and then sat down and proceeded to sketch him, which she did not at all badly, and the girls went naked to the Quat'Z Arts Ball and danced naked in serpentine chains with the boy artists in the streets of Paris afterwards, and at dawn plunged naked into the fountains of Paris—it was Modigliani alone who, obsessively, stood suddenly, not very drunk, and probably not drugged, and, unwinding first his six-foot scarlet sash, undressed himself slowly, until he exhibited stark naked the white torso of the handsomest man in Montparnasse—a description due Diego Rivera, or rather his mistress, Marevna.

Micheli was a rapscallion of another feather, looking like Errol Flynn; his white oxen, his "spotist" painting, as you may see today in the Museum of Livorno, he may have taken whole from Fattori, his master, but Guglielmo Micheli, thirty-three then in 1898 when Dedo started to go to school to him, was no mincer in life—with his jaunty goatee, hat on the side of his head, short pipe stuck into his mouth. His school was in the Villa Baciocchi in Via delle Siepi, a street then on the edge of urban Livorno. Houses stood by themselves there, among them that containing the cluttered room, easels, canvases, podium, which was lit by three large windows on the ground floor. It is five minutes' walk from Via delle Ville. In those days, the Modigliani homes were in the thick-grown sector; consequently can be seen today as they were then. But Via delle Siepi was in the open and now is built up with those structures, which you may call beautiful, derived from the art born in Paris when Modigliani was there: Fernand Léger, Archipenko. Modigliani did not like these people, and he did not get along with them.

Micheli had ten students, youngest of whom was the pixie-looking Dedo, a Huck Finn with his short-cut hair standing straight up, and a grin. He was called "superman" because he always talked about Nietzsche. Later he saw that Nietzsche is a very great psy-

chologist, not a philosopher at all. Was philosophy even possible? That his call to the Will to Power is an emotional bent; temperament, not a conclusion. That *übermensch* really means aristocrat more than superman. But at the time he was mischievous—an "intelligent, spoiled child," Eugenia wrote in her diary. He burnt up his life in fact, in part out of irrepressible gaiety.

Of the boys, seven became professional painters, three known, one world-famous. As in Venice Cadorin and Mauroner had the immediate importance, but Boccioni, the greatest of the Futurists, and Ortiz de Zárate, the enduring significance, so here Romiti, eighteen then, the right age, meant most, filling the gap left by the defection of Uberto Mondolfi. But ultimately it was Llewelyn Lloyd who mattered. For he lived across the street from Ghiglia. Because of this, Ghiglia eventually became a painter, after a most picaresque life. In Ghiglia, Modigliani found "someone of his category in Livorno," or so he thought.

Romiti was eighteen. Modigliani, writing to him from Seravezza, probably in 1901, when he first undertook sculpture, two years before the earliest assignment yet made, could gain immense pleasure by signing himself simply "Modigliani." He thus gained the level of the boy he looked up to. It is usually said that Modigliani was taught sculpture by Brancusi, with whom indeed he sculpted in Paris from 1909, but who he said finally was "worthless." An estimate not without merit, when sufficiently looked into. Modigliani was studying sculpture in Venice in 1903, simultaneously with painting, and he always wanted to be a sculptor. He was a painter against himself.

1901, Pietrasanta

Dear Romiti,
Write me here at Pietrasanta, Via Vittorio Emanuele at the house of Emilio Puliti. I hope to work, that is finish, and see you soon. Greetings.

Modigliani

In 1912, again in Pietrasanta, in a sweltering August, he hewed what may have been among the greatest of the tall, narrow

figures, their necks as though by Parmigianino, their eyes and noses African, but a particular part of Africa destined to touch his nerves, not the part of Africa of "African art"—Picasso and the others. It was the region where Michelangelo quarried, from Mount Altissimo, when he used the marble of the land of the Medici, not that of the lords of Malaspina at Carrara, patrons of Dante. Modigliani cannot but have looked at the green river, sliding down over pebbles of marble, and he may have glanced up to where the great *canale* were cut out of the mountain's breast, as by the bites of a pelican, hollows which held the emptiness of the statues of Michelangelo. He told Ortiz de Zárate in Venice in 1903: "I want to sculpture, but great, grandiose statues." He wanted "immense commissions," great, grand, enormous statues. He scorned ordinary sculpture. He wanted to work in stone, monumentally—like Michelangelo. He had, at that young age, a sense of destiny. He had seen at least the cavities of those statues by 1901, where the water flows past Seravezza carrying off the detritus of marble, and in Pietrasanta he had walked in the piazza onto which Michelangelo had looked when he lived in the room by the communale clock. His 1912 Tuscan statues, which could not have been giant (for none he cut were—though their conceptions and dreams were), ended in the Fosso Reale, miscalled the "Holland Canal" in all accounts. With them sank—and soon enough actually, for he sculptured no more after 1914 when his great period began—the art form he had really wanted. You search in vain for the "Holland Canal"—for there is none in Livorno—but in fact there are the Dutch Steps, the Scali degli Olandesi, siding the Reale Canal just as it runs off from Piazza Cavour, across from the Bardi; and as it is near not only the Bardi but the various Modigliani residences just below, here surely from the bridge Modigliani dumped his wheelbarrow. He did this. After World War II the municipality of Livorno dragged the canal, hoping for the statues of their poor citizen now worth diamonds, and municipalities, who have to justify appropriations, do not drag canals without reason—but they found nothing.

Micheli was a Macchiaiuoli—these were those who take to the thicket (*macchia*) like pirates. Blotchers, really, who make blots

(*macchiare,* Italian for "to make spots or blotches"), considered to be the Italian form of Impressionism, with which they were contemporary. But an examination of the pictures of, for example, Fattori, will show that it was not Impressionism at least in the Seurat, or late- or Postimpressionist sense, for it was not construction—a building up of the total thing by a placing of spots of color which would then gather into forms in the retina of the observer—but was simple, naïve observation. Fattori himself said it was naturalism, if it had to have a name and be something. He said he was a relative of Courbet—not Monet. His battle pictures, great composed formal scenes, now called academic, have a hard, egg finish, and it is the out-of-doors small pictures that are soft and blurry. And in fact if you go down toward Antignano, as Fattori did, and Lloyd after him, and look up the tree-screened paths or into the glades of sea-pine you will see the freckling of the flecks—for it is nothing but light and shadow observed. In Fattori's hand—though not while he lived, for his life was as tragic as Modigliani's—it recognizedly had a kind of natural greatness, for he had been drawn to it. He was like Turner looking out of the train window onto the mist of the Thames or into the steam of the locomotive, and then being almost ashamed of what he had simply observed, at the outset of Impressionism when it wasn't called Impressionism. And so, too, Fattori, if he was, was a Macchiaiuoli or Impressionist because he felt it, not thought it. And so naturally the others who followed never somehow did it quite so well.

He was a goliath; a rugged, immense man. Simple. Homespun. He ran through three wives, and was not true to any one of them, not even the last, whom he married when he was eighty-two. He received many honors, but practically no money, and then when he had died, just as if he were Modigliani, his seven hundred and thirty-nine paintings began to attain big prices. He sold few pictures at cheap prices, and became famous after his death. He refused knighthood—*commendatore*—and was always on the side of the people. One feels they were closer to him, somehow, than theory. *Macchiaiuoli* was applied contemptuously, blotchers, just as Impressionism after Monet's "Impression of a Sunrise," for there is an immutable law that movements that name themselves, and

thus have a program and intent, such as Futurism, come a cropper, for they sort out the mind too much. Fattori was of Livorno, and though he went to Florence, for he had to teach, and Modigliani went to his School of Nude in 1902, he remained of Livorno, and it of him—he left his mark on it, he was no Florentine. And doubtless, when the Macchiaiuoli "movement" was formed, in the years around 1850 in the Caffè Michelangiolo in Florence, he listened, but wasn't there. He became the greatest macchiaiuoli painter nonetheless.

And this was the system, thrusting out his billy-goat beard, that Micheli taught. Entrance into art school has triumph and tragedy in the shell within—for only the few can succeed, and these often triumph after death, a satisfying thing: Fattori-Modigliani. The two boys nearest Modigliani's age were Martinelli and Natali, all fifteen and sixteen at that time, and he was their friend, a better boon friend, ingenuously gay, than subsequent life ever permitted him to be—and not only to Romiti, "the older fellow" who fed his esteem, which never ceased to be hungry.

The Impressionist, pre-Impressionist really, he could see was Whistler; and of the Macchiaiuoli, Boldini, who didn't remain a Macchiaiuoli very long and became one of the most elegant painters of the female nude in Paris. He oughtn't to have selected Boldini; if he had had the slightest feeling of what this rough, country, outdoor art was about; but he did.

He was beginning, even so soon, vaguely to discern that the unconventional artist is not so in defiance of conventions, but because he is human—because he is one man and no other and therefore cannot have recourse to standard ways. It was conventional to be Macchiaiuoli in Tuscany in 1900; and conventional to be Cubist in Paris later. And Modigliani had the gall (the helplessness, in fact) not to follow.

His Spanish blood came out sometimes—and we see him dancing naked with la Quique outside the shack at 7 place Jean-Baptiste Clément as toro and matador; he is the matador and she, firm breasts wagging, forefingers from forehead like Devil's horns, the bull—but what is the urgency of the blood if it is not elemental,

and the exhibitionism of the Garsin? Picasso said—How is it Modigliani is always drunk at the corner of Boulevard Raspail and Boulevard Montparnasse but never on the back streets? But Picasso had a different image of himself, and a different theatre. Modigliani was—how human!—both really drunk and putting it on. It was Utrillo who was the real alcoholic, to whom a bottle of wine seen was the vision of the blessed Virgin at Lourdes.

Besides, personality is complex. The psychic personality has this advantage for us all—he shows us the enigmaticness of all personality. If Aleister Crowley has "magnetism" which simply cannot be explained, then perhaps also by extension all personalities are enigmatic—delved.

Of Micheli's students, Gino Romiti, who had a Satan-pointed beard and great ambition when he was nineteen, is dead. Like Ghiglia, the one who seemed the most promising petered out. The one who is most promising is he who is quickest at the expected place, and it is usual that he have ill-founded hopes, and tragic disillusion. Manlio Martinelli, then a little wistful-faced boy with a very small head, developed an art of his own which he refused to show, supporting it by storekeeping, and found himself at eighty-nine a recluse in a clinic, broken in body and bitter in heart. Renato Natali has pursued a reasonably conventional career his life long, though he has been shown at the Carnegie and has some name beyond Italy, and is still at it. "Picasso and Modigliani were great people, in their fashion." I was put to some thinking to give its proper weight to that "in their fashion." In the photographs showing these lads, nonagenarian now if not corpses long since, Modigliani vaults on—rather disconcertingly. In Romiti's studio with Bartoli, Sommati, who out of passion wanted to become a painter and became a baker, and Benvenuto Benvenuti, he is already the sure-of-himself fellow with his hands in his vest-pits. Only yesterday he looked out, impish and eager and puckish, from behind old Fattori who has come on a visit to Livorno—but Fattori is seventy-three and Modigliani fourteen, and Modigliani always did have this sense of what might be called artistic contrast. He was infused by the personality of another as though he drank

up living damp. He was an actor;* if that is not understood he cannot be understood at all. And we see him in a group outside the Caffè Bardi, now the Banco di Roma, in the first year of the century, in highbutton shoes and with a black Carbonari felt hat set flat on his head like a boat, to give him maturity. Natali told me Flaminio Modigliani, his father, had a *comptoir,* a counter, a counting house—that he engaged in *cambio,* changing money—it may be so. Giovanna says he pursued a wood-and-coal trade; but in fact she was not there, though Natali was, and did not join the family till Via Giambologna in Florence, when the Livorno days would be hearsay.

Bakunin had said: "A man obeys laws he feels, and rejects any foreign will whether 'divine,' individual or collective. Authority kills the heart. No authority is acceptable—we devote ourselves to overthrowing everything that exists—so that natural good, in the inner nature of all men, can prevail."—and Modigliani believed him.

Oscar

Oscar Ghiglia backpacked through the Apuane, carrying goods for sale in his knapsack, and pursued a tinker's trade, then became a blacksmith's apprentice, then a pork butcher in Pistoia, but afterward he returned to Livorno and became a grinder of paints for painters, and as he happened to live across the Via Paoli from

* Zavado told me he should have been a film star. "He would have been the greatest of all—for three-quarters of the picture. But he'd never have finished it." One day Zavado was entering the Rotonde when Modigliani emerged. They had not met. Nine years separated them in age. "Do you have five sous?" demanded the elder. "Yes." "Then come back in and have a drink." And afterwards, with generous camaraderie—"To the movies," and Zavado, the younger, would pay. Then: "Now— drink! drink! drink!" "He did not have to be poor. Menier, the chocolate-maker, wanted a portrait—but Modigliani insisted first that they sit across the street from the studio and drink *gros rouge,* by no means good in those days. So Menier had an experience, but there was no portrait." I almost felt as if there were revealed some *sign.*

"Long after he was dead," Zavado went on, "I caught fruit thieves in my orchard at Aix. Italian workers were brought into France, because no Frenchman would do menial work at that time. They were Italian workmen. One ran and vaulted the wall, but the other did not see me in time. He simply stood there, hands empty, welcoming me with an engaging smile. I accused him of stealing my fruit. 'Io? Io? I?' he exclaimed—'A thief?' And he went on in such vociferation over the sheer incredibility of the thing that one almost believed him, standing in my orchard as he was. My heart turned over. I thought—My God, Modigliani!" You could see the blanch of his heart in echo as he retold the story.

Llewelyn Lloyd, then commencing art school, the two last things came together and he became a painter. The remarkable thing about him is that he locked himself into his house in Via Paoli, saw no one, and, not having had a lesson from anyone produced his self-portrait (solid in composition, exuberant in color, vivid in expression, magisterial in design)—and it was accepted for the Biennale in Venice in 1901. This is a remarkable thing, apart from the way it bore on the fate of Modigliani. Ghiglia was back at the Biennale again in 1903 with a portrait of a woman, in the same year prizewinner at St. Louis in America, in 1905 shown in London. He was off the marks fast, to say the least of it.

He was twenty-three the year Modigliani was fifteen, which was the year they met. It was the year Modigliani entered art school. Llewelyn Lloyd was twenty. The two friends of Via Paoli combated the *bambinismo* and *nullismo* which characterized the genial *novità* in art—as it always does—but, at least in retrospect, they seem a little bit stilted. The new, as well as the academic, must always be combated in art; but there are combats and combats. What is needed is to be genial. It is unlikely that fifteen-year-old Amedeo seemed genial. They observed the strait (and narrow). Forthright confession; but forthright confession is not confession, and Modigliani's confession, himself in others, was far more profound, far more tearing. Besides, Ghiglia and Lloyd were pantheists, as suited the natural surroundings of Livorno, and compared to them Modigliani must be considered a diabolist. He felt that art stems from art, not from nature. They painted what *is*. Even today, their paintings are admirable. It was Modigliani's miserable fate to paint at the dawnstage; not the noonstage, when all is clear.

The Modigliani letters to Ghiglia, written in 1901 from Capri, Rome, and Venice, are among the most revealing in art, as to revealing the soul of the artist, and must be translated in full, without comment. Comment can come later.

Hotel Pagano, Capri
Dear Ghiglia,
. . . and this time answer, unless your honors make your pen too

heavy. I have just read in the Tribune the announcement of your acceptance at Venice: Oscar Ghiglia, Self-Portrait. I visualize the self-portrait of which you spoke to me and of which we already thought for those heroes of Livorno. I rejoice for you greatly and very sincerely. Believe that this news has excited me! I am at Capri (a delicious place in parentheses) for my health. . . . And for four months now I have brought nothing to conclusion—accumulated material. Soon I go to Rome, then Venice for the Exposition . . . I work at English. Yet I foresee the moment when I shall settle, probably at Florence, and work . . . but in the best sense of the word—that's to say, apply myself with faith (head and body) to organize and develop all the impressions, all the germs of ideas that I have accumulated in this place, as in a mystic garden. But speak to me of yourself. We've separated at the most critical point of our intellectual and artistic development and taken diverse roads. Now I want to retrieve you, and talk to you. Don't take this letter for one of vulgar congratulations, but rather as testimony of the sincere interest in you of your friend

<div align="right">Modigliani</div>

Villa Bitter, Anacapri, Island of Capri
Dear Oscar,
still at Capri. I meant to wait to write to you from Rome: I go there in two or three days, but the desire to pass a moment with you makes me take up the pen. I believe in your alteration under the influence of Florence. Do you believe in me—traveling in these places? Capri, the very name of which sufficed to stir in my head a tumult of images of beauty and antique sensuality, now appears to me as a land essentially . . . prefatorial. Within the classical beauty of the landscape is (for me) an omnipresent and indefinable sentiment of voluptuousness, while yet (despite the English invading with Baedeker) a glittering and venomous flower surging from the sea. Enough poetry. Imagine besides (these are things that happen only at Capri) that yesterday I went walking in the country under the moon alone with a Norwegian girl . . . erotic enough in truth, but also tender. I don't know yet just when I'll go to Venice, I'll let you know. Micheli? Oh Lord, how many are there not at Capri . . . battalions!

How's Vinzio? He must have started well with that little

<div align="center">**45**</div>

canvas. Will he go or stay there? Answer. And that's why I write, to know of you, and the others.

Greet Vinzio. Ciao

Dedo

Dear friend,

i write to pour myself out to you and to affirm myself before myself.

I am prey to the splintering and diffusion of tremendous energy.

But I want my life to be like a richly abundant river that spreads with joy over the land. You are the one to whom henceforth I can say all: then—I am rich and fecund with germination, and need to work.

I have the excitation, but the excitation which precedes joy, and which follows the dizzying uninterrupted activity of the intelligence.

I have already written you what I think is the advantage of such enthusiasm. And having this enthusiasm, I resolve to throw into the strife, hazard, war—an energy and lucidity never known before.

I want to tell you what are the new weapons with which I take up again the joy of battle. A bourgeois told me today . . . insulted me . . . that I, that's to say my mind, laze. It did me good. I could wish for a like caution every morning on awaking: they cannot understand themselves, or life.

Of Rome I shan't write. Rome, as I write, is not outside but inside me, like a terrible jewel fixed upon its seven hills as upon seven imperious ideas. Rome is the orchestration of that which encircles me, the closure within which I am isolated and drop my thoughts. Her feverish sweetness, her tragic countryside, her form of beauty and harmony, all these things are mine, for my thought and for my work.

But I can't tell you here all the impressions I have found in her, all the truth I have known how to take from her.

I have started a new work and since then have defined and formulated a thousand other aspirations stemming from outside the commonplace. I see the need of method and application.

I seek how further to formulate with the greatest lucidity the truth of art and life gained here scattered in the beauty of Rome, and as I feel also an inward link I shall seek to reveal and re-form the

construction and even one may say metaphysical architecture needed to create my truth of life, beauty and art.

Good-bye. Speak to me as I speak to you. Isn't this friendship: to shape and exalt the will according to its bent, and to reveal oneself to the other and before oneself?

Good-bye

your Dedo

Very dear Oscar,

you promised me the day by day account of your life from the time we separated until now. I await it impatiently.

As for my not maintaining the promise, I can't maintain it as I can't write a journal. Not only because no exterior event has for the moment penetrated my life, but also because I believe the inward things can't be expressed except when we are under their domination. Why write when you are *feeling?* These are the evolutionary stages necessary to pass, and without importance save for the end to which they conduct. Believe me, it's not the work in its stage of gestation, personifying and having to do with the shackles of all the particular incidents that contributed to its fecundation and produced it, that is worth the trouble of expressing and translating by a style. The value and necessity of a style is precisely in this—that it is the unique vocabulary apt for filling out an idea, separating it from the individual who has produced it, and leaving the way open for that which cannot nor should be said. Every great work of art must be considered as one considers any other work of nature. First of all in its esthetic reality and then as to the sources of its development and mystery of its creation, as they have agitated and disturbed its creator. This, pure dogmatism, however.

Why haven't you written me sooner? And what about your canvases? I saw the description of one in an article in the Corriere. Can't now expect a canvas from myself; am obliged to stay in a hotel here; realize the impossibility of dedicating myself now to a painting: however mentally and in the contemplation of nature I'm working a lot. I think I'll end by moving: the barbarism of tourists and holiday makers renders impossible concentration just when I most need it. I'll finish by going to the Austrian Tyrol. Don't speak of it yet at home. Continue to write Hotel Misurina, Misurina. Good-bye.

MODIGLIANI

Write me, send me what you promised. The habit of contemplation in the country and amid alpine nature will mark, I think, one of the greatest changes in my spirit. I want to talk to you about the difference between the work of an artist who has communicated with nature and that of those of everyday who seek inspiration in the studio and would educate themselves in *art city*.

Does one divert oneself in Livorno?

[no signature]

Very dear Oscar,

i received yours and regret enormously the loss of the first that you say you sent me. I understand your unhappiness and discouragement, and alas better from the tone of your letter itself than by the confession you make me. I guess at the reason and, believe me, have suffered and suffer real pain. I don't yet know the precise and immediate cause. As you are a noble spirit, only a sad reduction of yourself, of the right you have to joy and life, could bring you to such a state of dispiritedness. I repeat that I don't know the cause, but believe the best remedy from here, from my heart which is cock-feather these days, is to send you a breath of life—for you are created, believe me, for intense life and joy. We (excuse the we) have rights different from other people because we have different needs which place us—I have to say and believe—above the moral law. Your obligation is *not to consume yourself in the sacrifice*. Your obligation is to save your dream. And Beauty has tragic obligations, obliging however the most splendid exertions of the spirit. Every obstacle surmounted calls forth a swelling of our will, produces the necessary and progressive renewal of our aspiration. The sacred creed (I say for you . . . and for me) must be to exalt and excite our intelligence. Seek to provoke, penetrate those fecundating stimuli, thus only can you exalt the intelligence to its highest creative power. For which we must fight. Must we shut ourselves within the walls of narrow morals? Affirm and surpass yourself unendingly. The man who doesn't unceasingly spring from his energy new desires and almost fresh individual destinies—to assert himself always, and smash all that is old and a putrid ruin, isn't a man but a bourgeois, a grocer, what you will. You suffer. You're right, but your suffering—may it not become the spur for you?, because you chance renewal, and the further elevation of your dream yet higher,

stronger than longing. Perhaps you will go this month to Venice; but take resolve, don't exhaust yourself, habituate yourself to placing your esthetic needs above human duty. If you want to flee Livorno I can help you, but I don't know if that's the case. It would be a joy for me. In any case, answer. From Venice I got the most precious inspirations of my life; from Venice I seem now to go forth like one's increase after work. Venice, Medusa-head of countless blue serpents, sea eye immense green in which the spirit loses itself and is exalted toward the infinite . . .

<div align="right">Modigliani</div>

Upon these few letters follows the life as the garden the seed; flower and weed.

<div align="center">ॐ</div>

He had had several childhood lung illnesses, culminating in what may have been a recurrence of pleurisy in 1900, but nowhere in her letters does Eugenia actually say he had TB—and Lunia says that he did not have it. Other eye witnesses, with whom I have talked, report him coughing blood, but never—and it is crucial—until the very last. He died of a form of tuberculosis; but it was probably not lung TB. However, tradition has branded him, perhaps ineffaceably, with lung tuberculosis, perhaps because it was the romantic ailment of the nineteenth century. Natali told me: "He did not in the least feel he was damned by TB. He burnt himself up out of high spirits, appetite for life." And Zawadowski said: "He did not worry about his health. He lived too immediately to think of health."

His photographs show him now a healthy man; now wasted. And so he was observed to be by those who knew him.

He went up to Misurina because of Titian da Cadore. In his lifetime and for a long time afterward, Titian was known as "da Cadore," just as Leonardo is called da Vinci because he came from Vinci. Aspiration beat strong in Modigliani. Like any young man, particularly one who will become a genius, emulation too. For is not genius three parts theft?—Picasso thought so. He went

<div align="center">**49**</div>

to Misurina, in Cadore, on its incredible blue lake of Misurina eyelashed around by ozone-breathing pines which would have rejoiced his morbid lungs—if they were. Here it was Titian was born and this was the place from which (da) he had come. It was almost the last north of Italy, standing not twenty miles from Austria-Hungary across Dolomite peaks, as boundaries were drawn then. To the east, nearby, stood Croatia, then Istria. Yugoslavia did not exist. He was almost due north of Venice. He had come up through Treviso, for Trent and Bolzano were in Austria. He had gone to Venice, for there Ghiglia's portrait of himself was shown at the 1901 Biennale, and had there caught contagion, which would become virulent. It was love of the old Doge town, and a feeling it would give him something, something not available in the clarity of Florence. Something in the air . . . And here the Dolomites stood up like the old sex of the world, brown, crusted. Up here, a bird was printed clear—as it flew in the clear atmosphere. He must have seen his hotel inverted in the lake; did he see Cézanne's structure of the lake, built in planes of blue laid side by side, as one saw that construction in the Lake of Annecy near Geneva where Modigliani would begin that curious two-woman affair that led him down into the town of Paris? Unlikely. But maybe later in that unanalyzable crucible which is an artist. Anyhow, Cézanne was the only master he ever had, if he had one; not the Cézanne of Picasso and a hundred Cubists. If you have a different heart you see through it differently.

And D'Annunzio would set him on fire (*fuoco*) when he read *Il Fuoco* just now come out, with its glorifying descriptions of Venice; but perhaps he was on fire already? D'Annunzio, a man empty but gifted, as Modigliani would find out—but what a master where phrases were concerned!—the best in fact since Ariosto!—he had given Italy back language! And compared to its hue and call what was the content of a thing? Why, nothing. D'Annunzio was a plagiarist but— Like Lautréamont, who was the great author of them all for Modigliani.

He would imitate nudes from Titian, particularly that one he

finished for Giorgione—as though this were forgery!—where she has her hand placed just so. Well, perhaps it *was* for self-love. Hashish induces self-love in one inclined to self-love. A whole monograph could be written on love under hashish.

Almost at once, a dizziness rising in red waves in the head, stopping a moment in lakes one behind each eye. And then a sleepiness, which can be shaken off. Now this transfers imperceptibly into a stealthy stealing-in of levity, almost levitation, within the flesh—the body does not seem to rise from the floor but to rise everywhere upwards within itself, as though the meat had grown lighter. And from the luminous corpse the eyes glitter; and within it the spear of the consciousness grows humorously ironical, detached in space. The penis gathers wavelets of feathery tremor slowly closing in on the center of its base, and when they have washed lightly up they recede, falling back as if under the pubic hair, each strand of which becomes alert. It seems as if either from the pubis to the eyes to the woman, or from the woman to the eyes to the pubis, there is a radiation—and the radiation mounts in a slow reluctant thick quivering a little distance up the penis, and the penis straightens half up. The nipples of the woman have grown slowly and then suddenly hard at the suck of the eyes on them—pulling at them mockingly. The sleepiness is gone. Both persons now talk with a detached, peculiar clarity, the sentences seeming incised in a somewhat reddish air, as though they are almost seen. They endure a little longer than seems normal. The two lovers eye the sentences suspended in space, each his own a little more than those of the other. He feels suspended over his words and in peculiar command of them, and thus very ironical, a Garsin irony; and superior to them in an amused mocking superiority over them, as if he could touch them but they not him: as soon he will be suspended over the cuff, feeling peculiarly afloat, a detached head like a balloon, amusedly superior to the point of laughter over the opened flesh, morbid, darkened, livid with the tumescent flush of blood to the vaginal cuff; which he can rub suddenly hard with the whole palm and heel of his hand

without warning all up and down all of it three times thrice and stop—as Nietzsche writes: if you gaze long into the abyss, the abyss gazes into you.

She finds all he says excessively funny as they sit tête-à-tête. But what she says funnier. She commences to burst out in freshets of giggles—she looks at them with amazement there where they are in front of her mouth. Suddenly, having puzzledly studied it, she laughs at her laughter. She is naked to the waist, he clothed—as is right. But the languor has begun to coat the balls of her eyes: the *extase langoureuse*, Verlaine writes. No dizziness. Everything is very clear. She is engrossed wholly with herself, entirely delighted with her cleverness, and he isn't there, and he is as if he were about to paint her instead of love her, then paint her later, and she is already absorbed into him so that he does not see her, and she will reemerge upon the canvas transformed into himself in her form, so that he is wholly master of her and possesses her—and the sexuality and angry and exuberant and zestful copulation within moments to come are already present as though they had red, blooded steak on the platter but had not yet forked, and the saliva flushes the gums of the cuff. He exposes himself. He likes people to look at him naked. It's a ridiculous and ludicrous reversal; and he likes that about it. He likes to be naked in a group of people where it is inappropriate and they are clothed, helpless and seeming pitifully exposed, skinned off suddenly to the buff in a clad crowd and center of attention of those who look at him exposed—not nubile, a little feminine. Besides, immensely beautiful. Grandiose—is that the word? Something like that infused his short life, and had the stain of mortality. At least, if you disrobe among dressed people it disconcerts them, and that's good. Would it be sufficiently awful to expose Utrillo's boniness—? No, Utrillo knew how to humiliate and degrade himself in other ways because he was passionate for the cuff of his mother not cuff in cuff sense but abstractly, for surely he was impotent, and so he so loathed human beings that he could not paint them into his pictures; because he was one. Modigliani has taken off his clothes because that is a mockery of her somehow, who still has her skirt on—*she* ought to be naked, not he. And he has done this in a thousand

ways, and a thousand times. A great quality in Modigliani is his woman's instinct for putting other people in the wrong; it must have something to do with the way he takes out an immensely beautiful male body from his clothes and puts it naked in a gathering. Both of them are distant from themselves. Of course he is not invariably paradoxical—like that infernal Picasso!—but then he is Italian, not Spanish—but surely he loves the off note, the disorienting, as a correct exudation of his grace, something that is really velvety about him—that everybody notices—and that has made him a kind of whirlpool for the cesspools, that are women, and that are all helplessly drawn down. Distant from herself, she sees herself see the derision of his—stiff—

Of course this is a more grown-up Modigliani—in Paris.

He wanted to use himself up. "I want to be a tuneswept fiddle string that feels the master melody and snaps." So he said later. But perhaps he wanted to be tuneswept and not snap?

There is Cubism in the angular sense in his work around 1915, as there is Postimpressionist spotting in his portraits of Diego Rivera and Frank Haviland, if it is not a form of Macchiaiuolism, and it is interesting to see how he gave up Cubism completely. When he was dead, Picasso said: "Phew, thank God!", though he had gone to the grandiose funeral. Picasso was no talker, and Modigliani was; and Picasso did not like his success with women. So when once in the Rotonde Modigliani was doing his *"moi, moi, moi"* (Lanthemann) Picasso began to mock his exhibitionism. Modigliani overheard him. Lunia Czechowska: "At once he went over; said 'Vous êtes un salaud!' * and upset the table into Picasso's lap. He then went home and removed everything Cubist from his work from then on."

He went out to Capri on the vaporetto in 1901 from Naples. He stayed in the Hotel Pagano, then lying alongside the Tiberio. It is all different now, and there are two hotel Paganos, the Hotel Manfredi Pagano and the Pagano Vittoria & Germania, but if you

* You are a shit!

53

ferret Manfredi Pagano's sister out, frail in her nineties, she will tell you that in 1901 these Paganos did not exist, and the Hotel Pagano was where the Palma is now, wholly rebuilt, just a bit down the way, the Vittorio Emanuele now, from the old piazza that is the heart of the town and always was. It was winter, spanked with occasional soft rains or thrashing winds, but otherwise springlike weather. This is not invention, for Capri does not change. When you walk under the eucalypti in the narrow lanes I think their pungency assaults your old reminiscent nose of Livorno, then as now. Modigliani could not carry a tune, perhaps why he recited poetry—declaimed—and never learned how to dance—but he must have had something in his well-made body in that decadent island, rotten since Tiberius. He had seen Tino di Camaino now; is it possible he carried his head in a certain way, one moment or the other; artists *do* do things like that—the slantness that would be on a hundred portraits, and is on the tomb figures of Tino? The bent that is elegance, bend of the reed? It is true he acquired Tuscan art in Livorno, but that does not preclude that he acquired it from di Camaino in Naples too; meditated it now. Giovanna thinks so. Here he was on a Greek island that became Roman. It is said there is an *Etruscan* art influence in Modigliani, and the borders of old Etruria do coincide almost exactly with modern Tuscany—but there is an absurd reason why this is wide of the mark. There was no Etruscan art! You would be hard put to be influenced by it. It is all Greek; archaic Greek. Every artist who made Etruscan art was from Magna Graecia or Greece itself, or was an Etruscan trained by Greek artists. The slim figures, prick in air, on the archaic vases, whether they are found in Etruria or not, are early Modigliani.

Here Tiberius exercised his "abnormal" love of solitude, a word choice that might have seemed odd to a Garsin, and in the grottoes or his villas covered fifteen or sixteen women at a go in his sixties, as we are told. Up on the plateau of Anacapri Modigliani covered just one. But she was Scandinavian; and that was a beginning. Like hashish in Venice in 1903. We don't know her name, and have nothing to go by but the letter to Ghiglia, otherwise it would have been an encounter that vanished in air—but it was

the first known northern woman, North-Sea woman, and a precedent. He went out to do this from the "Villa Bitter." You can find the historic site. "Villa" is putting a bit of gloss on it, as was Modigliani's way. Today it is the Hotel Caesar Augustus, magnificent enough. It looks out from over the Phoenician Steps straight to Vesuvius (if it isn't cloudy). It's what Modigliani saw. Across the street is the Hotel San Michele, named after the villa behind it that hadn't been built in Modigliani's day (Axel Munthe's San Michele, upon which was based the world-famous book). It was the Hotel Molaro, vines in front of it, and below the vineyard wall was the walled road that ran down, down enormously, to Capri. Across the road was the little coffee house run by Herr Bitter. Herr Bitter rented two very modest rooms. This was the Villa Bitter.

And now he was to be influenced by Corinna! Not anyone has realized that there was an influence heretofore unknown, and that there was a celebrated Modigliani portraitist in Italy when Modigliani was still in school. A few have seen that portraiture, conventional portraiture (*Mauronet*, 1905), was his forte before, and even slightly after, he went to Paris. He must have supplemented his living by it, for he was good at it, and sold it to the hated bourgeoisie whose kind of style it was.

Laudadio Modigliani, brother of Emanuele, Amedeo's grandfather, and uncle of Flaminio, had died in Livorno in 1867. Three years after, the family went back to Rome. Little Laudo, the future lawyer, born in 1867, must have been one of his father's last acts. When, long after, Menè was trying to scrape pence as a lawyer after Mussolini had forced him out of his position as a Socialist member of the Chamber of Deputies, he met this colleague, now grown, and he looked so much like grandfather Emanuele, Laudo's uncle, that he wrote home—this was four or five years after Modigliani's death—that the nonno (grandfather) had stepped down out of the oil painting. "Many greetings from Grandpa's double!" In 1870, when the Laudadio Modigliani went back to Rome, of the children Laudo was three but Silvia was nineteen. She instantly married her first cousin, Moses, or Moïse, in that same year. His father died that year and, at thirty-four,

he became the Godfather. He was Regent of the Bank of Italy, Counselor of the Bank of Sicily, Counselor of the Bank of Naples. Modigliani within Modigliani produced Corinna, 1871. Then Olga, 1873.

Corinna, who did not marry so that she could devote herself to art (so that Olga too could not marry, though she would have liked to, because in distinguished families the younger sister could not marry before the older at that time), quite quickly became a rather celebrated painter. As did her sister, who was a ceramist as well. The girls, bachelor for a reason somewhat different from Margherita's, Modigliani's sister, and his double cousins, had a studio—with kiln—in Via Margutta, even today the street of the artists in Rome. At first, Corinna painted velvets for the palaces of Rome, with a Pre-Raphaelite bent, more or less like everyone else, Modigliani too for a long while. But Corinna moved very fast; she showed in Paris, Rome, Milan: in the year Modigliani commenced art school, 1898, she showed at Turin. Soon she was portraitist of the best families of Rome, cardinals, finally the pope himself. Olga, for her part, was an international gold medalist in St. Louis in 1904. Corinna's *Giovinezza*, painted in the years when the latter was flourishing, looks so much like Marie Laurencin as she hangs self-portrayed today in the French National Museum of Modern Art in Paris as to give you a most uncanny shiver. There can have been no cross-influence; simply a paralleling of souls across a half-continent.

Modigliani found that a Modigliani was not inferior to a Garsin; he hadn't known that. The Modigliani were one of five Jewish families permitted to live outside the ghetto in the early days. And so it had always been. His pride was reinforced.

Giovanni Papini was to become one of the most celebrated authors of modern Italy. Buck-toothed, pop-eyed, tall, elongated, head capped with short dark curls, with nervous slender hands, thick nose, amber eyes, receding chin, narrow mustache the length of a long upper lip, he wasn't very prepossessing in 1902, but he was already working at *The Twilight of Philosophy, The Tragedy of Each Day (Il Tragico Quotidiano), The Sightless Guide* or

Blind Pilot. "Every great artist is great because he realizes his insufficiency . . ." Modigliani probably did not like that much, even then. "And knows his partial failure . . ." No. He was inspired by his longing to wage war on men because they were not as perfect as he would wish them to be. That was better. Papini was skeptical, bitter, because he had had a loveless boyhood; he passed from Swinburne to Tolstoy: at first fiery, violent, sometimes coarse, he landed at last in a pastoral simplicity. Was it progress? He disdained poetry; admired the "scientific outlook." And yet, somehow or other, Modigliani frequented him, perhaps because Papini was three years older than he and he was still at an age when that makes a difference, or because Papini, as Gian Falco, was already a controversial writer at twenty-one, and editor of a small magazine, *Leonardo,* and—could it be imagined!—future adversary of that great man who was out there at Settignano with Eleonora Duse. But such gods were beyond reach; best do with a Papini. Nevertheless— "Superhumanity is all the more admirable in men who are ordinary men but who suddenly go apart, shut themselves up in solitude and are transfigured. The miracle of genius consists in that very ability to soar, for certain hours, above humanity, while remaining extremely and even vulgarly human the rest of the time."

Gabriele D'Annunzio was given to luxury, and while elegance, true elegance, is one thing, luxury is quite another; there was something soft and effeminate about him, as though there can be an intermediate sex which nevertheless is not homosexual, which in fact can be desperately, almost hopelessly virile. His writing was full of trivial heroics, criminal tendencies, he hadn't a worthwhile idea of his own—and yet—what marvelous poetry!—out there at Settignano with Eleonora Duse—she in her forties, he in his thirties.

He would come out from his twelve hours of writing without leaving his desk, the blue veins standing out bulged from the temples of his bald head, and Eleonora Duse would comfort him. And Modigliani could understand this—was he not to finish his painting sessions dripping with sweat? That was why he always bathed afterward; it was not ablution to "wash off the sin of art!" (Lunia

Czechowska told me). It was fastidiousness. He was the most fastidious of the artists of Paris, a very peculiar *"bohême."*

Fattori had just now been widowed—and who could foresee that he had yet another honeymoon, with all its splendid exertions, ahead of him? Modigliani went to him to learn life drawing—the Nude. The old master was now in his seventy-seventh year. He taught in a long smock, with his hat on, and his white mustache came down over his mouth. The podium may still be seen in Florence, and behind it is a sort of gallows pole, with two cords dangling down from it ending in loops or eyes. The limbs of the nude women must have been trussed up to it, to keep them in position for painting, and the nude men too. Fattori had little more than six years ahead of him. His seven hundred and thirty-ninth painting, and his last, not finished because he died, shows the beach near Livorno, seen looking toward the maremma; on it the single lone figure of a horse.

Papini's close friend was Soffici, thus Modigliani's too. Papini wrote a book about him in 1933; in his "improved" style—it is "mellow," rather sentimental. Soffici introduced Modigliani to Boccioni. Umberto Boccioni was living in Rome; he was a fellow art student of Modigliani in the year succeeding this, 1903, in Venice. Soffici, now in 1902, was twenty-five. Modigliani was eighteen; at thirty-five he would be dead. Soffici stayed in Florence, painting and writing, and his *Voyage Around Art* became the call to arms of Futurism in Italy, whose only worthwhile exponent— from the art side of it—was Boccioni. Possibly because he remained in Italy, and became a big man there, Ardengo Soffici helped Futurism pass over into the nationalistic blood-and-soil values of Fascism, which were implicit in it anyway. He survived Modigliani; that is, he perished later (1964). At the time, 1902, he was talking about Cézanne and Steinlen. Steinlen was a Swiss caricaturist for newspapers whose success, in Paris, caused Picasso, who was then a caricaturist for newspapers in Barcelona, to go to Paris in 1900. Steinlen had a social conscience that would have suited Menè. It

is one of the three reasons for Picasso's blue period.* The argument whether it was Steinlen or Toulouse-Lautrec who influenced Picasso, thus Modigliani, both directly and indirectly, through Picasso, still wages. It is idiotic. Steinlen influenced Toulouse-Lautrec.

From Ghiglia, we have some cold, clean art. It is distinctly clear, nude or still life with fruit. The colors are hard and enamel. Perhaps this distinct, detailed clarity appeals to us more in the nudes than the fruit, but somehow it does not suffice. He showed over a good part of the civilized world after a catapult start, and Modigliani looked up to him—but gradually he faded out, kept only to the company of his wife, Isa, whom he had shown us voluptuously when she was young, hard-fleshed, succulent and naked, as suited his technique, but then when in World War II his house was blown up in the bombings of Florence he suffered some kind of psychic wound, and shortly died, out of patience with life. He and Modigliani lived together in Florence in 1902, it is said for ten months. No calculation causes it to have been quite so long. Probably it was six or eight months.

In March, 1903, Modigliani entered the Academy of art of Venice. Ghiglia had a flamboyant *appearance*—to judge from his self-portrait of 1901—a pirate mustache, goatee, black brows, strong nose. In fact, he looked quite a bit like d'Artagnan, partly because of his hair style. What he wanted in art was that the work be *giusto*—correct, accurate, exact by a *regola stretta*. It is perhaps not the highest possible recommendation. Nevertheless, his *Nude With Rose* in the Detroit Museum is nice—her tits are very exact. His physical appearance made him a great success with women; among these Isa Morandi, whom he fell in love with, and married, late in 1902, quitting Modigliani.

The Venetian Period

Cadorin was the commencement of younger friends, that so marked the life—Soutine (ten years younger), Kisling (seven years

* 1. Social conscience. 2. Nonell. 3. El Greco. (see pp. 82–83.)

younger). One sees why, and it is pathetic. Ortiz de Zárate, who was to be his most enduring friend of all, whom he met now in Italy, was near his own age—but Zadkine was younger, even Pascin was a year younger. "He could only get on with his inferiors," Giovanna said. Pascin was not his inferior. Apart from Modigliani, he was the only Sephardi of the School of Paris. When he killed himself "like a Jew and like a Roman" he was forty-five. By "like a Jew and like a Roman" is meant he opened his wrists like a Roman and hanged himself like a Jewish dog. In fact, he slit his left wrist and with the blood with his right forefinger wrote all over the walls, "I love you, Lucy. Adieu, Lucy." Lucy was the wife of Per Krohg, who lived at 3 rue Joseph-Bara—where Kisling lived, and Zborowski, where Lunia Czechowska stayed—where much of Modigliani's Montparnasse life took place. Then Pascin sliced the other wrist, but he did not die, and as he had heard one plunges one's wrists into water to hasten the bleeding, he plunged them into a bucket of water, which he had already prepared, but it had got cold. It assuaged the bleeding. He then rummaged through the house until he found a piece of butcher's twine in the kitchen, and, placing this over the doorknob, and holding one end of it firmly in one hand, he looped the other end of it around his neck, and, kneeling down, hanged himself. The sequence of this need not be guessed at, for it was written in red all over the house when he was found two days later. This is one of the baroque episodes of the heroic days of Montparnasse, and warrants examination. He may have done it because of the hanged lackey thirty years before in Bulgaria.

Cadorin was thirteen, and Modigliani eighteen. Guido Cadorin may be found today at the Accadèmia, or outside it at the Accadèmia Bar; he is eighty-one.

The swan neck of *The Madonna of the Long Neck* by Parmigianino, which Parmigianino got from Ammannati, who got it from Michelangelo, who got it from Donatello, advances forward to Cellini, Gainsborough. Derivation can be traced, but what it indicated is *inclination*. Modigliani *always* adhered to Tuscan art, or to what is its moral equivalent in Egypt, ancient Greece, Africa, Polynesia, even India, though it was only when he had broken the

husk, his body, that it could finally emerge. Many have marveled that despite the destruction of his body his art held firm, and that it was then it increased; not despite, *because*. But when he went to Paris . . . before the use of absinthe, hashish, the senseless ceaseless fornication with many women, few of them attractive or his equal or worth, which must have been the deep-seated rule of selection, he took with him his picture postcards of his idols—reproductions of the old artists of Italy—and he pinned them up on the wall, and there on this wall or that they stood through it all. Duccio di Buoninsegna—that makes sense. He was really the founder of Sienese painting, old style, 1308–1311. Simone Martini. There is a Simone Martini, perhaps in Pisa, which has the loosed hand positions often employed by Modigliani; but even more important is the whole feeling of it all. It was the way a whole civilization saw art, whole civilizations. Perhaps it *is* art, or was. Picasso said to me: "I hope somebody will appear who will revive art. What I did was experimentation. Art is completely dead."

I was surprised to learn that among Modigliani's postcards was a Carpaccio. That didn't fit. Carpaccio is too correct and loveless. But the answer was in the Accadèmia. They have the *Saint Ursula* cycle of Carpaccio. As he went there every day, he got used to it. Familiarity is perhaps the sole single highest value in art. You get used to a thing.

The Accadèmia sits on the Grand Canal, across the narrow Rio San Treviso, not far from the San Barnaba Quarter where Modigliani lived a good part of his Venice life. At first he lived in elegant Via 22 Marzo right in front of St. Mark's Piazza, but soon he moved away to cheaper quarters. It was exactly the same thing he was to do in Paris. In Venice the smaller canals are called "rios," and a street is a "calle"—these are at once Spanish words and *veneziano*. A quay is a *fondamenta*. Indeed surreptitiously, certainly on the part of the third, did Guido Cadorin, Amedeo and the aging baronet "dressed elegantly in gray" pull up on the *Fondamenta* of the Island of Giudecca. It was the pleasure place, for dark fumous pleasures, those 1903 nights.

It is said that Modigliani lazed in Venice. It is also said he worked hard, with Mauroner. He probably did both—time is ex-

tensible for the young. They are very elastic; only perhaps not much fixed on one or two things and thus meaningfully intense. While Boccioni was the important friend, Modigliani spent his time with Fabio Mauroner. His portrait of Mauroner has been lost, as have been all his early bourgeois portraits because nobody attached any importance to them and mislaid or destroyed them before the time came when it could be seen they had great worth, but there is an excellent reproduction of the Mauroner portrait. When placed beside Corinna's portraits of that time the cousinage is evident; among the portraits of Modigliani's maturity, Corinna continues to show well what her subject is, but Modigliani shows more what might be called states of being. Are you tracing the shape of the eye, or that of the heart?

The baronet in gray identified himself as Cuccolo and Croccolo. He probably did so because his name was neither. He so exactly prefigures Pigeard, who would supply drugs to Modigliani in Montmartre, that it seems a joke of history. In fact, the whole Giudecca affair has an Arabian Nights smack that makes you doubt it. Was it not in Venice that André Salmon lays the enormous lengthy conversation between Soffici and Papini, and Modigliani, that opens the forward action of *La Vie Passionnée* of Modigliani? Lunia Czechowska has told me why Salmon fabricated—and had to. He is very good, however, on Picasso, in his book on Modigliani.

The Giudecca nights took place. La Giudecca lies between the Lido and the bulk of Venice, over the Giudecca Canal. The "fumous" (smoky) pleasure was hashish, though at that time hashish was both smoked and eaten as it is now, and also taken in little green pellets, as I don't think it is today. This was the way Modigliani and Ortiz de Zárate, who was also a hashishomane, generally took it in Paris. Ortiz had an unusual way of dealing with his wife, Hedwige's, objection to this. He clubbed her with a bar of soap— a cake of yellow laundry soap. Or so Zawadowski, close friend of Modigliani, tells me. I shall call him Zavado—though he calls himself and signs his paintings Zawado—to make the English pronunciation correspond to the French. Ortiz was as much an exhibitionist as Modigliani; and besides could sing. He stood up in a box

at the opera and told the tenor on stage he was singing the aria wrong, and then proceeded to sing it himself. He was removed from the box, and locked into the WC.

Giudecca was the flesh pen of Venice, the pound of flesh, where females were contained, and the cloaked baronet watched the younger men—one of whom was by this activity to condition world fame and the way we see his art—through a peephole. The eye was surprised. Nevertheless Modigliani refused to quit, but Cadorin felt this was not mere opportunism, the desire to have gratuitous cunt, though it meant being looked at; but something else indefinable—the spiritual need—of what? Complicity in something distinctly not nice? Adding something which Cadorin, thirteen, could not feel?

Modigliani lived at Campielle Centopiere, then on one of the *calli* facing a "rio." You look up to a marble-balustraded loggia, a kind of post of observation onto the rio; here the painter stood— when he was eighteen—and contemplated the boat passage of the gondole and vaporetti, the teeming confusion of life "upon the Rialto"; but you are not let go up there and share his experience. The present tenants won't let you in.

His toxics were, as said, hashish, cocaine, absinthe, and also ether. You must, he painfully, gradually knew, sacrifice everything if you would make art—health, life itself. Art, not the stuff of Léger, Archipenko, Lipchitz! That was not art! It was accommodation to a material revolution. These were the grosser of the mechanos.

Baudelaire had written: "There undoubtedly exists in intoxication not only dream associations but patterns of reasoning which, in order to recur, require the circumstances which originally provoked them. Poe's drinking was a mnemonic method, a technique of work appropriate to his passionate nature." When Swinburne, Utrillo himself, put aside their poisons they put aside their genius.

When Zborowski sent some of Modigliani's paintings to the Biennale shortly after his death, Mussolini having come to power two years after the discreditable event in 1920, they were ill-received. Slowness of reputation in his native land, however, came

from the fact that he was a *Modigliani*. Brother of the Socialist. The critics of course did not dwell on this but rather faulted him gravely for his style.

At the 1901 Biennale, he saw Rodin and Böcklin; the 1903 Biennale featured French Impressionists. They didn't impress him. The "bloodless, hallucinated, monochrome faces" of which the English poetess Wylda spoke subsequently on Boulevard St. Germain had a Pre-Raphaelite root origin, probably; though, on the other side of it, the very existence of a thing often pushed Modigliani to its reverse, as it did a good many. Rodin.

He was very much taken up by D'Annunzio; then later on completely against him. But, after all, anybody could be in love with Eleonora Duse. But when later D'Annunzio falls in love with Romaine Brooks, an outright lesbian, he is quite clearly attempting the impossible—and the impossible is that he find himself wholly male. Did Modigliani fear him? Perhaps Modigliani did not like too closely to contemplate the antics of a Don Juan. The Don Juan goes from bubbling source to bubbling source, and remains thirsty. For thirst is inbuilt in his throat.

Modigliani was prejudiced against Rimbaud eventually because of Verlaine. If it hadn't been for the upstart, *arriviste* boy would Verlaine, then married, have become a homosexual? Besides, Rimbaud's poetry was "first-rated" but not first-rate, like that of Apollinaire. It was very fashionable, and he was furiously overrated, and they have both continued to be. As for Nietzsche, it was precisely because it was introspection that it was so terrible. For philosophy is harmless enough, but introspection is real, because it comes from where reality *is*.

The soft, edgeless moons of dimmed vision in the light of Venice did not finally really affect him. He took away Titian and Giorgione, in his carryall, when he left, by way of Geneva—and then subject, not texture. The nudes who would emerge in 1916, 1917, 1918. When he was doing the nudes, primarily at 3 rue Joseph-Bara, Zborowski would slip in. His motive is obvious; Modigliani's more complicated. Modigliani would fly into a rage: when he painted the *Rose Nude*, one of his greatest, and Zborowski came in, Modigliani threatened to throw the model down the stairs

naked, and destroy the picture. Thus his sessions with the nudes had something of the intimacy of sexual love, apart from the consummation—a knock on the door is sufficient to disrupt it.

The Pre-Raphaelite urge was to get back to an Italy only an Englishman could believe in. How was it that tapestries, draperies and early nineteenth century chi-chi were pre-*Raphael?* Perhaps Modigliani went along with this because of the English affinities. He knew many English people in Venice. But he had been drawn to it before: it was in the wind. Picasso had done Art Nouveau, its germaine cousin, in Barcelona at the Quatre Gats until only five years before. The nineteenth century was dying in a ruff of froufrou, still on the neck of the nascent twentieth. The petulant must of Dante Gabriel Rossetti—whose names were attractive at least!— was in the nostrils. He had been romantic! When Elizabeth Siddall died he had his manuscript poems interred with her, for the world ended, but then in a few years he reconsidered and had her exhumed and dug them back up. It is said that the greatest single influence on Modigliani in Venice was Jan Toorop; it may be so.

In 1905 his uncle died; it was probably the real reason for Modigliani's departure from Venice. Amedeo Garsin had paid most of the costs.

❦

A rude jolt was ahead. In 1912, Tiberian Capri, the malignant splendor of Capri, rank with the evil dreams of Tiberius, was scene of the inception of dire events which have their repercussions today, as they will for decades to come, and into the next century. Gorki and his cohorts had settled there, exiled by the 1905 Revolution, among them future friends of Modigliani—Marevna Vorobëv, who would be Diego Rivera's mistress, and Lunacharski (Modigliani was not to meet Gorki). The Bolshevik Revolution of 1917 was forming there, as to its cultural side, amid swimming parties—when the ebullient Russians went naked, a thing never heard of in that day; picnics on the veranda of Gorki's villa—at Anacapri overlooking blue antique Tyrrhenian water; foregatherings fragrant with tea from the unsleeping samovar, rum; Lagrimi di Cristo wine from

Vesuvius; the sexual exchange of emancipated people; and the good friend absinthe from Paris, a new thing for them. The century had turned, for these present, twelve long years ago now, and the future was birthing. The "little father" of Soviet art, Lunacharski, would, not too willingly, dictate the tenets of revolutionary Constructivism fomented in Paris in Modigliani's time, principles agonizing Modigliani and in the person of Picasso and his Cubes probably contributing much to what, by reaction and revulsion, Modigliani's art would become. Constructivism was the true face of the Soviet, until another of Modigliani's friends of the Café Rotonde in Paris, the good Vladimir Lenin, who had wanted to become an artist's model but been frustrated, lost patience with it, as he did with so much, and ordered that it become simply Communist propaganda. The antique blue waters must have looked very far down from Gorki's porch, and the dead century very far in the past. It was, indeed, to have only one passionate exponent among the major artists of the twentieth century, a single outlaw, an outsider, albatross wing-bruised on the flat deck of mind-art.

He was drenched in poetry, poor man; he whom Ilya Ehrenburg—another denizen of Gorki's villa, and eventual friend of Modigliani, and eventually chief apologist for a Stalinian Soviet, but a dreamy poet then—called "The deepest-read man in poetry and Christ knows what not I have ever met."

Going from Geneva, he "bemused" a German woman on the train. He afterward said in Paris she was sixty—probably she was forty—her daughter was sixteen. It was the daughter he wanted. And having beguiled the mother, and told her to wait, he had the daughter in the vestibule of the sleeping car, an incident we can, allowing for voluminous clothing, enjoy. It is an anecdote of Modigliani, probably having some truth. He did not invent—he glorified!

He took a hotel on the Right Bank; Lunia says he stopped at the Scribe. His eyes ate and drank everything. Paris! It is an odd fact—so sensitive he was, that he is Italian in all his photographs until Paris, and never Italian after that. He did not use it—as, for example, Severini did—but he absorbed more of the new art in Paris than did any other of his Italian friends. They themselves said

so. Handsomely dressed, he disdained the bohemian—they were the one type he could *not* see. Soon he would go to the Butte—in velvet. It was "the garb of Bohemia"—and at variance with the proletarian dress of the Bateau-Lavoir crowd.

Soon he was on the Butte with Meidner—he hadn't met Severini yet. They went to the Lapin Agile. He is, in his bourgeois clothes, fervent with Toulouse-Lautrec—infused with Lautrec now, and his Tuscans of the postcards. But it wasn't so much what he said as the way he said it, as always characterized him. He had an infectious sweetness, some unknown blessing of grace, some fire of reminiscence that blew on the embers of past things in new and modern hearts, smalled now to accommodate to modern times, and made larger fires glow there; a moment, of antique things. The dress he took on soon—wide black hat, flowing tie, cape, or coat thrown over shoulders cape-fashion as so often was his way, sash, velvet suit soon nacre from much washing—was in reality that of the bohemian rebel in Italy imported into France, made famous by the "Pickwick Club" of bohemians of Mürger, that of the Carbonaro in 1820, the poet in '60, the anarchist in '90, perhaps not entirely a uniform of variance.

Could Vallotton have acquainted him with Toulouse-Lautrec's art? Such a man signalized Modigliani's brief Right Bank days till he went to Montmartre sometime before October, 1906. Thinking he was dying when he had been shot in the head in 1916, and then hospitalized in Paris, Apollinaire told Jastrebzoff (who would play a large role in Modigliani's life, or at least his sister would, being Survage's woman), considering them his last words and wishing to make them famous—"Someday it will be realized what a role the newspaper caricaturist played in forming modern art." These were Forain, Steinlen, Toulouse-Lautrec, Vallotton.

Vallotton was an ogre of rectitude, who loathed dogs, and children more, who had crises of tears and spoke of "the odor of suicide." His landscapes which expressed sex were execrably beautiful; he wept at nothing but "the light off" marble or off a nude woman, and Ingres; his Oriental vicious nudes bathing, shown rounded, odalisque against the sterility of flat red brick, could have been by Modigliani himself—save for the landscape background.

Lautrec said contemptuously that landscape was good for nothing but background; eventually Modigliani eliminated it entirely. Vallotton said that a nude had to have a little unacknowledged depravity in it, a dram of concupiscence. He was Swiss, but here was a Paris quality Modigliani had not known till now. It was hinted at in D'Annunzio, but in fact his horrendous medieval scenes of animal cruelty in human beings were *Abruzzi*, the rude province from which he had come—and pure evil was unknown in Italy, for Italy was no longer a dominant nation: until with Fascism it returned. When Vallotton's death-day came, which was five years after Modigliani's, he painted in the Bois de Boulogne, in snow, till noon, returned and cleaned his brushes and put them away in what he called his "commercial box" (because he got his living with it), and went to have the operation he had been told, rightly, he probably would not survive. "I am loathed at home, and everyone exhales an enormous sigh when I go out of the house," he said. "I am correct; and odious." He wrote a play called *The Strong Man* which was presented at the Grand Guignol, the theatre of puppet horror. Just such a puppet horror was Toulouse-Lautrec.

He had been Suzanne's * lover in 1885—a little too late to be Maurice's father. The role was contested; but after all it was obvious who Maurice's father was! She had been Renoir's model, and Puvis de Chavannes', at the critical time, and to them was attributed the fact that Maurice was an inexplicably genial painter, but that was rather naïve. Suzanne was a genial painter herself, in later life. Lautrec had named her. She was christened Marie, Degas's Marie, but Toulouse-Lautrec observed that she now needed a more imposing name. She was the great artist's model of Montmartre: she had posed every one of the figures, naked and draped, two of them boys, in Puvis de Chavannes' *Sacred Woods Beloved of the Muses*; you could see her in Renoir's *Country Dance*, or *City Dance* taking place in the Moulin. And since old men peeped at her all the time naked, T-L said she should call herself Suzanne, after *Suzanne and the Elders*.

He signed himself T-L, or T-Lautrec. He liked to watch executions, and operations performed in hospitals, which he contem-

* Valadon, mother of Maurice Utrillo.

plated with a cynical mirth, his hands folded in front of him holding his cane. He liked, at a pen *stroke,* which was like the cut of a knife, to dissect to the animality that lay behind the human visage, particularly that of a woman. He was dead now five years but his spectre still populated the Butte's slopes, going up this one or that one, bent forward stiffly like the half of a hinge, on his bantam legs—for he had fallen as a boy in Albi and damaged one leg, so that it never grew again, and then incredibly done the same thing the next year to the other, and it stopped with the first, so that he was four feet three inches tall with a full-grown body. He liked to prod the girls at the Moulin Rouge with the ferrule of his stick when he had got them to fight and they rolled on the floor. If pathos had made Steinlen's art, out of human pity, it was not quite so with Lautrec.

Modigliani followed him a while, in the early days of Montmartre, as Picasso had in the same way, but six years earlier. It was natural that these younger men have these passing adulations, as they sought their way: Lautrec was not all bad, and he portrayed Van Gogh as though he were Van Gogh, as Modigliani would Soutine, thus showing sensibility, but the brief emulation of Lautrec by Picasso or Modigliani was that of a greater artist following a lesser. The great distinction between Picasso and Modigliani showed in African art. Modigliani saw the arabesque of African art, the exterior; Picasso the fang, the rage within, the incomprehension of the savage heart. Each saw his own image. Modigliani represented the deception of innate grace confronted with reality; Picasso the rage of reality against grace—alas present in him.

Jan Toorop was a Belgian symbolist decadent who had been born in Java and who eventually turned away from Symbolism to religious art, and whatever influence he had on Modigliani in work now lost did not survive Paris. In painting, the symbolists were the Nabis, a Hebrew word meaning prophet, and Mallarmé was their god, around whose knees they theoretically crowded. Perhaps Modigliani took alarm; he had a kind of psychic sight. Mallarmé's creed was, as expressed toward poetry, that there was a triangle of equal forces: the force from without, that held within, and lan-

guage. These three produced the poem. Later he said: Paint not
the thing but the effect you wish to produce. And then: "We must
suppress everything else in the name of language; language must
be completely freed." That road, of which Modigliani did not live
to see the end-stop, ran straight to automatic writing and Surreal-
ism. The one corner of the triangle had got the upper hand of the
others. In painting, language meant color, and, finally, synthesis
was dubious. It meant the synthesist might get adrift, anchor
pulled up. The mark on Modigliani, however instinctive, was that
he was against the incursion of either method or man on Man; and
Man is what he was after. Perhaps he thought Mallarmé slight
(certainly he was compared to Baudelaire). At any rate, it was not
Mallarmé who held against the darkening eventually within Mo-
digliani. He was not one of the poets Modigliani carried about torn
in segments, in order that they would fit in better, eternally in a
pocket of his velvet jacket.

By October, he had moved to Montmartre, for that was when
Severini met him as, subsequently, when Modigliani had become
famous, Severini reported. Severini himself became famous. And
even now a Cubist *Bear Dance at the Moulin Rouge* in the Mu-
seum of Modern Art in Paris, something else Cubist in the National
Gallery of Art in Rome, mourn dimly in great museums. He made
the right moves. He married the daughter of Paul Fort, the Prince
of Poets; it was the right thing to do.

Modigliani's friends, Italian, were not so for the same rea-
son that, at the outset, Picasso's, for example, were Spanish. It
has hardly been noticed that the Bateau-Lavoir crowd, called
the gang of Picasso, at first was largely Spanish—Pablo Gargallo, a
great artist, to be Modigliani's friend too; Manolo, who was at
least picturesque, who rode out of Spain and the Spanish Army
on a Spanish cavalry horse, which he then sold to provide for the
first steps of becoming a never very capable sculptor, and who by
his literal depiction of Frank Haviland, showing how Haviland
looked, by contrast revealed what art is in Modigliani's portrait of
Haviland showing how he looks and *is*; present too was Paco Durio,
whose studio Picasso took over; Durio afterward went to the ma-

quis with his collection of Paul Gauguins; he had been one of two to say good-bye at Austerlitz Station when Gauguin set off to die in Polynesia. Picasso had to surround himself with these people, because when he came to France he did not speak French. But Modigliani was entirely bilingual, and if he chose Italian friends it must have been for affinity.

Severini was the most important, but earlier friendships linked him with the critic Bugelli and Anselmo Bucci, both whom saw him stupefied with hashish at the Café Vachette in mid-1906. These friendships endured for a time—as late as 1907 he sketched Bugelli and gave the portrait to Bucci ("Modigliani all'amico Bucci") as did also that with Ludwig Meidner. Meidner was an art student from eastern Germany Modigliani's age, who went with him from time to time to the Lapin Agile, before he started to go there with Severini. A coffee was then four sous, one cent. Modigliani spoke of art with a fire, Meidner recorded, quite different from that of anyone else. He was lively, enthusiastic, eager, bubbling, full of paradox, in the half-dark of the Lapin Agile—there they talked all of the night, and went home in the morning, for a few sous. Modigliani knew weird, strange things that seemed to be out of character. And perhaps he had picked them up at the occultist sessions on Giudecca Island Cadorin witnessed. He was a mixture at that time, an epicurean in search of sensations and refinements, a lover of Wilde and the decadents, who listened eagerly when anyone spoke of drugs and poisons, hashish, morphine, opium, yet was fresh, boyish. He was unselfconscious and enchanted everyone.

Some time in these days he moved to, then vacated, a shack in the maquis, and put on the bohemian clothes he was to wear till the end of his life, but Meidner saw the "ruined barrack" at 7 place Jean-Baptiste Clément before he returned to Berlin in 1907, taking with him some of Modigliani's paintings, which he tried to sell at five and four marks, and couldn't.

The shack in the maquis has disappeared, though, almost incredibly, the shed at 7 place Jean-Baptiste Clément still stands. Here, though that with Mado must have preceded it, with the

weight it bore on his relations with Picasso, occurred one of the first movements in the symphonie érotique of his life, the affair with Quiqué. For, for a man with so much love in him, and a need to aspire to, to "look up to," perhaps a heritage from his treatment by his mother, to whom he wrote till the end of his life as if he were a child, and sprung from a certain real sweetness in his character, his love affairs were all strangely exclusively erotic. Perhaps one sees why.

La Quique, or Quiqué, was apparently a girl of the Place Pigalle; one of those passage entertainers, birds of small talent whose wings are dipped in another profession, who had gradually been driven down off Montmartre with the development of the quarter, from the Moulin de la Galette area, and more secret and poisonous clubs yet, to the lower breadth of the Boulevard de Clichy, Place Blanche, Place Pigalle, and the circus where first Degas, then Toulouse-Lautrec, then Picasso painted the equestriennes, dancers and the clowns. She was meridional, probably from Marseille, and said she had been kept in Berlin by a Dutch baron, which was probably true, for she spoke German, and when in the 1914 war she was caught with a troupe near the front lines it was disbelieved that she was an entertainer and she was shot as a spy, because she spoke German. She was Spanish, and it is said that Quiqué was a corruption of chica, which means girl in Spanish. The English writer Goldring, who had been with Modigliani and Beatrice Hastings on Rue Norvins at times, returned to Montmartre, and by persistently replenishing her glass, got an old woman (not old in 1907) to describe the affair, the finale of which she had witnessed herself, because it occurred in public. Modigliani and Quiqué had met in a club and at once experienced one of those bolts the French call *coup de foudre*, lightning-blast of love, but in reality lightning-blast of sex, probably always and certainly this time. They had locked themselves into the shed at 7 place Jean-Baptiste Clément and had for days lived on alcohol, snow and sex. I do not know if cocaine is such an erotic stimulant; hashish is. When at last they emerged it was to perform their naked dance of bullfighter and bull to their own priapic and cuntal glory, and for anyone who might pass. Goldring saw almost a reprise of this

when in the patio of her Rue Norvins house Modigliani danced with the feminist Beatrice Hastings whose breasts proved to be "remarkably flat." By that time, Modigliani had fallen to exposing himself automatically. And not only for observers, for sometimes he insisted on sleeping stark naked among the plants and on the soil in Beatrice's garden. That was 1915. When one time he walked with Goldring in the cemetery across the street from the Lapin Agile, he began to recite the *Chants de Maldoror* of Lautréamont, and when Goldring, addressing a gravedigger, replied: "Gravedigger, it is beautiful to contemplate the ruin of cities but more beautiful to contemplate the ruin of men," Modigliani, weeping, threw himself into his arms.

Dedo [Papini wrote him]—

It is the privilege of the afflicted to make discoveries. But they have to pay for them. Harlequin himself was a hypochondriac. Unless an artist has experienced suffering he cannot give us enjoyment. Misery is the microscope of souls; and it is even a sort of relief to sensitive natures.

The Mechanos

It must not be thought these were grim times. It was a larking time in the heart for the young: only history has historical perspective. If Modigliani went to Pigeard, in the Château des Brouillards, he did so because it was an adventure. It is a flaunting thing to smoke hashish, or take opium, when you are young. He wasn't alone. If Paris was creeping up like an assassin's (hashshashin's) hand upon the throat of Montmartre, who noticed that except the old? If he took Mado, did he even know she had been Picasso's?— if he did, or if she told him, he would have laughed! It dewed her laundress-girl's skin with a new aroma! She had been mistress and model of Picasso before Fernande moved in, mistress of the Bateau-Lavoir and on whom Picasso kept such a jealous eye that he would not let her go out of the house and did the shopping himself, from the pushcarts down along Rue des Abbesses, but whom Van Dongen had painted naked nevertheless.

Mado was blonde. And that tasted good in one's young mouth. As did Gaby. Her lawyer-lover and would-be musician wanted to break Modigliani's head, but Modigliani embraced him, took him into a café, poured sympathy on him, which he really felt, and let the lover pay for glass after glass, until at last they went out arm in arm, royally drunk, friends forever.

Meidner reports Modigliani selling Japanese woodcuts like a mendicant; but he wasn't poor, merely a very great spender. He had as much as, more than, the other *rapins*—itinerant painters— of the Butte, who had but lately crowded around the barn-large door of the Moulin de la Galette contesting with the vanished

apaches, of a Montmartre that was gone, for the grisettes, under gaslight. Gaslight still burned on the Butte; and the Boulevard du Montparnasse was paved in blocks of wood, and a trolley ran up it, between the Rotonde and the Dôme. But the girls were ceasing to be called grisettes, and were outright laundresses or models or whores, only the first of which was considered a dishonorable profession at that time. The *apaches* no longer laid their knives on the wooden table at the Lapin Agile, called the Café des Assassins in an earlier time. And nevertheless Frédé, the patron—with his red yarn hat and white beard that made him look like Santa Claus, and his donkey, whose tail Salmon and Mac Orlan had caused to paint a modern painting by dipping it into paint and letting it wag and the painting was accepted at the Indépendants—carried a gun. And nevertheless his son was shot in the neck and killed while serving at the bar. And nevertheless a decapitated head was found one morning outside under the outdoor table at the corner of Rue des Saules and Rue Saint Vincent.

Meidner when he shows Modigliani selling woodcuts, being thrust out by concierges, once hurriedly cleansing his soiled velvet with his own sputum when he has been repulsed, is contributing to the magnificent legend of Modigliani. But when he shows him skipping credit at a restaurant when the end of the month comes, delighted at this, delighted he is winning enough to get credit again soon at another place, where the patroness is likely to be a woman, he is probably telling the truth. Modigliani's life is running at countercurrent: he is declining inwardly into injuredness of spirit, and he is going forward gaily. And it was so, the proportions altering and again altering, until the end of his life. He had gaiety, a corrosive bitterness. It is not nothing to be the handsomest man in Paris! It is little, when your paintings will not sell.

He emerged through the thickness and ill style, as had Picasso before him, of what may be called Lautrec, or Steinlen, or Nonell, or Greco, these being the things that coagulated in the Blue—or of Picasso himself.

The African influence on him was Ivory Coast, not Congo—that is important. Not *Art Nègre*, primitive art. Picasso was the

primitive. Ivory Coast Negro art was a long-ago importation from Egypt. It was hieratic. That is, it was the coming together of things in what might almost be called a sacrament of form. It wasn't primordial. But it was the beginning of what it was. The static artist, called conventional, reproduces nature already formed, but the creator catches it in the moment of formation. Modigliani would be archaic Greek or Egyptian at a time when they were not yet archaic, once he found himself. He did some wood carvings, perhaps as early as the maquis, in métro ties stolen at the site of Métro Rochechouart, then being built, perhaps carving in emulation of Gauguin, whom he admired then. If he stole the ties it could have been because he was twenty-two! They are not hard to carry, it wasn't the grueling business of later, when, money spent, at least looking the part of the consumptive, he lugged home the blocks of limestone stolen from building sites, terrified of a passing *agent* on a bicycle.

Yet when he was cutting them—at a go, like Michelangelo—he set lighted candles on the heads of them, and worked as if in a kind of church. Something peculiar was working in him—it could have been "a sense of art." His method of meeting the anarchy of Impressionism, which terrified everyone, was "going back before"— but before naturalism. It was not necessarily true that anything would be found by going ahead, except an act of going. It *might* be, that if the Egyptians had hewn so, and the Polynesians, and the Greeks had painted that way, it was because there was an accord in the human spirit. He won incomprehension, which is the staple food of original creators; and immortal fame when he was gone and could not know it.

It was not the Garsin way to respect money. Cocteau said it best: "And if he had lived? . . . he would have let his millions stray out through the hole in the pocket of his tattered velvet trousers." He *had* money: in 1914 the war came and abruptly shut it off. As for his health, it must be considered that he would exaggerate either illness or robustness.

The continuing friend, so far as documentary evidence goes, was Papini. But Soffici, too, was to give his naked heart a blow.

Papini was born in the Year of the Moloch, that is to say 1881, the year of the birth of Pablo Picasso.

ೲ

 Latourette, the French critic, has described Modigliani in the maquis. What we get from this is that he was very dissatisfied with his work; that he did not, out of pride, nudge up to critics, as was the way of the time. Gauguin himself did it, rock heart of egoism! Critics and artists formed mutual aid societies. One of Modigliani's closest friends advised Simon Mondzain: "When you sell your first paintings give fifty percent to the critics; you'll get it back," Simon Mondzain told me. Even Picasso and the venal Apollinaire were tarred, though that was qualified on the side of Apollinaire, who got most of his information across the *place* at the Restaurant Azon from the second-raters, and hangers-on such as Fernand Léger, because Picasso wouldn't let him in nearly as often as he made out.

 The maquis stood on the upper side of Rue Caulaincourt, a wasteland, given over to being a vast vacant lot and rubbish dump, because the earth was pitted and insecure, out of which had been quarried the stone for the building of Sacre Coeur. Squatters put up shanties. Modigliani had one of these; Paco Durio another. And so Modigliani lived in a collection of shacks roofed in corrugated iron, half of glass, half overgrown with scrabbly vine, tumbled together on uneven ground amid pits of quarries glutted with rubbish. His own has been furnished in the mind: Modigliani furniture invented out of Modigliani, instead of Modigliani deduced from the furniture, as ought to be. We know this—the postcards were on the wall: Duccio di Siena Carpaccio, Simone Martini; and the zinc tub was there—no matter what happened, he always bathed carefully, in the direst times. Picasso, too, had no other inseparable possession, apart from the implements of his art, and whichever woman it was who "kept him from the necessity of looking for a woman," as Max Jacob said, than his zinc bathtub. The ogre was far more fastidious than he ever let be seen. We see Picasso arriving below Boulevard Voltaire by char-à-banc, where he

is to share a room with Max Jacob at Jacob's expense, the open cab jammed with the zinc tub and Picasso—little else to be seen than the anthracite eyes, the black forelock (Max Jacob—letters).

Gauguin, who three years before had died despised—for he had failed in art—was now exceedingly prized; and collectors flocked to the shack of Paco Durio, who was poor, and offered him great prices for his Gauguins. But he would not sell Gauguin; *that* he would not do. But if they wanted his own work— But they didn't. Construction began to grow up from the Boulevard Clichy, where Picasso would go to live a bourgeois life in only two years' time, already grown rich, and Rue Caulaincourt—Montmartre was grandly swelling; and even the gutted terrain would have to be filled in, so that it could support the foundations of fine apartment buildings. Modigliani had to move.

Paris was a village then, Zavado has told me. Mud holes in the Boulevard du Montparnasse. And a great woodyard where the Coupole is now, patrolled behind its fence of wire by a great baying dog. And the incommunity of nations come to assemble at the Rotonde, a small place then, which had a tricorn terrace, and an inner room where Trotsky and the like could come to play chess, and Trotsky could write his polemical articles for the Czarist and revolutionary press alike, as he actually did, for he was a journalist; the artists of all the world, Poles, Russians, Japanese, Spaniards, and Arthur Craven. The Fauves were already across the street at the Dôme, and the Germans, until one day suspiciously before August 3, 1914 (outbreak of World War I), they all began to disappear, suggesting that the First World War had been planned and their consul had warned them to quit for Germany. The women lifted their huge skirts to get across the mud holes at the Boulevard du Montparnasse and Rue Delambre corner, which nobody thought to bother to fill up, and showed a bit of ankle; or alternatively came naked under a coat for a glass. And down in the Rue Delambre not fifty steps, where the *grosse* Fernande lived and Foujita whom she'd chased away came back to her with a blue blouse he'd sewn at for her all night and she let him stay, and the two of them embarrassed Zavado when they had him to lunch for they insisted on eating naked, and Fernande remained until she was taken away

to the hospital in 1972—there were vacant lots boarded up by planks. Behind these, tramps slept. Zavado tells that their snores could be heard in the street. Sometimes Modigliani slept there, drunk. "He dashed into the Rotonde, insane. 'The devil has got me!' Two cats, fighting, had fallen on him as he slept, alcoholized. A gross woman named Simone had a sub-basement apartment there and sometimes Modigliani would tap on the window and she would open it and he'd go in and for shelter share her bed for the night. At the end . . . he worked slowly, a bit at a time. He was too weak for his old method. There is much black in his last work. He had given up; he painted in the color of his despair."

When he left the maquis, he went to the Hôtel du Tertre, which was run by a man named Bouscarat and was thus also called the Bouscarat. It was on the Place du Tertre at the Rue Norvins corner. There, unknown, at 13 or 17—it is disputed—was the house where Modigliani would lodge with Beatrice Hastings almost a decade hence. Facing it, the madhouse where Dr. Blanche had treated Verlaine. Modigliani wanted nothing, really, except the eighty sheets of drawing paper a day he eventually used, and his stimulants. He could not pay Bouscarat. How should he get out of the hotel? But one night part of the plaster ceiling fell on him and it occurred to him to say winningly to Bouscarat that he meant to sue him. Bouscarat threw him out; and he went.

Picasso tells you of Modigliani, and he showed Françoise Gilot the shack at 7 place Jean-Baptiste Clément as she tells in her book—"That was where Modigliani lived." But it is rather funny; Picasso is really name-dropping. I ascertained through Rafael Alberti, who being a great Spanish Communist artist in exile too was one of the few friends to the last, and one of the few friends there ever were, that Picasso's Modiglianis were bought *after* the death, when the fame had begun. Modiglianis sold for 100 francs, 200 francs; within a decade they had mounted to 300,000, 500,000— the most rapid climb until then known in the history of art. Arnold Bennett paid £50 for his *Lunia* in 1919; but when he saw a Modigliani portrait in 1929, though one of the best-selling authors in the

world, he could not afford it, for his offer of £6,000 was declined. *Peasant Girl* owned by Osbert Sitwell he had acquired just before the death for £4; he resold it in 1925, when death had had its effect on the price scale, for £80, but it was resold the following week for £4,000. What matters is the increase, the vault. But to put it in U. S. dollar terms this is $20–$40 in Modigliani's life; $60,000–$100,000 in 1929 (he died January 24, 1920). In Sitwell's case, this was an increase from $20 to $20,000 (the resale price) in five years.

The Whores

Picasso's art was essentially Catalan: Cubist houses (Punic), Gósol and ninth-century Catalan primitivism; the grotesque in *Art Nègre. Niger*—the Negro under that immense heat tended to fashion funny gargoyle grimaces in the face of the terror of life. But Modigliani is Ivory Coast, a different business. Razorback nose, sphincter mouth, empty eyes. Egyptian, as we have seen. Refinement. Not Negroid at all. Lengthening gives elegance; flattening gives bluntness, like the head of Pablo Picasso. Leonardo, whom Eugenia writes Dedo so passionately admired after his trip to Rome, may rightly say that painting is an extension of physical structure—that you paint as you are, and must. The asymmetry of eyes heightens expressiveness—of eyes that look right at you; but Picasso displaces eyes to achieve simultaneity of perspective, immediacy, front and profile at once, as did the Old Stone Age painters of bulls. It is a primeval thing. The T-nose of Modigliani is simply an inverted T with two lines closing the points together, and was an erotic sign of the ancient world, and we shall see to what degree Modigliani uses esoteric signs. Gertrude Stein said she was at the origin of Cubism; she was nearly right. Picasso tried to paint her portrait more than eighty times, for it is nearly impossible for a very great contemporary artist to make a portrait, except by transmutation; but then in the summer of 1906, which was the same year, Picasso went with Fernande Olivier to Gósol remote in the Catalan Pyrenees, and there saw pre-Roman Catalan

art. He went back, and the first day painted from memory the Gertrude he had given up, and he painted in effect himself, and that self he painted was the self he had found in Catalan primitive art. He immediately sat down, he painted squatting with the canvas stuck into the *v* of a chair in those days, and did his own portrait—I saw it hanging on the wall at Notre-Dame de Vie, and it was as much Stein as he, and she as much he as she. Later it was found that these autobiographical head studies were the first movements of *Les Demoiselles d'Avignon.*

Cubism began either in L'Estaque, the *petit* country of Cézanne, as could not have been a coincidence, when Braque went there in 1907, and again in 1909—Picasso and Braque met in 1908—or in the summer of 1909 when Picasso saw the Punic, which is to say Phoenician, which is to say geometric, sugar-cube houses at Horta de Ebro in Catalonia—typical Spanish houses of the region after all. Neither of the participants was ever quite sure; and they are both gone now. But in 1907, when Modigliani was at 7 place Jean-Baptiste Clément, which is in sight of the Bateau-Lavoir where the thing was done, Picasso painted *Les Demoiselles d'Avignon.* Women of the whorehouse on Barcelona's Calle Aviño (Avignon in Catalan)—in Barcelona near where he had his first studio at fifteen, and was precocious in many things, but traditionally thought now to be women in Avignon, in France.

The J.-B. Clément shed and the famous Bateau-Lavoir (*bateau ivre* of modern art, to take Rimbaud's title of his most famous poem, "Drunken Boat"—actually laundry boat after the washing-women's barges in the Seine) were so close it is incredible that Modigliani never, at that time, entered the place; but it seems to be true. Had he, he would have been appalled. *Les Demoiselles d'Avignon,* the most famous easel painting of the century, the beginning of twentieth-century art, horrified Braque—"It is the worst painting I have ever seen," he recalls he said. It horrified Apollinaire, who always put his opinion where it would do him the most good. Who liked it? Gertrude Stein, Daniel Kahnweiler, Picasso's dealer—two who were *physically ugly.* Not Picasso. He turned its face to the wall and so it stayed essentially for some

thirty years. "The picture which originated Cubism" was not shown publicly until the thirties, when every worthwhile Cubist had long since abandoned Cubism. It did not originate Cubism; but it originated Picasso.

Let us go a little bit back. Isidro Nonell, and Miguel *Utrillo*, and a number of others, were Picasso's friends in Barcelona before 1900. He went to Paris because Steinlen's success gave him confidence; he was a very ambitious, determined, hypochondriacal, humorless (except for black humor, which is cruelty) young man.

Isidro Nonell was born in 1873 (and died in 1911, and Pablo Gargallo, who influenced Modigliani, made his death mask), so that he was eight years older than Picasso and started earlier. His crayons of 1892–1894 are identical with early Picasso of about 1900, and in the tragic Nonells of the beginning of the century is the Blue Period of Picasso, though in morose greens and dark browns. Picasso tried to buy up Nonell later on, he who never gave a spit gob to public opinion, or the opinion of anyone human; had he succeeded the pictures would now be in the Louvre (Picasso donation) instead of the backwaters of the Museum of Modern Art in Barcelona.

The occasion for the inception of the Blue was the suicide of Carlos Casagemas. Picasso made the blues blue because at that time he admired El Greco. He thought it was a very sad color. He, Casagemas and Pallarés made the first trip to Paris together in 1900 (Manuel Pallarés saved his life at Horta de Ebro in 1898, was his host there again in 1909 at the possible inception of Cubism; is alive today at ninety-seven on Via Layetana in Barcelona; he was ninety-six when he made the trip to Mougins when Picasso died in April, 1973; he was refused admittance)—Picasso stayed with Nonell at 49 rue Gabrielle. El Greco had been carried around in triumph in the streets of Barcelona in consequence of having fallen into oblivion; and Picasso had got fond of him. Carlos Casagemas had some particular hold on him. He was what is either called a sensitive young painter-poet or an hysteric, and when, after the Paris trip, his nerves flared up, Picasso had done with him, as he always did with anyone troublesome or who had outlived his usefulness; the trouble was Casagemas had fallen in

love with a faithless girl in Paris, but as it was Casagemas's love affair and not his own, Picasso did not see why so much attention should be given it. Casagemas went back to Paris alone—this was in 1901—he found the girl in a café with another man, and he took a shot at her, missed, and shot himself through the head.

The Burial of Casagemas is, effectively, the first Blue Period picture; Steinlen's popular success had let Picasso see that this downbeat sort of thing was probably what is nowadays called a "calculated risk." But still, even two years after Casagemas's death, Picasso was still transmuting himself into Casagemas—in *La Vie*, 1903, all the early sketches show himself as the man upon whom Age looks and the naked young woman leans, but finally it becomes Casagemas. The Blue Period influenced Modigliani—*La Juive* (*The Jewess*) shown in 1908 at the Salon des Indépendants—but this was merely an accident of the time of his arrival in Paris during the first ascendancy of Picasso. Already by *The Violoncellist*, Salon des Indépendants 1910, the influence is Cézanne. The blue period had essentially nothing to say to Modigliani.

He was accepted for the difficult salons: 1907 Salon d'Automne —at which fifty-six Cézannes were shown, for Cézanne had died the year before. It was the beginning of the "age of Cézanne." * Salon des Indépendants 1908, 1910; Salon d'Automne 1912, *sculpture*. Accepted; but not bought, except by Dr. Alexandre, then actually an intern at Lariboisière Hospital and living in Avenue Malakoff.

He did tell it on himself that his first buyer was a blind man. It was almost true. Léon Angeli, who lived in rue Gabrielle, where Nonell had lived, and near the then Place Ravignan where the Bateau-Lavoir was, had nearly gone blind, but he went on buying young painters, without much judging, for they were very cheap, and certainly he would one way or the other get a winner. He did own paintings that would one day have been worth an immense fortune, but he had to sell, including the Modigliani, during the First World War, and died a pauper.

* It is a pity that in the art business death is frequently awaited before a "launching." Then it is assured that the dead artist will not, by further production, compete with himself.

Modigliani's mother, and to some extent Menè, who became a Deputy in the Italian Camara in 1913, supplied him about forty dollars a month—it does not seem much but dinner was then a franc, twenty cents, at Rosalie's. At Marie Wassilieff's canteen during World War I it was half that and a repast that consisted of a soup, one dish, a glass of white wine and one cigarette was obtained for fifty centimes by Modigliani, Braque, Chaim Soutine, Lenin, and certainly Trotsky. Though certainly Trotsky did not pay. After the Bolshevik Revolution, Marie was arrested for having been the mistress of Trotsky. She listened in angry silence during the arraignment in court, a physically diminutive woman but with vocal power, then in her middle thirties, who had been sent here to Paris in 1905 on a scholarship by the last czarina of Russia, which was surely a point of pride, even for the mistress of a Bolshevik—and when she was to reply she rose up and said in a loud voice: "I am a decent woman and the mother of a Frenchman!" It was true she had a little illegitimate French son. *Vive la France!* was cried from all sides; the charge was dismissed. Aicha Goblet, a Belgian Negress, and Marie's friend, a mulatto in fact, former circus rider, Pascin made a model. She lived at the Cité Falguière —Kisling was there, then went to 3 rue Joseph-Bara. She had kinky but blondish hair, used cocaine but did not drink, and never aged.

Modigliani, the anarchist, perhaps feared the anarchy in art implicit in Mallarmé. Of course if Mallarmé had triumphed—; but he didn't: he declined. Picasso was not to be considered opportunist; he was that, and a great deal more. He had the head of a scientist—on the body of a man. He carried a gun, and he wore the blue overall of the mechano. Was this canny? or picturesque? or precautionary? He was an *extremely* careful man; as careful as Modigliani was reckless. As though he knew what he had been given in charge.

One day—it was in 1905—Picasso went out to the public fountain in Place Ravignan—it is not there anymore—to get some water and he saw Fernande Olivier. He asked her to come inside and look at his pictures. And right then two things happened—his great heart opened; and his father in him came forward, the effete, elon-

gated, melancholic teacher of art and North Castilian who was called "the Englishman" for his appearance. And bull-like aggression, which was his mother, and Andalusian, receded. Fernande had on a pink-colored blouse and he took it off her, and quite soon it was framed and hung upon the wall. That *day* the blue ended; the rose period began.

And it was the closest to Modigliani Picasso was while Modigliani was alive. Not that Modigliani saw the *vie en rose!* But Picasso in the pink view of the love-elation of love for Fernande saw closer to what was the classic in him, perhaps because it was elemental grace, and his father was released. Picasso made a nude on a rose background, almost immediately from Gósol, and there is something primitively down-looking in the face; and then a full-face nude of Fernande that could be Greek.

Impressionism terrified everyone because the time element was put in. Monet painted the same haystack five times on the same day, in different lights. A haystack had been just an idea! A haystack *when?* And soon it was seen that if there were to be an observation there had to be an observer and therein was anarchy. The observer would take over. It was not quite so clear that if you built a thing—and were not *limited*—the constructivism would take over.

Mac Orlan writes:

When he entered his atelier on Place Ravignan, Michel Kraus hurried to open the window that gave on the square. He scornfully watched the butcher go, and then avidly followed the play of the shadows of Nelly and Rabe cast by a candle on the closed curtains of a window of the Hôtel Pommier.

A rickety window was slammed with violence, and the square slept again in the cold silence of dawn.

The window closed, Michel Kraus stood more than a quarter of an hour gazing at the snow on the square, hesitant. Now everything would follow the order of a tragedy, half-sentimental, half-literary, of which he would be both author and hero.

He was blond; he seemed extraordinarily young, the youngness of a girl. His hair, in the mauve-gray shadow, took on an

extraordinarily rich and romantic coloration. Michel Kraus sat down in the one leather chair and looked around at all the things that brought him Germany through the exoticism of Paris. A great mechanical calm turned in him like a phonograph record. He shut his eyes and followed the rhythm of his thoughts by tapping with his fingers on the chair arms.

His life recomposed itself in his memory like a miniature. He himself circulated among the marionettes like a little felt puppet, lifelike enough, yet discreetly deformed—very distinguished. Michel Kraus wanted to live a long while among these Nuremberg-painted puppets, so well-dressed and so full of good humor. Joviality blew out their felt cheeks, a little dusty. They lived to the melancholy air that sprang from the violins.

"Ah, if I were the size of that little toy soldier," thought Michel Kraus, "I could live without that disgust for everything that comes every time I open my eyes."

He squinted his shut eyes with rage, as one clenches one's fists in anger.

A large wool puppet threw itself like a mechanical spider on a second of the same cloth, but which represented a romantically slim person such as you saw in the first drawings of Böcklin. The big puppet bit the other on the neck, at the nape, and stayed bent on its victim a long time without releasing its teeth, and half closing its big eyes the color of scraped bone.

"Memories of my youth," grimaced Kraus.

"On the count of three I will open my eyes." He counted three slowly. On three he opened his eyes and got up.

"Plenty of time, eh, Juni?" His cat, balled in a chair by the cold stove, watched his every movement with luminous eyes.

"Here's your soup." He fetched a plate of cat food from the cupboard. "You can eat for three days. I'll leave the fanlight open, and then you can abandon this funeral hall."

The concierge knocked and slid a letter under the door. It was an invitation to a masked ball.

He tore up the letter. He threw it into the cat food.

It was Thursday, no school, and the boys came for their snowball fights on the square. The little girls already laughed like the women of Montmartre. They showed their spindle legs in black stockings. Perched on a bench, they chanted in chorus:

> Oh it's great, mademoiselle
> Oh it's great next to you
> However, the girl said
> That homeland's only a hole.

Kraus listened to the refrain, a refrain of Germany. He wasn't moved. His homeland was in the window with the puppets, on Kaiserstrasse, in Wiesbaden.

He took his bath. He shook with the cold. He shaved, naked to the waist, and put on clean clothes. He combed his hair.

He had two hundred marks left. He put them into an envelope addressed to an old beggarwoman who had posed for him several times. She lived in a hole in Fort Montjol.

He took a knife and cut his paintings to pieces. He tore up his drawings, and those of his friends. He squeezed out his paints onto the floor. He broke his palette. Then he took the skipping rope he'd bought in Rue des Abbesses and looped it over the door handle and pulled with all his strength. It held. Juni, paws pulled under him, was on top of the bureau, watching with round, green eyes.

"I don't regret a thing. As for Rabe and Nelly, I could paint Rabe and Nelly without being afraid . . ."

Suddenly Michel Kraus felt the tears come to his eyes. So he put a record on the phonograph and put the phonograph on top of the bureau, next to Juni.

He climbed on a chair and fastened one end of the jumping rope into a ring in the ceiling and passed the other end around his neck, and knotted it. With one hand, he turned on the phonograph. He heard the scratching of the needle. Then he gave a great kick of his foot to the chair and hanged himself. (my abridged translation from his *Wharf of Shadows*)

His name was Dumarchais but he changed it to Mac Orlan because like Vlaminck and Apollinaire he had lived by writing pornography. The Hôtel Pommier (apple tree) is the Hôtel du Poirier across Place Ravignan from the Bateau-Lavoir; there Modigliani stayed after he had been ejected from 7 place Jean-Baptiste Clément for nonpayment of rent, when Mme Escartier would give him a room for one franc a night. The Poirier was named for an enormous pear tree, *poirier*, which once stood in Place Ravignan,

so huge it is said a small restaurant was perched up in it. Rabe and Nelly are invented; but otherwise Mac Orlan's "fiction" is an exact description of the painter Vigel's suicide—in the Bateau-Lavoir. I quote it because it is contemporary writing. It conveys the peculiar romanticism of that time on the bridge, a swelling romanticism into which nonetheless one must prick a hole. Romance; and you see reality prick through. Vigel hanged himself, maddened by opium, which Pigeard had provided him. His funeral was a romanesque parade of Montmartre. Pascin and Frédé led the procession, and because Vigel had liked the high colors of German Expressionism, the painters came with their clothes brilliantly striped and daubed, and followed the funeral car to Saint-Ouen Cemetery in gay hues. From a carriage, a girl, dressed all in red, high on ether, threw kisses to the crowd; it is said she thought herself the Queen of Spain.

Picasso immediately abandoned opium. He tried hashish for a time. Fernande Olivier says that when he was gone with it once he declared he had just invented photography, and that there was nothing further to be done. This had a profound sense; photography *did re*move the last need for representational painting and after that if there was anything further to be done or not was a real question. Léon Bakst, whom Modigliani painted, was put out of business by Picasso's first stage set, designed for *Parade*—and what had Picasso's stage set to offer? Novelty. Picasso was well aware of this. Diego Rivera: "He had the best brain of anybody. He was the most intelligent man of the twentieth century." Fernande Olivier, who had met Modigliani at the Restaurant Azon, wrote of him in her book *Picasso and His Friends:* "He had a beautiful Roman head, and an astonishing purity." But she didn't write more.

You didn't go cap in hand to a new art movement—not if you were a Modigliani and particularly not if you were a Garsin.

Braque wore the mechano uniform, spoke *"merde"* (dirty talk) until he could afford not to; and then he gave it up, it wasn't his way.

Not, as Orwell said, were some pigs more equal than others—

but many men sought to be more equal than they were. The technique was publicity.

> The painting has become a veritable value of speculation that, taken at its emission, that is to say at the beginning of a young talent full of promise, represents an operation of the first order. There is not an instance where a collection patiently and intelligently formed, then dispersed ten or fifteen years later, has not realized a plus-value representing five to ten times its purchase price. What other financial investment can say as much?

This, which I translate literally to preserve its tone, was not merely an opinion but an actual financial brochure issued by the dealer Chéron, for whom Modigliani painted for a while in 1915. We shall see how elegantly he locked him into a cellar on the Rue la Boétie with a model and a bottle of booze, and only let him come out when he had finished a picture, for which he paid him fifteen francs and which he resold for two hundred.

Art was now interesting in terms of what could be said about it, rather than for itself. It was natural, since the critic wanted to shine. Apollinaire, once firmly seated on the *Intransigeant* and *Paris-Journal*, could afford to pay Adolphe Basler five francs per art critique, telling him merely whom to puff and whom to knock down, sign the criticism after looking it over for language faults, and sell it to his journal for twenty-five francs, and see himself become the official voice of Cubism as he is to this day.

Thus in part, though eventually he did learn something about art, was written Apollinaire's *Esthetic Meditations, The Cubist Painters*—editions 1913, 1922, 1950, 1965. He was genuinely pathetic when he was thrown into Santé Prison charged with having stolen the *Mona Lisa*; for he was moved to real feeling. His first book of poems was published by Daniel Kahnweiler, dealer of the new men, with illustrations by André Derain; and the next illustrated by Raoul Dufy; and the next by Picasso; and afterward illustrations by Juan Gris, Georges Braque, Henri Matisse. Indeed, one tilled one's garden by tilling another's. Apollinaire contributed largely to the reputations of Marinetti, Picasso, Boccioni, Severini, Braque, Derain, Matisse, and in part their permanent qualities are due to what he said about them. His declared enemies were Dante,

Baudelaire, Art Museums, Florence. Meanwhile, undercover, he was writing for a press in Avenue Malakoff—*Memoirs of a Hot Little Girl, Written by Herself* (1910), *Fanny Hill* in French (1910), *The Beauty Without a Blouse or Eve Rediscovered* (1910), *Dialogue of Zoppino Become a Friar, and Ludovic Whoremaster* (1911); he produced an edition of the Marquis de Sade in 1909. His name was not really Kostrowitzky; he was the son of a Sicilian named Francesco Flugi d'Aspermont, but as his mother was not married he took her name.

Surprise, Apollinaire said, is the thing now. That means effectivism. Just as Mallarmé had said paint not what you see but the effect you wish to make. The door it opened perhaps cannot be got shut now. But, as an artist, Modigliani was locked to the esthetic sense. He could stunt in that less important thing, life. And he has triumphed!—posthumously. Once the macabre launched him—his death in the charity hospital, Jeanne's suicide—and his art was *seen*, it turned out that the public liked it, and for itself, more than that of any of his confreres, which is why he is the dearest painter of the School of Paris—and that is what is most important about him.

Picasso was half one thing and half the other, and because he was entirely both halves of what he was, his father and mother, he was greater, but less pure. But impurity—is it not a particle in the size of greatness? Picasso had a quality which pertains only to the very greatest—Shakespeare, Leonardo. Usually it is called universality, but perhaps it should be called displacement. Picasso moved; but Modigliani *was moved*, and so was like Botticelli and the other great somewhat feminine artists. Picasso moved *en bloc*, as a piece; and, crude or graceful, did not seem to be touched at all—except that he revelled in the sheer act of making. But Modigliani was vulnerable to those he painted.

Utrillo

"He only had to touch Utrillo to get drunk," Picasso said. It was witty; and another of his knocks at Modigliani, suggesting he

didn't need much to get drunk if it would make an effect. He more than anyone could know that a painter had reason to dislike Modigliani. He laughed, to me, at the very idea that Léger could in any sense at all be considered an artist, or Chagall; and Matisse, though you will everywhere read the contrary. He called Braque *ma femme*—his wife (that was not fair, and he knew it, but if you are Picasso you say whatever you like and do not let yourself be stopped by your own opinion).

The art editor of the *Enciclopedia Universal Ilustrada*, Madrid, 1929, was Miguel Utrillo. It contains a lengthy and sympathetic appreciation of Maurice Utrillo; nowhere does it mention why Maurice was called Utrillo. Maurice, at that time, was only four years really famous in France, and unknown outside it, and encyclopedias ordinarily take some time to assemble, so that their general articles are usually written two or three years before publication. There is also an almost affectionate, for encyclopedia language, article on Suzanne Valadon; nowhere is there mention that she was once a model. Miguel Utrillo was an engineer in France, Bulgaria, Belgium and Germany; and afterward Paris correspondent of *La Vanguardia* of Barcelona, his natal town. He was friend of Picasso in Barcelona, and in Paris of Picasso's eventual Catalan friends, Manolo, Rusiñol, Nonell, Ramón Casas. He was in Paris in the spring of 1883.

Suzanne Coulaud was born at Bessines, near Limoges, in either 1865 or 1867—as Lautrec, who was eventually to give her the name Suzanne, said she was a pathological liar, it is not necessary to think she was accurate on this point of her age on which all women lie. She was born Marie Clémentine, and as the husband of her mother "Madame Madeleine" was at this time some four years in prison, for counterfeiting it is unlikely that he was her father. She threw off the legal name under which she was born, with an honesty that was both premature and partial, rejecting Coulaud—her mother was officially Mme Coulaud—and called herself by her mother's maiden name Valade, changing it to Valadon for the more male resonance. She was either sixteen or eighteen when she bore Maurice Valadon, who, on January 27, 1891, when he was seven, became Maurice Utrillo by a fallacious recognition

of parentage,* as you will read in all accounts—in the mairie of the Ninth Arrondissement. Maurice disliked the name Utrillo, saying he did not want to be the son of a man he had never met, and when he became a painter, figuratively marched to it by his mother with a pikestaff-end in the middle of his back, he refused to sign himself Utrillo and signed himself Valadon, until at last he gave way to her, half lovingly, half abjectly, as he always did, and thereafter signed Maurice Utrillo V.—the V being "Valadon," and he retained it to the end of his life. "Madame Madeleine," perhaps because of the embarrassment of the little bastardess, left the Limoges area not long after Marie Clémentine's birth—for Montmartre. It was when the latter became a painter that Toulouse-Lautrec thought she needed a more forceful name than Marie Clémentine Valadon and suggested Suzanne.

She was small, vivacious, carnal, with a fleshy mouth, a mouth like a bruised pear, fruity breasts, hands so tiny Renoir had to comb Paris for a pair of white gloves small enough for her dainty pose in *Country Dance*. She had a country-girl aspect, full in the shoulder, fresh, with black hair, the ideal "country girl come to Paris"; she was nervous, boiling when she painted gross female sexual nudes such as a large man might paint; in middle life she painted herself as heavy, black, peasant-looking, full of health, overpowering—she smelled like fresh-killed meat. She had been a bubbling girl; when Lautrec painted her as *The Absinthe Drinker* in 1889 she was debauched and either twenty-two or twenty-four. She had blue eyes, an oscillating pelvic stride which might have been the result of her circus experience. She slept with the artists who painted her, which included Renoir and Puvis de Chavannes, but not Degas who neither slept with nor painted her no matter how many times it is said; and the occasional young man, for no better reason than that she thought him good-looking. Nonetheless Degas was the most important man in the world to her except one; and after May 8, 1903, the most important of any. You could neither change, modify nor correct her, Degas said. Her handwriting was closed, incised, as if sawcut. She was proud to be

* Miguel Utrillo acknowledged fatherhood.

sought; and refused to do anything for it. She discouraged encouragement (and was astonished that she was an artist at all).

She was at first a seamstress with her mother, but she did not like it. She went into the Cirque Fernand. She was audacious, madly convivial; she appeared on the tanbark the night of the day she applied. She went to Puvis de Chavannes, hearing he was hiring a model; he was fifty-eight, she fifteen or thirteen. She chattered like a jackdaw, she asked questions interminably. She was lively, young. She was painted as a little circus juggler by Renoir in 1879. She joined Cirque Mollier in the Place Pigalle; perhaps because Mollier was a fanatical ringmaster, dominator of horses, famous for brutality. He made her an equestrienne. Toulouse-Lautrec painted her as *The Equestrienne*. But she wanted to be an acrobat.

In her painting, later, there is no indulgence, no pity. In Rue Tourlaque, just below the maquis, where other painters lived too, Derain, Bonnard, she lived on the ground floor, Lautrec on the third floor; it was there that he found out she was drawing in secret, and he told Degas. Lautrec had her undress once between courses so that when Léontine, his servant, came in with the next course she would be surprised to find her in only her stockings and shoes, and opposite her the little monster with his starched collar and pince-nez. She became independent. She maddened him with her willfullness; she posed when she felt like it. Sometimes when he came home he would find pinned on his door a receipt from her: "Valid for a glass of vitriol." She refused to account for herself or her moods to anyone. She came to have a small face, square jaw. Joseph, the old acrobat, who had taught her the rudiments of the trapeze, forbade her to go up as it was too soon; that very night she appeared during the circus, fell, broke her hip, and ended her circus life. She had for lover Erik Satie, an episode in his life that is not known. He was then a young esthete, finickily bearded, with pince-nez. He played the piano at the Posada del Clavo. Later he became the stocky nonconformist composer and collector of umbrellas, who did the music for the famous Cubist ballet *Parade* of Cocteau and Picasso. Cocteau told me that when he had died and

they went into the room where he had lived alone at Arcueil on the outskirts of Paris, and walked to and from the center to save the fare, they found over forty umbrellas, many of them never un-wrapped, and underneath the blotter on his desk all of their letters to him, unopened.

She married, or did not—one had her word by which to judge —Paul Mousis, a lawyer, of a millionaire family which refused to recognize her existence. She left him for, or before, André Utter; once again the authority is Suzanne. Up until Mousis, Maurice had always been checked with his grandmother "Madame Madeleine," who was self-effacing, or had become so by this time. Suzanne did not like the bourgeois life with Mousis. When she met Utter, she was forty-two or forty, Maurice was twenty-four, and Utter was twenty-three. Turnabout was fair. She hired him to pose for her the three nude male figures of *Les Lanceurs de Filets:* The Fishnet Casters.

Degas had a studio in the Rue Victor-Massé which was just below the Boulevard de Clichy. He lived there in intolerant isola-tion among lifesize dancing girls of red wax, their tulle skirts dust-laden. He had learned to fix a position of life, a girl dancing, a girl nude at her tub, with an incomparable livingness; but Modigliani was, sometimes, to catch the motions of a life in stillness, so that a figure would merely sit on a chair and look at you, yet contain the moments that had brought him there as though proceeding up a hall of mirrors. Degas was an "Impressionist"—yet everything he was and did was against their beliefs. He shut a form up within a line, did not let it diffuse; the naked girl had to be *prisoned* there. He looked through the keyhole at the girl in the bath and she did not know she was observed; he copied, therefore, what *is*, with a brutality at times like a female nude of Suzanne's, but not so mascu-line. He said drawing was what mattered, and then you colored within it. And sometimes Modigliani did this. De Gas (his real name) had taken a Fascist-like position during the Dreyfus case. Dreyfus had been exonerated, and the War Department official who had forged the documents had cut his throat; nevertheless it was the Dreyfus case, ending in the quashing of all accusations against the

Jew in 1906, that brought anti-Semitism to Paris. This was why, because he now for the first time encountered anti-Semitism, Modigliani began to declare belligerently: *"Je suis Juif!"*—I'm a Jew. He had never thought of himself as a Jew in Italy. It was very different for the Middle-European Jews who came to be so close to him now, Soutine, Krémègne, Kisling, and, first among them, Max Jacob here in Montmartre.

Painting was, declared Degas, a private affair; was painting "done to be *looked at?*" Surely Modigliani envied him this, for it was really true. But Degas was the heir of a rich banker and—

And this was the man who came to call Suzanne "the terrible Marie." She came to him trembling. Not then named Suzanne. And soon enough she disdained him. She thought he was the greatest artist living, surely, except one, till 1903. What was that? The letters he wrote her, when he was seventy, she in her thirties, about drawing questions, and supplications that she visit him, are really love letters, though they had no physical relationship, but she did not answer them. He was not only a great artist to her, but he was a holy man, for when Gauguin had had his disastrous exhibition, having come back to kiss art critics at the Café Voltaire, before he returned to Polynesia to die, Degas alone had backed him, and bought, and Gauguin had looked on this with his cynical eye. Only, when Degas was leaving, Gauguin went after him, and said: "Monsieur, you forget your cane." And he handed him a stick; and it was the stick he had carved in Tahiti.

Utrillo said: "A fine Christmas present she got." But he was not born on Christmas, 1883; at one in the morning, December 26, 1883. He was a half year older than Modigliani. He constantly asked his mother's approval of his work—if she approved he was joyous, he felt he dared drink a bottle of his beloved Anjou or raw Beaujolais without risking her terrible frown. If she disapproved, he went to sit in a corner as when he was ten, silent, crushed. He liked only *gratte-col*, rough wine. "I like to feel it going down. It makes me somebody else." Locked up at Gay's he drank eau de cologne, Mme Gay's dentifrice. Lunia, later, smuggled a bottle to him in the insane asylum. His hands trembled so when he took it

that he dropped it and it smashed, and he threw himself on his hands and knees and licked the liquid up from the floor.

He was beaten all his life, as a schoolboy, by his mother, by her lovers, by the police with Modigliani.

<div style="text-align: right;">August 1, 1917</div>

Dear mother,

It is useless to torment yourself, I have a will of iron.

A scalded cat flees cold water.

Your place is in the Louvre and mine in a madhouse. I know it. I spoiled my life at sixteen and it's too late for me to enter the bourgeois world.

Call on me, if you need unexpected help; sustain me.

You have more than a son, you have a slave, but I have a devil: alcohol.

I fight and believe I'll win.

Goodbye for now, dear mother. Regards to Utter.

<div style="text-align: right;">Maurice Valadon</div>

Braque saw the pair at Impasse de Guelma, where he lived too, when they were not at 12 rue Cortot. Utrillo would be brought home bloodied from his drinking bouts; times without number he and Modigliani were passed *à tabac*, thrashed in the police post with truncheon, fist and boot almost or actually to unconsciousness; and finally Utrillo tried to break his head on the wall of the police station in Rue Cortot. In 1912, for example, he was arrested on 26 March, 9 April, 27 April, and in December coming out of the Belle Gabrielle. Marie Vizier, who ran the Belle Gabrielle, which was in Rue St. Vincent, had eventually a number of his pictures, which she attributed to having accorded him her favor, and on one of them he inscribed—"To commemorate the happiest night of my life"—but if this occurred it must have been a unique incident. He venerated his mother; his saints were finally Joan of Arc, the Virgin Mary and his mother. He shouted abuse at expectant mothers; he set upon respectable old women emerging from their devotions at Sacre Coeur, and tried to pull out their hair. He wanted to be a scientist and when his mother insisted he become a painter he lost his paints, fell sick, kicked his easel to pieces, at last jumped out the window; and when bars were put

on his window high up at 12 rue Cortot he dropped his charcoal pencils one by one out through the grid and sat listening to hear them strike the paving, but her strong will prevailed.

Modigliani defended his friend to Bakst. "Why does Utrillo paint only grim subjects? He paints what he sees. Dealers expect landscapes, etcetera—we live in ugly circumstances, and that is the record we leave. Renaissance painters lived in palaces and velvets. Utrillo lives in *filth*—and paints *filth*."

When they met, to show their mutual admiration, they exchanged jackets.

"You are the greatest painter in the world."

"No, you are the greatest painter in the world."

"I forbid you to contradict me."

"I forbid you to forbid me."

"If you go on I'll kick your—"

And they fought.

Did this actually happen? But I think it says something about their souls.

Modigliani painted only humans, portrait or nude, except two landscapes, and only in rare instances are the humans not alone. Utrillo painted some five hundred street scenes without a human in them, or if there are any they are going away. He painted from postcards; the postcards are in the Bibliothèque Nationale and often the painting is an exact copy. He used calipers and a slide rule. He painted walls—the white walls of Montmartre, urinated on, spat on, scrawled on. When Rheims Cathedral was bombed during the war he wept; he had never seen it but it was one of his postcards. In 1907, he commenced to paint zinc white, eventually with sand and eggshell mixed in. And then he gouged the actual plaster out of the walls and put it into the painting of the walls.

Mousis tried to be a father to him; he hated him for it. He saw Suzanne more, for he had always been left with "Madame Madeleine." He brought his mother a painting, trembling, for her nuptial anniversary, real or fraudulent, with Mousis; the painting was inadequately done, and she slapped him in the face.

He had an infallible sense of placement; it came perhaps from his yearning for science. Yet he was, all his life, till he died in

97

1955, somehow like, many said who knew him, a primitive animal in the city; not one incapable of learning, but who simply did not have the code. "We had our differences but he was a god to me," he said of Modigliani after Modigliani was gone. They made airplanes of paper money and sailed them into the trees of Paris. Utrillo wrote poems on Joan of Arc, Valadon, and Modigliani. He wrote the following:

There once was, in Montmartre,
An ethereal young man of chaste sentiments,
Who drank and painted, working the livelong day.
He was very kind and nicely dressed.

Oh! his heart was purity, and innocence,
But he had, alas, a touch of indecency,
He spat on those who cried: "here's the madman"
For hopeless drunkard he discommoded all.

Then dreaming of vengeance in pure Republic of Montmartre
He shit on Marianne of France * and gave her the third finger!
Oh long live Anarchy was his true cry
I think it yet, I who write this.

When Modigliani was desperate he would seek Utrillo—"Only he understands me." If Utter or Valadon would try to take care of him he would leave without a word. Yet at the end it was Suzanne he sought, when he knew he was going to die. She was fifty-five or fifty-three—a short-haired, weary, unbreakable woman.

Valadon had been to a school of nuns on Montmartre; and was a bitter atheist. Maurice, painting churches, was praying before he knew it. One day, being stoned in the street, he ran into the Eglise St. Pierre, refuging as in the Middle Ages. Dead drunk, he again wandered into St. Pierre, oldest church in Paris, and passed out at the foot of the altar. Modigliani was an atheist—it was one of the "differences they had."

They met Utter together at the Lapin Agile. He was an electrician in the electric substation on Avenue Trudaine. He tried painting. He had a small mustache, wavy hair combed to the sides, and a little line of beard along his jaw. He was good-looking. They

* The French Uncle Sam.

became friends. Utrillo naïvely took him home. One day he came home and found his adored mother in bed with his great friend, a year younger than he.

One day walking in Montmartre Boissy appeared, and Suzanne said: "That is your father." Boissy was a sometime singer at the Lapin Agile, a sometime painter, but above all famous as an alcoholic. His father had been an alcoholic; his mother a suicide. Maurice believed her, and always thought Boissy his father. Utrillo's first "sales" were to the picture-framer Anzoli, who took paintings in exchange for stretchers. Clovis Sagot, a retired clown, had taken over a pharmacy in Rue Lafitte, and there sold art; as pharmaceutical supplies were left over, he dispensed them at random to his painter friends, including a "cure for anxiety" for Picasso (Fernande wrote of the Picasso she knew when he was in his twenties: "He was a sad fellow, sarcastic, hypochondriacal")—but Picasso was too prudent to take it. These were the type of improvisers who commenced to sell paintings. The lesson of Impressionism had been learned: when Bouguereau * was selling for 25,000 gold francs, the first of the Impressionists, such as Manet, who never earned a living throughout his life, were selling for a hundred francs, two hundred. Now the values had very much reversed! Utrillo sold for five francs the small size, fifteen francs the middle size, twenty-five francs the large size. Octave Mirbeau, a writer, bought some Utrillo and then began to puff him; this way, the value of Utrillos would rise, and his with them. As soon as the *resale* value of Utrillo began to rise, everyone rushed to buy, for the rule was get there first—the policemen who beat him, the café owners who would liberally give him a bottle of wine, until his resistance diminished.

Zborowski would have him in for a drink at Rue Joseph-Bara eventually, and when, as it now invariably did when alcohol had him, the rage to paint seized him, as though the despised profession had become as much an escape from reality as drink, would kindly provide him materials. And then he would buy the result cheap. Once, overcome with joy at so much friendliness, Utrillo

* Adolph William Bouguereau (1825–1905), one of the last conventional painters of the nineteenth century.

painted on *both* sides of a cardboard; and then, to have two Utrillos instead of one, Zborowski split the cardboard in two with a knife, but unfortunately cut the belly out of one side. So he patched it up with cardboard glued on behind and had the Polish painter Henri Hayden paint in the difference. Hayden was one, or was not, who, at the instance of Zborowski, or not, forged Modiglianis at the death, to augment supply. But one should not be hard on Zborowski. There is a sure measure. You look into the face painted and you *see* what he was; it is so with every portrait by Modigliani.

Utrillo's top resale price rose to 1,580 francs in 1919, for *Notre-Dame de Paris*. Five years after Modigliani's death his price had reached 50,000, but he didn't see much more than the fifteen francs, twenty-five francs for a long time. He knew he was being taken advantage of; he smiled a small weak smile; like Modigliani, *drink*, and then "pay with a little painting." When he had been handed over to Gay, a retired policeman who had the Casse-Croûte at 3 rue Paul-Févél, or had fled there to escape "the geniuses of Rue Cortot"—for Utter was painting now too—he would paint a picture for a bottle of wine, or sign somebody else's. Gay watched; then began to imitate Utrillos, but Maurice corrected them, did them over in effect. Later, Maurice signed Gays. The result was: there were authentic Utrillos authentically signed Gay, and Gays authentically signed Utrillo. But eventually he signed an exclusive contract with Libaude, Valadon's dealer. When he was in the insane asylum of Villejuif or Picpus, furniture screwed to the floor, a park of these cages, painting from his postcards, Libaude said to Suzanne: "He should be kept there for life. He paints better." Libaude thought Maurice's father was Spanish. So did Utter.

Once Berthe Weill saw a photo of Miguel Utrillo in the *Vanguardia* of Barcelona. She was astonished. She went to Suzanne and asked if it was Maurice's father. "Yes. No." The artistic talent of Maurice Utrillo is considered the evidence that he was the son of Renoir or Puvis de Chavannes. With Renoir and Puvis, Suzanne (Marie) was intimate around March, 1883, and in that month she copulated with someone, but the list is not necessarily complete.

I don't know if she's in the Louvre or not; Maurice is. But they occupy side by side an entire room of the French National Museum of Modern Art. What need had she for the prick of genius to produce a painter, except the usual? There are two reasons why Maurice may have wanted Boissy for father. Boissy was a drunkard, and so he had inherited it—and it wasn't his fault. And Boissy disappeared. Renoir didn't, and Puvis didn't die till Maurice was sixteen, and Miguel Utrillo was back and forth between Barcelona and Paris. The great problem of his life was that he was neglected by one parent, and possibly he didn't want to be neglected by two.

Suzanne's mouth didn't tell the truth, but her brush did. There is a portrait by her of Miguel Utrillo, 1891, and it is the reverse profile of her portrait of Maurice, 1910; and Ramón Casas's portrait of Miguel Utrillo could be a portrait of Maurice. Miguel Utrillo, the son, may be seen most days at the Circulo Catalan in Madrid; he thinks he is half-brother of Maurice Utrillo whom he so resembles, and so he is. When he went up to Montmartre a number of years ago people were astonished—and Suzanne was exceedingly nervous. There is something more remarkable. While the 1910 Maurice is Miguel Utrillo, it is also Gauguin, with the black mustache and goatee, as he portrayed himself in 1896. What moved Suzanne? For, until he died in Polynesia in May 1903, Gauguin was the most important man in the world to Suzanne—perhaps really the only one; on that egoist with the hard gray eyes she modeled herself. Perhaps they never met. When he came to Paris he didn't come to Montmartre, but stayed in Montparnasse, at 8 rue Grande-Chaumière, from which Modigliani would go to the Charité to die —in the studio, with his Annah the Javanese and her monkey, where Ortiz de Zárate would paint. Up over the door, Gauguin carved in Tahitian *Te faruru:* HERE ONE FUCKS. Gauguin has been too much praised, too much maligned. He and Picasso had the most self-assurance of any, an inconceivable self-assurance; which had the better reason? A self-assurance that carries all before it, and makes schools of art, art apart. He had all of Picasso's egoism about his painting and almost nothing of Picasso's success as a painter, but he had been a violent success on the stock market

when he was almost a boy. He did not abandon the stock market for art; after the Paris Bourse crashed in 1882 he tried several years to get back, in fact until the collapse of the Panama Canal Company—which brought on the Dreyfus affair because it was laid to Jews. He was not heartless when Van Gogh cut off his ear; Van Gogh came at him with the razor from behind before running off for the self-severing, and his intention was to cut Gauguin's throat, which is done from behind; and if Gauguin disclaimed knowing anything about the affair (the declarations are in the police registry of Arles) it was because at first it was thought Van Gogh had been murdered, and he was trying to exonerate himself of having murdered him. Van Gogh's brother Theo accompanied Gauguin back to Paris and they stayed together for a time, so Theo was heartless too—or else the father of Expressionism was, during the Arles-St. Rémy * period, insane.

Abdul's widow showed me a drawing by Modigliani of Utrillo: *le 5 Sept 1919.* It is that of a seedy man of fifty; Utrillo was thirty-five.

<p style="text-align:center">༜</p>

The only member of the Bateau-Lavoir mechanos, at first called the bande de Picasso, though the movement spread very wide, who liked Modigliani was Max Jacob. The reason is not far to seek. Modigliani was a superlatively good-looking young man. The death mask, got ineffectually by Kisling and Moricand, and salvaged by Lipchitz, shows a classic profile that could be Greek. At, for example, a café with Abdul and Basler, Modigliani is beautiful. Abdul himself was the second-best-looking man in Paris. Jacob, though a Jew, converted to Catholicism as did Utrillo. He one night saw Christ on the wall in his bedroom. Kisling said: "If I were Christ, alone in a bedroom with Max Jacob is the last place I would want to be." Jacob was unenthusiastic about women.

Jacob was a pixie, a mime, a masochist, a poet of the *written*

* After the Arles episode, he was for a year incarcerated in the madhouse of St. Paul, St.-Rémy-de-Provence.

word, not spoken—his were worked out like cryptograms on paper
and have no sonority, whereas Apollinaire chanted his while walk-
ing up and down, and then wrote them down—Cocteau told me
Jacob, not Apollinaire, was the true poet of Cubism. He was a
palmist, an etheromane, an Ashkenazi.

A *Study of History* by Arnold Toynbee (abridged):

The characteristic qualities of the Jews under penalization
are well known. What we are concerned here to find out is
whether these qualities are due, as is commonly assumed, to the
"Jewishness" of the Jews . . . or whether they are simply pro-
duced by the impact of penalization.

At the present time the Jews who display most conspicuously
the well-known characteristics commonly called Jewish and popu-
larly assumed in Gentile minds to be the hall-mark of Judaism
always and everywhere are the Ashkenazi Jews of Eastern Europe,
who, in the so-called Jewish Pale, have been kept morally, if not
juridically, in the ghetto by the backward Christian nations among
whom their lot is cast.

The Ashkenazim are descended from Jews who took advan-
tage of the opening up of Europe by the Romans and made a
perquisite of the retail trade of the semi-barbarous Transalpine
provinces. Since the conversion and break-up of the Roman Em-
pire these Ashkenazim have had to suffer doubly from the fanati-
cism of the Christian Church and from the resentment of the
barbarians. A barbarian cannot bear to see a resident alien living
a life apart and making a profit by transacting business. . . .

Acting on these feelings, the Western Christians have penal-
ized the Jew as long as he has remained indispensable to them and
have expelled him as soon as they have felt themselves capable
of doing without him. In the expanding of Western Christendom
the Jews have been evicted from one country after another as
successive Western people have attained a certain level of eco-
nomic efficiency. In the Pale this long trek of the Ashkenazi Jews
from west to east was brought to a halt and their martyrdom
reached its climax; for here, at the meeting-point of Western and
Russian Orthodox Christendom, the Jews have been caught and
ground between the upper and the nether millstone. When they
sought to repeat their performance of trekking eastward, "Holy

Russia" barred the way. It is not to be wondered at that, with these antecedents, the Ashkenazim whom this ebb-tide has deposited among us should display the so-called Jewish ethos more conspicuously than their Sephardi co-religionists whose lines have fallen in more pleasant places.

"Co-religionist" was not the question with any of the great Jews of the art school of Paris. Sephardim were Modigliani, Pascin. Ashkenazim: Soutine, Kisling, Chagall, Mondzain, Krémègne, Zadkine, Lipchitz, Jacob. The Jewish Pale extended across Poland and into southwestern Russia; a look on a map of ghettoes and concentration camps gives a dreadful measles. The Jews had a motive beyond escape from the ghetto and the attraction of Paris for artists: orthodox Jewry (not Sephardic) forbade the reproduction of the human image: Soutine was locked in a hen coop in Smilovitchi, Lithuania, for having painted his teacher. The Jews from the Pale region tended to congregate in the Ruche, in Quartier Vaugirard, because, largely, they could not speak French. Soutine did not even speak Russian–Yiddish. At the Ruche in the 1909–1914 years were Modigliani, Soutine, Krémègne, Cendrars, Lunacharski, Archipenko, Lipchitz, Chagall, Léger, Zadkine. The Vaugirard slaughterhouse was and is fifty yards away and the stench of death on certain winds terrible. When Soutine painted his halved ox à la Rembrandt he added—a demonically fast painter but an endless corrector—the perfume of the putrefaction of beef. When he tried to hang himself, Krémègne cut him down and walked away without a word.

Not all from the Pale area were Jewish. Zborowski, to whom more than any other person we owe Modigliani, was not Jewish. Zavado is not Jewish. He told me: "My father had shown me French paintings. I wanted to see the Louvre." The usual definition of School of Paris . . . foreigners from more exotic countries, most of them Jews, subjected to the rationality of Paris. Modigliani—Italian; Pascin—Bulgarian; Foujita—Japanese; Kisling, Mondzain—Polish; Soutine, Chagall, Archipenko—Russian. Salmon's beautiful phrase descriptive of Modigliani—"the campanile of Florence mirrored in the Seine"—has great truth. In fact, he was seeking to show old art, which perhaps *is* art, in terms of a changed

world. Chaim or Shaïm is pronounced Ha-eem; evidently it was originally Soutin, and the *e* was added for pronunciation in French. I was surprised that Pascin was not pronounced approximately Pa-san; among those who survive from the School of Paris I was told it is Pas-keen because that was the pronunciation in Bulgaria. Yet this was mysterious because his name was Pinkas and Pascin is a pseudonym.

The land these people came from was terrible. The mid-nineteenth century riots had undone everything Moses Mendelssohn had accomplished. Death roamed the streets, the fields showed a nude poverty, words stuck in the throat. It perhaps accounted for, accounted for but could not excuse, Soutine. And Krémègne—so like his name, which means flint in Russian.

Krémègne painted nudes; the starved nudes of a land of rotting straw roofs, forests that cried out from their depths with a terror that seemed their own. Soutine, the minute he finished a painting, would run with it clasped to the breast of his overall blouse, all he had, so that the blouse was dappled and often a painting smeared, terrified that someone would see it. Foujita taught him to brush his teeth when they were all together on the Riviera in 1918—Soutine, Foujita, Jeanne Hébuterne, Modigliani. Paulette Jourdain—the last female Modigliani painted, and whom Soutine painted twelve times—told me that when there would be a step on the stair while he was painting her Soutine would cry out: "The police!" And immediately set to hiding everything, trembling with terror. And there was no cause for this at all. When he and Modigliani lived together at the Ruche, the dirtiest man in Montparnasse and the cleanest, they had to build a moat around their pallets on the floor to keep away the fleas that were accustomed to feed on Soutine while he slept. In the coffin-shaped studio, for so all the studios of the Ruche are shaped side by side in a circle leading in from the outer wall to the staircase hole in the middle, the pair sat on their plank island, and by kerosene lamplight—the Ruche did not have electricity until after he was dead—Modigliani read aloud Nietzsche or Baudelaire, and Soutine listened.

MODIGLIANI

After Kisling's wedding, there was a celebration at his studio. Max Jacob did his imitations. "Max, may I do Dante?" Modigliani pleaded. "I know him so well. Please listen to me, Max. May I?" Modigliani was pushed aside, as usual. They asked Max to do Shakespeare. "Max, let me play the ghost." When he was like that, how refuse him? He rushed into the marriage chamber, seized the nuptial sheet. He came back out draped as the ghost of Hamlet's father. He cried out as Paris ragman and king's ghost simultaneously, the two voices in one—"Rags, bottles, have you rags, bottles?" A damned voice condemned to carry a vat full of sins and remembrances, rags and bottles, throughout eternity.

Max played a great part in Modigliani's life. A good many of the people Modigliani met he met through Jacob—Lipchitz for one, Paul Guillaume. Max knew everyone. It was, after all, his profession.

> Monsieur Guillaume Apollinaire Kostrowisky [sic]
>
> I have to copy two enormous manuscripts for a non-professional in a very short time, whose money I await with impatience.
>
> Doucet, the amateur in question (don't mention to him what I've just said, it's a secret)—Doucet asks me if I have collections of old literary reviews or books which have sold very few copies. I made it my business to tell him you have stacks. He wants you to get in touch with him. He's in the Midi near Sainte-Maxime, Var. I have given him your address. Here's his. I think there's several hundred francs in it for you, which is not bad.
>
> <div align="right">Max</div>

Doucet would receive little-known publications and out of them would be patched together a manuscript by Doucet.

Jacob lived at 7 rue Ravignan adjoining the Bateau-Lavoir in a dark room on a courtyard, some of the time with a young painter-poet named Macler. The room was so dark that the oil lamp had to burn by day. He painted, badly . . . having to use cigarette ash and coffee in his impasto, because he was very poor. He lacked only simplicity, severity, and the incapacity to understand. He lacked: innocence. He was something of a court jester, a He Who Gets Slapped. He had a groveling need to please every-

body, which he masked behind a fallacious gaiety. He danced, barefoot, forty, balding, his pants rolled up on his hairy legs, imitating a girl of la Galette, which he did inimitably, fists on hips, eyes batting; some almost wanted to weep. This was at the Lapin Agile. Fernande was there with Picasso and sang, having a sweet, high voice; and Apollinaire wrote a poem for Mondzain, which the latter treasures to this day and showed me in manuscript in Apollinaire's large, unsubtle hand.

Max managed to be facetious till the end, even when the Nazis "visited" him at Saint-Benoît-sur-Loire where he had become a lay monk (although they had already taken his sister and killed his brother-in-law). Primary for him was to maintain his position with the *tout-Paris*, and his role as buffoon, by which he got his handouts, and eventually his status as one of the great poets of France, being automatically mentioned by the great (name-droppers themselves too) into whose circle he had wedged and ass-licked his way. And so: "*Ils* m'ont rendu visite, but I am 'classified.' I am a yellow star in their dossiers; and there I shine," he wrote humorously to Cocteau, in the tone of mock levity become the lingua franca of the in people of Paris, employment of which did Cocteau infinite harm too.

Max had fêted Apollinaire, even though Max was the root poet, behind the whiteface of the traditional tragic fool-figure of Pierrot he insisted on assuming. But after Apollinaire was dead (in 1918) he soon commenced writing to Cocteau: "They say Apollinaire, sanctified by death, and incidentally removed from competition, was a great poet; it makes me laugh! C'est *toi* who are the great poet, and the rising star into the firmament of Hugo, mon cher petit Jean."

Essential to the reputation of Max is the fact that he is not read. At the end, when he was taken off to Drancy—to die of "pneumonia" in five days, although a letter of his from Paris en route, February 28, 1944, shows him to be in perfectly good health —he did become serious. To Cocteau he wrote briefly: "Sacha [Guitry] said, when it was my sister, that had it been Max himself he could have done something. Well, now it is Max himself." To his holy confessor he wrote, from the Jew cattle car, and a friendly

Nazi guard posted it at Austerlitz Station as they passed through Paris: "Pray for me. Pray for my soul." Diego Rivera's mistress once saw him on the floor at Kisling's entwined with a young man in postures that were more than sentimental. He had been Picasso's first friend in Paris. Picasso would omit him from this or that function; and doubtless it gave them both pleasure.

Modigliani painted him twice; drew him—as he did Moricand, Picasso, Diego Rivera.

On a Modigliani drawing of Moricand are symbols which Joseph Lanthemann, the greatest authority on Modigliani authentification in the world, told me may be homosexual signs. There is a curious hieroglyphic which may be two question marks crossed, the one vertical and backward, the other horizontal and lying on its back. *Mori quand?* When will he die? He may have meant that in a mixing of languages. Modigliani often affixed such cryptic signs; the poetic inscriptions by him, their content thoroughly analyzed in order to interpret his character, are all quotations, usually from Dante.

In one painting, Jacob is so dapper in top hat and grosgrain-lapelled coat that Mondzain, seeing the reproduction in my sheaf, said that it was a portrait of Pascin. Indeed it was more in Pascin's sartorial manner, and economic possibility, than Max's, but Max had got himself up, as he sometimes did, even to monocle and stick, concealing who knew what humiliation behind a rakish garb that mocked itself. He stayed on the Butte until long after everyone else was gone—often into international fame and success—a lone passenger on a foundering island of romance.

Modigliani, Zavado told me, was often thrown downstairs, even at Kisling's. Some incomprehensible rage would seize him, as if he were blinded to evident reality, for there was no cause. He would smash the crockery on the table at a party. Douglas Goldring, who had known him well, went back to ask about him when he had become so celebrated—many had avoided him. That was why they had so little to say about him. Salmon, said Lunia, lived across from 3 rue Joseph-Bara at 6. They saluted each other

disdainfully from street to window, window to street, so that when fame came to make Modigliani a good subject Salmon had little to say about him. Modigliani seemed to want to get along with no one. Yet he yearned toward people. There was always something fresh, something spontaneous about Modigliani, whether in his painting or comportment. His eyes had a quick something in them, a "taking up"—some rapid acquisition in his eyes. I had him twice before me. Zavado was telling me, near Aix-en-Provence, of when he had cleaned up the studio at 8 Grande-Chaumière the day after Modigliani and Jeanne Hébuterne were dead. A litter of sardine tins, oil spilled from them on the two beds, bottles; as the floor buckled, the bottles if laid on their sides rolled slowly to the center, bottles empty, partly full—Modigliani believed that the best gargle was alcohol—then: why waste it? Zavado cleaned out the filth, then, as it was vacant, undertook the studio and lived in it, first with Nina Hamnett, the nine years subsequent to the death. He stood up; he made a certain down-sweeping flourish of the hand, a certain *Roman* lifting of the head and looking about. He had been telling me how Modigliani declaimed: with a certain magnificence. He fanned out a hand down at his side as though it displayed three or four drawings, down at the side at arm's length as though not to see them. "Five francs?" he asked. "Four francs? Three francs?" He shrugged and started to walk on, across the farmhouse floor near Aix. My eyes had seen Modigliani offering his drawings at the tables of the Rotonde in Paris.

A year before this I had gone up to the fourth or fifth floor at 42 rue Cherche-Midi in Montparnasse. In an apartment full of mementoes of André Derain were Roger Wild and his wife, the former Germaine Labaye, Jeanne Hébuterne's best friend at the Colarossi Academy. Wild told how he, André Derain, Alice Derain, Isadora Duncan, and Modigliani had dined at the Trois Portes shortly before Modigliani was taken to the hospital—he thought Modigliani had seemed ill. Wild had met him in a bare upper room of the Colarossi in 1910; he was twenty-six, Wild fifteen. Wild described his grand entry at the Rotonde, how he would cast a glance around, his mocking mimicry. He would mimic

various ones ironically in sign of greeting—"Delhay, crapaud!" ("Delhay, you toad"), to André Delhay, writer, whose letter I possess about all these people, of Monday, 13 May, 1918, Paris. Modigliani wore a black wide-brimmed soft hat with the crown in a little peak, a velvet suit brown or beige, and colored foulard. For the young man, he was incontestably a mythological figure— Commedia dell'Arte, and something of the Spanish Theatre. He was robust; later very reduced. Wild was sitting at a table framed in a window, aged seventy-eight, and past him I could see the new construction going up on Rue de Sevres. His wife was beside me on a piano stool. He commenced saying how he had heard as a young man Modigliani striking the marble table top in the Rotonde to emphasize the strophes as he recited Dante, and as he did so he commenced to strike the table top and recite Dante. My blood went cold. His wife leaned toward me and said: "That's Modigliani's voice, you know." "Could you do that again?" I asked. He started over. His voice had changed as soon as he had begun to recite—a resonant voice with a hard, grinding edge: a sound both resonant and strangled. The actual voice of Modigliani spoke across the gap of over half a century.

"He was a naïve and modest boy," Augustus John said, *"when not on hashish."* But hashish calms you. Much has been misunderstood.

He occupied various addresses before Laure Garsin possibly (Giovanna believes so) found him a first-floor cell at the Ruche. He lived in the Château des Brouillards, site of Pigeard's opium den; he lived in the ruins of the Convent des Oiseaux. Here one of his adventures did take place. The secularized convent had been given over to tramps, derelicts, and, as it was near Place Pigalle and the Guignol, unemployed actors. These last had improvised a vernal theatre in the weedy park, and with one of the actresses Modigliani had passage love. Could she be the *Suffering Nude,* 1908? Much has been written of Modigliani's sexual encounters, and in detail. I have myself been in touch with two women who I think were present at a copulation of Modigliani—only two people are. I received no details. He was, it is written, a lord over

women, and had all Montmartre for his harem. Names are assigned. "Gilberte." "Lola." What D'Annunzio called the rose would no doubt by any other name— The creeping enthrallment of a vaginal encounter, always thrilling for a male in his twenties, had, in the case of Modigliani, in addition to the excitement of the woman's attraction, the superb, flawed satisfaction of his invariable supremacy over her. Sooner or later he had recourse to hashish. Pigeard supplied it. It is simply necessary eventually, if you are denied being the pursuer by being pursued, to sustain the erection at certain critical moments, and, if not the heart, then hashish does this. Gaby, a second and subsequent one (authentic, for the account is from Goldring), was a woman of some situation, a society woman, married, or kept: she picked him up, probably, because of his extreme good looks, his strangely ambiguous appearance of a ravished athlete; or he had begun the café-table sketching and sat down opposite her. Her husband or lover, who had been away, returned home unexpectedly and found Modigliani painting her in the nude. He had introduced her to hashish and commenced to corrupt her as though taking a sort of vengeance. There was an element of chastisement, certainly, in his later loves; but for the chastisement to be pleasurable has the woman—or on the contrary has she not—to deserve it? If he did seduce every nude he painted—he certainly did most—then for "little Jeanne," Dr. Alexandre's charity patient, presumed prostitute, late 1908, he, who had so much of it in him, must have felt a good-humored love. There is much compassion in the two nudes he painted of her. He loved only one woman. Which, for me, is tragic, given the love he had in him.

His breath stank of absinthe and ether. Already by 1908, Dr. Alexandre was saying he took too much hashish—but he did not oppose it, aware that intoxication is the food of genius. Alexandre's slightly younger brother, Jean, died in 1913; it is a mystery of Modigliani's life that, after Paul Alexandre's return from war, he apparently never saw Modigliani again. Did he, too, find Dedo intolerable?

An absinthe—a "green"—cost three sous. Absinthe was outlawed in France in 1915, during the Great War. In Spain absinthe

is still sold, but it is hard to find. Is it sold elsewhere? During the Civil War, its production was stopped and afterward most absinthe makers made pastis. The bar *absenta* of Spain is pastis, and much is sold. It lacks wormwood. *Ajenjo* is in fact Spanish for absinthe and absenta is Spanished French. A little *ajenjo* is made today in Tarragona. It is ice green, with water it turns moonstone color, the color of glacier runoff. It has a medicinal, acrid taste, and it is aphrodisiac.

Ether was very available in the pharmacies of Paris. It has a hot, sweet taste and its very rapid evaporation produces a sensation of intense cold, numbness. A teaspoon was enough for about an hour; it speeded the heart. It is highly explosive. One of Archipenko's or Dunoyer de Segonzac's pupils forgot her bottle by a stove and came home to find the wall of her studio blown out. It has gone out of fashion.

Dearest, [to Dr. Paul Alexandre]
I waited till ten to six. You didn't come. *Terrible.*
Assuredly then Friday, and *after death*—naturally
Have you seen Drouard?
Till Friday.

Modigliani

Dr. Alexandre and his brother Jean maintained what is called a phalanstery at 7 rue du Delta, which is in the Rochechouart Quarter off Avenue Trudaine. A phalanstery is a kind of lay monastery, after Fourier, the Socialist—he established a number of these communities believing that men should better survive if they lived in small units, rather than big ones. He lived in the first half of the nineteenth century and thought that men could live neither alone nor in teeming heaps.

In fact, the Rue du Delta place was not different from the Convent des Oiseaux. A hall-like or barnlike building had fallen into disuse, in a Paris not then very crowded; washerwomen had set up their business there, stringing their lines; they were evicted and room was made for artists. Around the vast hall, with a few cubicles off it, was a shaggy garden. It was much like Rodin's place near the Opéra, where upstairs his secretary, who was Rilke,

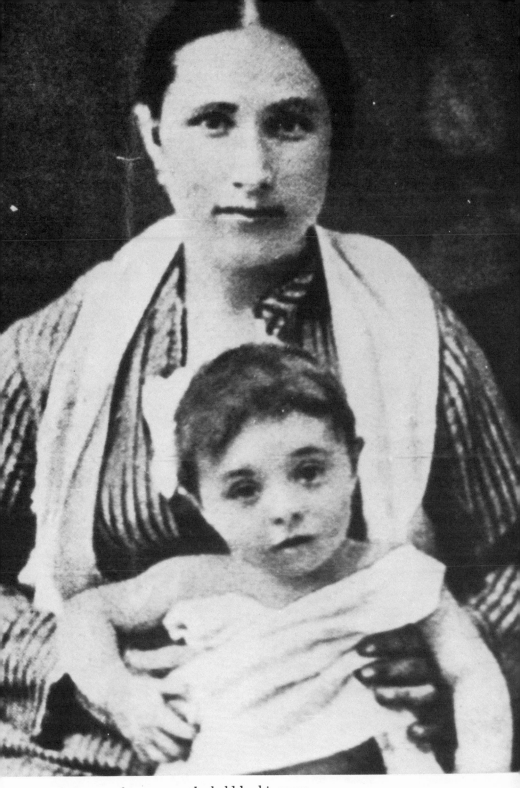

Modigliani at thirteen months held by his nurse
FATTORI MUSEUM, LIVORNO

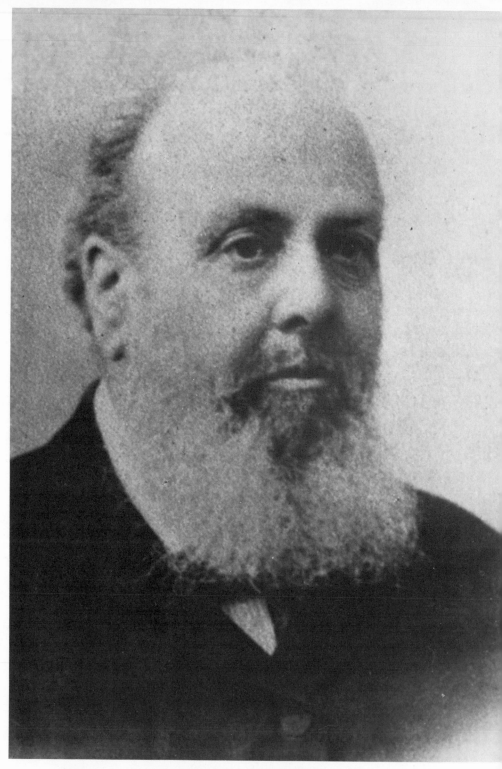

Flaminio Modigliani, father of the painter

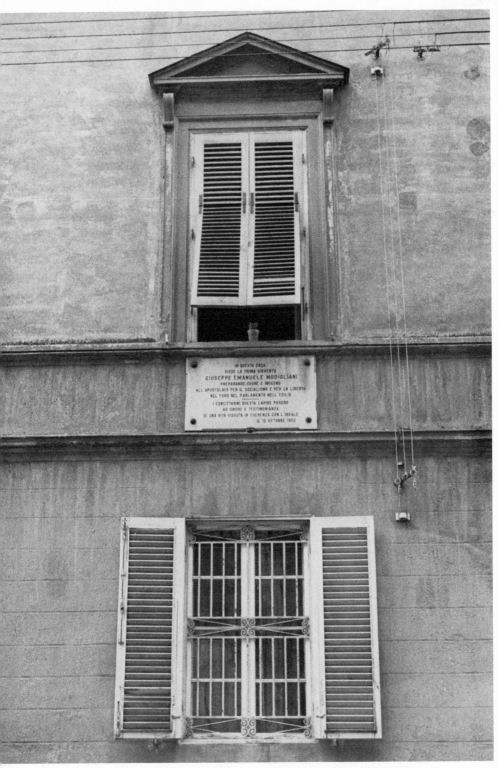

The house in Via delle Ville, Livorno, where Amedeo Modigliani grew up. The commemorative plaque is to his brother, Menè, the great Socialist.

FATTORI MUSEUM, LIVORNO

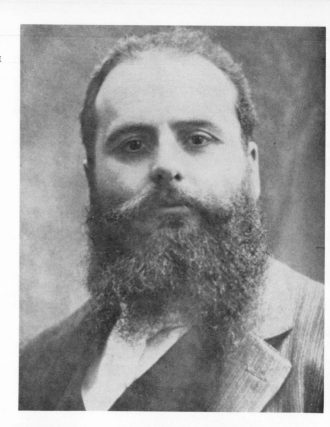

Menè Modigliani in 1908
COLLECTION VERA MODIGLIANI

Modigliani, bottom left, in
elementary school, Livorno
FATTORI MUSEUM, LIVORNO

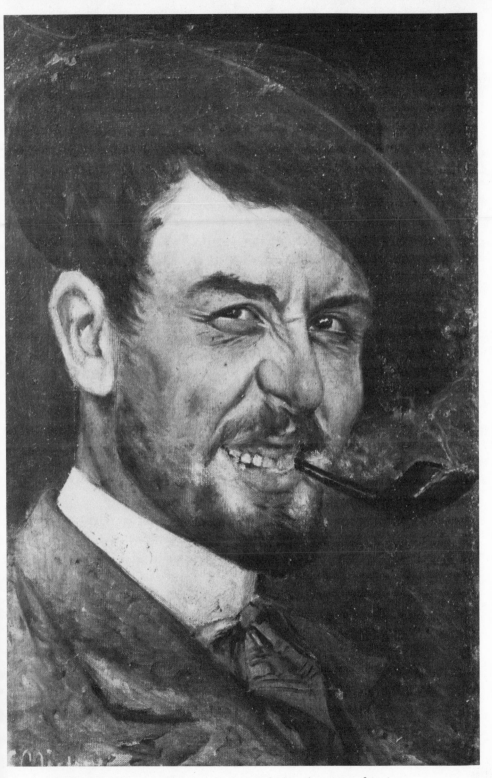

Self-portrait of Guglielmo Micheli, Modigliani's art teacher in
Livorno

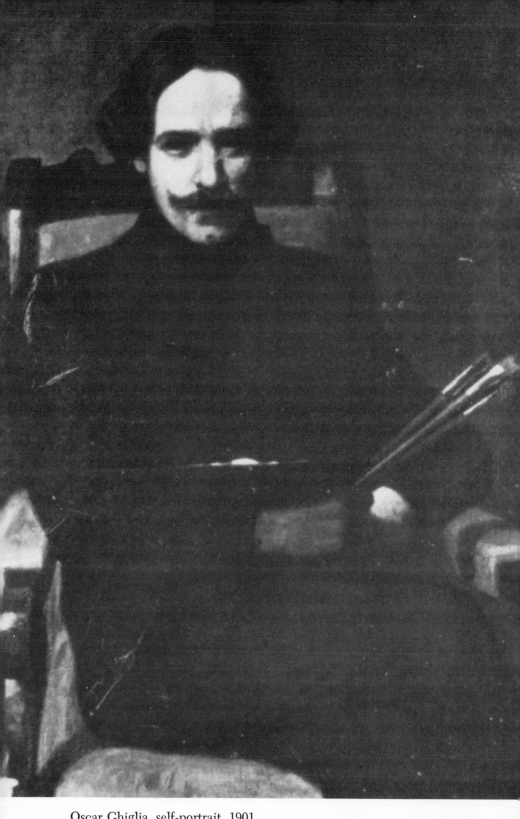

Oscar Ghiglia, self-portrait, 1901
FATTORI MUSEUM, LIVORNO

Corinna and Olga
Modigliani in their studio
in Rome
COLLECTION MODIGLIANI FAMILY

Modigliani's studio in
Venice
FATTORI MUSEUM, LIVORNO

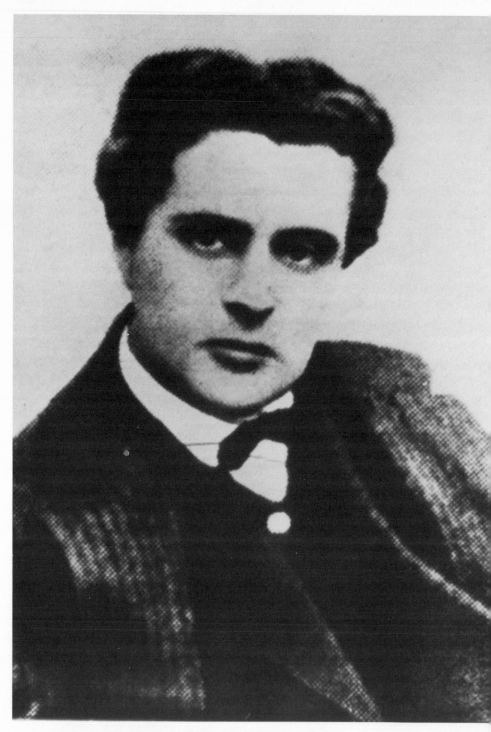

Modigliani in Venice in 1903

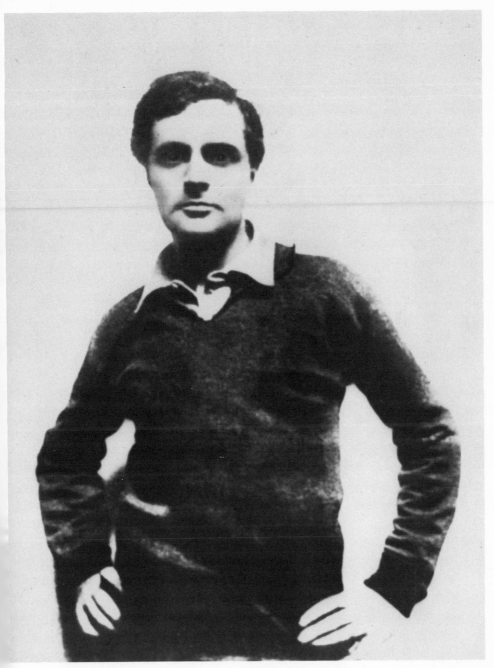

Modigliani in 1908 or 1909, not long after his arrival in Paris

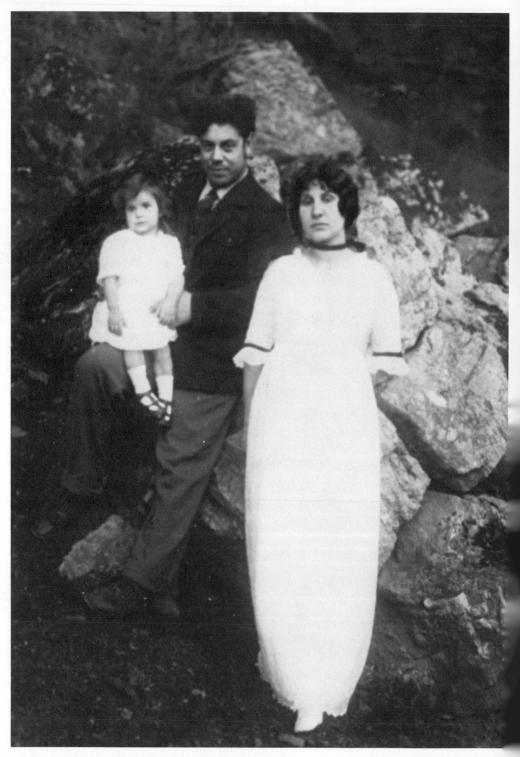

Ortiz with his wife Hedwige and daughter Laure in Brittany, 1914

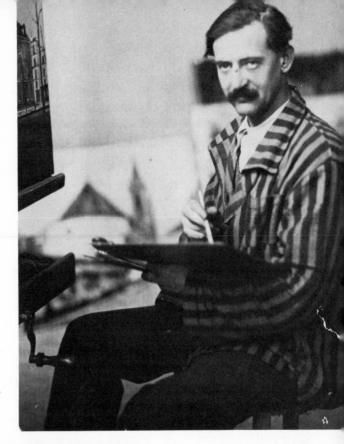

Maurice Utrillo
COLLECTION PAULETTE JOURDAIN

Max Jacob by Kisling
COLLECTION JEAN KISLING

The Cité Falguière in Montparnasse when Modigliani sculptured
there
FATTORI MUSEUM, LIVORNO

toiled obscurely, while down below the master *modeled* Balzac's stomach, by patting gobs of clay onto it, very misguidedly in Modigliani's opinion. There were ties available from the métro station then just being built a block away at Gaîté Rochechouart and into them Modigliani probably cut some of his lost wood sculpture—direct carving was the only way *to* do it, and modeling was effeminate, flabby, *Rodine*sque. It was the passing of the hand over the fesses (buttocks), as Renoir would later explain. Better Brancusi—but just the same when you carved bird in flight you should not, to make flight, abandon bird!

Hoarding was not in him—he could not conserve. Giovanna told me that many of his works were lost simply because he moved so often from place to place. Like every young artist, he sometimes destroyed works in a rage—material is *intractable!* He sometimes left art work in lieu when he had had to skip the rent, wistfully hopeful it would be valued.

Nearly all his early work sold was bought by Dr. Paul Alexandre. I asked Giovanna how it is that it is so difficult to see these works, still in the Alexandre family. It is said the postcards from Tuscany are still in the hands of the heirs (Alexandre, after a very long life, died not long ago) and I should like to see which Masters— Giovanna looked at me a moment as I asked why the door was not open (she is a small woman, who looks like Chagall; yet when she was twelve she so resembled Modigliani's most famous portrait of Jeanne Hébuterne, her mother, which Lanthemann says is not Hébuterne but another woman, that I ventured in my heart to wonder if Lanthemann might be wrong), and then she replied in three words: "The tax inspector."

Modigliani painted Paul Alexandre five times; eventually he asked him—*he* asked *him*—to introduce him to Brancusi. He painted Jean Alexandre. He was invited to the house, and he painted the father. They found him an exceptionally well-bred boy. Severini had a similar experience; he was on the make and had come to know the Mollets in the inaccessible Boulevard Port-Royal—they had interests in silk, and the father, who had been an industrialist,

had become the administrator to the editor of an important periodical, a man to cultivate—and he hesitated to take his sometimes unpredictable friend. But he did it and Modigliani charmed them.

Modigliani did not live at Rue du Delta, but worked there. His companions included Doucet, a painter, and Drouard, a sculptor. *Maurice Drouard* is of a dark, brooding young man with black beard—interrogating black eyes under black brows.

He heard from Papini sometimes, in letters of which Papini kept copies—in which Papini tried out ideas for his books. He was deep in Schopenhauer. Schopenhauer! Papini had a long horse lip over his pulpy, fat lower, and seemed eternally to suck at its nether fleshiness as he brooded; and short thick dark hair in a woolly cap. Nietzsche, a very *young* man, had set out to praise Schopenhauer when he broached writing, and had succeeded in demolishing him. Question of superior qualities! In less than a year Modigliani was to write philosophy—with Laure. Returned to Livorno, during his first serious illness—his head shaven on this or the second trip. He went straight to the Bardi and called out— "Where's Romiti? Where's Natali?"—had Ugo Bardi serve him absinthe, which he somehow found. And what was philosophy? It was introspection made formal. It was what *you* knew, obtained by osmosis or generated within. *Wine and Hashish Compared as Means Toward the Multiplication of Creative Capacity*—Baudelaire. But he would tempt the Devil to get painting!; and cling to structure. Because it was the common accord.

At Christmas, 1908, he went to the phalanstery and smashed up some of Drouard's sculpture with a hammer, and destroyed Doucet's paintings.

André Warnod was an ex-sketcher who was becoming a writer on art. He gave a New Year's Eve party in his atelier to welcome in 1909. Modigliani stood at the door offering each guest a green bullet of hashish. There was a great cauldron of punch under the Christmas streamers, and when festivities were high Modigliani poured kerosene on it and set it afire, to have a great punch flambé. The streamers caught fire and fire traveled up the streamers. Everybody thought the beams and walls would catch and the whole studio would go, and everyone ran to and fro screaming.

Modigliani danced up and down in front of the flaming cauldron shouting incantations from Nietzsche, D'Annunzio.

Severini has recorded how they met. They simply passed on Rue Lepic, and recognized one another. Then they found they had a common friend, Boccioni. Severini had known Boccioni in Rome, and Modigliani had been to school with him. They simply knew one another for Tuscan. Modigliani found a gay fellow in Severini, a man with whom to discuss the art concerns of the moment. He confided himself to him.

Artificial Paradises

He was living the nether side of great expectations. But if he was a romantic it was a romanticism of the *tenebra*, the shadows, the heritage of Pre-Raphaelitism, Gustave Moreau, Baudelaire, Poe—when suicide had its dark charm, consumption its aura, and, in an ink universe of plush velvet, it was attractive to snuff out: a too brief candle. What had "machinery" to say alongside that?— Léger and his girders?—Lipchitz with his hacksaw sculpture?— Zadkine with his jag cutlery of oblique statuary of angles and juts? It hadn't the beauty of a rose butterfly of tongue-yellow candle flame guttering out in an airless room. Where was the romance if the visiting card were not edged in black as though to announce a death? *Risk* gave intense doom music to everything, a dirge and not a jangle. To live on poisons had the great black beauty, unknown to all who had not done it, of heightening night, in a black room, enclosed by black velvet curtains. The shade projected by Salmon, Cendrars, Carco, Coquiot—these the first to write of Modigliani and from whom all subsequent biography has been drawn and to one degree or another refashioned—has about it the validity of Gauguin quitting business for art, or dying of want in Hiva-Oa, in which there is much moon and little sixpence, rather than (as he did) of debauchery and high spending; or of Van Gogh driven by a lust for life. "Modigliani" would have seemed to Modigliani inadequate. He participated in a higher romance than that.

The agonia of decadence ended essentially in the 1870 war, for most. For France, following on the victories of Napoleon and

128

Louis XIV, had not had the benefit of disaster, but rather the long period of prosperity, which brings irritation, and dissatisfaction, and disgust; and erotic, dismayed art and literature, until the collapse of well-being and subsequent national shame shall cheer, or at least bring forward more virile and less thin-skinned people. But Modigliani never got out of the romanticism—its *mystique*. It may have been because he was not French, and so did not feel the disaster of France, which stimulated and provided base for the triumphs of the twentieth century—Surrealism, Cubism the constructivist art which enthusiastically concentrated on breaking the whole up into its component parts—smashing, that is, what had always with calm faith been considered to be reality. Modigliani still lived in that discredited reality. Had there not been such success in France, Baudelaire could not have squandered his large fortune ($40,000) in a few years, and romantically pauperized himself, and erected upon the dunghill his Flowers of Evil.

Cocteau said to me that Picasso was the king of ragpickers, and that Modigliani was a ragman king. He had somehow preserved his sense of awe; which lived quietly amid deception. He little frequented the Right Bank—but when he did, and painted Bakst, Bakst later said of him: "You could not miss his nobleness, though he was shabby. He was a nobleman in frayed cuffs. He strode in—disdained the offer of a cup of tea, going straight to work, for it was for that that he had been summoned. He flung the sketch at you, as though to clear his fingers of ordure—with a curious flash of pure pride."

He strove back, it would appear at some drive in his blood, for the human. He took the drugs and drink of an artificial paradise in order that the human condition be regained, fresh, passionate, unheeding.

He bore the taint of the idealism of the late nineteenth century, when men were stifled because the immeasurable future seemed secure—itself sullied by Théophile Gautier, Borel, Lorrain, children of the spirit *maddened* because let run on pastures without edge, of whom only Lautréamont continues widely to sow his black pearls in the human heart today. Modigliani corrupted the

flesh because he did not like it; intolerable sack to house the spirit, the beating brain, throbbing with Garsin.

In World War I, Apollinaire wrote a fascinating letter—it is from the ambulance, in his own shaky hand. He has just been shot in the head on the Aisne Front, and he communicates the news of this at once to Paris. It was the spirit of the age.

```
   here news for bulletin     been wounded
head . . . the 17th
                    Ambulance
                      1/55                    [several words
                    Sector 34                  illegible]
```

And before he had really been trepanned in Château-Thierry hospital, they would be talking about him in Paris.

Albert Gleizes showed that the Golden Measure (Golden Section, they called it) had to be sought. And his widow talking to me of him a whole boozy afternoon in the disheveled *mas* at Saint-Rémy-de-Provence made me know how much this was temperament more than theory. Rule found which was common to all things—the art would converge on it. As it was, art splayed out, chaotic, because, depicting, each artist depicted individually. There were these people of the Section d'Or, Gris, Léger, Archipenko, Gleizes—on the other side people of a different temper. When Max Jacob's brother, an agent in colonial Africa, sent an indigene drawing to Paris in which the buttons of the tunic had been removed and become a halo around the subject's head, Picasso had absolutely shouted: "Dissociation of objects!" And between them perhaps not much room. But Modigliani was simple about these things. He thought the rule was in the heart, not theory. He thought that art should touch on some chord, and a permanent resonance in the human heart would resound. It didn't seem to be a very contemporary idea; nor did it get him cohorts. Later, when he was so isolated, it was people to talk with at his level that he missed most.

To be drunk, drugged, so that he should "look away" and

could paint. Utrillo was like that, and Baudelaire, and Poe, and Cocteau—the great purveyors of lucidity (oddly enough). To find what he wanted by looking—that was only possible if you were a pharaonic animal like Picasso: the bull that charges. You found, if you looked, what you knew.

Baudelaire said hashish intoxication will be nothing but one immense dream, but it will reflect its dreamer. The same man grown larger. The same number raised to a very high power. It is a magnifying mirror, but a true one.

The appearance of Modigliani with cropped hair, in torn clothes, soiled linen jacket, small cap with brim torn off, pants belted by a string, a pair of espadrilles dangled from it, face alabaster, the whiteness dappled by blue shadows, is remembered in Livorno as being 1909—but it was probably 1912, because there is a photo of him with short-cropped hair, looking very robust as though he has just returned from a rest cure, standing beside a sculpted head in Paris. It is the only photograph of him with his sculpture. This cannot be 1909; and the assumed 1912 or 1913 is probably right; it is the only photo of him in his maturity in which his hair is not a tree of curls. It has probably grown back so much, after being shorn.

Abuse had reduced him. This was true in both 1909 and 1912. In 1912, Ortiz de Zárate found him unconscious on the floor of his atelier and collected money from friends to send him back to Livorno. Since childhood, said Giovanna, he alternated between shy reserve and abnormally high spirits and violent tempers, and "stimulants and drugs produced rapid and irreparable changes in both body and mind. The only thing that might have helped him would have been to take a cure, and his family claimed that while he was in Livorno in 1912 he gave the idea some thought. But his eagerness to get things over and done with, the pressure put on him by the dealers, and the dissuasions of his friends, led him to a simpler solution, which was to take little drinks at regular intervals all the time he was working."

He did this all the rest of his life and everyone he painted describes it—through Paulette Jourdain, whom he painted 20 De-

cember 1919, 5 January 1920. Midsession in painting he gave her a small empty bottle. "Now you are going to do an errand for me. Go to the coal merchant—just say it is for Modigliani." "He called me 'fillette'—I was fourteen. He worked fast. He didn't closely regard you once underway. You could get up and look at the canvas. The neck was long—'Oh, that's the fountain at Rome,' he said. He would drink off tiny glasses, drink off one, then another, as he worked. He would finish drunk, then take the Via Sacré, he called it, from the studio to the Rotonde—he was drunk three-quarters of the time. He didn't sleep enough, burned the candle at both ends. He very often had to be carried up the five flights of stairs, often by Ortiz. Beatrice Hastings was the ruin of Modigliani. She was like Marlene Dietrich—a long cigarette holder—a femme fatale. She may have been a spy for the Germans. Pascin's wife Hermine David supplied Pascin women. His morals were atrocious, but he was very kind. He paid rides for all us children at the *fêtes foraines*." She said that Salmon, across the street from 3 Joseph-Bara where she was the Bretonne servant girl of Zborowski and later his mistress and mother of his child, was a heavy user of hashish. She often smelled it in his house. (March 5, 1973, Paris)

When Modigliani was still in the maquis, the Frenchman Latourette had received a shock—or a reproof. He was present when Modigliani opened a letter, and at the first lines he began to cry. And there was nothing in it. It was merely the first letter he had received in Montmartre from his mother. And when Souza Cardosa, who was even more his friend in sculpture than the more famous Brancusi, as is not known, died of Spanish flu in 1918 in Portugal—learning of it he wept openly.

He must have understood, returning to Livorno in 1909 and 1912, things his younger eyes would not have caught. Eugenia could look around her with independence and realize she ran it all—which makes a woman happy! The pair slept with the bedchamber doors open, though they were estranged; and there were the shadowed flitters, no doubt, of Eugenia robing and disrobing. Flaminio was kept away by some species of mildness (not lacking, actually, in Modigliani, though it showed itself in a different way

—inverted). But the apology that Flaminio must have radiated upon his wife the times he did broach her, a luckless expression, very winning, you see in the single photo of him Eugenia kept in her album. I have caught the exact eye in the photographed eye of Modigliani, unposed. Eugenia now had a husband whom she could signal to approach indefinitely through that open bedroom door, and warn to keep off, and the writing and translating, and the school of which she and Laure were mistresses, and it must have been a happy time for her. Flaminio had round, beseeching eyes, a round head, a soft beard. I find something very touching about him. When, in 1914, Modigliani for a few weeks had a short beard—the only time in his life—it makes him and his father very like. Eugenia standing there, her eyes lighted, holding out from her the sleeping garment she had to handle, in which her husband slept, as Giovanna saw—he permitted her to be what she was— her disdain is perhaps very understandable. Nevertheless she was mama, and Modigliani loved her all of his life.

He never dated his letters, but it must have been near the end that he wrote:

Dear mama,

I am painting and I am selling, which is a lot. As for Laure . . . it touches me that she thinks of me, remembers me, and is concerned about me in the state of oblivion of things human in which she is. It seems impossible that such a spirit may not be brought back to human life. Letters and I are a little bit enemies, but never think I forget you or the others.

I hug you hard
Dedo

For Giovanna, only person now living who knew the immediate family well—Flaminio, Eugenia, Menè, Aunt Laure, Umberto, Margherita—all these who were Garsin had something about them *sick*. *Pazzia,* which Plato called the madness of genius, but which for most people is just simply to be nuts. Flaminio was exempt. Having no Garsin blood, he could do little more than erect himself to the pathos of a whipped dog under the fine lash of the admirable Eugenia. Amedeo had something of both sides. He did.

"See?" said Giovanna, isolating a photo of Margherita. She was more concerned with Margherita, her adoptive mother, than her illustrious father, whom she never knew. "Do you see?" I saw a black-haired girl, with strong features, in middy blouse in the line with her university schoolmates, in the photo in the brass-hasped album Giovanna spread before me, not seeming to me anything particular except very Italian; but evidently she became a female chauvinist sow. "Ha!" said Giovanna. "Let a man come near her!" And I divined inklings passing into a little girl of things obscure, of which her inexperience could know nothing concrete —female soixante-neuf, the postures of Pascin. This concerned her much more than did Modigliani (except when she is interviewed). She limits herself, beyond expressive grimaces, to speaking of such things as Margherita's excessive smoking. "Far beyond the conventions of her years!" But she must have fought subterraneanly against the influence from Margherita. The result is she is very masculine, but very much involved with men. In fact, it has complicated her life.

Modigliani might have thought Laure—"her marvelous intelligence," her dissociated personality—an ideal companion with whom to write of philosophy. He saw philosophy for what it was now. He clung only to him he contemptuously called "a barbarian hammer"—Nietzsche. When he tussled once with Utrillo, after their drinking match in which they vied glass for glass in Utrillo's beloved *gros rouge*, and before he ran out into Boulevard du Montparnasse and throwing his arms wide tried to kill himself on the oncoming trolley, and Utrillo was cornered in an entryway and *matraqué* by the police, he fell and a half book was flung from the side pocket of his velvet jacket. It was *Maldoror*. He segmented books to make it easier to carry them in his pocket. Hastings said he everlastingly read *Maldoror*. Of Lautréamont's *Maldoror*, he said to Nina Hamnett: "That book ruined or made my life." Rimbaud had come to seem superficial. He had great facility; that is nothing. His tone was brisk, Verlaine's a measured grave hashsha-shin music.

He drank Livorno punch, which was half coffee and half

rum boiled together, and had Livornese fish soup (*cacciucco labronico*), but he was an alien in Livorno. His friends did not sufficiently esteem him. He was little seen at the Caffè Bardi on a Piazza Cavour that had got smaller.

Back in Paris, he had an affair with a demimondaine named Elvira. It has caused confusion with the young girl Elvira he painted twice seated, and then, standing, all but nude, six years later.

The style of the sculpture of Modigliani has been laid to Nadelman, but Modigliani did not see the sculpture of Elie Nadelman until an exhibition in 1913 when his own style was completely formed. A sexual opulence which will be seen in his nudes appears in his caryatids—a lascivious posturing. Often Modigliani's drawings of nudes are almost boylike, as was done in the androgynous Renaissance, but the caryatids have a round opulence as though he passed his hand in imagination around the curves.

Pablo Gargallo had an immense range. He was talented, various, elegant. He showed that absence was positive, by emphatic windows in the iron. If Modigliani had known Archipenko was doing much the same thing he could not have maintained his intense dislike for him, but it seems he knew only Archipenko's machinal phase. Pablo Gargallo's perforated wrought-irony did not influence Modigliani's sculpture but reinforced the suppression of background in Modigliani. It was simply wonderful how subject surged forward if narrative was suppressed. A beast in gunsight was very *seen:* at such point the treescape's fine green is irrelevant. And a nude, in Modigliani, is waiting love—not "Ajax," or the Minotaur, or a man riding up on a well-drawn horse. She is on a couch or bed, plateau not defined much, and against a flat background of blue or black or maroon. He painted sections of his wall at 8 Grande-Chaumière in these background colors, so that they were really there. There is no anecdote.

Brancusi was born in 1876 in the Carpathians in a nameless hamlet where there were no police, no schoolmaster, no doctor— no sickness, no crime consequently. He was a shepherd. He made

a violin out of an orange crate and thus attracted the attention of a local maecenas, and was sent to art school. In 1904, he walked (lacking funds) to Paris. His art didn't support him and he became a cantor in the Rumanian Church in Rue Jean-de-Beauvais.

He was Rumanian. He had lived in Pestisani Gorj, then studied art in Bucharest. He moved into 54 rue du Montparnasse in 1907. He was then just a step from the Boulevard du Montparnasse and, when it opened four years later, a block from the Rotonde. The Rotonde was just across the street from the Dôme, which was much older, and, because it was south-facing whereas the Dôme faced north, very soon collected a peculiar, brittle world at its terrace tables. The tram was no longer fire red on the Boulevard du Montparnasse drawn by two ponies, and in an hour and a quarter reaching the Gare du Nord; the vogue was for cocaine, ether, lesbianism, Cubism.

Brancusi wanted to live in the vital tension of Michelangelo, but he was against Michelangelo save for his method of cutting. It was a curious thing in him, rustic, homespun, wiry, that he wanted to make egglike edgeless essential form. Zavado recalls visiting him. "This is absolute form." Zavado: "Do you believe absolute form exists?" "This is absolute form!" He in no way was limited to the large, noble, calm, profound character of the Carpathian primitive—a subtle irony burnt in his eyes, and he was very arbitrary. He was a solitary independent rebel, having nothing to do with contemporary trends, disdaining success, intuitive, primordial, but with a very lucid intelligence, and he was of all the people of the Left Bank the one who appeared most often at the soirées of the Right—which meant Cocteau, the Ballet Russe, Bakst. He made his own furniture, did his own cooking, beefsteak, wore wooden shoes, and drank Pommard wine; he had an ethereal serenity, and was really very touchy. He kept by himself—and was there ever any woman in his life?—and went nightly to the Rotonde. He commenced with rough, hewn stone that resembled himself, and moved toward a refinement so immense that Modigliani disliked it; which was why Brancusi disliked Michelangelo in whom roughness was everything, and who had moved in just the

opposite direction. He said that if you lost your childhood you were dead—and he was always very childlike.

He accused Modigliani, in 1919, of having stolen the idea for the caryatids from him; and indeed they had made caryatids together at 54 rue du Montparnasse in 1911, but Modigliani's were refined, opulent, and Brancusi's crude, Stone-Age-looking. Before Modigliani went to Cité Falguière he sculpted with Brancusi at 54 rue du Montparnasse. Brancusi diverged to the ovoid, and Modigliani elongated *"nègre"* (Egyptian). When Modigliani ultimately judged Brancusi worthless—which was his way of saying "of not greatest worth"—it was because he thought Brancusi had stylized too much. But he stylized too.

The *Raymond*, painted in Modigliani's Cubist period when he lived with Hastings, is Raymond Radiguet. *Alice,* an adorable nymphet in blue with great elongated eyes and a simple cross on her breast, now in the Museum of Copenhagen, is "'Marthe" of *Le Diable au Corps* (the devil in one's flesh). Radiguet, when fifteen, had seduced the wife of a soldier at the front; he wrote *Le Diable au Corps* about it, calling her Marthe, and as it was finished just at the end of the war when antiwar spirit was very high the betrayal of one of the soldiers of France was judged a popular theme, and Cocteau, Radiguet's lover, managed to get for it the highest advance until then given a novel in France, one hundred thousand francs. Radiguet took the money and moved into a hotel by himself. It was 1921; he was eighteen. He had a love affair with Beatrice Hastings, who was forty-one. Very probably she met him through Modigliani. She killed herself in 1943. It is a curious thing that the two main women of Modigliani's life were suicides.

Radiguet died in 1923. Cocteau told me that his main characteristic was heartlessness; he provoked a desire to break open the shell and make him feel. In the year between his death and Hastings, which was 1922, he one night returned to Montparnasse with Brancusi, from an evening with Cocteau, Picasso, Moses (or Moïse) Kisling, and Brancusi, and Brancusi proposed that they

simply go to the Gare d'Austerlitz and continue to Marseille. Without baggage, they did this. There they decided to continue to Corsica, where they "spent a number of days enjoying peasant life and Corsican wine" (according to Nina Hamnett, who lived with Zavado in Modigliani and Jeanne's studio from 1920 after they were dead). Brancusi was in loden cape and rough woolen trousers which he always wore unaffectedly even to formal occasions; and Radiguet in tuxedo. The latter had to buy a boy's sailor suit in Marseille for the voyage to Corsica.

I wondered if Brancusi could possibly have been homosexual. I asked Zavado, and while the idea surprised him he did not, on reflection, think it impossible. To go off at forty-six with little Radiguet—what possible motive? Michelangelo was homosexual. There is no more sinewy, tough man in the history of art, five feet two inches tall, which was three inches less than Brancusi and Modigliani. Inquiries to others who knew Brancusi well brought no reply. I do not know.

Modigliani painted Brancusi in 1909, on the back of the study for *The Violoncellist*, shown at the Salon des Indépendants in 1910. The characteristic Modigliani had burst forth the year before in the final portrait of Dr. Paul Alexandre, when, suddenly, after the earlier Alexandres of which Whistler will not let go, he breaks the grip of Whistler; freed of it forever, he elongates—it is said the elongated style comes from the sculpture but in fact it preceded it, though it may come from the lost wood carvings of necessity stele-form (for they were railroad ties). In *The Violoncellist* the full Modigliani arrives—Cézanne, here naïve, whom Modigliani perhaps met more on his own terms than did any other, surely more than the constructivists. On the reverse of the study, intersected by the board of the stretcher, is Brancusi. The great image he carefully diffused, the sage of the Carpathians, hasn't come yet—he is surprisingly soulful, dark, with a black wiry thick beard.

They had a lot in common—modelling was *mud*. Mud gobs. But Brancusi thought that aspiration toward the infinite left spatial considerations behind. Modigliani certainly didn't. If you

left measure, which was contemptible, behind, what moored you? Art was a crisis of the nerves—that was true. Rodin was opposed because he was eminent. Modigliani expressed as his own various of Brancusi's convictions, probably, for the rest of his life, but certainly when they were together he opposed them. If he did have a debt to Brancusi, that eventually caused him to dislike him— like anybody. And it *was* absurd to try to find the egg form in a head till you carried it from being half-disinterred Rodin, and clumsily beautiful Michelangelo, to being an actual marble egg. Fettered motion was—somehow—more poignant than Flight.

They deplored Rodin because he was established. Brancusi had worked with him briefly the year Modigliani came to Montmartre. But "nothing grows in the shade of big oaks." Yet, only a decade before, Rodin, with his Balzac, had provoked a scandal equal to that of the Dreyfus affair, which split Paris and brought anti-Semitism to Paris. He had not been able to make a living until he was forty, and had had to do bric-a-brac; his *Age of Bronze,* now in the Luxembourg Museum, bought by France, was despised; his *Walking Man* without arms or head, father of Henry Moore, was a laughing stock; his *Balzac* was commissioned by the societaires of the Society of Lettered People of France, and they refused it. But he was now in 1909 sixty-nine years of age and a very great man, which was sufficient reason to refuse him.

When Soutine first moved into the Ruche he lived with Krémègne. Afterward, unable to pay the feeble rent of fifty francs a year for a studio of his own, he lodged with this one and that one—then it was that he was guest of Modigliani. The two would carouse at the Rue Dantzig bar. Sometimes when they came back they would see petrol lamplight leaking from under Chagall's door. He painted at night—the seeking of isolation true too lifelong of Picasso; when the arc lights on the canvas, or petrol lamps, induce a species of hypnotism and the canvas looms up out of the dark with an overweening importance that causes it to dominate its artisan and squeeze or suck from him that other, greater, something, perhaps from the subconscious, which makes him an artist. Modigliani was suspicious of the subconscious. He

said: "To paint, I have to have a living model in front of me. Abstraction exhausts and kills. It's an impasse. Let's be on guard against falling into the subsoil of the unconscious; it's been tried. Organize chaos. The deeper you dig, the deeper you plunge into the formless. Organize form and guard the equilibrium between the depths and the sun." But then he had a tradition, which practically nobody else did, and the incursion of his unconscious upon it could be no more than the battering, as one batters with a peen hammer on copper to get the final dimpled idiosyncratic form. He could not break through the copper. Tension would have gone, run out like blood through a wound, and left the vessel exsanguinated, weak. He could not, probably, have fully known this; and probably defended his method by blind instinct, as a creator does (for he cannot know of what he is creator until he has created it, and can then look at it, and see what he shall have set out to make some time ago at the inception).

The thinner the membrane of Modigliani's physical being stretched, the clearer Tuscan reality looked through, so that it almost seems he drank not because it induces bravado whereby a shy soul thrusts forward aggression as though a brazen shield, or took hashish to induce the erection required in order to fulfill the inadequate, almost ugly women he somehow was compelled to choose, but because the abuse, which was what counted, stretched his membrane taut—and it thinned to transparency.

And Chagall, for some reason, perhaps the heat of his kerosene lamps, painted naked. It was an inferno in the Ruche in summer, as it was Thule in winter; or perhaps he thought to get closer to Bella, who was in Vitebsk. He was, in chronological order, one of the two most disliked (or least liked, which perhaps puts it better) painters in Paris: Picasso, Chagall. They did not carouse, never took a drink, with Chagall perhaps always, with Picasso after the beginning when he shucked off the character of *petit* Goya (as he had been called from 1900, with uncanny prophetic accuracy). Jean Kisling possesses a letter to his father from Max Jacob, Picasso's best friend, intended, with Max's usual self-satirizing obsequiousness, to resolve a quarrel, and it ends: "At least you are a

man, and not a *salaud* * like that Picasso"—and it was considered, and rightly, that Picasso and Chagall abstained from every conviviality, or distraction of any sort, or least risk, because they were wholly intent on getting ahead. Yet, naked, Chagall painted himself and Bella in the spring, vernal joy of the miraculous birth of love, he so joyous that he floats in air above her, only kept, like a helium balloon, to the ground by the tether of her hand as they take a springtime stroll, getting close to this naked as though he would touch the canvas surface he wets with his Russian sienas and blues . . . and ultimately sick green of misery and despair overlapping the edges of the figure because it is so intensely felt it cannot be contained by mere cessation of beggar upon the air (*The Jew in Green*). Or his uncle fiddling on the roof in Vitebsk or a donkey floating upside down in the sky, for so donkeys *do* float. And Modigliani and Soutine, who have been carousing at the Dantzig, threw their shoes against the door to disturb this soulless laborer to whom career is everything.

The Ruche

The Ruche
Stairs, doors, stairs
And the door opens like a newspaper
covered with visiting cards
Then it closes.
Disorder, you are amid complete disorder
The photographs of Léger, Tobeen's photographs
 that you can't see
And behind
Behind
The mad works
Sketches, drawings, the mad works
And the canvases . . .
Empty bottles
"We guarantee the absolute purity of our tomato sauce"

* Shit.

MODIGLIANI

Says an ad
The window is an almanach
When the great derrick cranes of the lightning empty the
 hold of the sky resoundingly and bend the hamper
 edges of thunder
There fall
Pell-mell
The decomposing sun of the cossacks of Christ
Roofs
Sleep-walking goats
A werewolf
Pétrus Borel
The intoxication of winter
A genius split like a peach
Lautréamont
Chagall
Poor kid dragged along by my wife
Gloomy pleasure
The shoes are down-at-heel
An old pot full of chocolate
A lamp that divides in two
And my drunkenness when I visit friends
—Empty bottles
Bottles
Zina
(We've talked about her)
Chagall
Chagall
In the ladders of the light

<div align="right">Cendrars</div>

Blaise Cendrars and Modigliani were friends at the Ruche,
and met again in 1918–1919 on the Riviera. By that time Cendrars
was a film scriptwriter at the embryonic Gaumont studios near
Cagnes. His mother was Swedish, his father Scottish: he was
Swiss. He had red hair, a grimace cynical for effect, and bright
blue eyes. Not all he wrote about Modigliani was fundamentally
false.

They met in Rue Dauphine.

"Do you have any money?"

Cendrars: "Fifty francs."

They bought wine and sat by the Seine at Vert Gallant beyond the Pont Neuf. Hundreds of washerwomen knelt nearby on floats in the Seine.

"Do you have a cord?"

"Why?"

"To cool the bottle in the Seine."

One bottle went down noosed into the Seine and the other was broached, for Modigliani, leaning far out, borrowed a cord from the owner of a barge.

Reflectively they drink, and then the wine gradually, nearly gone, inclines them to toast the washerwomen with great courtesy. The hags from their knees reply with obscene gestures. Modigliani offers the ugliest of the women the remaining bottle on the condition that she permit him to kiss her on the mouth. She refuses. He gravely makes himself nude, bringing out the white, splendid torso slowly before the washerwomen, commencing with the sash, and then, fishing up the bottle, loosing it, holding it before him, he starts straight for the washerwoman across the interval between embankment and barge. As he cannot swim, he disappears. But then he surfaces, and Cendrars seizes him by the hair, with a single hand. When he has been hauled out, and the barge owner has thrown him a towel to dry himself, he sits laughing happily at all the commotion he has caused. He opens the bottle, which he has not lost hold of.

Art was in a pickle. France had done much to disintegrate the modern mind, and produced social problems from 1789 (the French Revolution) which perhaps cannot be solved. Nevertheless France produced the single fundamental artist since Leonardo: Cézanne. Van Gogh was certifiable; Gauguin a decorator. These are the two crucial painters of modern art, and the third is Cézanne. Seurat—but this was really only structuring of picture, optic *law*; whereas Cézanne was engaged in the structuring of nature, a new way of seeing it, closer to what it "is." Then the demonic Picasso applied the method to the human image, which is *not* seen

that way—and a good deal was smashed up. The fragmented image was *decoration*.

Art needs a very great deal of self-assurance, or "inhabitation." To release oneself to this required intoxication in some. It would be different if society sought alchemy, the changing of lead to gold, life to art. Mondzain went to see Picasso's stuff. He asked: "What would you think of me if I did things like that?" "I would think you an idiot," said Picasso. And there was something remarkable about the work of Modigliani; by it you could gauge the exact temperature of his feeling for the model. In the last of the five portraits he did of Dr. Alexandre we see the true inner Modigliani, but "Modigliani" came somewhat later: talismanic. Talismanic art would evoke deeply buried feelings: the cunt, the awe, and the tribe. And what would "originality" evoke? Comment. Was painting done to be *looked at*? If you interposed the audience then art stemmed from their outlook; it was dangerous. Driving toward a goal of faith, you strained at every part to realize the image that would match the Unseen. Faith fell. So you strove toward the Golden Section, the rule common to all things. It receded as approached, for it did not exist. The rule common to all things was human viewing.

Finally, it is the monotony of Modigliani's art that gives it meaning—a meaning different from what it would have if it were variegated. An intensification of what he wants very much to say, for he says it repetitively. He was stoppered, somehow. What is it in our time that quells the heart? It seems as though gold is brass; or workable metallurgy. A Tuscan sun is no longer rising, and the rhinocerous-hided or supremely egoistical triumph. The insulated. Modigliani was not insulated. His whole portraiture attests to that, each portrait, seeming of a kind, is different, made by the sitter. The psychological interchange between himself and nude, said Lunia, was almost making love. He was permeable, permeated by the sitter; yet what emerged was himself as that sitter. Splinters of himself, in that vastness, and that abyss, which really is the self— little of it ever used.

In 1911 came the amusing *Mona Lisa* affair. Apollinaire had a secretary, or a man who sometimes served as such, Géry Piéret. He was a Belgian, and spoke seven languages. He used to approach tourists: "Listen, I'm polyglot. What language do you speak? Whatever it is, I speak it. Do you want to see Paris? I could be your guide." And they would mount on top of the Madeleine-Bastille bus. When they passed the Crédit Lyonnais Bank he said—"The Palace of the Luxembourg." When they passed the Samaritaine Department Store he said—"The Académie Française." And so on until he had shown them the Panthéon, Notre-Dame de Paris, and so on. Before he met Apollinaire, he one day stole two small Phoenician statues from the Louvre.

Piéret then went to the United States; in San Francisco he wrote and sold, in English, a story called *Hands Up!* which was published in October, 1911, after he had gone back to France. It tells how a plausible fellow Robert Astuce (*astuce* means astute trickery in French) robs a boxing champion who could have lammed his head in if he hadn't been fooled. Back in France, he recounted versions of certain of his adventures to Apollinaire who at once embellished them again and fed them into the pulping machine of his imaginative invention—and they came out mint-new. Apollinaire was a sausage, with a head shaped like a pear, a fool in love, who knew nothing of his own, but it is a curious thing about him that, as to surfaces, he invariably wrote well. In May, 1911, Géry Piéret went into the Oriental Antiquities room of the Louvre and seeing a small feminine head cut in stone that he liked he put it under his American overcoat and took it with him.

In August, the *Mona Lisa* was stolen. This gave Apollinaire an idea. Piéret still had the *tête de femme* and he had obtained it very easily. Apollinaire wrote, or signed, art criticism for the *Paris-Journal* and he saw a good piece of journalism with profit on the side. They would sell the woman's head to the *Paris-Journal*, and having it as proof, the newspaper could substantiate its story, which Piéret would give them anonymously, under guarantee of silence, detailing just how easy it was to rob the Louvre, the laxity of the guards, the administration, the Republic of France, and so on. Coming just now when the theft from the Louvre of the *Mona Lisa* was boiling in every head, it would be an excellent piece of

journalism, a move toward the defense of the national treasures of France. Chichet, publisher of the *Paris-Journal*, agreed. Piéret took his share and took also, being experienced in these matters, the first train for Belgium. The story appeared, and was the sensation hoped for. Chichet was "visited," and, grilled, he talked.

It happened that the stone head had not yet been handed over, and Apollinaire ran with it to 11 boulevard de Clichy where Picasso was in his last year there. They decided to throw the head into the Seine, but every time they approached the river they saw an *agent* and turned back.

On the seventh of September, Apollinaire was arrested for having stolen the *Mona Lisa*. He was thrown into Santé Prison. He called on Picasso as a witness. The police went to Picasso, who said he had never heard of him.

> Before they put me in my cell
> They stripped me naked
> And what dread voice ululated
> Guillaume what has become of you?
>
> Lazarus enters the tomb
> Instead of coming forth as he ought
> Good-bye good-bye roundelay
> Oh my good years oh the young girls
> —Apollinaire

His sole subject was the misadventures of Apollinaire, here intense, and he wrote well. Polish and Sicilian, he was nevertheless French enough to forgive Picasso. Picasso might have been deported: what else could he have done? Apollinaire (Kostrowitsky) understood him well.

Apollinaire had not stolen the *Mona Lisa*, and, upon the urgent appeal of artists, whom he had publicized, he was released—after a week formative for his poetry. The dossier against him, however, remained with the préfecture, and prevented him from ever getting the Legion of Honor; but it was destroyed in 1930, because he had by then become a great poet of France. He would propose to a woman the first time he met her, which would have made Modigliani laugh! That wasn't the way you went about it! He

went to war for France because he was jilted by a girl and because he was still worried about all that stood against him from the Louvre affair, and he wrote to her anyhow erotic poetry inspired "not by love or debauchery but by forced continence." But he did the best he could.

> Humble that I am and filth
> the Child I was given I have worked upon

Two days before the 1918 Armistice he died of Spanish flu. As he was dying, Cocteau says, the crowds were shouting in the streets: "Down with Guillaume! Down with Guillaume!" They meant Kaiser Wilhelm (but Guillaume Apollinaire thought they meant him). He was sick with love for the new spirit all his life.

> Laugh, laugh at me
> Men everywhere and above all here
> For there are so many things I dare not tell you
> So many things you will not let me say
> Have pity on me

With Gino Severini, Modigliani had much in common. They were within a year of the same age; burnt with aspiration, then. They were both from Tuscany, Severini from the same town as Signorelli, muscular guide even to Michelangelo in his bathing, male, sinewed nudes. They had a common friend in Umberto Boccioni, whom Severini had met in Rome in 1900, and whom Modigliani had known briefly two years after, and then the following year at school in Venice. Their styles approached; Modigliani freckled later,* Severini sooner, and with neither it endured, and was merely experimental, but it shows likeness of heart when two young men try their ardent steps along the same ways. Gino was generous. He once hailed Modigliani as he was passing, famished, as he often was then, and would not admit, and asked him to join him and friends on a terrace for a meal. And Modigliani agreed with such will that Severini could not pay the check. "*L'addition* —and the gendarmes"—as Manolo had said, when he had invited Kisling to Restaurant Lepic, not a sou in his pocket.

* *Macchiaiuoli;* or Postimpressionism following Seurat.

Modigliani let Severini call him Dedo. Rosalie, for example, the restauratrice in the Rue Campagne-Première, in whose hole-in-the-wall everyone ate—Modigliani, Jeanne Hébuterne, Vlaminck, even, it is said, Picasso—called him Amedeo. Most called him Modi: he wrote it Modì—in the Italian way. Rosalie's place was an oblong lozenge thrust into the wall, with tables and benches paralleled along the two sides, like seats in a streetcar, and façade of lower third of wood, blue-painted, then glass across which the name of the proprietor was written, like practically any bistro of France. There, up from the cellar, the rats streamed once, munching the drawings of Modigliani, with which Rosalie sometimes kindly let him pay, for she thought they had no value. This unlikely story happens to be true, for the drawings, not delectable in themselves, had got daubed with spilt oil, meat sauce, where they lay negligently thrust aside. Little before he died, Modigliani's famous evening with Utrillo commenced here, which ended in Utrillo's being put in the insane asylum, though not, as is written, for the first time. They ate, and could not pay, so then they offered to paint one of Rosalie's walls, and could not be dissuaded, and then they painted a great mural there, side by side, working furiously, vying with one another. But Rosalie was furious that they had dirtied her wall and made them rub it off with rags and turpentine. She lived long enough to rue that. Zborowski, better advised, kept the door at 3 rue Joseph-Bara on which Modigliani had painted Soutine, though "Zborowska"—they did not marry—hated the defamation of her household and was outraged. And, after death had made it valuable, he sold the door at a high price—400,000 francs. Then Modigliani and Utrillo went out to celebrate. Utrillo was too drunk to go back to Montmartre and slept with Modigliani. He woke in the morning to find Modigliani had taken and pawned his overcoat, and at the deception of this he went berserk. Their friendship ended with Utrillo banging on lunatic bars; and Modigliani aghast at human treachery he could not understand.

Utrillo, as I have said, did not paint people, and the one time Kiki (the model) posed for him nude she was amazed to see result on the canvas a tall lonely house of Montmartre; but such eroticism

as he had he had exclusively for the kind of women his mother painted, those of the big butt and the broad shoulder. He went one day with canvases under his arm to his own exhibition in the Rue Royale, but he looked so dilapidated that the doorman turned him away, and he was content to go to a neighboring street and sell his pictures to the passersby.

I have read that Jeanne Hébuterne called him Dedo; but the biographer who wrote this said that Jeanne Hébuterne was known as Haricot Rouge, Red Bean, and that was in fact Germaine Labaye. And for various reasons I do not believe it. Modigliani was bad at names; but when on July 7, 1919, he wrote out in his own hand, witnessed by Zborowski and Lunia, the paper engaging to marry the woman who was now three months pregnant with what would have been their second child, so soon as his documents should have arrived (he had lost them when one night, drunk, he was jackknifed by mirthful people and thrust into an ash can)—he wrote her Jane Hébuterne. That is a phonetic mistake, as well as orthographic, and seems to indicate a colossal indifference. Probably the last person to call him Dedo was Gino Severini. He prized his Italian friends. It is said he was altogether disdaining, but perhaps it was not quite that.

By 1910, the Futurist movement had achieved momentum. There was a tremendous surge, in Italy, toward its principles. Supine since the Renaissance, which had, in eighty glorious years of creativity, brought it to its knees, a subject country, pawn of France—Italy could now commence to raise its head. In eight decades, Piero della Francesca, Paolo Uccello, the successful Bank of the Medici, the free spirit, had managed to level what had once been a hard country of *condottieri* who could ride like Attila and were not careful how they fought, to a country elegant, democratized, refined, full of consideration, ruined. To France nevertheless, with the returning armies, it had exported all its black decadence, the dark urge, the ways of Imperial Rome now renascent, first in republican Italy, then France. The only free country of Europe—Italy; because organized in republican City-States not feudalities.

So there had been the eighty years of magnificent flowering, comparable only to Attic Greece, which had at once fallen to the Laconians; and the four centuries of subjugation. But now there was a chance of revival! To excited meetings, halls holding sometimes as many as three thousand people, Boccioni, Balla, Marinetti, talked of the new ideas—it was an amazing thing to see such zest in the leaven of a whole people apparently on subjects having to do with art. D'Annunzio had been precursor—the first Italian of whom one could be proud in *so long*. Now it spread everywhere. It overran the Italian border; an *Italian* movement taking on European importance! Apollinaire, after due study to see that participation in Futurism would not interfere with his relations with the Cubists, fell in. An auto race was more alive than the Victory of Samothrace! Once one thought of it, who could deny it? The *machine* was the future. Speed. It followed that women had to be put down, museums *shut*. A thing to be seen had to be exhibited, and exhibitionism was called for.

An Italian born in Egypt, Filippo Marinetti, a poet (although his poetry is not to be found), had first hit on these truths, in 1909. He had realized—a tenet of this century—that if you could not do anything well, you could do something different. He attacked D'Annunzio, not very fairly, calling him the "phosphorescent cretin," a phrase that caught on, though he had borrowed the worship of automobile speed from him, but the point was that an attack on D'Annunzio was sure to get attention. In fact, he revered D'Annunzio, and was just like him, his twin in diminution—but he had to sacrifice him to the movement. He aspired to D'Annunzio's position, who had called himself a pig with wings, and, lacking only his phosphorescence, did have his cretinism.

It may have been the wide publicity given D'Annunzio's affairs that caused Modigliani to turn away from D'Annunzio at this time. Certainly he would have seen that he was a tinsel Nietzsche, but it would be hard not to see, if your language was Italian, that here was magnificent language. He began to say: "D'Annunzio, shit," and to praise Dante. If there were not the severity of Dante, justified only when let out onto the wider plateau of the spirit of Michelangelo, probably here was better writing. Nevertheless something queer was happening to D'Annunzio. He took an apart-

ment and it was in the Via Capponi (of The Fattened Castrates)—
that could be a coincidence. But his villa in Settignano he had
named La Capponcina, and that meant of the little capon or cas-
trate. He was now in Paris and behaving like a fool, as must have
come to Modigliani, even though he never read a newspaper. *I am
dying of the desire to bite the nape of your neck and lick your arm-
pits, Spicanardi, Spicanardi.* Such things found their way into
newspapers and were doubtless mouthed around Montparnasse.
Perhaps Modigliani heard of D'Annunzio's invariable demand for
what he called "oral homage"—fellatio. To a man frustrated by
homage from women, that may not have appealed. Modigliani
may have thought it undignified in Eleonora Duse.

Marinetti wrote in the first Futurist manifesto (1909):

You must condemn every form of imitation and glorify every
form of originality.
You must revolt against the tyranny of the words "harmony" and
"good taste," words with which it would be easy to demolish
the works of Goya and Rodin.
You must sweep out every old subject, in order to be able to
express our turbulent life of steel, pride, fever and speed.
Painting must follow absolute freedom of words, in poetry, and
polyphony in music.
Painting must render our dynamism as dynamism.

In short, you were to espouse dissonance. By "imitation" was
meant the whole thing, the seed of the past, for, as Apollinaire
wrote later, "history was dead." Time and space were dead and
we live in a permanent present of velocity. "We wish to glorify
war, the health-giver of the world," wrote Marinetti. The antagon-
ism against women, which was a part of natural sex, had been
smothered in silk too long. The Futurists were *for* war, and when
the good moment came, in 1914, were vehement for entry into war,
and in their bellicosity even preceded this.

Marinetti wrote:

We shall sing of the great crowds in the excitement of labor,
pleasure and rebellion. Of the multi-colored and polyphonic surf

of revolutions in modern capital cities. Of the nocturnal vibration of arsenals and workshops beneath their violent electric moons. Of the greedy railway stations swallowing smoking snakes. Of factories suspended from the clouds by their strings of smoke. Of bridges leaping like gymnasts over the diabolical cutlery of sun-bathed rivers. Of broad-chested locomotives prancing on the rails, like huge steel horses bridled with long tubes. And of the gliding flight of airplanes, the sound of whose screw is like the flapping of flags and the applause of an enthusiastic crowd.

This was the future itself. Apollinaire wanted to lump the whole avant-garde movement under the name of Futurism, but the Cubists would not have this, and naturally Apollinaire conceded. Cubism had copped the terrain of space; to Futurism remained time. When you sat on a sofa, you entered the cushion, and, psychologically, the cushion entered you, and this had to be painted. Time, and the essence of things, had changed; therefore absolutely nothing from the past was usable. Nude-painting was excremental. The static figure, simply humanly rendered, was unthinkable. The floor had to be *scoured*, with a brush of steel wire. A woman looked out a window—where was the salable novelty in that, and the quench of the new, for which the crowd thirsted? A woman looked out a window and, to be realistic, the traffic she looked at, even if you did not see it, its noise, entered her eyes and her head, and that had to be painted too. The Cubists had appropriated fragmentation, but simultaneity was left unplucked, and the harvest would be headlines. People would not like the new art, of course, but they would flock to an oasis of nonsense in the nullity of their boredom. Did not Apollinaire, in his "Antitraditional Futurist Synthesis Manifesto"—*for* dynamism, paroxysms, unfettered words, invention of words—condemn dolorous poetry, punctuation, theatrical form in the drama, the subtle artist, boredom? Balla, in his painting *Dynamism of a Dog on a Leash*, did get all the exhilaration of simultaneous movement by painting all together the successive movements of the legs of a lady walking her dog, and of the legs of the dog, each succeeding leg a bit advanced over the one before it, and received the sincerest flattery in the slightly later and much more famous Duchamp *Nude Descending a Stair-*

case. Boccioni, Modigliani's friend, "fell from a horse"—this was rather comic because in 1916 in the war he did fall from a horse and was killed—in his *Elasticity,* where a horse and rider are everywhere at once and in one place. In sculpture, he opened up his mother's head to show its various movements, much as you might an apple with a cleaver. Later, Marinetti tried to make Futurism the voice of Fascism, but Mussolini was stronger than he, and it ended up a sort of advertising. Meaning having played out, he turned to action; led Fascist brigades in Ethiopia and Russia, and fell gloriously at Bellagio. But, at the time, the simpleminded conviction that you could find a style corresponding to modern taste without relinquishing the blind and foolish inheritance from the past was shown up for the nonsense it was.

<div align="center">

SHIT

ON

</div>

Critics	Bayreuth, Florence, Montmartre	Dante, Shakespeare, Goethe
Professors	Realists	D'Annunzio, Rostand
Museums, Ruins, Historians	Shitty artism	India, Egypt, Fiesole
Grammar	Venice, Versailles, Pompeii, Bruges, Oxford, Nuremberg, Toledo	Montaigne, Beethoven, Edgar Poe, Walt Whitman, Baudelaire

<div align="center">

ROSE

TO

</div>

Marinetti, Picasso, Apollinaire, Boccioni, Severini, Archipenko, Balla, Papini, Soffici, Jastrebzoff, Salmon, Léger, Cendrars

<div align="center">

GUILLAUME APOLLINAIRE

</div>

Severini brought the Futurist Manifesto to Modigliani for signing. He flung it from him.

The meeting place of the Futurists was the Closerie des Lilas; Modigliani would go there with Lunia in the hot summer of 1919.

<div align="center">

153

</div>

That was a little hard—it had been the café of Cézanne, Gauguin, Whistler. Paul Fort was the leading spirit, the Prince of Poets.

In 1913 Severini married Jeanne, daughter of Paul Fort, the Prince of Poets. Apollinaire was best man; Modigliani was not present.

The little magazine Papini had brought out when Modigliani was in Florence was called *Leonardo*, after the great da Vinci. Following a little fencing, he and Soffici went over to Futurism, and together brought out a new magazine, *Lacerba*, which was the voice of Futurism in Italy—favoring the individualism of the machine, Italian imperialism, interventionism, war against Austria.

A difficulty for Modigliani was that Bergson was the moral force behind Futurism. With much of Bergson he agreed. A creator was madder and much saner than a normal person. Creative people invite altered states of consciousness, refusing to accept habitual states of perception as being definitive, using drugs to alter the chemistry of the personality. As Baudelaire said: "I worked up my hysteria." Intellect is the organizer, coordinator, arithmetician in the mind, but suspect. The true nature of things is obtained by introspection. The only true world was that unadulterated and within one. But he did not think that outward reality was whatever you wanted it to be.

Modigliani's work attests that he was not interested in distributing reality on a plane, conventional Cubism, which was decoration, nor in following the sequential steps of motion simultaneously in imitation of the cinema; rather in creating structure. He was still a portraitist, not a decorator. He thought, at bottom, humans were important, or he felt it. He had a truer appreciation of what Cézanne was about than did the famous continuers, the Cubists. Cézanne wanted to bend Mont Sainte-Victoire closer and closer to him, so that it would impinge upon you—so that he would find not the Golden Section but how the particular panorama was made in the exchange between panorama and eye which was the only place it existed. It implied a love for the mountain, an immediacy of the mountain, rather than the utilization of it as sensation or the embellishment of a wall. Geometrical negroidism was refractory to Modigliani's spirit; he did not possess the jawbone for

it, as some did—but it gave him resistance. Before a woman, clothed or nude, you dominated or were dominated; either you held the subject off or it tilted onto you. It then remained to convey it, and here a certain *intarsiatura*—a cutting into it—was useful. Not to find its components, as though to analyze them, but because the edges would provide resistance. It is what he got from Cézanne, and it is what Cézanne had got from Mont Sainte-Victoire, blue-white and shadow-fraught as it is—and the Lake of Annecy. With Modigliani, a certain pathetic inclination, a Parmigianine lengthening out, a Leonardesque drawing, would come of themselves.

Pride goeth before an empty room. He wanted isolation, a heritage of his Garsinism, but it is possible to have more pie than you can want. Futurism was an Italian movement, and he was the only Italian who did not follow it. He may have enjoyed his isolation in his nerves, but it hurt him in the warm furnace of his heart. André Salmon wrote of him that his speech consisted nearly exclusively of *merde* and *sans blague,* the latter meaning No kidding. He wrote that Modigliani was without the power of conversation and was almost mute! What an insight is given into what really went on in Montparnasse and Montmartre. Because of course André Salmon is reporting what he actually saw: Modigliani the few times he was—Tuscan—alien amid the band of Picasso. No kidding is a natural enough expression in anyone. The *merde* was probably profounder.

His work exhales an atmosphere of love; and the necessity of physical and chemical paradises. There is a presence of annihilation.

The Ogre from the Sweat Mine

Soutine was the tenth child of a starving tailor, who could not collect, the village being impoverished, for the few garments he did get orders to make. The family lived in a single room. Rats swarmed in the cellar below, where Soutine was stuck whenever he was caught at making art, for which he claimed to have a greedy, insatiable passion. It was unrabbinical to draw people,

and it was a Hebraic crime. It was perhaps not so much art as the muffled, subterranean desire to draw the thunder on his head, and the birch on his bottom, that made him do it. Suffering is a way of distinguishing oneself from the herd, it is an actuality, it is better than nothing—and the Slav has a great appetite for it. The Letts are said to have been the most savage people of the Baltic, and if this is so Soutine was a prime example. He remained unwashed, stinking, cringing, leering all his life.

In the middle of the nineteenth century, anti-Jewish riots commenced in Russia. It was "revealed" that Christian blood was used to leaven Passover bread. Right-thinking bullies entered the Jewish quarter to correct this. Courageously, they beat and killed old men, and raped the offending daughters of Judah. In 1881, 200,000 Jews were made homeless, 167 villages set afire, and the year following, the Czar, to protect them, issued the Temporary Order Concerning the Jews—the ghettoes throughout the Pale were made stringent, and in the few places they did not exist they were created. However, the order did not prove temporary. It was remembered, as had been forgotten, that it is pleasant and useful to have men who may be kicked like sheep, and women who may be raped without recourse, and their helplessness sweetens the covering; and that it is economically convenient to have a race which must work for less. Racial prejudice was not altogether idealistic.

It was into this land promised of Isaiah that Soutine was born in 1894, ten years after the birth of Modigliani in Livorno. His primary subject as painter was decomposition in death. His ox brutally macheted open within which colors of corruption fought with discolorations of blood owed its thematic derivation to Rembrandt, but not its passion. He many times painted a plucked fowl —the yellows and blues of its livid skin, the inflamed tomato red erupting between its clenched claws. Compared to this, the evil strumpets, the whores, sexual threesomes, lesbians, black girls and white, of Pascin's inspiration, were seductively pleasant.

The trunk of Soutine's body was like a box, upon which sat the oversized head of a dwarf, with immensely sensual mouth of red, burst lips and little eyes that ferreted about. Even when he became rich, he refused to wash. He moved into a hotel in the

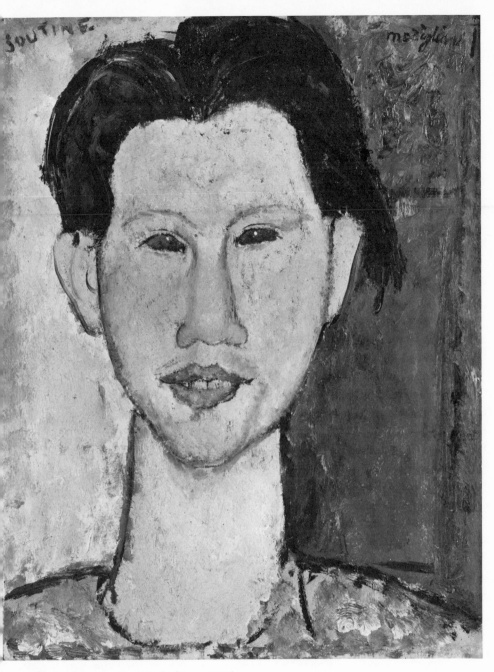

Chaim Soutine by Modigliani, 1915
STAATSGALERIE, STUTTGART

Madeleine quarter, probably the majestic Crillon, and refused to wear anything but silk underwear, which he discarded rather than permit that it be washed. He had a filthophilia that surpassed the filthophobia of the most fastidious woman, only it led in the opposite direction—that to which he had been born. He had to be dirty at first no doubt, the soles of his single pair of shoes strapped to the uppers with wire, a coat five times too large for him coming to his feet, and the sleeves hanging below his hands, beneath which a nakedness he often had no other means to cover; but afterward it was pure joy. Because it degraded Soutine. Zborowski had by then a car and chauffeur, but owing to his gambling habit he couldn't keep them up. Soutine took them over. He didn't want to *ride* in the car, when he would be little seen. He wanted it to follow after him, like Mary's lamb, when he strolled the boulevards. When the chauffeur could not throttle down so low, Soutine was enraged. He had no guile, no artfulness, and so when he looked at his work he saw himself mirrored—and he couldn't bear it. Yet he ran to Krémègne or Modigliani for approval when he had finished a work, and if he saw the least doubt he would howl like an animal, and run out and destroy the canvas. Nonetheless, painters coming up at the round tables at the Café Dantzig, he would say: "There are no painters; there is only Soutine." It was like Modigliani's eventual "School of painting? School of Modigliani!" —not the flamboyance of the beginning but the acid braggadocio of a ravaged heart. It was in the days when Modigliani dripped a venomous sarcasm, which he himself despised.

At the Dantzig, near the Ruche, in the days before the great chemistry of August 3, 1914, that altered the world, they would sit with the butchers and killers from the abattoir, blouses of the latter stained with blood, Cendrars professionally cynical, mouth caught up at one side as if by a hook, battered felt hat on one side of his head as though he were a newspaperman from *The Front Page*, eye squinted from the sempiternal cigarette whether it was in his mouth or not, Soutine crowding next to the stove, shaking— some elemental fear had got into him, and he trembled all his life —Modigliani characteristically putting his flat palms out upon

nothing, again and again, as though to quell or calm nothing. The stink from the slaughterhouse was vast and alive in your nose when the wind was westering, like thick worms turning in the nostrils.

The Ruche stood, then as now, on the Passage de Dantzig, which is a spur off Rue de Dantzig. It is a round brick building with a shingle roof, a cupola. The coffin studios are all radiant from the center like pie slices not taken from the tin. Up the empty center yawns a wooden stairs. Around the landing, as below around its beginning, circumference the deal doors. A, B, C . . . T, U, V—the artists are identified. It was, at that time, a house of rats, of mice, of starved dogs. The organ grinder would come from Charenton Quarter, and the artists would dance, and there would be a desolate gaiety. The true, not the recognized, originators of Fauvism had refuged here: Czobel, who hated Modigliani and was by him hated, Valtat. Valtat had been so promising that Vollard, who had had Picasso in 1901 but let him go because he thought he had no future, signed him to an exclusive contract but, genial in the way of painting dealers, stockpiled the paintings without putting one on sale, speculating against Valtat's death. When a dealer is lucky enough to have a painter die, he rejoices, for then product is stopped off, and naturally the value of what exists, but of which there will be no more, increases. But Valtat outlived Vollard, and never had an exhibition, and was completely unknown. I saw the benches where Soutine used to sleep the night, when there was a party and he was repulsed and not let attend.

Soutine was "K" at the Ruche. When he painted his *Still Life With Herrings*, the veritable portrait of hunger, starved herrings on a plate, and, at either side, prongs on the edge of it, two gaunt forks that are like skeleton hands, a rat scampered up the door of "K" and in through the peephole. Soutine was so mesmerized he could not move, and the rat, ignoring him, seized a herring in his jaws and made off with the subject of the still life.

There was something of the Kalmuck in Soutine; Modigliani caught it in 1916. The hands are delicate tendrils, like those even more narcissuslike in the portrait of Krémègne made at that same time—in fact the beautiful hands of Modigliani himself—but the

yellowish, closed face full of suspicion is Mongolian. Later, Modigliani elongated him, and the hunched man, with his immense head swelling from him, acquires a kind of Modiglianian beauty, like a sick lily. It is one of the few times Modigliani is very untrue to his subject, for his portraits are usually faithful. Yet they are the season and stage of the man or woman painted. Perhaps melancholy, exhibitionism, a feline lasciviousness. They are themselves as Modigliani, his phases; truest is this in the nudes, for nudity of woman had the openest of doors to the equivocal selfness within Modigliani. Their conditions are conveyed by planes of color, peach, salmon, vermilion, flesh, or their postures—the nude with writhing shoulders and hips in Buenos Aires, as though in the very moment of orgasm, the imminent point of climax driven into the twisted torture on her lips, the horror of joy-anguish fixing her eyes; the Great Nude (almost certainly Lunia, though she would never admit it) in the Museum of Modern Art in New York, tranquil after love; the rose nude in Milan lascivious with hashish; she with arms behind head sinuous with expectation looking at the painter, her moist mouth fallen open, or the black-haired woman again, with, in Tokyo, her hand in the position of self-love, as found also in Titian and Giorgione. The sense, almost as if from within them, of humans.

Léger, too, was with them in the Ruche. His father was a stockbreeder in Normandy: a "magnificent brute." And the son took after him subtly. He stood with his great feet flat on the ground, nothing sentimental about him. He almost completely lacked the sense of doubt when he painted. To his immense praise it could be said that if he hadn't been a painter he would have been a construction engineer. He said it himself. His close friend was Archipenko. In those days they would go out at night, Léger burro for Archipenko's harp, and Archipenko would strum it as it was on the great Norman's back, and sing Russian airs in his deep voice, and they would collect a few sous.

The pair made Modigliani's flesh crawl, and he theirs, though there wasn't for this anything of what is usually called natural grounding. That is, they hadn't anything against each other. They

were simply separated by antipathy. Archipenko preferred absinthe but also used drugs, had a beard, wore a green eyepatch, was in the claw of Eros. Like Modigliani, when he wanted to heighten effect he took drugs and alcohol at once. His father was a mathematician and professor of engineering at the University of Kiev, but his grandfather a carver of icons. In a disastrous leap of logic he realized that if the figure is composed of geometric planes it can just as well be constructed as carved.

Modigliani hadn't done with him when he left the Ruche. Archipenko went, in 1914, to Cimiez, which is just behind Nice, accompanied by a D'Annunzian "rose" and breasts and he was there when in March, 1918, Modigliani, Foujita, Mme Foujita, Boris Savinkov, who had assassinated the Grand Duke Michael of Russia or alternatively the Russian Minister Plewe (there was some confusion about this), Jeanne Hébuterne, and Soutine arrived.

Fettered motion, aspiration in impasse, dream grounded, the yearning stopped by what is—chained, congested, smothered. Thus with Brancusi, and at the Cité, the Temple of Ideal Beauty was a grandiose plan—perhaps thus out of the reach of possibility precisely, so that it could not be achieved. The caryatids for it remained exploratory drawings, very beautiful, or a few heads—rudimentary stumps of what was to have been the huge temple to human spiritual accord. In 1911, Modigliani showed seven sculptured heads in the studio of Amedeo Souza Cardosa, who was a Portuguese and the son of wealthy people, and whose scant surviving work, said to be like Modigliani's as it is not in the least, is a mockery of, or crude submission to, African mask, grotesque; all seven were later shown at the Salon d'Automne in 1912, and Modigliani wrote his humble joy to his brother at the remarkable achievement of having so many pieces in such a difficult salon. Later he said, to Lipchitz, who met him through Jacob, that it was a composition and the heads were not to be considered as individual pieces—like the stops of an organ, he said. He was gladdened by his first recognition, he meant to make puppets, enchanting dolls; he projected stage sets, as was beginning to be done, did draw a few actors, calling on his invention, which he practically

never did, but the enthusiasm vanished. Perhaps he was flawed. He turned from what he had done and tried to surpass himself—did not Nietzsche say you should always surpass yourself? Where was the Superman in merely doing what you were capable of? Possibly there was nothing more than escape from challenge; the fletch into the irreality of the blue of the earthbound dreamer, unimaginable until it had happened. He frequented his inferiors. "He did not come to Paris to be second to anybody," Lunia said. He was probably helplessly attractive where women were concerned, a fatal attractiveness (a touch theatrical). It deprived him of their reality, when he was not painting them, for he could not go to them; they spread over him, too there, too soon—to be seized. He loved Soutine—it is said that this was perverse. But are there any human motivations that are perverse? Or are these simply the surface not sufficiently mined?

A dreadful time had begun for the Jews. It gradually spread west, and climaxed, for the present, in the atrocities of Hitler. International protest greeted the May laws, so called because they had been promulgated in the month of May, 1882, the "temporary" order concerning the Jews which was never rescinded—but the Czar was contemptuously adamant. "Never speak to me of *those people* again," he said to the British plenipotentiary, who came as the emissary of the civilly organized protest of people of goodwill all over the world. As this was then Holy Russia, not yet freed, there was little to be done about it. The plight of the Jews was terrible, for some Jews, and theoretically for people everywhere.

Soutine, when he came to Paris, spoke only Yiddish and a little Lett. Later, he would have nothing to do with anyone who spoke Yiddish. He despised Jews. He would slide along the walls, with his drowned look. He was insanely lustful. When Margot, a thin-boned model of the Ruche, was willing, perhaps out of pity, he drew back, shaking like a tree in a storm at the mockery and his desire, and suddenly ran off. Krémègne tells how, when they were art students together in Vilna, he would haunt the exit door, to look at the girls, violently and secretly licking his thick lips—

but he dared approach none. They had to beg in the streets, and when they got a little money, from Jews—for Vilna was three-quarters Jewish—Soutine would bolt for the whorehouse. He could not wait a minute. Krémègne would watch him dare choose none but the ugliest girl; and she would lick her mouth and laugh at him before she consented. The brothel remained for him the center of love all his life. He had decent women, when he became famous and rich, but he despised them for going with him. Fame perfumed his stink, all but salvaged his ogrish ugliness, causing a really different Soutine, but though women saw this, Soutine could not, and could rarely get a hard-on except with a debased creature. And he remained an anti-Semite all his life.

But with Modigliani, Jewry was flagrant. He flaunted it. When he overheard *bretteurs* (Royalist bullies) condemning Jews he strode to their table and said: *"Je vous emmerde. Je suis juif."* (Shit on you. I'm a Jew.) And, remarkably enough, he silenced them, rather than being thrown bodily into the street. When he met Nina Hamnett he said to her with burning eyes in the little English he had: "I am Modigliani. Jew." He came not from the ghetto but from Sephardic Livorno. Why should he despise Jews?

Pascin at first lived in the Hôtel Beauséjour at the corner of Rue Lepic and Place Blanche. Then he moved into the large fifth-floor apartment-atelier in Boulevard de Clichy in which he slit his wrists, wrote, "Lucy I love you," in his blood all over the walls, and hanged himself. There he would bring the mulatresses he collected at Café Louise or the boîtes of the Rue Pigalle, which was the hangout for *filles de couleur*. He had a taste for this color, and perhaps the whiff emitted from between their thighs—like the great Baudelaire. He made a model of Aicha, the Belgian mulatto who eventually became a chief model for Kisling. Kisling's chief model was Kiki, of Montparnasse, for he was called Kiki too—the painter. She must have been very young, fourteen or fifteen—thirteen when Kisling fought the first duel ever filmed for newsreel, in 1914. Kisling's son showed me a photo of her, stark naked on some hill on the Riviera, white as bread dough, reclined on herbage—the inscription was *À mon très cher Kiki Kisling* • *Kiki*, but, with a

magnifying glass, he showed me that under this, which was written in another hand, is what Kiki really wrote: "I am enamored and I give myself to you." He admitted, when pressed by me, that they may have had some contact, but then, in honor of his mother, the great Renée, who with Modigliani maintained constant relations of mutual contempt, he took the odd escape hatch of insisting that Foujita had really fallen in love with Kiki; this exonerated Kisling.

At Pascin's, the door was opened to you by a girl wearing only stockings and shoes, meals were served by a girl wearing only stockings and shoes, and, as an exotic touch, the female cook was dressed in like manner. I have this from Zavado, a frequent witness. Pascin liked to fetch there the large woman who was the bouncer in the women's latrine of the Gare Saint-Lazare, Zavado told me. He would have her dance nude for the crowd, Zavado said. As she did it well and took it seriously, it made it all rather pathetic, he said.

In his racetrack-tout tight blue suit, bowler down on a bruised eye, livid face, hooked nose, with jet-black stiff straight hair, a lock of which was always on his forehead as if glued there, small, with thin body, heavy eyelids, sensual lips, Pascin was a singular figure. But he could paint. He and Modigliani, when they met in the Rotonde, greeted each other with raillery, insult, Paulette told me— neither had a kind word for the other, no consideration. Were they not both Sephardim? They had no need of consideration!

He was born at Vidin, which is on the Danube in Bulgaria, across from Rumania. He grew up in Rumania. His mother was Italian; his father Iberian. Both were Sephardim. When he was five or six, a landsman of his father's, who had a large estate, married, and his father, even though this was near the turn of the century, exercised his *droit du seigneur*, and the landsman, torn between loyalty and male pride, hanged himself in the barn. The young Pascin (Pinkas) found him. It greatly impressed him and he talked about it all his life.

It is a curious thing that the three most gifted—by this is meant linear grace, the old Leonardo–Michelangelo–Raphael thing, not the Masaccio thing, the inception of modern art—of that epoch in Paris probably all had Arab blood. To be Sephardic means to be

Jew subjected to the culture of the Arab caliphate. Modigliani was on both sides Sephardic and did, in his remote origins, have Arab blood, and Pascin was on both sides Sephardic. Picasso once told me that on his mother's side he may well be Arab. The universal story, he said—born of the double *ss* spelling, which is not Spanish, fortified by the fact that there were in Italy a General Picasso and, in Genoa, a painter Matteo Picasso, contention that the Picasso were Italians who came to Spain—was the reverse of true. "The name was Picazo and a branch went to Italy," he told me at Notre-Dame de Vie, then in his eighty-sixth year. "My mother's people were from Córdoba, seat of the caliphate, and the 'z' is Arab spelling." His name was Ruiz, Pablo Ruiz, as he is still known widely even today in Spain; the Picasso, from his mother, Maria Picasso, was added on in Spanish usage. He suppressed the name Ruiz for Picasso at the beginning of the century, because it was more attention-getting; though he always said, with that either yes either no manner of his, that this was not so, and that he called himself Picasso because that was what the lads called him when he was growing up in Barcelona. "The name was Picazo and it may be Arab. You could go to Córdoba and spend a decade in the archives and find out." When he became eighty he was "a hundred years old," and going to the bullfights at Arles or Nîmes, about fifty miles, it was always "a hundred miles away!" A peculiarity about Picasso —picazo oddly means magpie in Spanish, the bird that collects whatever catches its eye.

Pascin's *Ginette and Mireille* (Paris Museum of Modern Art, *Ville*) are lesbians, or whores waiting to be accosted, pensive in chemise. He painted life as he lived it—whores, lesbians, threesomes of girls at one another in feminine wonder, black girls and white mixed, nudes grotesquely short-legged, almost as if stumped, legs spread—all rendered in a wistful, yearning lilac, iris, pastel. He had great delicacy. At only sixteen, he sent drawings to *Simplicissimus* in Munich, the leading satirical magazine of Europe; and was accepted at once. If any artist made more money than Picasso before the 1914 war, it was Pascin. If any challenged Picasso in influence, it was Derain.

165

In 1909, Pascin met Hermine David, a miniaturist (her work is in the French National Gallery of Art); in 1911 he met Lucy. He married Hermine. Later, when he had been away from Paris and returned, he found that Lucy had (1915) married Per Krohg who lived at 3 rue Joseph-Bara, where Kisling lived, and Zborowski, and, in the apartment with Zborowski and the woman considered to be his wife, Lunia. Doubtless, Pascin had a turn for the exotic in bed; Hemingway said of him that he was the only truly obscene man he had ever met, and he describes how Pascin, at the Closerie des Lilas, when he Hemingway was a boy, proposed to him one of the two sisters he had with him, that Hemingway, as elegantly put, might take her some place and bang her. Pascin had a dark intent upon the gorged ravine that divides a woman, and the diverse uses to which it could be put; the perfumes of Arabia that dripped from the comb.

He was convivial. One night he collected the hoodlums of Rue Mouffetard, ascending from Place de la Contrescarpe and a block from Rue Amyot where Jeanne Hébuterne would kill herself; a tough place then, *flics*, then called *vaches*, at every café door—and he bundled the crowd of roughs and blackguards into three taxis and took them up to a cabaret in Montmartre. For these people of the depths, Montmartre was a wonder. Montparnasse and the rest was lighted now in the galvanic sizzle of electricity, but Montmartre was mellow under the hiss from the beaks of gas which still existed, slowly guttering out. At the cabaret, they were refused admittance because they hadn't ties. Pascin woke a shopkeeper at one in the morning and bought neckties for all. How could they repay him? Did he have a friend that needed "correction"? If he wanted anyone—oh, a barber—they were there. One petty criminal was so happy that he walked on his hands.

The door opened at 36 boulevard de Clichy, the "rose" advanced on the visitor, the blush on the vaginal cuff, and the corals eyed him, and within an atmosphere of orgy prevailed—but whatever piece of filth he was he was admitted. Girls came, fresh as milk from rural places, as had been Kiki—but touch the twig and the peach would fall to the ground, and squash. The parasites fed

on Pascin; his wife, no inconsiderable artist, procured for him, Paulette said, though others deny this. Zavado told me the reason for his suicide was impotence. "He just couldn't go on." Futility? He had to bear the weight of an almost supernal gift, which makes of the world wall-less space, without barriers, a vacuum in which the brush can go anywhere, not self-limited, or—now—by any tradition.

Picasso told me—referent to his liberty, perhaps the greatest ever possessed by a painter in the history of the world—that "It frees you to know what not to do."

Picasso—by some considered driven to produce a mass of art ever surpassing himself until he should have arrived at "truth"— of his ceaseless activity told me: "I paint to fill up the void." Pascin tried to break from it all. He moved and did not give out the address. But whenever a friend passed in the street, said Zavado, he would run out and insist he come in—then cognac, champagne. He could not break from it. I asked Roger Wild, who knew them all, himself a fine artist, how did he rate the leaders. 1) Picasso. 2) Pascin. 3) Modigliani. He asked me how it was that Modigliani was much more highly quoted, when Pascin was the better artist. "Capacity is no longer respected in art," he said. "They scrawl. They have not learned to draw."

It is generally said Pascin killed himself because he was to be forty-five. He killed himself on the day of his opening at the Georges Petit Gallery, June 20, 1930, on the verge of forty-five— because he had said that no creator ever creates anything after forty-five. That is the official version. He had in fact been forty-five two months and twenty-one days when he killed himself, but perhaps, like Jeanne Hébuterne, he hesitated on the edge of an action that seemed abhorrent, even fearful. He had often spoken about suicide. He liked the resolution taken by the landsman, which he sometimes called draconian (decision by steel), sometimes solomonic (cleaving the child in twain that its parts may be equally distributed). Perhaps his anguish was that he wanted Lucy Krohg because he couldn't have her? But he did have her. She slept with him every night and went back at dawn to 3 rue Joseph-Bara for the sake of appearances. Krohg accepted this. It was Pascin who

was jealous. She traveled with him in Spain; she accepted his debauchery so long as the girls were whores and models, but she would not have tolerated a rival.

Hermine's mother had sewn her daughter's bloomers to her shirt when she had started to go out with Pascin, but Pascin had pulled apart the thread, and not bothered to stitch it back, and eventually they married. Lucy had little, piercing eyes, and a constant smile on her lips like the smile of a madonna, which was somewhat deceptive; Per Krohg painted her four years before he became her husband: a small bowed mouth, smooth brown hair, bangs, doll face. They tangoed at the Chat Noir in Oslo to make ends meet. Per was dapper. He had great vitality, was cold, very intense, very intent; his work was clear-minded, scalpel-sharp, sarcastic, highly sexed, high-strung. He was influenced by the pastels of Pascin. He had emotions but concealed them, was ironical, cold, humorous; he did tiny figures eventually, marionettelike, isolated in stagelike constructions, or cages. He believed you painted by will. Persevere, that was all. He was antilandscape, not having the breadth of heart for it. He is now considered perhaps Scandinavia's second painter of the century, the Diego Rivera of Norway, murals; including the Assembly Room of the United Nations in New York. Constricted men such as Krohg are given to sexual perversities but haven't the luscious heat of a semiorientalized Jew. Lucy's position is comprehensible. Krohg took his wife on his arm to Pascin's funeral; but then, when it was all over, he suddenly felt that he had had enough, and he went back to Norway, where in fact he had not lived since 1897, when he was seven.

Paulette Jourdain says Modigliani lived in Rue Boissonade, which is in the Observatoire quarter, before going to the Cité Falguière, though this is in no other account; and says, which seems corroborative, that for years his abandoned sculpture was to be seen lying about at Rue Boissonade; and then someone came and carted it away. She was young, fourteen, when, just before his death, Modigliani painted her—in contemporary photographs fresh, eager, with fine straight teeth, clear greenish eyes, black hair cut

short, neck somewhat long, but in the portrait exaggerated; not at all pathetic and wistful, as painted. She continued in the art business, running, having become his mistress, Zborowski's art gallery in Rue de Seine (his business in Modigliani's lifetime was from 3 Joseph-Bara and before that Hôtel Sunny in Boulevard de Port-Royal)—so that she should have known something about art matters such as abandoned statues. She continues selling art today in a modest way from the rez-de-chaussée of 29 rue Berthollet in Montparnasse, not far from Rue Amyot, where she lives on the fifth floor, with one of the dozen copies of the death mask of Modigliani, his palette, Jeanne Hébuterne's drawings of him and of where they lived in Nice, and the documents of Zborowski. She was with Jeanne the evening and morning of the night before Jeanne flung herself from the fifth-floor window at Rue Amyot, and she it was who discovered the truth about the razor Jeanne had under her pillow that night.

We called it the Villa Rose because it used to be painted in true rose, but at that epoch it was already pale and discolored, faded by time, negligence and the spirit of economy of the proprietor.

However, such as it was, it still shot a small ray of sun, a joyous note, into the sadness of the buildings surrounding it.

It was in that oasis that I knew Modigliani. We had neighboring studios. At that time, there was neither gas or electricity, and the tenants had to use candles if they didn't have petrol lamps.

The proprietor, who was her own concierge, was also a seller of candles.

Modigliani esteemed her highly. "She's a woman out of Balzac," he said, and if anyone uttered the least reproach, capable of diminishing the grandeur of that person, you saw him tower up and go to her defense. "She sells candles, true," he said, "she doesn't give them away—no. She marks against you your smallest purchase, but she has that breadth of vision which enables her to understand the difficulties of the life of an artist—she gives credit! If her ledgers are impeccable, she is satisfied, and the length of the list of unpaid accounts, far from troubling her,

seems to delight her—for it adds to the quantity of paperwork of which she is proud. A woman maecenas in her fashion, you may say."

He worked at different hours of the day, following the form in different lights. Toward evening, he wet the heads. As flowers one tends with love, perfect gardener of his sculpture, slowly he let spray fall through the eyes of the showering can—and the hieratic and primitive figures born of his chisel glistened. Then Modigliani, squatted on the threshold of his door, calm and happy, watched his sculpture shine in the last rays of the setting sun.

The proprietress wasn't young and died one fine day. Her son succeeded her. He was a sick man, changeable, but not a bastard.

He and Modigliani didn't get along. Nevertheless, he didn't insist that Modigliani pay up.

Life went on as before, painters and models making a family.

Little by little, the art of Modigliani evolved. The heads took on the form of an elongated egg, you might say, surmounting a perfect cylinder, with just indications for the eyes, nose and mouth —in order not to destroy the plastic form.

His admiration for the black race increased. He wrote fallen African kings; he obtained their addresses and wrote to fallen African kings letters full of admiration for the genius of their race.

He was desolated that he never received a reply.

He didn't sell; he lived on credit, and from his drawings— exquisite—sold at ridiculous prices.

Jew, he defended his race against the charge of covetousness.

"Jews are good businessmen," he said. "When you are a businessman you have to have a sense of business. But if you are an artist you must not be a businessman. Still," he went on, "you must live by your work, as others live by theirs. The artist mustn't give his work away." Seeking to conciliate the necessity to sell with the distinterestedness and nobility of art, he said—"You must sell at five francs."

He was the image-maker of Montparnasse, and the excesses that ruined his health he thought necessary to realize his work.

That day blessed by the gods protectors of the arts, when proprietors waited payment with angelic patience, ended. One day the proprietor of the Villa Rose told Modigliani to get out.

This anonymous contemporary report concerns Cité Falguière, as it is more generally known. There Soutine and Foujita had ateliers adjoining on one side of a court, and across from them Modigliani.

Anna Akhmatova introduced him to the Russian crowd— Ehrenburg, Voloshin, and, married, Larionov and Gontcharova, who did sets for Diaghilev. Marevna Vorobëv, eventual mistress of Rivera.

Voloshin had a tummy, was short, stout, gentle, with little-bear eyes, a great soft beard and mass of hair, was middle-aged, a theosophical poet, but not devoid of the ordinary human emotions for all of that. When Léger had been long away at war, and before he was gassed and demobilized, Marevna and Voloshin went one day to Rue Notre-Dame-des-Champs, and Jeanne Léger did not leave off what she was doing—which was ironing at the living room table, stark naked, because it was hot. They chatted; Voloshin became quite restless on the sofa beside Marevna, and shifted about, shifted about. And finally Marevna spoke up and called Jeanne's attention to the situation. She looked up, eyes flashing with sexual malice, and then she went and fetched a kimono. "Oh, I was only joking," she said.

Soutine loved Modigliani. Modigliani would give him one of his cast-off shirts, which were always checkered, and he would wear it with great pride, because he thought he looked like Modigliani. He followed a Russian about for days, for no other reason than that the long, drawn-out man was the Modigliani type. He tried to paint like Modigliani but he could not do this for reasons which resided in his hand, his heart, and his experience.

The Cité Falguière is just off Rue Falguière above Gare Montparnasse. It ends in a cul-de-sac of modern hostelry now, but at the time it was the complete U. There was a single WC for the entire Cité, until into the fifties. No gas or electricity. A wing of it remains; the rest is gone. But going there you can gain an image of what it was. A narrow corridor gives access to what is left, and wooden mail boxes, handpainted, and artists' names and grimy cards tacked up, and a wilderness of messages, some of them with

dates months old, look at you. Suddenly you abut upon vacancy, a gap of space. It is the court, around which walkways extend, as they do in a prison, or did at the Bateau-Lavoir, where you entered at the top as the construction was downhill, four stories, tiers along the wooden stairs. When, having got so famous, the Bateau-Lavoir was declared a National Monument, it at once burnt to the ground. Here, at the Cité, you are over a yawn of space, for the floor of the courtyard is three terraced levels below. Each studio has a slanted skylight tilted into the roof. There is no trace of rose. Some of the doors are carefully padlocked, and some are not even closed, though the occupants have gone off.

Modigliani's studio was carpetless, the window shadeless—undecorated, empty, stark, one wall of glass, the others very sparsely covered with drawings, and the postcards: a divan, table, chair, the zinc tub. Modigliani had no acquisitive instinct. He collected nothing; destroyed all he considered unnecessary. I quote Hanka Zborowska (her name is Sierspowska; she and Zborowski did not marry; however it is as Zborowska that she is known): "He was often in a bad temper and worked better when he was." However, she considered him the *poule aux oeufs d'or* of the Zborowski menagerie, and disliked him actually. There were books in a corner: Baudelaire, Nietzsche, Verlaine, Bergson. Biography has augmented these to Ronsard, Petrarch, Spinoza, Bergson, Verlaine, Mallarmé, the *Vita Nuova* of Dante, D'Annunzio. Perhaps the *Vita Nuova* was there.

Here he reached both the noon and twilight of his sculptural career. As late as 1916 and 1917, Giovanna has him slipping onto the premises of building sites of the Boulevard du Montparnasse at midnight, furtively cutting into blocks of stone, pleading with workmen the following morning when the stones were engulfed in construction in progress, never to be seen again. A thirst for stone. It is possible; he "sculpted" in paint all the rest of his life. But, when the war came, he stopped sculpture—either because he could not pay for the limestone blocks (a single surviving cutting is in marble), or, his money from Livorno cut off, he had to turn to some quicker means of procuring cash, which painting may have seemed to be, or because, if indeed they were, his tubercular lungs

could not stand the dust of the stone. He stole stone blocks some-times, sometimes with Ortiz de Zárate, who was a very strong, large man, but he did not, save in his glorious legend, steal tomb-stones from cemeteries and ghoulishly change them from mere reliquaries for the recollection of departed souls into splendid African and Oceanic faces with blank eyes blossomed wedge-thin upon columnar necks.

Ejected from Cité Falguière, he refuged at 216 boulevard Raspail. There you seek his ghost in vain; there is a narrow, tall apartment building there now, and a cinema—but it was a shock-ingly miserable, tiny atelier. It was a "cage of glass" with a small patio and single tree at the bottom of a yard. He worked in the patio, just before the war, and there his sculpturing career ended.

"He had, in these years, a growing bitter and sarcastic aggres-siveness in the face of nonappreciation," Giovanna said. "All the Garsin generally thought themselves above everyone." But he wasn't unappreciated; he simply didn't sell. It must be remembered that she was prejudiced on behalf of her mother. Renato Natali told me: "She came to see me. She had a cult of the madre. She loved that woman. She did not know her babbo"—Italian and in-variable Livornese for papa—"she did not understand him." Myself, the first time I was with her she said: "I have no cult for Modig-liani. Perhaps I do a little for Jeanne Hébuterne." Her voice broke.

We do not know why he destroyed his friends' art works; he destroyed his own. They were inadequate. But to a man twenty-four, all art work may seem inadequate. To set, when one is twenty-four, a tub of punch afire and dance in the glow, is, or is not, signifying. Conversing with Dr. Kinsey at the time *The Kinsey Re-port* was in formulation, I was told a great—perhaps the greatest—sexually founded anguish he uncovered was that of staid men and women who simply could not account for sexual things done in their youth, and doubted the structure of their own personalities accordingly: the board chairman who had cohabited with sheep, and sometimes doubted, in consequence, his ability, or even right, to make overriding corporate decisions, even in his sixties, having committed so filthy and incomprehensible an act, as surely had no other of the board he sometimes had to override. It would seem

that in human nature are these brute or very free tendencies; those few who do not stifle them in the crib include the creative geniuses. Nearly all the people of art in Montmartre and Montparnasse were romantic skeptics—they celebrated cynicism, the New Age—but Modigliani was a skeptical romantic. He doubted, because in our age unbenefited by lunacy you could not do otherwise, what he celebrated. A dark lovely all-but-nude girl vaults with ultimate grace upon the back of a white bull mottled with patches that are as if filigree or lace three thousand six hundred years ago in Crete— what had that to do with art, now? It was of course the deep human pulse and aspiration of humanity when humanity was young and fresh. Modigliani came to Paris to make art, not a name in art. An anomaly; a unicorn among the beasts of burden of art. There continued to be the little women, though he was being borne forward now to the few women who mattered. It was fine to be so handsome—and Italian! The cunt raced upon you like a typhoon—how then were you to yearn for it?

❧

Zadkine saw him at 216 boulevard Raspail. Zadkine spoke English. He was from Smolensk but his father was a professor of classic languages. Zadkine had been to Oxford. Cocteau once said to me: "My French was perfect for I learned it at Oxford." As much stonework had been abandoned at Cité Falguière, Zadkine had to go to Boulevard Raspail to see the statues. A small passage led to a tiny courtyard. Modigliani's atelier was a glass closet, a greenhouse. The skylight was treed over as though to protect the hopeful man. Zadkine saw Modigliani within asleep on a sofa, which doubled as bed; and perhaps as platform for the one nude of his Grand Style, so he called it himself, he perhaps did before 1916. Modigliani left 450 paintings, 900 drawings, and twenty-nine sculptures; of the paintings thirty-nine of them nudes, all but five done in less than four years, the last.

About the cot, on the board floor, Zadkine saw drawings strewn everywhere. The cubicle, such as it was, was clean: Modi-

gliani showed disorder only among his art works, as if they inhabited him and were therefore on every side. He picked up drawings and showed them to Zadkine; Zadkine six years younger than he. He showed him his sculpture, which was in the court. The heads were ovoid, like eggs, the nose an arrow to the mouth, which pudicity kept small.

Jacques Lipchitz, his junior by seven years, met him in 1913. Modigliani suddenly began to recite the *Divine Comedy* at the top of his voice. This was in the Jardin du Luxembourg. There was an inescapable air of the comedian about him. "Too much mud," he said of modeling. But Lipchitz disagreed. Modigliani abruptly walked away. He came one night to 54 rue du Montparnasse at three in the morning and knocked on the door of Lipchitz's apartment. He had suddenly decided he wanted a volume of Villon he had seen on a shelf. Lipchitz lit the kerosene lamp and found it and gave it, hoping to get rid of him. But he plunked down and began to read very loudly in a hard-edged, resonant voice. Bangs commenced from the neighbors. A strange scene in the lamplight, the ghostly figure, the orchestration of bangings all around the small room. He was overbearing, sweet.

Zadkine one day introduced him to Nina Hamnett. Later, he probably introduced him to Beatrice Hastings. Nina said she did, but her best friend, Abdul's widow, whom she brought to Paris, informed me—"She was charming; but of course there was no reason to believe a thing she said."

"He would disrobe more or less at certain times," wrote Nina Hamnett in her autobiography, which she called *Laughing Torso*. "Sometimes they seized him and bound him with his red sash to prevent him. He would strip naked and sleep outside his studio too. A strange and complex exhibitionism."

"He adored Picasso," she instances the mixed quality of her veracity. "Picasso wore a blue serge suit and a yellow brown cap. One day Modigliani sold a stone head for a hundred francs, and he went out and bought a blue serge suit and a yellow brown cap. He strutted up and down outside the Rotonde to be admired. Un-

fortunately, toward evening he got very drunk and fell into the gutter, covering the beautiful new suit with mud, and was very battered and sorry for himself the next morning."

This may be measured against Zavado: "When he made money finally," Zavado told me, "he said: 'Now! I will go back to Lee-vor-no! But first . . . a new suit.' And then he got terribly drunk and wrecked it."

Zavado told me many things, but not of Nina Hamnett, though he lived with her as man and wife. He did say that years later she got drunk and fell out of a window and was killed.

She herself was a "laughing torso." Fresh from the Slade, she danced nude, exhibitionistic as Modigliani. She was one of those bobbed young Englishwomen received with a certain horror by Montparnasse.

Nevertheless she danced naked with such fervor, all legs and goodwill and grin, that it imparted a certain attraction to the fur at the joining of the sticks, and the flat bounceless English breasts.

She was a Bloomsbury luminary, an artist, not loath to pose nude, take lovers. Zavado she simply calls "the Pole" in her book, as she called Abdul "the Arab." The latter was the direct descendant of the last Emir of Almería and heir of the best family of Tunis, a Moslem nondrinker led into a bottled world by Modigliani. In 1961 at seventy he got drunk and toppled to his death, as did Nina, though it was down a stairs.

She went with "the Pole," Foujita, and his wife Fernande, to Roussillion; she and the Pole were then living in Modigliani's studio at 8 Grande-Chaumière, which they inhabited from the time of his death. Fernande bullied Foujita terribly, ranting at him in a gruff, angry voice even when not angry, but Foujita was angelic and silent—and a good cook: for she had beautiful legs, though a shapeless body, and they always went naked. France must have seemed a sort of South Sea Island to Foujita, so much white flesh! —where the women wore not even the *tapa* over the well of conception—though eventually, after two or three whites, he commenced marrying Japanese wives.

Aleister Crowley indirectly brought Nina to Paris.

He had been to bed with her, but her angularity "had not

caused the flag to rise"—or the staff—so he said, to her discredit. Crowley, when he established his beast's coven—*Je suis LA BÊTE* he said in Paris—in Sicily, and before Mussolini threw him out, had, however, adequate means of causing the staff to rise. He would place a nude woman, fettered by "sexual magnetism"—a kind of hypnotism—on a scalding rock in the boiling sun until she was cooked, delighting the passing Siciliani and filling them with awe of English manners—and when she could absolutely stand no more would "untie" her, and then, in his Sanctum of Black Magic, which was in fact a six-room one-story bungalow, but on the walls of which he had painted the Demon Babalon holding the Cup of Abominations, and other abominations and excrementi and vaginolae, he would, by the various apertures in her roasted body, slake himself, and presumably please her. He was not without qualities. Once, seeing a friend he knew was afraid of him doodle nervously as he sat as far away as he could in a bar, he got up from his corner table and walking past the friend to exit dropped in front of him an exact duplicate of the doodle the other was in the process of making.

He was hashshashin. A specialty of his was to sublimate his sexual energy in the anus of an unnerved male friend, as he expressed it.

In 1906, at Cambridge, with A. R. Orage, who was his best friend, and the cause of Beatrice Hastings going to Paris in 1914, he met Victor Neuburg, then twenty-five, who eventually became a small literary figure of an editorial importance in the discovery of new writers, which position, greatly enlarged, subsequently passed over into the hands of Orage and Beatrice Hastings. Crowley acquired domination over Neuburg. His claim that he turned Neuburg into a camel and sold him to the Alexandria Zoo, where he stayed for some time, is disproved by the unlikelihood that Egyptians would care to put so commonplace an animal in a zoo. But he did have some power. Merely passing a young woman looking into a shop window with her husband, whom she loved, and who moreover was a professor and muscular, he somehow caused her to disappear, for she had taken his fancy, and pass five days with him in a hotel room "practicing every sort of abomina-

tion"—behavior for which, at the subsequent divorce trial, she could not account at all, and in which she had had no previous experience and for which she had no taste, so far as she knew. At about thirty, Neuburg fell in love with Ione de Forest, an actress, and when she married another man he went with them on their honeymoon. This roused Crowley and he bid Neuburg again present his anus. Ione de Forest (then in the late summer of 1912) shot herself through the heart in Chelsea, leaving everything she had to Nina Hamnett, who then went to Paris.

I naturally wondered if Modigliani had Nina.

Ramón de la Cruz, Madrid 1974

I really have no idea if Nina slept with Modigliani or not (Nina slept more or less with anybody who was of any apparent interest at all but just like having a glass of wine with a friend— I mean she was apparently completely frigid—she told me once that she had never felt anything. Not even with the Belgian husband her more or less first love who went off and left her pregnant—she had a baby that died—in a London hospital with no money at all) and she never heard what had happened to him but could never get married again.

Widow of Abdul

She is herself, Nina, somewhat inconclusive. She writes in *Laughing Torso* of nights until all hours with Modigliani, and often also Zadkine, who, black-haired and with flashing eyes in those years, would play on his concertina, and how they would talk, which is all well enough. She describes Kisling distributing a world of violets at the Rotonde, having bought up a poor woman's entire basket to his last centime, because he had sold a picture, and Modi's delight in this, and tender appreciation of it; it squares very well with Kisling, and I believe it. Modigliani—no. He would not have been moved. He would have been deeply moved if *he* had done it. She describes Modi reciting. Grace was his—or he its. Many have told me how he built castles in paradise with hands as eloquent as his declaiming, gesturing to the winds. As for the love, she says that Modigliani was hot for her. She tells (in *Laughing Torso*) how Modigliani chased her up a lamp post on Boulevard

Saint-Michel. She does not tell us what happened after that; and there she remains, at the end of a paragraph.

When Crowley himself came to Paris, he conceived the idea that Zavado meant to kill him. One morning he sent the Scarlet Woman, number one concubine, Leah Faesi, to rap on Zavado's door with a long shepherd crook. Zavado, because he slept naked, slipped out of bed and opened the door only a crack. Then he asked that she wait till he should have got back into bed before she came in; and then she entered and asked in perfect French, though she was Irish-American—why did he wish to kill the Maître? Zavado said that he did not. Nevertheless, concubine number two, Ninette Fraux, *Soeur Cypris*, appeared later and asked him the same thing, and then Elisabeth Fox, number three, who explained that she had been mounted by a goat. 666, or the Great Beast, having sources of information not available to Zavado, remained unconvinced that Zavado would not attempt to kill him, and it was then, though Zavado is of a size to put in one's pocket, that Crowley commenced to carry the great iron staff, like a four-foot crowbar, to ward off Zavado's imminent attack.

Conrad Moricand, drawn by Modigliani with an elegant fur collar in 1916, had powers similar to Crowley's, and was his great friend. Simply walking up to someone he had never seen before, Moricand would name his birth *minute*, and thus with great justice his zodiac sign, and consequently his inescapable future, and past as well. His sex life was delimited. When it was not the sphincter it was the prim rose of a little girl. He told Henry Miller this and it shocked the man. These hashshashin and mystics formed a coterie; they had their green truth, presumably. There were many pederasts in Modigliani's life, but when I asked Lunia Czechowska if . . . perhaps . . . she burst out "Modigliani? No!"—with an astounded emphasis that perhaps told me something.

The work of his rivals irritated Modigliani. He called them unfeeling tricksters. He boasted in exact reverse of his success, would burst out in abrupt laughter which seemed without cause. Prince Constantin Lahovary-Soutzo, his elder, a subtle poet, was

a Parisian of finesse. For him, Modigliani had an eager filial affection. He confided his enthusiasms to him, seeking the correction of erudition. He talked opinionatedly. He *covered* his food with condiments, self-destructive as though aware of his talent and wishing to punish it. One's contemptible surroundings had to be *put down*. They must not be let tincture the being. *Noli me tangere.*

Giovanna tells how when a casual wanted to pay ten francs for a portrait drawing because it was so lovely, Modigliani became angry and sundered it—because the price was five francs. She finds that an example of his disinterestedness, his disregard of money; but it is subject to another interpretation. "The artist is a superior being," he said. "He is not subject to the laws governing other people—the so-called moral and social laws. He is alone. The only natural man is the man who works the land; all others are freaks. The creator is a divine freak. A sick human. The artist is one thing, the bourgeois another." *

These views persisted to the end of his life . . . for Survage set them down—in 1918, or some time afterward before he died at ninety in 1969. Germaine, his wife, miscalled Germaine Survage in all accounts referring to the Nice years, 1918–1919, is a repository for all of Survage, Modigliani's only truly important painting friend after 1913 (but for an occasional encounter with Utrillo), save for Soutine. "The artist must be free, without attachments," he told Survage in 1918. He told Survage in 1918 (this was the Jeanne Hébuterne period) a woman might be accepted but *must* not interfere with the artist's art. He was not interested in the intrusion on his identity of things, women, action (which involves interchange and modifies), or his own thoughts.

Beatrice

Beatrice then said: How have you dared mount so high?
Purgatory, Canto 30 Dante

Beatrice Hastings acquired the name Hastings in 1896 by marrying in the Cape Province of South Africa where she was born

* Recorded by Survage, as uttered on the Riviera.

seventeen years earlier in 1879. The man seems to have been physically strong. She left him some time in the first decade of their union. In 1906, attending a theosophical lecture he gave in London, she met A(lfred). R(ichard). Orage. She had adhered to theosophy before him, and she did again after, but now while she was with him she decried it. It contended that you should get your guidance not from objective experience but from a master. That was what she sought; and didn't want.

She earned in twenty years as a writer twelve shillings and sixpence—it would not be correct to say "apart from *The New Age,*" for there she paid and was not paid. She became its literary director in 1907, entitled to select all manuscripts for publication, while sharing bed and board, the cost of which she paid, with A. R. Orage, who was not only one of England's leading theosophists but also editor of *The New Age,* toward the cost of which she contributed £50 a month, a very considerable sum in those days. This was done first in Hastings, causing a certain confusion in British Modigliani-Hastings research, then in Reading, Buckingham, Brighton, London, locations of publication of *The New Age.* Her first year, she accepted for publication George Bernard Shaw, and, under various names, herself: Alice Morning, Robert West, Cynicus, Beatrice Tina, Robert à Field, T. K. L., occasionally Beatrice Hastings, which authors she describes as "brilliantly gay, witty, talented"—and yet, save in the files of *The New Age* in the Reading Room of the British Museum, her writings have not survived. She was an independent woman; she wrote of various situations where she is "chained down where she wants to get up."

She was for legalized abortion, since children put a woman in a "demeaning" position relative to a man; and she was against childbearing—"an iniquitous imposition of men upon women." She expressed the new spirit, which she characterized thus: "So far as I can see the new spirit is the substitution of selfadvertisement and log-rolling for the old tournament where everyone was liable to have to prove his controversial merit." At the time of her affair with Radiguet, she wrote a long poem in alexandrines to Jean Cocteau to convince him of the rightness of this passion; but she did not persuade him.

She discovered Ezra Pound. She was first to print the short

stories of Katherine Mansfield. She came to know her well. If she knew her in the Biblical sense is of course one of those private things hard to find out—but when, in 1914, Katherine Mansfield decided to marry John Middleton Murry, and go to live with him at Menton, she was violently against it and Orage was eagerly for it, and a fierce four-way quarrel broke out involving Orage, Beatrice, Katherine Mansfield, John Middleton Murry. In the end, Katherine did marry Murry, and in May, 1914, partly because she could speak French, Beatrice took off for Paris to become the Paris correspondent of *The New Age*, and join *les suffragettes* as they were called by the French, the English young women who wore their hair short, and, some of them, trousers—as had not been seen put on the legs of a female since George Sand, who had to get legislative permission to do it. For a year and a half, Orage groveled and insulted her in "love letters"; and then he fell silent. Light may be thrown on her friendship with Katherine Mansfield by Modigliani who drew Beatrice as Sappho. She said he was complex.

The weekly "Impressions of Paris" by Alice Morning, running almost to the end of 1915, mentions Modigliani by name only once. However, Alice Morning is erudite—she is knowledgeable on the problems of Paris sculpture and art in Paris—she writes about freeing line from "geometry," a considerable insight, for it was not usual, in 1914, only six years after its inception, to question the fundamental tenet of Cubism. Picasso did of course, but he was rare. Alice Morning points out the evils of hashish; and in one of her articles very sharply attacks *Maldoror*, a hateful book, Modigliani's favorite. Beatrice Hastings said of Modigliani after he was dead that the devil himself could not have induced him to sit on an office stool. He was a pig and a pearl, she said; and a medium into the bargain. Alice Morning may have disliked hashish because it brought out the woman in her. Beatrice Hastings was a lush, but nowhere in all her writings is there a line against alcohol. But she writes against drugs; yet they took them together. However, they were Modigliani's love. Hashish may have brought out the woman in her in the sexual way, and made her sexually frantic, which would have put her in the danger of dependency, so there was the risk she might be dominated. Nevertheless, the evidence is

too ample that they did take the green bullets of oblivion together, and then, his head a mad tree of curls, she was ridden off into the wild wind. After one such occasion, he complained to Jacques Lip- chitz, who neighbored them in Rue du Montparnasse, that she had bitten him on the balls.

When they met, in 1914, he was thirty and she was thirty-five. He raised his hat in a pretty gesture, according to Hastings. Blushed to the eyes; and asked her to come and see his work. She did it.

For a time they lived together in her flat in Rue Montpar- nasse. It was a luxurious place, and Modigliani could indulge his theatrical Italianism. He could stretch indolently now, like the black cat he in part was. He did not have to rely on the voluptuous pleasure of offensiveness, Italian exaggeration among Celts, misery, to quicken him, to provide the exceptionalness he felt sensually, that divergence from normalcy which is a palpable necessity for the artist. He was intolerant of anyone's opinion, including his own. His rancor was not make-believe; he simply exaggerated it out of existence, perhaps so it would become unreal. The pictures now considered his masterpieces were least highly regarded, for they were most Modigliani—the slow process of familiarity had not brought forward recognizability, the only gauge, perhaps even for him. It is not so that a genius—especially not so unassuming a one, though he was very assuming, as Modigliani—is sure of his genius. He is as likely as anyone else to consider his missteps, later his genius, as missteps. And yet he is sure of them after all, and outraged that others do not burn, do not *burn*, at his ventures. It makes him argumentative.

He entered his great period with Hastings. With *her*, unable to sculpt. He initiated his Grand Style—as he asserted grandilo- quently enough, because it struck people dumb—and which is now considered his grand style.

He liked the bitch ardently enough, for she paid the bills, and his money from Italy had been stopped off by the war; though naturally he had enthusiasm for the crotch he frequented, at the crucial times. He had the great advantage, for women, that he

did not really like them. And his chin was blue, though he shaved twice a day.

He painted Hastings as *Madam Pompadour* in 1915, under one of the great hats *fantaisie* she often wore, when she was not going around with a little flower basket on a ribbon looking for her lamb, à la Marie Antoinette in the honest rusticity of the Versailles milkhouse. It is clearly Beatrice: he writes, on the canvas, Madam Pompadour, not Madam*e* Pompadour, and while he was a horrible speller this use of English is a referrent clearly meant. He wanted to leave no doubt; the hat substantiates—it is a kind of flat black boat with feather mastery, and rigging. Mme Pompadour, mistress of King Louis of France, was guided by ambition, not love.

There were, then, at last, the ingredients of a violent sexual life, and it ensued. He beat her, and perhaps roused recollection of her husband, the amateur boxing champion of Cape Province in South Africa; but if she enjoyed it and wanted it, gratified by what no theosophist gave, which had perhaps caused a gulf and an abeyance in her life, then he had reason to beat her the more, until at last it would be really impossible for her to like it. And so she was very superior as a love object to all her predecessors. He did not drag her about by the hair, because it was short, as he later did Jeanne Hébuterne by the long braids—against the palings of the fence of the Luxembourg Gardens just before he sickened to die—but when he brutalized Jeanne it was himself he was brutalizing. Had it been Beatrice, it would have been not so.

Marevna Vorobëv writes [*]:

> Sometimes we used to go in the evening to Montmartre to see Max Jacob, Modigliani and his friend Mrs. Hastings, who had then moved into her cottage on Rue Norvins. One went up big steps from the street through a little garden. There were two rooms on the ground floor, separated by a little entrance passage. Perhaps there were others, but we always stayed in the same well-lit room, in which were an Empire bureau, a table, chairs, a sofa and shelves full of books. A mountain of sandwiches awaited us, and bottles of every kind.

[*] In *Life in Two Worlds*, Abelard-Schuman, London and New York.

I thought of my last visit to Picasso—a pleasant commodious environment. His strength had failed him. Jacqueline had taken over.

One evening, I remember, there were Ehrenburg and Katya, André Delhay, Mitrani, the Greek philosopher, Carmen, a girl from Montparnasse. Beatrice Hastings, Max and Modigliani were expecting us. The scene, then, was as follows: Mitrani making love to Carmen on the sofa, both of them drunk, Max discussing philosophy, and Delhay watching the Greek's games with the girl. Ehrenburg, Katya and I sang Russian songs. Modigliani was having an argument with Beatrice Hastings, which turned into a fight. They went for each other like fishwives. And suddenly Modigliani seized her by both shoulders and threw her backwards through the window. She crashed through the panes and then all you could see of her were her legs and thighs, the rest of her outside in the garden. Everyone rushed to look and help. I took a wrong door and saw Vitya kneeling in the middle of a room making signs of the cross. He was a Russian Jew baptised Catholic who wanted Max Jacob to be a good Catholic. "Oh God, save us and preserve us from sin," he was repeating in Russian, and touching the floor with his forehead.

Beatrice Hastings was carried into the house and laid on the sofa—wretched, poor woman, she was daubed with blood. Modigliani kept striding up and down repeating—*Non mea culpa, non mea culpa*. He covered her with a Scotch plaid and began to comfort her, lovingly. We heard the crunch on broken glass. Mitrani and the girl Carmen, stimulated by the excitement, were going to the end of the garden. When we left, much later, Modigliani was methodically tearing strips of wallpaper off the wall singing *Capelli biondi, Vestito bianco*, which amazed me.

She was small—had a little pert head set up on a neck that was long, if not so long as Modigliani made it. Her hair was black, short, and pulled back into a sparse bun. She had pretty, high breasts, for Modigliani has showed us them. The dating of Modigliani is confused. Except for the nude seated with her head on her shoulder (so much like Sodoma's *Christ at the Pillar* in Siena it is impossible to think there was not at least unconscious

infusion on the peripheries of memory or just beyond) which is now in the Courtauld, London, he is considered to have done no nude of his great period before 1916. And he never saw Beatrice again after 1915. It is thus presumed that if he did Beatrice nude he did her from memory, but this he never did—depicting only what was before him. He almost never dated: so we haven't his authority. Lanthemann, however, told me: "The works are often transferred to a good year, so that they fetch higher prices. There are therefore for instance two hundred Modiglianis in 1916, but he did not paint that many in 1916. They were simply carried forward"—which may explain Beatrice. He almost never resumed a painting, painting only in the immediate, thus never the recombinations said to be "studies for" or "further copies after . . . ," which is one way of detecting forgeries, according to Lanthemann, who detects them throughout the world. The nose, seeming the same, varies throughout his periods, another way of detecting forgery. Nineteen Fourteen nose, 1916 face will not do. The forged Modiglianis now "valid" in number approximately equal the real. Often, said Lunia, the Modiglianis are false but the authentifications genuine. "How can these experts call themselves experts?" she demanded. Goldring said of the breasts of Beatrice that they were pathetically flat—as though Modigliani had "pressed her between ironing boards"—when he saw them, when the lovers danced naked together in the garden at Rue Norvins, but Modigliani in graphite gives the lie to this. Goldring is generally reliable, but apparently not good on this.

Joseph Lanthemann leads an interesting life. I met him at four o'clock in the morning on a back street in Nice, after a week of mysterious phone calls and rendezvous that did not come off. His address is unknown; he lives from hotel to hotel; he receives mail at General Delivery in a French city, but not at the central post office. His publisher, himself obscurely enough located in Barcelona, knew even less about him than I did. Lanthemann is Swiss, descendant of a family whose fortune was made by managing the renting of Swiss mercenaries to foreign armies, and he is producing the *Catalogue Raisonné* of Modigliani, which when it is supplemented and finished will determine which are Modiglia-

nis and which not. He receives essentially two types of phone calls: "Monsieur Lanthemann, I have here a Modigliani which has just turned up. I am sure it would delight you. Wouldn't you like to come here and agree with me that it is a Modigliani? Of course you would need expenses. Would a million francs be enough?" "Monsieur Lanthemann, I have a magnificent Modigliani, as you must know, and have had it for twenty years, but inexplicably it is not in your catalogue. It ought to be in your catalogue, but never mind. Of course your catalogue is not absolutely completed, and in the end those that will be Modiglianis are those in your catalogue and those few undoubted Modiglianis that you did not get to. You can imagine what it means to me monetarily that my Modigliani is a Modigliani, and I would remind you that a gunman can be had in France for ten thousand francs."

The owner of valuable paintings leads an adventurous life. On a Sunday afternoon, Jean Kisling, who knew me only by telephone, opened the door for me a slit, though at the time I did not notice. We walked in lockstep, he behind me, through the room where the glorious Kislings are. Finally in his inner office he said to me: "Did you not notice that I walked right behind you as we came through the apartment in which we are alone?" I said that I had not. "I had my gun in this jacket pocket pointed into the middle of your back," and he took it out and showed it to me, "and if you had made the least false move a beautiful Kisling is the last thing you would have seen on this earth." Kisling was robbed of his father's paintings; some men came, just as I, and once inside with him where he was alone they beat him almost senseless with the butts of their guns, trussed him, and then removed the pictures. He could not report the theft, because they told him that they would destroy the pictures if he did, and make off. It was a legitimate case of kidnapping. Telephone contact established, they held the paintings ransom for over six months until finally Kisling beat them down to a price he could reach— with everything he had, and all he could borrow. A great collector may not have the sentimental involvement of Kisling, but his paintings are usually uninsured. How so? Because to insure them would be to spread honey on them for the flies (by night) of art thievery.

Ordinarily a catalogued famous painting cannot be resold and few even among the rich owners would readily have the money to buy it back. But the moment it is known to be insured a picture lives in peril. It vanishes, and shortly the insurance company receives the following telephone communication from a public phone: "You have insured Monsieur X's picture for X million, and alas it is gone. But we have the power to cause you to find it at such-and-such spot, for only 800,000 francs, a great bargain, particularly in view of what the payment for loss would be."

I am told that since quite recently the catalogued pictures are no longer safe. It seems that there is a ten-year statutory limitation on recovery of stolen property in France, though elsewhere it is longer, and you only have to hold an acquired artwork ten years and a day and it is yours; the difficulty, then, is in getting the art treasure out of France. Then an Arab chief, with his pocket money, buys it, and puts it in a vault, and waits.

❦

Gaiety was not lacking to the love-hatred of Modigliani and Beatrice. One night there was a ball and Beatrice "had nothing to wear." He had her put on an old dress of black silk, a husk of silk over her naked body, and on it painted marvelous flowers, summers of butterflies. They went gaily to the ball; it was a triumph. She danced too much with a Nordic sculptor.

She said he was psychic. If he was, then things about him cannot wholly be explained in our present state of knowledge. He "inhabited" people. Once within, he *knew*. Lunia says that the nude feels *his* soul naked, and that Modigliani is in the strange position of being unable to dissimulate his feelings. His soul, not hers.

Often, at Rue Norvins or Rue du Montparnasse, Beatrice and Modigliani were separated by what were really grinding, infuriated quarrels. Once Modigliani tried to set 53 rue du Montparnasse afire. Another time he possessed himself of her key, said furiously that he had earned the place, and would not let her in. In these days, borne by something, he would run to Soutine.

Soutine painted on used canvases in the beginning, able to procure nothing else, overpainting, vindictively, the painter beneath —but when he became successful he continued to use used canvases, and never employed any other, all his life. When famous, he one day saw one of his canvases in the window of Percier, in the Rue la Boétie, one of the most exclusive places and exclusive streets. He went in and asked to buy it. "Oh, no, Monsieur Soutine, I will not sell it to you," he was told. "You would only destroy it. It is fine." He doubled the price, tripled it. Then he went away in fury—and sent a friend to buy it without mention of his name. And then he laid it flat on the floor before him as one does a woman, and contemplated it. And then he raised it up and gave it a kick, right through the center. And then he ran into the kitchen and seized a knife and ran back and cut the picture to pieces.

Action was the diametrical opposite of *meaning*. Modigliani had hated activity all his life. *Sportsmen*. When you *did* you ceased to be—except that in painting doing was becoming, for no inwardness accounted, beforehand, for the idiosyncrasy of the individual brush stroke—which was where the painting *was*, for its maker. It rendered all theorizing nonsense for the *real* painter, for it was all *ex post facto*. You painted a painting and you were *living*—in the tips of the hairs. And then you looked at it and you saw what was—in you. But in living it was the opposite: a quarrel with a woman, Beatrice, and instantly you ceased to *be*, for, the first thrust made, next you parried; you became angrier than you were, prouder than you were, more hateful than you were, until she, or your own extremity, touched you with a sudden, immense love.

Modigliani, in these days, worked for Chéron. He was paid fifteen francs a day, and on each day he must paint a full-size picture; and the merchant locked him in the cellar at his place on Rue la Boétie with his servant girl, who would serve as model, and a bottle of marc, absinthe just now having been suppressed. Kicks on the door; and he would be let up, it being understood the picture was finished. One day, as a collage, he glued a phrase of folk song around a picture in a halo; and Chéron replaced it with

lines of Baudelaire, which Modigliani ought to have thought an improvement. "No!" he said, when he saw it. "Sheephead!" "If I am a sheephead I won't handle you." "Lick my ass," Modigliani said. Late in that year, through Max Jacob, he was undertaken by Paul Guillaume, and in his joy painted him, lettering below *Nova Pilota* and above *Stella Maris*—guiding star of the sea—but his accursed gift caused him to show what within he thought him: a prissy, affected fart with a wisp mustache.

The élan vital (creative evolution) had been misunderstood. Yearning might shape a man, but he was not the potter of his own being. The clay was not free of its stuff. Forming yourself was the difficulty, not making the art work (an idea taken over from Brancusi). The artist's creation was the artist, and he must ever surpass himself. The artist he made would make the art, in that rapidity of arabesques too swift for seeing. But the artist he made had to be an increase of himself. To think otherwise, because the times had abruptly changed, and an uninstructed, thick-skinned public had come to be the judging crowd, was to carry creative evolution (Bergson) too far. A man could not make himself a winged pig because the judging crowd longed for this Icarus of the same species as itself, because this encouraged its cowardice, and flattered its ego. Only aristocrats *created*. "History is made by those who are conscious of the nobility of their origin and cannot be made by the violent protestation of the masses."—Bergson. To the laboratory where thought is cleansed, the noise of the masses hadn't access.

> Few men have the right to rule, for few have great passion. And as today everyone wants to rule, no one knows how to govern. In the schools of art, which are nothing more than academies of organized invention, men worthy of the name absorb the weak, and it is right, for a great production is nothing more than one thought with a thousand arms. Individuality, that little freehold, has eaten up originality.
>
> Baudelaire

Sexual practices recommended now, were not then publicly approved, though they may have gone on in private with even the

prevalence of now. As we do not know, we cannot know if Modigliani's way, begun at least early enough to be captain's-eyed in Venetian peepsight on Giudecca Island, was merely commonplace and the practice of every day, or another of his blood-drawn returns to the antique, for it was common in the classical age, as the mosaics of Pompeii, for example, attest. Given the kind of women he chose, not Beatrice, the rose cannot always have smelled quite sweet; and that must have increased its zest.

Juan Gris, from the positive-negative of the cutout hewn iron of Pablo Gargallo, Modigliani's friend, learned, in 1915, the effects of contrast he was able, with laborious industry, eventually to apply remarkably. He was exceedingly unsure, and he worked with immense anguish, until his rigorous intellectualism should have squeezed out the caprices of sensuality for which he is famous.

Not believing (he was wrong) Modigliani could work in the chaos with Beatrice, Guillaume procured him a studio in the Bateau-Lavoir. He was there by November 9, 1915, when he sent a postcard to his mother giving this address. Gris was the sole survivor present from the great movement of Cubism, and Modigliani wanted his friendship—he was made that way, and he needed kinship. He painted him insultingly, making him look quite effeminate, almost homosexual. And he spent his time with Celso Lagar. Lagar went from deception to deception, finally ending in a madhouse. In his *Pastorale*, a naked man, wife and child show the blue ugliness of the wrong side of Cézanne selected by a man who did not know how to paint. Viking Eggeling, who was virgin to them, Modigliani corrupted with drugs.

Drugs

There is an invasion from all sides, the face stiffens. As though you are at a dentist's, a club-thick tongue tries teeth that seem cased in wood. A chlorine cold vaporizes the eyes, the cheeks. Waves of goose flesh run over the skin and converge on the heart, and it beats madly. The waves surge up and fall back, from toes

to scalp, as if a sea beats in a too-small isthmus. The angel of the drug works with a cold indifference, like a surgeon, cruelly, like a masseuse, to bring spasm. You think you are going to die. (Cocteau—cocaine.)

My body had dissolved. I saw very clearly inside me hashish, an emerald which radiated millions of tiny sparks. The lashes of my eyes elongated, rolled like threads of gold on little ivory wheels, which spun so fast. All around me I heard the shattering and crumbling and shining of jewels. I still saw my comrades, but disfigured and grotesque, half men, half plants. (Théophile Gautier.) A naked woman, detached, becomes a great fringed eye (for Modigliani). A breast, a mountain. An immense mouth navigates the pearly water of a face. (He took drugs and absinthe together for the greater effect.)

We don't know how he took cocaine. He would have had that numbing effect, a freezing, one of those exquisite pains that by its intensity paradoxically passes the threshold into the land where tears and laughter meet in one, the land of erection and even ejaculation under torture, of mirth upon receipt of the news of a sudden death, of the smile that pulls curiously on the lips' corners when one hears a child has been kidnapped, or raped, or that cataclysmic war has broken out; the weeping in joy of the bride, for at last the vulture of love is captured and sings in its gilt cage forever. This anguish-pleasure of anesthesia you had too with Max Jacob's ether. Under cocaine Modigliani would have known the green river surging solid rippleless through his whole body, the affirmation that he was the great being he actually was, the cleansing of him as by that miraculous draught off Mont Blanc of all the glut, all that he had done to himself, and he was again what he had once been; the unbelievable full freshness in the lungs inflated like bellows of young leather. Cocaine probably contributed to his never sleeping; it was the drug of marathon days.

Zborowski was a charming creature—extremely amiable—everybody liked him. But *nobody,* as far as I know, liked his wife.

I saw the photo (extremely like him)—but the person who wrote the caption wasn't even sure if it was Abdul. Quite absurd! Whoever wrote doubted it could be Abdul because in the photo [with Modigliani and Basler] he is "elegant"—quite ridiculous! Abdul was always extremely elegant in the early days, as Modigliani was too—then lost all his money and in the later days simply didn't bother about such unimportant details. Abdul always liked spending hours and entire nights talking to friends and of course drinking wine all the time, but when he arrived in Paris (round about 1911) I believe he didn't drink at all (with a religious streak, a non-practicing Mohammedan, sympathetic to the Catholic religion). Of course no tradition of drinking, therefore wine always had a too rapid effect. I have always had the impression that Abdul learned to drink with Modigliani. He was always a great talker, and Modigliani also—so they got on marvellously, both very exquisite, both drinking interminably, and both noctambulists and marvellous conversationalists. Also André Delhay and another writer and musicologist who I think *must* have been a friend of Modigliani also—Charles-Albert Cingria, one of Abdul's greatest friends. They used to spend night after night, whole nights drinking and talking until the late morning, in the Dôme and other places. There was a period when the Dôme never closed at all.

On one occasion (an all-night drinking bout) Modigliani made a great quantity of drawings and Abdul went on buying them one by one and had quite an important packet of them, but the next morning they finished up very late extremely drunk and the drawings were all lost—left in one of the innumerable bars they had gone to and of course undiscoverable. Probably thrown away by a waiter. What a pity! It happened to so many.

I will tell you about him. Abdul was extremely cultivated, extremely charming, and a very talented painter. In later years, he left off oils and did the most refined watercolors—very French. He was an authentic grand seigneur. He belonged to the most aristocratic family in Tunis, the descendants of the last Emirs of Almería. He was offered the curatorship of that marvellous Bardo Museum in Tunis, but he refused it. You see, he was completely noncommercial—and completely "above the questions of this world." He quarreled with most of the picture dealers and lived more or less retired, without compromise. That is why he is not

cotisé. I have most of his watercolors. Occasionally I sell one—
but prefer to keep them.

Widow of Gilani Abdul-Wahab

Modigliani drew Abdul three times. The "Portrait of Gilane"
20 Nov 1919, so listed in the official catalogue of Modigliani draw-
ings by the Director of the Brera Gallery in Milan, is so by a mis-
reading of the final letter: it is Gilani Abdul-Wahab. He perhaps
called him Gilani: on two of the drawings he has printed and writ-
ten Gilani, and on the third: *à Abdul Modigliani 1616* with his
usual precision. The 16th of 1916, not troubling about the month?
Or the year 1616?

Abdul is not even mentioned in the biographies of Modigliani.
Modigliani's chief companions in search of artificial paradises were
Ortiz and Abdul.

Both Ortiz de Zárate and Abdul were men of pedigree, but
fallen. Or by themselves cast down. No one would have had the
originality to be an aristocrat. But there was a remembrance of an
aura, particularly with Abdul and Modigliani. While Modigliani
was pro-anti-aristocrat, he was anti-Socialist, perhaps because his
brother was a Socialist deputy of repute. When Modigliani, at the
head of his queue—Modigliani, then Soutine, and then Krémègne
—would enter the Rotonde nobly to cadge drinks, he liked the
sensation created among the women, while Picasso ground his
teeth; there was about him always something grandiose; but Abdul
was made of different structure, and similar attention mortified
him.

Long after Modigliani's death, Abdul one night stayed at
Zavado's farmhouse (*mas provençal*) near Aix. In the middle of
the night, after they had drunk hugely at dinner, Zavado and his
wife Tamara suddenly roused up, and they found Abdul stealing
along the walls, trying doors, and they feared for their female
guests. Abdul was in urgent quest of something, and then he found
it in Tamara's cupboard and upended it—the wine Modigliani had
made him acquainted of, and that he could now never get enough
of.

A journalist found a ploy to be funny, used it; it was a laugh
when Ortiz was alive. Then another one used it viciously and

from there Jeanne Modigliani wrathfully used it. Then Peter S————* as gospel truth. And there we stand, my brother Julien and I, struck and enraged. No, he was not raised in Naples. Hashish may have been tasted, as a lark, perhaps between '14 and '16. But I really don't know where. Not dans l'appartement.

<div style="text-align:right">Laure Ortiz de Zárate</div>

The ploy was the following (*Gazette des Beaux-Arts* for November 9, 1934):

Offshoot of a race of "conquistadors," he loved to brandish his memories of grandeur, until he would intone in his baritone voice:

"Formerly my grandfather of the same name—Manuel Ortiz de Zárate Pinto Carrera Larrinaga y Carvacal—found himself, followed by troops, at the foot of a mountainous rock ridge, when suddenly . . ."

This became, in the great tradition of biography:

At the least occasion, he would proclaim his illustrious origin: "My ancestors, ardent knights of the cape and sword, noble adventurers of the race of Cortés and Vasco da Gama, furrowing the seas in their frail, bulwarked caravels, defying the storms of men and nature to bring the civilization of the Catholic Kings to the end of the seas and the savage continents . . ." Thus a long time in a swollen tone to conclude inevitably: "I, Manuel Ortiz de Zárate, Pinto Carrera y Carvacal, am universal inheritor of one of the most glorious epic periods of history. Yes, I am the last son of a mythology of heroes and princesses." [My faithful translation from the latest Modigliani biography, Paris, 1969]

At twenty, Ortiz de Zárate was a young bravo of Naples, a poor artist whose guitar enchanted the girls. [André Salmon, *La Vie Passionnée de Modigliani*]

It was a bit much to say, perhaps. Still, the Ortiz de Zárate were of the Basque nobility: their arms may be seen on the stone escutcheons in the Basque and Navarrese provinces today. And at one time people did sail forth from those ports in caravels. They had heroes, then. As for the guitar, he did play the piano, and could sing, having natural pitch in the baritone range. But it

* A Modigliani biographer.

seems unlikely his grandfather had the Pinto name too. It came from the mother. Anna Pinto bore him in Como, when his father was studying musical composition in Milan.

I don't know if he bragged of these things. Like a reincarnation of the future, Montparnasse was a sort of Greenwich Village of its green days. They were pranksters; café elocutionists. Kisling's son told me that the charge leveled against his father— that he forged Modiglianis when the death had sent the Modigliani market to fever level, for there were Modiglianis that betrayed the touch of his hand—is both true and untrue. Kisling helped Modigliani in his final years, when his talent exploded in a paroxysm, except for the most famous of his paintings of all— Lunia, Jeanne Hébuterne and Zborowska. He lent Modigliani his studio, paints. Criticism says the material debt was chromatically repaid, for from Modigliani Kisling got Modigliani aspects of his style. The truth is somewhat different. The Modigliani aspects were by Modigliani; and the Kisling touches, the Kisling cast in certain Modiglianis, indeed by Kisling, were in genuine Modiglianis. "They were young," said Jean Kisling, "and not without gaiety. Sometimes my father would do a portion of the anatomy, Modigliani another—say, Modigliani portrait head, Kisling a necessarily Kislingesque belly. They did it as a joke, for fun." But this did not convenience the solemnity of the art market, which knows where it stands, where dollars are concerned.

Modigliani must have noticed something very striking in Ortiz: the exceeding likeness to the work of Ghiglia. The same correct, Courbet-spun naturalism, a rendering just, but somehow waxen, the difference, imperceptible, between, in still-life, wax fruit, perfect in replica, and real fruit, waxed to a shine under a bell jar. Soutine and Ortiz both took off from Courbet, though Soutine was heavily derouted by Van Gogh, and Ortiz was good at this, but Soutine inadequate. I don't know if Ghiglia's painting and Ortiz' have ever resided in one place except my head and Modigliani's, but when they do the resemblance uncannily speaks.
Ortiz was "the last of the Patagonians"—a phrase I believe

originally Apollinaire's. By this is not meant the present inhabitants north of Tierra del Fuego, but the Tehuelche Indians, now mostly sent to their forefathers by the ancestors of Ortiz and others in the improvement of the continent, but, when Magellan found them, in their deplorable natural state, a pacific people about six feet eight to ten inches tall, with "very big feet." They were for a time, exclusive of giants, considered to be the largest people in the world.

> Ortiz' appearance physically: large feet, upon which he wore sandals. Leonine-headed, a noiseless walk, soft curly brown hair, brown eyes—an appearance muscular but not given to exercise. A two-hundred pounder, of herculean strength and pacific disposition. He was a vegetarian, at least when my mother met him.
>
> Laure Ortiz de Zárate

He had the Gauguin studio at 8 Grande-Chaumière. There *te faruru* undoubtedly, but in the domestic way. Not, like Gauguin, with a half-caste, in a manner intended to incense Paris, and in emulation of the great Baudelaire and his Creole, Jeanne Duval, who gave him an anguished time and thus did not bore him. Ortiz was passive, and he deliberated long over a work, even over beginning it. Hedwige, his wife, did everything to animate him, but the person she animated was herself. She, as did Marie Wassilieff, made dolls. Marie Wassilieff made kidskin dolls of smooth white flesh kid with elegant eyelashes and brows sewn on in silk and glass eyes from the taxidermist, detailed portrait dolls of an astounding likeness, clothed, or nude for those who preferred themselves that way. Hedwige de Zárate's were for connoisseurs, but Modigliani wanted them to be monstrous—and given to children.

Modigliani composed, Cocteau told me, his people intellectually in accordance with his idea of line, but the resemblance was to his heart. "He was full of malice, and charm. His drunkenness, abuse, his abrupt, disconcerting laugh, all very exaggerated, were his defense against intrusion. He had something sanctified, which he held with his hands, as it were, under his heart—it was his 'difference.' Caricaturist making the rounds, like Fellini on

the Via Veneto, he made you think of those gypsies who read mortality in the palm of the hand. Oh he was gay!—and bitter," said Cocteau. "Did he know what he guarded?—perhaps he no more than divined it was threatened. He painted my portrait in Kisling's studio, 3 rue Joseph-Bara. Picasso was there too. You can see him in the background in the pictures the two made of me, in a checkerboard shirt. [You cannot.] I posed for both painters simultaneously. The portrait by Modigliani was a hundred or so francs, and now it has gone around the world like a snowball rolling in gold—but can you see the painting any longer?"

Like Survage, whom Modigliani met in 1913, *cavalier servant* of Baroness Hélène d'Oettingen, Modigliani was *cavalier servant* of Beatrice Hastings.

And he was scornful, rather beseeching, fatigued, nervous, anxious. His style firmed.

A dealer tried to bargain over drawings: he was going from place to place in 1915, folio under his arm. He walked straight into the WC and speared them onto the hook for the toilet paper. He had a sense of affliction. He was proudly apart from the social mechanism. He expected credit as a right. Imperceptibly, life was falling beneath his expectations. At the last, he was convinced his nonsuccess was owed to a concerted plot against him. Bergson quit his mind: the authors left to him—Baudelaire, Villon, Nietzsche, Verlaine—evidenced the superb discretion which marked his art.

The antiquarian Brummer was, at that time, among the first to exhibit and merchandise the African masks, and for him worked a clerk named Martin Wolf—weak, sickly, ineffective. He liked to play the artist and circulated in the guise of an artist at night in Montparnasse; Beatrice took up with him. Why did she do this?

Possibly she went also with the Italian painter Alfredo Pina, encouragingly inferior to Modigliani.

The "Impressions of Paris" of "Alice Morning" ceased late in 1915. Light satire, the "Tales of Peri," followed, but lasted hardly at all. She came into a large inheritance; she became ill with a tumor and had many hemorrhages; she was always drunk and

looking for a row. Finally she was in bed five days out of six. As the year ended she left Paris for the Midi and did not return until the hour of Radiguet, 1921.

Paulette Jourdain thinks to this day she was probably a German spy and left Paris at that stage of the war because her task was done. Others think she was run out because of drugs.

After her suicide, there was no mention of Modigliani found among her many papers.

Modigliani may have feared the hesitation of Gris. He himself did not hesitate. He plunged in. He could not correct; he could not resume a thing.

Lipchitz saw this when he had him paint himself and wife, one of the few Modigliani pictures where the subject is not absolutely alone. He, Lipchitz, had come into a first success in 1917, and wanted to distribute largesse to Modigliani, who was broke. Modigliani did not love him.

He saw Modigliani make a few preliminary sketches of himself and wife, posing them as in their wedding photo, with a sureness and rapidity the miraculousness of which he, Lipchitz, was able to judge. And the next afternoon at one Modigliani came and, only drawing back to look at it a few times, and scarcely looking at them, he made the portrait in a few hours. *"Voilà* another piece of *merde,"* he said, stepping back, astonishing them that it could be so soon done. But Lipchitz was paying him by the session and his real purpose was concealed largesse, so he said: "Couldn't you put on a few touches more tomorrow? A sculptor likes to see substance filled out." Modigliani shot him a look. "If you want me to ruin it I will," he said. With him was Simone Thiroux. She had a peculiar alikeness to Jeanne Hébuterne, whom he would soon meet. A peculiar poverty of spirit marked each of them, Roger Wild saw of Simone, and his wife, Germaine Labaye, of Jeanne. And they told me of it, comparing it. Each had blue eyes—Jeanne Hébuterne's were blue-green. Each was hardly more than a child, though Thora Klinckowström, in 1920, found Simone "not pretty and even not young." Jeanne Hébuterne's complexion was olive; Simone's more bruised apple, but each had something

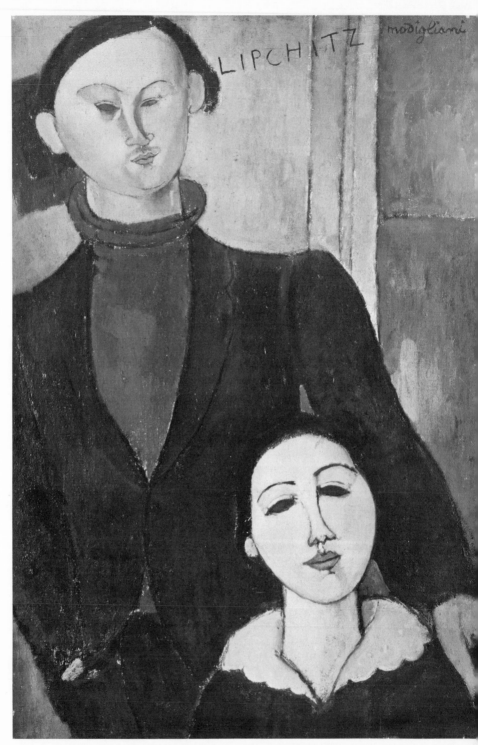

Jacques Lipchitz and His Wife by Modigliani, 1916

darkling about her, a morbidity of skin and flesh, almost the physical manifestation of a willingness to be humbled, hurt. Modigliani had of them eagerly, hopefully whatever he wanted—it a little tinctures the way he treated them. Simone Thiroux's father was Canadian, her mother French. She lived with an aunt in Boulevard Raspail. She taught English lessons to Scandinavians. She made the mistake of loving him humbly. In front of Lipchitz, he insulted her, called her a slut. Struck with pity, she had taken him home when he was drunk and filthy, and by virtue of this became his mistress. By a totally different theory, she was a scalp-catcher like Isadora Duncan and wanted to sleep with famous men, these only, but as many as possible—though Modigliani wasn't so very famous. She became the mother of his vanished son: who can never now be recovered——he may be living today, fifty-seven, having no idea he is the son of Modigliani.

<div align="right">31 dec 1919, 207 B. Raspail</div>

My dear friend,

My tenderest thoughts go out to you on the occasion of this new year, which I hope will be a year of reconciliation for us. I put aside all sentimentality and ask a single thing which you will not refuse me for you are intelligent and not a coward—it is a reconciliation which will permit me to see you from time to time. I swear on the head of my son, who is everything to me, that I have no devious intention. No—but I have loved you so much, and so much suffered, that I beg this as a last supplication. I shall be strong, you know that. My material situation is such that I can earn my living, even generously. My health is bad; the pulmonary tuberculosis does its work. Ups—downs—

I cannot go on. I beg, simply, a little less hate from you—I beg that you look at me kindly—console me a little, I am too unhappy, and beg but a bit of affection which would do me such good.

I swear I have no hidden motive.

I have for you all the tenderness that I must have for you.

Simone Thiroux 207 Bvd Raspail

The letter went unanswered. Was not acknowledged. He had refused to acknowledge the child, saying she was an immoral bitch who slept with anyone. Twenty-four days later he was dead.

Vita Nuova

The last thing he penned on a drawing—of Mario Varvogli on January 1, 1920, twenty-three days before he died—was: "Il Nuovo Anno. Hic Incipit Vita Nuova." Here begins a new life.

Diego Rivera was born in Guanajuato, in Mexico. He was an immense man, a fabulous liar, a double-size Picasso until he shook Picasso's influence abruptly off with a prodigious effort, a faithless but a careful (contraceptives) lover, capable of working steadily before a canvas twelve hours standing in an unheated room in wartime Paris, who carried an immense Mexican cudgel as a walking stick, and sometimes inexplicably whitened and fell in faints like a girl.

He used the blue of Cézanne but not the icefield-white Cézanne blue of Zawadowski (actually seen in patches and lobes on Mont Sainte-Victoire); rather, the emaciated blue of Cézanne's *The Bathers*, gaunt creatures, all one woman in fact, bent in bleak harmony with the stark trees, as imitated by Celso Lagar. For figures, Douanier Rousseau: in one instance a fat beaming Rousseau self-portrait Diego, beside him his mistress Frida (copied literally from a photograph); acknowledgment of Cézanne in inclusion of the Cours Mirabeau fountain in Aix. These in the days when he was still a true painter, and a gifted one, before an assumption (social system) let him splay out.

No Cézanne inhabits Modigliani's palette; he took but his construction. His palette: rose, spent blue, earth brown, profound black, and white, sufficient to render a great melancholy—people

seeming weary beneath stress, spanned, regretful, or in a moment of abeyance of disaster: ironical, or ironically seen. Something compelled him at the last to paint children on the threshold of sexuality.

He could be filled with amazement at himself—nothing Commedia dell'Arte about it—to see his lucidity clear as a beacon no matter what poisons. Did poisons—drugs, alcohol—dull art at all? Perhaps only torpor could. And he felt he had his inexhaustible youth.

He was so *exasperated* that he did not sell. He is celebrated for his rude treatment of dealers, clients, his high-handed self-murderous haughtiness, his arrogant refusal to play the game, curry favor (he did curry it, swallowing his phlegm)—but they would not buy.

Baudelaire: "It is understood that in default of inspiration, wine, alcohol, hashish, opium can replace it. Anyone who has had experience of these drugs knows that, contrary to popular opinion, they determine a climate fruitful to the expression of the profundity of the personality." If you could only absorb enough!— without vomiting onto your clothes, without falling asleep suddenly at the Rotonde table as though bludgeoned. Ivresse *extinguished* the thinking part, and then you thought. The River of Lethe was running on underground, all the time.

This was a time of a sexual sequence of girls. They may be identified from the portraits, from when Beatrice Hastings left until Jeanne Hébuterne appears. The aperture sought, little differed. Whether worn by Almaisa, Renée or Lolotte.

It was of a dull, bruised, melancholy hue. It was a ravine with dank thicket-banks. *Ennobled by hashish, I plunge my head amorous of drunkenness in the black ocean where the other is. At the feather-touching banks of your twisted hairs I intoxicate myself with the tangled scents of musk and tar.* (Baudelaire.) Up a torso-length from it were two pillories that, giving forth milk-sperm, fed children.

Baudelaire:

Hope, like a bat,
Bats the walls with its timid wings

And cracks its head on the rotten ceilings.
When the rain shafts,
Imitating the bars of a vast prison,
A mute people spider
Threads deep in our brains.
Suddenly the bells leap with fury
Screaming to the sky;
While homeless, wandering spirits
Complain.
And the long funeral processions without drums or music
File by slowly in my soul; Hope
Weeps; and Anguish
Plants its black flag in my skull.

In the photographs, Modigliani's face has the hue of ivory. And, later, he spoiled it. The nose, noble, is peculiarly pinched in (the septum) and flared, at the nostrils: the nose of John Barrymore. The eyes are deepset, under thick black caterpillar eyebrows, a little arched. In the photo he gave Lunia Czechowska, which therefore must in his opinion have been his best, the double ridge of the upper lip to the fine lips of the mouth is especially stated—patrician. Something in the Lunia photo carries you back to the little Dedo with classmates on Via delle Ville, under the ruler of Mondolfi, at about four—distinct in kind from all the others even then, an essentially sweet, wondering child, willing, with the future before it.

The resonance of each portrait by Modigliani was different— Cocteau angular, Rivera round. He was one whom things tilted onto, feminine.

Rivera, a brilliant lad, had been sent by his country to Europe in 1907 on a scholarship; he would study art, but he went to Spain, not France. There he was with María Gutiérrez Blanchard, Maria Blanchard as known in French art. He was over six feet tall, weighed almost a sixth of a ton: even then. He painted immensely, having a monkey faculty that almost surpassed belief. Voracious for art, he went up to Paris, though he did not feel he had absorbed all the Spanish masters, and, speaking what he took to be French, he settled in, mostly with Angelina Beloff—he quit Beloff for Ma-

revna, then Marevna for Beloff. They were twelve years apart in age, Beloff the older, and he stood exactly between them—six years younger than Angelina, six years older than Marevna. The switching seems mainly to have been to avoid children; and for sexuality. He had the sexuality of an immense man of exceptionally high metabolism. He was antisocial, having time for nothing else but to paint, all of his life, and very extroverted when journalists were at hand. I found him morosely, gloomily extroverted at San Angel, Mexico, observer present, at the very end, like a great leviathan looming up out of self-preoccupation into the light of a world he did not like.

He was antagonistic to philosophers—but he too was well-read, though he had gulped books pell-mell all in a mulch, as he had painting, rather than feeding as Modigliani had. He had a *feeling* for Marxism, he was wont to say; he would "grasp" a writer, but hadn't the patience to read him. And so with Marx. He ranted against Futurism, but not in Modigliani's presence—then he would blandly say that Boccioni, for instance, surely seemed to have things figured out.

He liked to work Modigliani up. Although he hadn't really read Marx, that latter-day Emiliano Zapata in Rivera's view, he was certainly proletarian—and Modigliani's idea that the artist was an aristocrat of special breed did not sit well with him; though he himself was so madly devoted to the production of eclectic art that he got up at four in the morning to begin, and indeed did all his life, and said, learning his mother was coming to visit and fearing the interruption, that he would commit suicide if she did, and meant it. By the same obsession he caused the death of his son, though not outright. (The infant Diego died of complications caused by deprivations of the war years, though Marevna thinks he might not have if Diego had not been so preoccupied with art, and Angelina, the mother, with Diego. It was Marevna who kept the grave green, in the Montrouge Cemetery, when Diego had gone back to Mexico, and Angelina seemed not to care. For a time. And then it was forgotten.)

Marevna, wearing lion-tamer boots and nothing more, painted him naked. Gottlieb, who fought the duel with Kisling, painted

MODIGLIANI

him. When Diego first met Marevna, he gravely explained that they should go around the house naked, until they got used to each other, and then one day he solemnly showed her condoms and said that the moment had come. She had to wash him in the tub; otherwise he would not bathe. She said that if he seemed to be selfish, neglectful, it was really because he was simply a child.

Modigliani *gave* character to those portrayed: Soutine became more Soutine than Soutine, Kisling more Kisling than Kisling. Snapshots of Rivera taken thirty years later in San Angel are of a man not the pouted, rose-lipped, fat child Modigliani conceived. The difference is not only time. Jeanne Hébuterne—a woman—was *not* a Polynesian or Sienese flower on a long-necked stem. She was, as her photo shows, rather common, rather dark, almost gypsyish—a girl of circus tents and sideshows.

Rivera's friends were Savinkov, the anarchist-terrorist who was in Nice with Modigliani, and especially Trotsky. Lunacharski.

Just as Trotsky had somewhat to accommodate his ideas to triumphing reality (backing of Lenin from opposing him when Lenin had won), so did Lunacharski. He had temperament, feeling; therefore it was not easy for him to accept Constructivism as art. But it was the official art of the Soviet, by ukase lovely, and as he had to administer it, then he had better like it.

It seems true that before leaving Paris in the month after Modigliani died (for Italy, where Giotto's art persuaded him to be a mural painter, then Mexico), Rivera ranked the artists (after Picasso, of course, with whom however he had quarreled and broken) as (1) Modigliani, (2) Soutine—by no means an obvious judgment at that time.

Lenin, a schoolmaster's son, was schooled by the father of Kerenski, whom he deposed. He was against democratic method and believed in professional revolutionaries militarily disciplined to form cadres, for these you could count on. He conceived the idea of the dictatorship of the proletariat, which dictatorship he felt he could assure. He believed in rule by men—directly. He considered art and culture a minority concern. In Paris, he lived

206

in Rue Marie-Rose in Quartier Denfer-Rochereau. He did go to Wassilieff's, Trotsky's mistress's, but seldom. At the Rotonde in the narrow back room leading to the WCs, he sat with architects of the Bolshevik Revolution—among them Diego Rivera, Lunacharski, Rappoport, Ehrenburg. He appointed Lunacharski Commissar of the Fine Arts after the Revolution: thus Chagall, Lunacharski's friend at the Ruche, became a commissar too. Lenin did not concern himself with that portfolio, but one day he did, and decreed that the securing of the Soviet system by the machine-parts art of Constructivism—evidenced in Paris by such as Léger, and in Russia most of all by Natalie Gontcharova, who produced seven hundred paintings of it, some of which, painted in sections, covered forty square yards of surface—was too far-seeing. He ordered that they had better get down to straightforward propaganda.

Cocteau told me Lenin wanted to become an artist's model but was too short, and came to the Rotonde to "look at the painters." He told me they one day asked him what did *he* intend to do? "Overthrow the government of Russia," Lenin said, and they all laughed.

There are no narrative paintings in the work of Modigliani, no backgrounds, no detail—all is stripped away. There is said to be not a single art book on the painting of Modigliani which does not contain forgeries. I myself have ticked, in a number of monographs, Modiglianis so schematically Modigliani that I was sure they were forgeries, the forger, being objective about the artist's style as the artist at least partly is not, picking out the most characteristic aspects. Some of these caricatures of Modigliani indeed are not in Lanthemann's *Catalogue Raisonné;* one, however, that I had especially marked I later found on the wall in the photographs of the first posthumous exhibition, the first big Modigliani exhibition of any description, five years after his death at the Bing Gallery in Paris: it was a stylized Jeanne Hébuterne full-face, so mannerist that I thought someone wholly detached from the inner mood of Modigliani, and his interchange and traveling combat

with his subject, had done it—the *Modigliani picture* always merely that point somewhere between Modigliani and the model where exigencies cause him to arrest in time.

It was the emotional tuft (cuff hair) that ruined his sole Paris exhibition while he lived, which he had so counted on. Berthe Weill, the little quaint bespectacled old lady who had been first in France to buy Picasso, decided to give him a show, December 3–30, 1917, in Rue Taitbout. Cendrars prefaced the catalogue:

> The interior world
> The human heart
> The come-and-go of passion

Zborowski decided that the nudes should be featured. There was even a thatched nude on the cover of the catalogue—thatch concupiscent, filth, beauty, that called you irresistibly.

On the opening day of the exposition that he had so much counted on, the police came. People stood in packs like bee swarms in Rue Taitbout. The cunt *en soi!* When Berthe Weill rushed angrily to the commissariat she was told: "One sees the h-h-hairs. Take them down." She at once closed the gallery, and the people locked inside helped take down the pictures. His aberrant sexuality, the generosity of his sexual violence, had betrayed him. If, with each model, at the end love was consummated, it was himself that he breached. Or the consummation would be beforehand; then you had the pallid women exsanguinated by sex—it was himself blanched by sexual excess. The skinless pictures of the greatest artists approaching death stop the heart.

Kisling's best friend over the span of his life Paris-long:

> Except for anti-Semites or gray cases, no one, certainly not in Montparnasse, called Kisling anything but Kisling, or, above all, Kiki. In the latter case, something had to be added such as "the painter" to distinguish him from Kiki, the model. Moses, or Moïse, had a certain racial connotation. He lived at 100,000 volts days twenty to twenty-three hours long. He was conviviality itself, the King of Montparnasse, bon viveur à la Polonaise as all

Poles are, candid, inexhaustible—foyer of the fever of life. But you are right. For me, something inside the cuirass—as if his gaiety were an armor worn to protect a profound sadness. In our consumer society, the press is avid for the sensational. And even when journalists write the serious studies of the bipeds they have known, they forget perhaps that they are not writing for a daily and keep to the most spectacular, the most readily graspable. That is, after all, where their sympathies lie. If they wrote of Pascal they wouldn't write of his *Pensées* but with immense verve over his invention of the Bath chair. Even in Jef [Joseph Kessel of the French Academy, author of the definitive *Kisling*, 377 pages, 646 reproductions including 109 nudes, 92 full-page, half of them in color] you find only in the last three or four pages, between the lines, a suggestion of an allusion to psychic problems.

<div align="right">Guy Dornand</div>

At the Restaurant Leduc, Kisling invited everyone to a banquet, hiked up his shirt, and danced the "dance of chastity"; then, shouting, "You pay the check!" scooted out a side door. There was the duel with Gottlieb, plainly 1914 in the press cuttings (1912 in all the accounts—they must copy from one another). Jean Kisling: "He would go to work at eight whenever he had gone to bed. A gong would summon him to lunch at one. Then back to work." He and Modigliani did not fully hit it off, owing to essential differences of temperament; their legendary closeness has been exaggerated. But Kisling was truly helpful, a good businessman, and, as struck horror and admiration to the heart, could control himself. The sign stood on his door as he worked: "Do not knock until 6."

Marevna:

It was always gay at Kisling's. He was always gay. [He was the only one who was.] I went one night to Rue Joseph-Bara. I heard a lot of laughing. I knocked, and silence fell. I opened the door, and heard a Jewish hymn for the dead. There was a catafalque and on it two seven-branched candelabra. [The Jewish menorah, once used in a drawing by Modigliani.] And there was an open book. A small body lay stretched out covered by a sheet. I thought I had come to the wrong place and turned to go, but then I saw crowded together on the sofa, and on the carpet, Kisling and all the gang, most of them Jewish. They went on singing

the Hebrew hymn, looking extremely mournful. What little child was lying there in the atelier where I had seen so many orgies? Kisling asked me in a grave voice to put my name in the book before I left; and I hurried to, because I wanted to get out of there. "The poor thing is dead," he said. "We are assembled here to weep over her. She was beautiful—but her curiosity and gluttony were too great. She ate my paints. And she is dead." At this, everyone broke out laughing. It was his cat, a large striped one; she had been found bloated that morning, her mouth still smeared with paint. In the end they made a package of her and left her with the cashier of the Rotonde for Ehrenburg.

For Thora Klinckowström, for Lunia, Modigliani wrote on portrait drawings of them: *La Vita è un Dono dei Pochi ai Molti di Coloro che Sanno e che hanno a Coloro che non sanno e che non hanno.* (Life is a gift from the few to the many, from those who know and have to those who don't know and haven't.) He wanted to pass it off as his; and critics have said: was it a quote?; if so, what source?—surely it is the expression of his own poetic soul. It is D'Annunzio, *Convito*, 1895, plagiarized from Dante. It expresses Modigliani's attitude, near enough.

He lived, surely, in the terror of not making a good picture. So did Soutine—who frequently broke into tears over the sheer *difficulty* of painting. Modigliani *dared* not, once the habit was established, not drink while making a picture. If he did not establish the same conditions each time, how could he know that the terrible bridge would be crossed? Whatever it might do to his health, he could not take the *risk*. Had not Baudelaire said that the realm of intoxication was a special world, and when you reentered it you reestablished contact with the feelings of that world? Maybe Modigliani of the grand style lay there and nowhere else. *Every* painter was not the same man painting as the man in dailiness. Every man joked at, kicked, the painting he had just spent his life's blood at. Probably even Léger—Gleizes—experienced this. But maybe it wasn't for that that Modigliani drank.

Kisling came from a bourgeois background. It made an immense difference. Krémègne and Soutine didn't. They knew the diet of potatoes, herrings and black bread; at the great inns of

Vilna, where the gypsy music, full of nostalgia, poured through the cracks, they could gaze in through a window, and on Fridays, when the well-off Jews were moved to ritual charity, they could partake of the traditional free meal in the kitchen. Soutine romantically said that when he had seen the butcher cut the throat of a fowl and bleed it living a cry of protest had risen in his throat, but when he saw the joy on the butcher's face the cry had lodged in his throat, and that it was there still. The colorful memories of Jews rocking forward and back and whining as they prayed, in rooms full of the smell of the sweat of fear, and children crying as they slept on pallets filled with rotting straw, were lacking to Kisling's experience, but he succeeded in producing a beautiful art that has an odd orientalism in it.

It is said of Kisling's nudes that they were influenced by Modigliani, but it is hard to sustain this—looking at them. Some of the positions perhaps; if it were not the reverse, and he influenced Modigliani. Kisling's nudes seem more . . . pensively waiting for something; here is certainly less *te faruru*. Once or twice one does have her hand on the love-piece, but it seems almost more for concealment than for incipient friction. Once he does have a pair of Leonardesque girls placed nude in opposite orientation side by side in a field, yet it does not seem that they are about to do what in Pascin they would have to do, but simply remain there thinking things over. The *Great Red Nude* certainly does have her tits in the air, as does she of the first nude of all *Expectant Waiting*, but more characteristic is the reticent young girl, eyes downcast: and when the semaphores of sex are burnished off and there is a curious waxenness it is most Kisling—doll-like. His nudes are musing; scarcely ever on the fringe of a very commonplace and very celebrated act, as in Modigliani. Kisling doesn't pursue them down the hedgehog burrow to where, ceasing to be general, they become individual, truly real humanity. He has supporting detail, even anecdote; Modigliani worked burnt-off ground.

One must not exaggerate: Kisling's middle-class background was very relative. It was to be well-off—a Jew in Poland. His father, a tailor like Soutine's, had his booth; and *his* father had been a prominent lawyer. He grew up in a primeval forest that

had never been cut, though it was on the outskirts of Cracow: there was the paternal manse. It was a boyhood Tolstoyan not Dostoyevskian—a *Beyond Sing the Woods*—and of course it influenced him. No question of being a harness maker or shoemaker, the intended fates of Mondzain and Soutine, bread for the salivating mouths; but his father wanted him to be an engineer. He chose art, and was let enter the Beaux-Arts of Cracow. It is no wonder that a pathology of his nature remained subterranean, and only emerges on the canvas around 1940. Not like Soutine, who felt at his back forever one who meditates some unnameable crime—yet Kisling was more dual. When I said he seemed, as presented by everyone including himself, too *uniface* (a French word I think I invented)—the Kisling people were very struck.

Every account says Kisling and Mondzain came to Paris together: but Mondzain came in 1909; Kisling in 1910. Kisling soon appeared in the blue coverall of the mechano. But he found out the flaw in Cubism almost at once—it was antihuman. He stuck with Picasso as friend, and that must have hurt Modigliani. Vollard was going to take him up—he who had discovered Cézanne once Cézanne was clearly enough established in the inner circle so that there was no risk in it—but decided to wait. "Exhibitions show that those usually the worst are the new artists," Kisling said. This was essentially true. Why, if they are not neglected entirely, are they taken up at all? Because the merchants can buy them cheaply— and hope for a coup. This was the time when, the Cézanne boom having started, it was considered that one might destroy some of the Cézannes. That way, the price for each remaining Cézanne would be much higher. The merchant would decide which Cézannes were worthy of retaining, which not.

Kislings were not so much flesh made woman (Modigliani) as woman made flesh. Kiki, the model, may have had something to do with it, for, naked, she is the great round hills, and her nipples are colorless, and her pubic patch while present is so small in the roundedness of her Percheron thighs as scarcely to be there —the photograph. Yet not in such way, essentially, are art styles made. For the painter picks the model who speaks to him, even if he hasn't yet heard.

Kisling is said to be the luckiest painter of Paris. He had no money when he reached Paris. He met, almost at once, Sholem Asch, the great Polish Yiddish writer, and told him of himself and what he meant to do. He received, not long after, a letter from Moscow with 150 francs and the unsigned note: "This is sent on the recommendation of Sholem Asch." One hundred and fifty francs arrived each month until the war. Demobilized, he was broke. Back at Joseph-Bara but nine days, a notary sought him out. A casual friend, Chapman, an American, had been shot down over France and left him $5,000. I don't think it luck. I think his qualities were rewarded. He was the only School of Paris artist who never knew want; it was probably hurtful for his painting, but there was torment within.

Zborowski came from Zaleshchiki in Austrian Poland. Poland had been divided up three times and now a country once larger than France did not in effect exist. There were Poles but no Poland. By their passports, they were Prussian, Austrian or Russian.

Zborowski's father was a jeweler in Austrian Poland. The family emigrated to Canada. Zborowski, at twenty-five, from Cracow, in the year Modigliani was thirty, went to Paris on a grant from his government. He was a poet of the Avant-l'Intellect, precursors of Dada and Surrealism. He was determined to be a great poet, but had absolutely no talent. However, he had a poetic soul. He had blue eyes, a loving smile; and he wore a soft short beard.

On Modigliani:

> Afterward, each day I went on foot to his atelier.
> A storeroom vast and somnolent.
> That was the epoch pathetic for him.
> Oh see the sculptures; a spectre, a phantom, I will not touch them.
> His melancholy eyes in strange reverie regard the caryatids of so simple a form—the long heads—the women with upheld arms.
> He paints
> On the white canvas pour the floods of glory.
> Ah in their laughing heat, the nude girls.

213

MODIGLIANI

A miracle of measure.
The explosion of his palette is full of fire,
The fire jets from the heart,
He follows his inner vision borne in a high state of love. . . .

Oh! life was atrocious for him
Silence of stone
Are you blind, men?

<div align="right">Zborowski</div>

Possibly he did not think that good enough. He copied out by hand an ancient Greek classical poem in translation and placed it on his wall. When visitors saw it and praised him he said nothing, and smiled, complacent. Once become a seller of paintings, it was hard to bring him to terms and detail. He would recite a bit of verse: "Ah, isn't that wonderful?" "Yes, but how much is the painting?" Those who found the cue to what were really his own poems had but to praise them, and then they could have anything of him they wanted. He gave away paintings, gently. But when Modigliani died he said: "Now I will not sell a Modigliani under five thousand." And when two days later Jeanne committed suicide he said: "Now I will not sell a Modigliani under ten thousand. Now they will buy."

Two months after he came to Paris, the war came. His fellowship stopped. In fact, an Austrian, he was an enemy alien. Kisling had for his first merchant, from 1912, the moist-palmed Basler, Jew, Pole, overeager, but he broke with him, and after his war experience in part employed Zborowski—thus it was Zborowski came to know Modigliani. To make a living, his grant cut off, he bought books on the quay and carried them around and sold them. He took paintings on consignment and sold them if he could. He sold Japanese pornography. Eventually, he would look up names in the telephone directory and spend all day walking up and down flights of stairs. One day he went into the apartment of a hairdresser and in the sitting room behind a vase of flowers spied a small Cézanne. "This man has taste," he thought—and sold him three of his stock of Modiglianis at one hundred and fifty francs each. Libion, lame, silver-haired, who owned the Rotonde, would

take Modiglianis against drink; and Zborowski would faithfully buy them up. Libion advanced seventy-five francs in credit for Kisling's portrait of Cocteau. After Modigliani's death, when Mussolini came in, Zborowski went in search of the Fascist Secretary on the Quai d'Orléans on the Ile St. Louis—he did not know the man but accosted everyone, for he was certain of selling an Italian painting. Suddenly it was announced the Secretary was going to deliver a statement. Zborowski stood in the crowd and whenever looked at held up the painting. Later, an undersecretary came out and asked him what he wanted. Perhaps it is fortunate that he did not know the painter's name, the "Socialist" name Modigliani, for he re-emerged with a check. When he had money, Zborowski would go to the Rotonde and hand out hundred-franc notes to painters, for he could not bear to be anything but loved.

Hanka Zborowska (Sierspowska), an aristocrat whereas Zborowski was not, was probably cold and unable to give herself. To her, Modigliani was probably simply a means to money. She helped him, fed him, by her accounting discovered him, but it is likely this is so he would produce. Zborowski decided he wanted to marry her; she had another suitor too. Learning this man meant to propose to her the next day, Zborowski went to her at daybreak and banged on her door till she answered. "You have to get there first," he told Zawadowski, perhaps his closest friend, for they were both Poles—neither a Jew. But he did not marry her. Paulette Jourdain, his mistress later, showed me his identity card. He is registered as Man of Letters, unmarried.

Kisling could paint before others, talking as he did. This was not Modigliani's way, who had a great sense of privacy, as did all the Garsin. Besides, *te faruru*. Perhaps he feared the cunt because he wanted to be entirely isolated. But he did not want to be isolated.

Kisling, painting, like an oriental dancer, squat and muscular, with gold brassarts and gold on loins, established a rhythm; he actually pistoned up and down, before he began. He was creating a personal rhythm. Modigliani, consciously or unconsciously, was seeking a more hieratic level. In Modigliani, the *intarsiatura* went deeper—faces more individual. Kisling achieved his best by obliter-

ating accentuation. Kisling wanted to take an ambassadress and make her an evident lesbian—Lesbos itself, without comment or caption, without inflecting the "fashionable" aspect of the picture—or a batting-eyed virginal girl and, nothing said, you knew she was a courtesan. But Modigliani wanted to make states of being, which, highly individualized, cut through whatever category to essential humanity or femaleness, where all men are alike, athlete and philosopher, and all women, as said, the submitting opening unto. Perhaps he was kept so much on the qui vive by cocaine. Kisling was truculent; gay too.

Hanka was outraged at the way Modigliani would splatter water all around, when Zborowski would let him have a tub, sweating from his work, after they had moved from the Hôtel Sunny to Joseph-Bara. He would pose out on the balcony naked, drying himself in the sun, saying he did it to outrage Mother Salomon, the concierge. But perhaps he did it for Lunia Czechowska?

Malraux says Modigliani drew his inspiration from Neroccio. Perhaps Malraux did this because Neroccio is obscure, and if one is guide to the Museum in the Head (*Musée Imaginaire*) one is proud of knowing the remotest corners. In fact, you did not have to look so far. Neroccio, but also Parmigianino, Cellini, Sassetta, Angelico, Botticelli, Sodoma, Simone Martini, Donatello, Desiderio da Settignano, Leonardo, Camaino, Pisanello, Michelangelo (necks), Lippi—in fact a whole age and its sequel, a way of looking at life, and the continuation of aspects of it in some artists, after life was no longer looked at that way. If one had to choose one certain artist—then perhaps Sassetta: his three girls (*The Mystic Betrothal of St. Francis*)—they are in flight in the angelic world. Siena. Fifteenth century. At any rate, Siena. What washed over to Florence was pure Sienese, elegant grace in art, and already before Masaccio the strong town had begun to squint into things in a different manner, with firm brow. It would not be too much to say that the spirit of investigation showed so long ago, when the dark and bravura qualities of the Italian heart passed under the dominance of reason. But Modigliani holds with such men as Sigismondo Malatesta, elegant tyrant who used the elephant prick for his

blazon, or the dark, gleamy, elegant, and essentially dangerous Caesar Borgia. In fact, Modigliani stood at the waning-point of the human spirit, confronting the onslaught of twentieth-century materialism. His tormented strength, bent in the winds of the war in his spirit, as can be seen in the images he painted which always seem to recede away, was both muscled and maimed by the exact time-point in which he found himself, being the Italian, romantic idealist he was. His images, strengthened by being tried in the cold forge of the explicit mind, the brain-cloud then beginning to pass across the heat of the sun of what it is to be human, had their inexplicit talismanic charm. There is a certain dangerous hardness in the Renaissance Italian, and Modigliani had this thrust before the eyes of his spirit by a mechanical civilization, inadequate to the heart.

Art Nègre was widely dispersed throughout Europe, but Vlaminck *saw* it. Pre-Columbian art moved Dürer profoundly in 1520 —but whom else? Our *uncertainty* has revived interest in the primitives, with their art confronting an awesome uncertainty. If anything is certain now it is that certainty is of uncertain value. There had been a vault back, not to the modifications of the past but, our anxieties matching theirs, to the past itself. Modigliani jumped one way, and everybody else the other. Direct statement had to be achieved, not approximation, direct statement be it Cubist or primitive—because we had to know too badly. Great centuries, which are always centuries of desperation at gunpoint—ours is—are not content with pleasant rendering, and are impatient with finesse. Yet finesse was a part of Modigliani, as inseparable from him as his anarchy.

A nude had to be this nude and all nudes; her smallest peculiar characteristic physiognomonical expression and her great universal body too, tranquil, and mounting toward you with a great rose rush, and had also to be Modigliani rising helplessly within to the yellow incandescence of her female sexual flesh, and her submission.

Vlaminck was first a professional bicycle rider, then a musician, violinist in popular bands, then an author on anarchy and of

MODIGLIANI

pornography—*From One Bed to the Next* (1902)—and then a
painter. He got to be a painter because he met André Derain. They
were both large men, Vlaminck with a Flemish flush to his face as
if it were cuts of raw beef.

Vlaminck hated towns, and would only come in to visit Derain,
who lived on Rue Tourlaque, Montmartre (in the same building
where Suzanne Valadon and Toulouse-Lautrec carried out their
fantasy of love), but Vlaminck had need for gross love, binfuls,
country-style, with the tumble country women. He had little ap-
preciation for the grisettes of Montmartre, flickering out in those
days, nor the head he took back with him after vinous all-night dis-
cussions with André Derain, nor the smell of furnished rooms, nor
the toilets. He would pedal off on his bicycle to "get Paris out of
him"; and then have a huge beefsteak somewhere washed down
with red in some bistro on the bank of the Seine, to fill up the
cavern in him. He was tremendously outright; said you could never
meet a Cubist and know what he was about, whether he was send-
ing you up or not, what he had up his sleeve. What impressed him
most with Modigliani were his beautiful sensitive hands, delicate-
boned, with small fingers—not surprisingly, considering the
chapped slabs he carried about at the end of his sleeves. He said:
"Modigliani above all hated the power of money but had to cede
to its preeminence."

Vlaminck struck out for individuality, and that was right; but
of course to be *autodidacte* in painting it would be better to know
how to paint. He imbibed everything from Van Gogh. Van Gogh
had lost his mind, but he still had his color sense. Vlaminck thought
you might as well throw red right against yellow—squeezed straight
from the tube. Wasn't the idea to explode a stick of dynamite in
people's heads? He would hear nothing except Van Gogh, and it
is said he never entered the Louvre.

He and Derain were simply thrown together by propinquity.
As for the Louvre, Derain never came out of it. The interesting
thing is that these two equally proved failures after youth's lark-
sprung enthusiasm, and the art enthusiasm that spanned Modi-
gliani's life in Paris, played out. Experimentation proved a failure;
and classicism too. The two died as twins, their backs to the world.

Many, Zavado included, who had known him well, wondered aloud to me at the *strange* collapse of Derain's painting.

Modigliani was gay enough. Cocteau described his bear dance before the Balzac statue in Boulevard Raspail just around the corner from the Rotonde. He had a kind of wild, spent, flaring gaiety. Cocteau described him dancing madly in the night round and round Rodin's statue. And once when Kisling said that he must go home and grabbed his belt, the belt turned out to be a scarlet sash, and Modigliani, pirouetting, rolled himself off down the length of it, and ran away into the dark, laughing.

He shuttled back and forth between 3 Joseph-Bara and 8 rue de la Grande-Chaumière the tragic last months. His large friend, Ortiz, with the palm-leaf appendages, had, often, to lug him up the three flights, not five as Paulette Jourdain misremembered and told me, to his studio at Grande-Chaumière. Ortiz' own was just below. "The Gauguin studio—the amenities of four walls, one of them glass. A small pot stove, l'eau et les cabinets au fond du couloir à gauche. No gas or electricity," Ortiz' daughter Laure told me. Ortiz, like Modigliani, exhibitionistically stripped naked—perhaps in direct imitation. Modigliani wanted Ortiz' wife Hedwige to make soldiers for little girls, dolls for little boys. He wanted them to wake up on Christmas morning and rush to seize the little incongruities in their hands, and experience the sickening disappointment which is the nature of life.

He had switched over to Zborowski as his dealer. There are three distinct versions—all first-hand. Mme Foujita—Fernande Barrey—says she first proposed it, having already gotten Zborowski to take up Foujita. When eye witnesses disagree, one immediately seeks temperament, the bent of the witness, or venal interest, not appropriate here. But when the witnesses are in one case an eighty-six-year-old woman in a rest home (Mme Zborowska), sometimes lucid, sometimes not, or a woman once called *la grosse* for her immense, raucous vigor but now on the verge of real collapse (Fernande Barrey), one does not know quite where to cast faith. Misremembering may enter in, that which is the wandering of age,

that which is the assertion of self-importance in a situation of weakening sense of reality.

Behind the chess moves on the overt board is the aura of something. Modigliani must have moved from Paul Guillaume to Zborowski because he wanted to. Much is said against Zborowski (that he was really a venal merchant and *not*, as is said, "the one art dealer who cared about art"), and more is said against Guillaume. But Modigliani is now a denuded personality, transparent sack through which the muscles of talent could be seen to flinch, an interesting demonstration of the sensitivity of undefended nerves, and as portraitist he could not have lied. Perhaps as portraitist he never could. We see what he thought of Paul Guillaume, portrayed with such mockery; and Zborowski, painted with love. He continued to "have to do with" Guillaume to some extent (the exigencies of commerce), but from mid-1916—probably June—he is Zborowski's man. Guillaume died abruptly "on the operating table" in 1935, still a quite young man. Salmon says he shot himself. There is one piece of evidence not until now brought to bear. In 1933, crossing on the *Ile de France*, his wife met the famous and very virile exploiter of African lead and tungsten, Jean Walter, and so soon as Guillaume was dead she married him. But this is not conclusive evidence.

Hanka (Polish for Anna; on one of his portraits of her—*Zborowska with White Collar*—Modigliani inscribes Anna) says that Zborowski was on the Riviera in the summer of 1916 recovering from illness, and that Modigliani, drawn to her by her "Modigliani look," which she actually has (overlong neck—something mouse in the face even now), twice portrayed her; and that they then sent money to Zborowski who, characteristically, had overspent and could not come home; and he returned to Paris and then definitely took Modigliani up—selling, first, a Kisling to secure Modigliani his daily twenty francs or fifteen (disparity of statement from those who were there).

Lunia Czechowska:

We spoke Polish. One day Zbo said to Hanka and myself: "Dress especially well—I have someone in view." He was excited

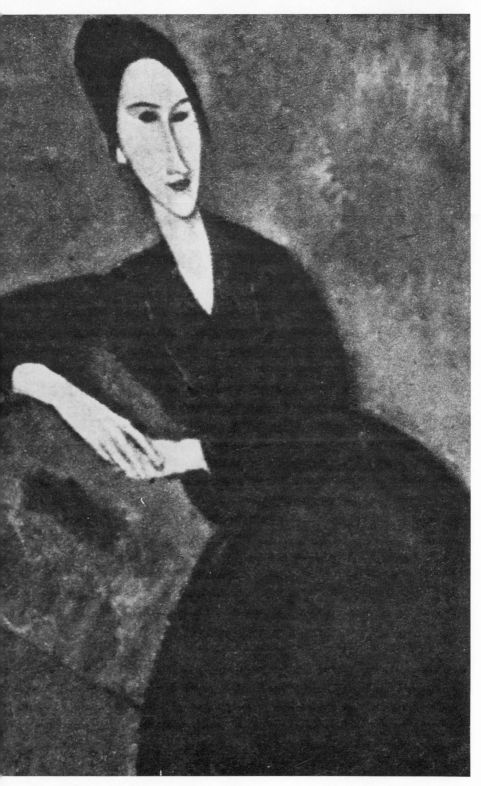

Hanka Zborowska by Modigliani, 1917
FATTORI MUSEUM, LIVORNO

because—"It is a painter twice as good as Picasso." We went to the exhibition, it was the Lyre and Palette, and Modigliani was present. He was very good-looking, somewhat noble, and he was performing. He said he hadn't time for Leopold, but seeing that we women were with him he returned and said perhaps we could all meet in an hour. And we went to the Rotonde. He wanted to paint me. I was always the mysterious woman to him—the Sphinx, Cleopatra, but there were things he did not know. He was willing to contract with Zborowski but was tied to Guillaume. Zborowski said Guillaume was a friend of his and they could work it out, and in fact Guillaume, much occupied with many painters more established, shrugged and let Modigliani go. Then began the "regular afternoons" when he came to paint. Hanka and Zbo were in the Hôtel Sunny then, a small hotel in Boulevard de Port-Royal, but in about a month they moved to 3 Joseph-Bara. There they had a *double* apartment, 3 Joseph-Bara. They had parties—orgies— but I was kept apart as I was Czechowski's wife.

When Zborowski had money—not obtained from Modiglianis— he distributed it among artists, it is said in order to frustrate his wife. But who can know to what measure a man does a thing to win the love of friends, and what measure vex his wife?

They lived high, when they could. "Zborowski always lived beyond his means, gambled, played the horses—dressed well, thought himself the new Vollard"—Lunia. Though he is not dressed especially well in his photos, and wears a worried expression. "He was utterly impractical, didn't even wear a watch"—Paulette Jourdain. He had the peculiar Slav defeatism and friendliness—a tired yet affectionate smile. "None was gay; only Kisling was gay. He [Zborowski] was impractical. He had a bad heart. He had a great number of attacks—a considerable number. And at last on twenty-fourth March, in 1932, he died. He was forty-two. He had too much confidence in human nature"—Paulette. Salmon has him dramatically drop dead, clutching his heart, after a great loss at poker. Lanthemann says he probably died of syphilis. "When he got Paulette pregnant he couldn't be quit of Hanka because she knew too much"—Lanthemann.

Generous himself, that he earn love, Zborowski disliked Modi-

gliani to give away drawings. He held out a hand in protest, but at one look from Modigliani he withdrew it—he was like a dog with Modigliani.

In the beginning of the war, new art came into vogue. Everyone wanted a placement for his money, for warmaking is profitable but futures insecure. Everyone had grasped the lesson of the Impressionists, for seemingly absurd art, bought cheap, resold dear. Also, Picasso's prices had kited, and one who had got in on him in 1910 sat golden eggs in 1914. But Modigliani did not come in much on the general inflation.

As he was not in the trend, he was probably not considered a good investment. His beautiful skill was admired—by some. Others thought his distortions grotesque. He was both too avant-garde, not being academic, and conventional, for his innovations were not in the trend. He received applause, which he hungered for like a starved man, and disdained; but not sales—or few at low prices— and the money, which he really despised, he very much wanted. Like Derain, he said: "I cannot understand why Picasso is so very much prized, and I—less." Very much less. "Life is worthless."

There were essentially none who now regarded art as esthetic experience. It had become clear to the dullest mind that vogue, resale value, governed the heart—and two perfect Bouguereaus were quite evidently not worth a Picasso scrawl, a Dufy ball-less wash, an erection (not the old esthetic kind) given you by Léger.

Then Modigliani began to sell. "Netter bought, and Libaude, and, because of this, Schenemayer, a banker, without even looking at the pictures," said Zborowska, "but then the Big Bertha commenced to fire on Paris and sales stopped. Vlaminck, Derain, Valadon were offered at such low prices that no one would buy" (for if their price were not high their resale value was doubtful).

When Zadkine came back from the war in 1917 he was horrified by the change in Modigliani. His face seemed emptied as though drained from below; his eyes had taken on a strange mortal beauty—that of the man, yes, always magnificently attractive. But his clothes of chestnut corduroy were stained and spotted now. And he had around his neck an ordinary red cloth. Others (but perhaps it was because they saw him every day) seemed not to

notice this. Yet Modigliani strangely fluctuated. *This* in one presence, that in another. He seemed to imbibe atmosphere as though he had some strange transparency. He was like a man in an hallucinated chemical dream. Perhaps, for this, he was so fatally successful with women: unknowingly just the man they wanted of him, wived to their cadence, to accord with the shape of their being, arrogant, or winning, decadent as a rotten apple in the photo he gave Thora, complement to sexual qualities they perhaps did not know they had, and perhaps never consciously in their long lives would find out they had.

There were those, he knew, who said he was burning the candle at both ends. He was burning it at the center. He was living a life of a thousand midnights. And what an economy! He went from sable to sable, no day. He had broken the cyst, and suddenly he shone forth.

OPENED BY THE MILITARY AUTHORITY

> Paris
>
> Monday 13 May 1918

Life in the quarter is calm; nobody talks of anything except the North. Amadeo [sic], excited like a virgin by the bombardments, has gone to Cagnes near Nice over a month ago now. He took the girl with the braids,* and her mother. At Cagnes they found Vallin, the ménage Zborowski, Henri Matisse, and the maître Renoir. (The latest exploit of Dom Robert is something— he takes his coffee every day with Renoir, and he has known how to set up the old boy by knocking the Cubists as one ought—to such an extent that Renoir asked him to pose—and gave him the picture. Thus our man is set for a few years!)

Mitrani, whom Wild called the other day "the little Levantine," has been very down: the cannon and the Gotha planes brought him back to life, disgorging fear, but now that all is quiet he's fallen back into a daze and reading *Figaro* is the only thing that stirs him up a little. Besides, always the same scruff on his scalp, and he worries at it.

The little Thiroux is running after Scandinavians—read rich Americans—anybody famous will do. Your friend Vlaminck has

* Jeanne Hébuterne.

Oil painting by Marevna Vorobëv. Left to right: Rivera, Marevna, her daughter Marika, Ehrenburg, Soutine, Modigliani, Jeanne Hébuterne, Max Jacob, Kisling, Zborowski

FROM *Life in Two Worlds* BY MAREVNA VOROBËV

Soutine, photographed by
Paulette Jourdain
COLLECTION PAULETTE JOURDAIN

Soutine, in black, and
Zborowski
COLLECTION PAULETTE JOURDA

Jules Pascin

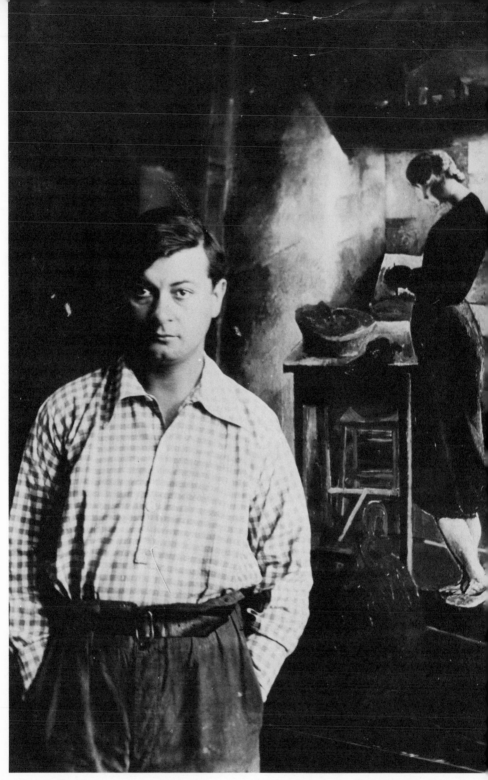

Kisling, in 1920, standing before his portrait of Paulette Jourdain
COLLECTION PAULETTE JOURDAIN

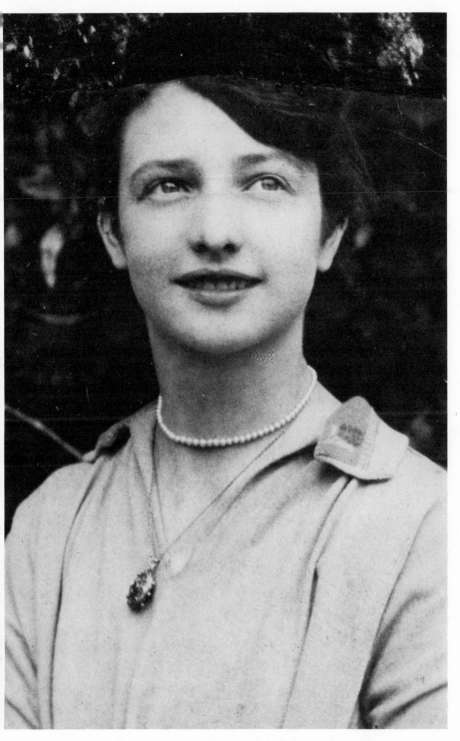

Paulette Jourdain in 1919, at the time Modigliani painted her

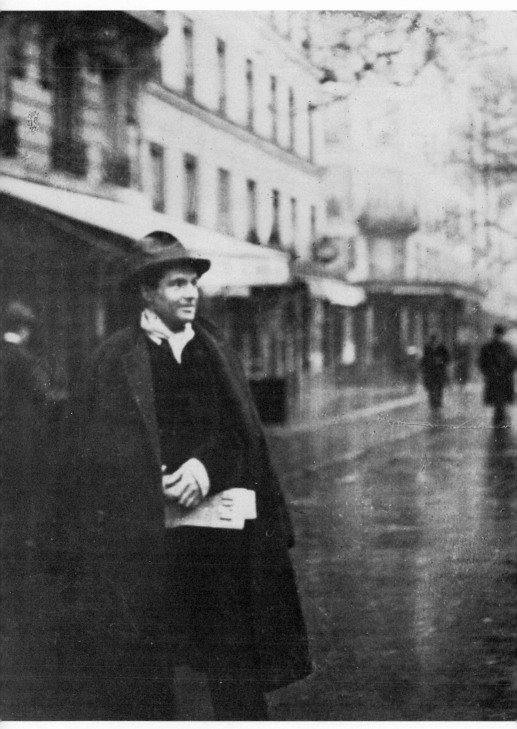

Modigliani in characteristic Bohemian dress, Paris
FATTORI MUSEUM, LIVORNO

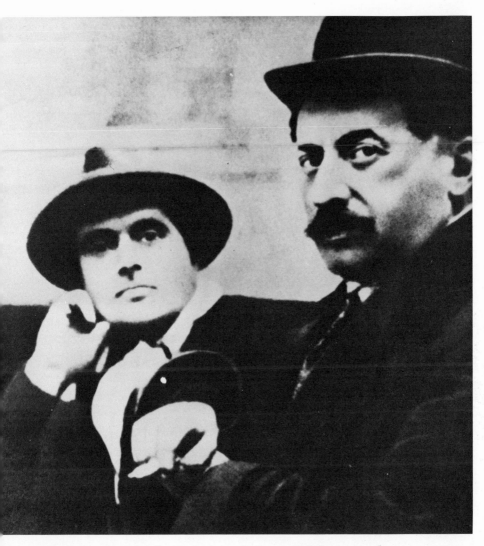

Modigliani and Adolphe Basler, art dealer and ghost writer for
Apollinaire
FATTORI MUSEUM, LIVORNO

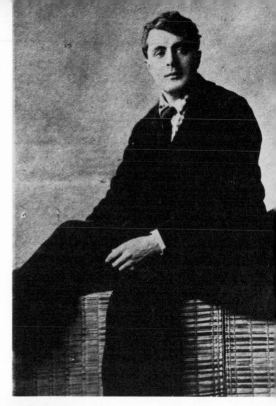

The photograph given by
Modigliani to Lunia
Czechowska
FATTORI MUSEUM, LIVORNO

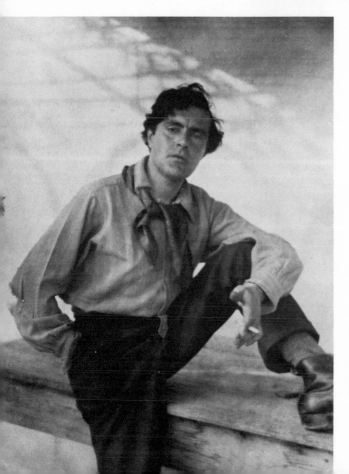

"Modigliani as I knew him"
—Thora Klinckowström
COLLECTION COUNTESS DARDEL
HAMILTON, FORMERLY THORA
KLINCKOWSTRÖM

Modigliani and Paul Guillaume on the Promenade des Anglais in Nice in 1918 or 1919

FATTORI MUSEUM, LIVORNO

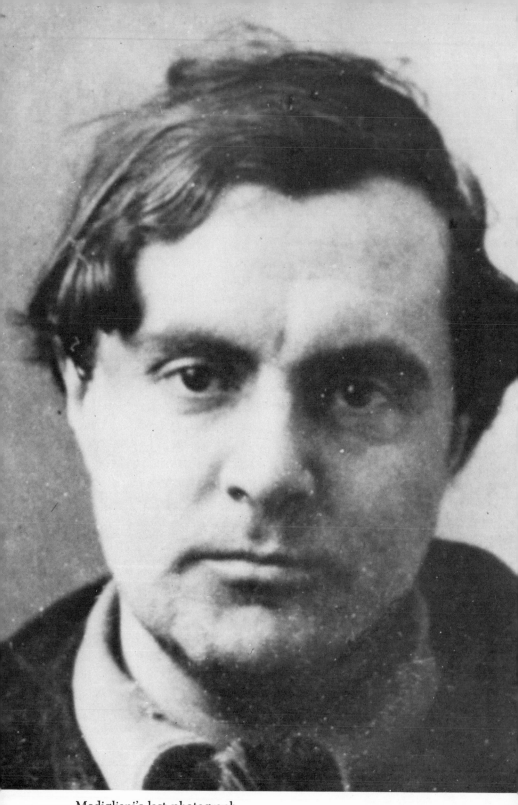

Modigliani's last photograph

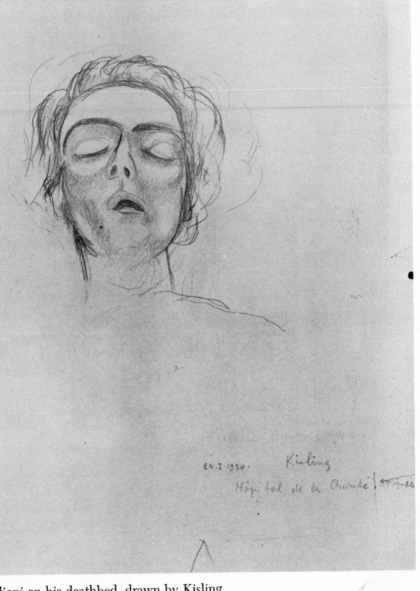

24.1.1920. Kisling
Hôpital de la Charité, 24-1-20

Modigliani on his deathbed, drawn by Kisling
COLLECTION JEAN KISLING

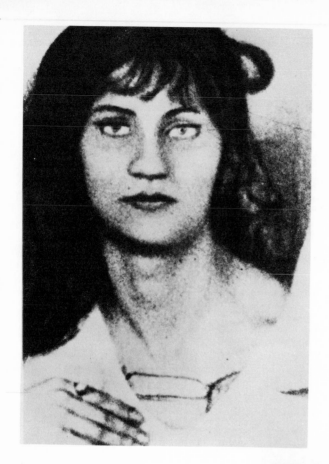

Jeanne Hébuterne in 1917, shortly after she met Modigliani. One of the three photos of her in existence.
FATTORI MUSEUM, LIVORNO

Jeanne Modigliani, daughter of Modigliani and Jeanne Hébuterne, in the arms of her aunt, Vera Modigliani (Menè's wife)
COLLECTION PAULETTE JOURDAIN

turned up a couple of times—no more helmet, and much, much more serious; the same basic good fellow, however. Basler, scared by the Gothas, has taken refuge in some secret place in the country, but not before delivering this piece of good sense: "The Kaiser, before ordering a bombardment, ought to take into account the fathers of family." Picasso is holed in, but when he comes out he sports a bonnet.

<div align="right">André Delhay</div>

Zborowski could not put up with Soutine. He was too much *Jew* for him. Soutine's landscapes of Cagnes (Louvre, Louvre) were as if painted from a crazed boat, staircases, houses madly askew. Modigliani painted two landscapes at Cagnes, the only landscapes known in his work. They are very Cézanne. It could have been unconscious. Simply Cézanne entering him, now that he was in Cézanne's country. Zborowski had wanted Krémègne, but as he wouldn't quit Paul Guillaume he had had to be satisfied with Soutine. He *loved* Modigliani, was devoted to Kisling; were they not Jews? He had nevertheless been brought up in the Pale and perhaps somewhere deep down, evidence is . . . It would be almost inevitable in someone from that climate. Kisling had been against racism all his life; to him the conception of "Jewish art" was unthinkable. Yet when in 1939 he was driven out of France, and almost lost his life, soon a tortured face emerged on his canvas, as if by itself. And he said finally: "Jews have a tendency to melancholy; it may be that, at the bottom of each of us, are pathological dispositions. That, in a temperament both gay and tormented, I am, Pole, nonetheless masochistic Jew." He too was of terrible Cracow—Ashkenazic. And not Livorno—Sephardic.

Foujita's nudes are an ice world; white skin was perhaps too real to him; he makes Youki and the others snowy; there is a certain cruelty; and the white skin is too present. It is the way we paint blacks. I think in every nude Modigliani ever painted in the grand style the pubic brush is ostentatious, except when she is canted in the other direction and you see the palpable moon of her *fesse* cleft down the middle in the fine descent to the hidden distinction of her queenly anus. With Foujita he loved to discuss

Japanese art; he had found again a kindred soul, someone of his level in Livorno.

What better expresses their exchange than great haiku?

> A cloud of blossoms
> An evening bell
> Ueno? Asakusa? *

> Oh this, oh this!
> Far beyond words it is
> Mountain of cherry bloom, Yoshino-yama.†

> On a journey ill,
> And over fields all withered, dreams
> Go wandering still. ‡

Pure Modigliani. The last perhaps more than his resonance merely.

But he grew tired of Foujita's chatter. His thin, high, piping voice irritated him. One day Foujita was painting in a woods toward Cagnes, and he turned around, and there was Modigliani standing looking at him. Modigliani simply turned and walked away.

Modigliani often talked of suicide, Jean Kisling's parents had said. He cared for Jeanne, particularly on account of the child, but "he was a god to her, she was no goddess to him." So Kisling and Renée-Jeanne, his wife, had related many times. He was warmly human when not unbearable, and there was something in him that made Kisling love him. Ortiz and Hedwige de Zárate never spoke of Modigliani. "That was not the tone of our family life. *Lachistar per li bamigni* [*sic*] ['Leave off on account of the children']—I used to hear: or something equivalent. *Pas devant les enfants.* Their private language was Italian, to ward off the curiosity of us children," Laure Ortiz de Zárate wrote to me. Evidently (for the Ortiz de Zárate were then still at 8 rue de la Grande-Chaumière) Modigliani was not considered a fit subject to speak of in front of children.

* Matsuo Basho.
† Yasuhara Teishitsu.
‡ Matsuo Basho.

Nice, 1918

When they arrived in Nice, Zborowski settled his troupe—Soutine, Foujita, Mme Foujita (Fernande Barrey), Modigliani, Jeanne Hébuterne, Mme Hébuterne—on Place Masséna, but Modigliani couldn't work there, the Riviera light bothered him, he grew irritated with the others, and soon he moved away, first to Rue Masséna, then 5 rue de France, today no longer a hotel, then 13 rue de France, today 15, next but one to Rue Massenet leading down at once to the Promenade des Anglais, a small, tall inner court down onto which wrought-iron balconies look.

The others, thus, saw little of him. They seem, almost at once, to have gone to lodge with Curel in Cagnes. Zborowski's idea of sale was to go to the great hotels and there bribe the doormen, and then stand patiently a-wait outside until tipped by a nod onto a quarry, sure that the millionaires of grand luxe would be interested in pictures for which he asked no more than a hundred or one hundred and fifty francs. He sold little, in fact nothing, and sometimes hadn't the money for the tram and had to walk back. Derains, meagerly, sustained him; and eventually he got a few Renoirs. Fernande, naked of course, had to endure Foujita's stare through his enormous round glasses—and, though she doesn't say it, doubtless scolded him in her jay voice. Zawadowski told me she was, in her great years, a tremendous saleswoman. "You don't mean to buy? Why you—" and she would launch into a tirade of abuse. An unusual method. Often the client would be so astonished he would buy the picture out of sheer chagrin.

Soutine was hungry; but not as hungry as he seemed—because he had a peculiar habit of gourmandizing with his eyes. They would become tumescent with watching, intently fixed on another's eating, swollen with looking at the food and avidly following it from plate to mouth, licking his thick, sensual lips on their inside: and as this continued after he was rich and could have anything he wanted it must have had its origin in a profound starvation. He had used, sometimes, to take home Kiki—he would not touch her; he was too terrified, or too respectful. He would give her a *tartine* with salted lard, probably all he had, and, dispossessing himself,

give her his bed and go to sleep in a corner with his nose to the
wall. Marevna confirmed Soutine's sexual proclivities. One night
she stayed the night with him. "He was a bad lover. He was shy.
What he craved was tenderness and affection. He talked of himself,
his sickness [he had acquired syphilis in Vilna and had it all his
life], his loneliness, his work and his bitterness toward life and
toward women." But with Fernande, thanks to Zborowski's failure
to sell his work, he had real hunger. Sometimes she (and Foujita)
would feed him. Once he said: "Which do you want?"—in return for
a meal. And offered her a bird or one of his paintings. And she,
young, chose the bird—and so soon as she had it it at once flew
away. And "Hee! Hee! Hee!" Soutine giggled, with his peculiar
high-pitched laugh. It must have been at this time that a decent
woman offered herself. He couldn't get a hard-on. Only with vile
whores could he get a hard-on. He told these things against him-
self, to make himself shameful.

Salmon reports Foujita telling that Curel, who was their land-
lord and whom they did not pay, confiscated everything except the
paintings—their battered, worthless trunks, old shoes, disregarding
Soutines and Foujitas, very shortly worth a fortune. And Foujita's
subsequent glee at this. A difficulty of School of Paris biography
is that these were all inventive men: Foujita was School of Paris;
so, on the writing side, was Salmon. To my own experience, Coc-
teau was so generous that he would improve truth for the pleasure
of the hearer, or, if he were a writer, his use.

Modigliani was now with Jeanne Hébuterne.

It is clear why he stayed with Beatrice Hastings—he was kept.
He rebelled, he trounced her for it—but he was kept.

There is reason to think his sexual practices attained actual
abuse. It is perhaps depravity, after all, which gives his nudes such
unforgettable sexuality. *Grand Nude on Divan*, by Kisling, surely
attains, in beauty, the level of the nudes of Modigliani—but there
was nothing depraved in Kisling. Therefore he had not the *per-
versity* of Modigliani which makes sex, for the woman, so magneti-
cally fascinating—in life, no doubt, as in art. Kisling certainly did
not abuse Renée-Jeanne, nor did he constantly expose her nude
(I believe there are no nudes of Renée-Jeanne), but Modigliani,
and probably not only for economy, painted his women repetitively

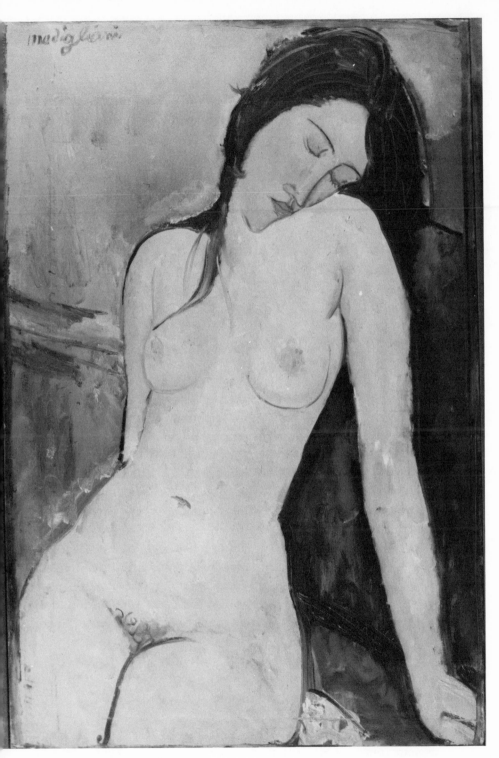

Seated Nude by Modigliani
COURTAULD INSTITUTE GALLERIES, LONDON

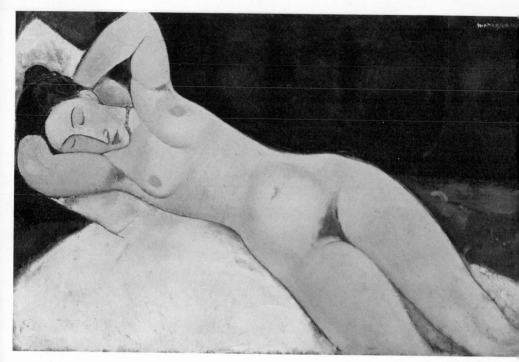

Reclining Nude with Necklace by Modigliani, 1917
SOLOMON R. GUGGENHEIM MUSEUM, NEW YORK

as nude models, were they the women only of a night—it is probable he wanted to defame them in a way, and this gives his nudes something unknown in modern art and links them, erotically, with the nudes of primitive India, Japan, when women were regarded as beloved chattel. It is actually easier to have *sexual* feelings for a woman when she is not an individual, certainly not an equal—in the latter case there is the Jacob-and-Angel wrestle which diverts some of the attention and consumes some of the disposable energy, and she is not pure defamable cunt. Ingres, in his harem nudes, came close thematically but he is far less intense and so he is nearer Kisling (there is one Ingres that is pure Kisling to the point of confusability—*Mlle Rivière*, Louvre) than to Modigliani. And Modigliani, leaving apart Beatrice Hastings where he is *"cavalier servant,"* had relations of duration only with the Hébuterne type of woman—Jeanne herself, and Simone Thiroux, with whom he seems to have spent a good deal of time in 1917 (Gérard, their son, was not the consequence "of a single night," however the first night came about). It is evident that the victim sort of woman is indicated for that *cleft sharp* sort of sex (his paintings) which is incandescent abuse—probably of the actual labia, et

242

cetera. In Modigliani, it freed the way for the mounting and penetration of, as though *split* open, the real raped: his despicably too self-sure self, which no humbling could break to the gregarious and common level where *people* are. Thus all his nudes, and portrayed too, are isolated: there is no sequence. And solitude is his drear music: *maladie de solitude* released him from the *heavy weight of well-being.* He is—esthetically less than some he actually knew closely, esthetic though he was—individual, and because so deeply human, for actually humanity never resides except in *one* case, so that the deeper *cut into* the one, the closer approached all: what it really is to be human. Why did he do Jeanne so badly?

Severed from the group, apparently even from Soutine now, he spent time with Boris Savinkov. Savinkov was a peculiar kind of anarchist assassin. Conservative creature that he was, he was run after by women—because he was an assassin. He had written *Pale Horse*, and was quite literary; and he preferred classical over modern art. All in all, they could talk. He was married, decent, half bald, an immense smoker with smoke-yellowed teeth (Modigliani had begun to smoke more and more, in order to induce a cough) and lashless eyelids. He talked out of a twisted mouth, around a cigarette, like Cendrars; but always wore a black derby— like the little man in Survage—and was very correct. He did not here, as in Paris, always have a huge billowy black umbrella hooked over one arm.

With them might be Archipenko. Bad enough in himself, he was the friend of Léger. But he was also the friend of Survage. Survage could be forgiven in that they knew one another in Russia. Survage was not really Russian—Finnish, his father, and Danish, his mother—but he had been born in Moscow and at the Beaux-Arts had known Archipenko. And the very first person he encountered in Paris, on the very first day, in front of Notre-Dame, was, by accident, Archipenko. Survage had come to Nice to see Germaine Meyer, his future wife, we are told by the best Modigliani biographer, who has penetrated the error stemming from the two portraits *Germaine Survage*—1918. In fact, though both were there, and both portrayed by Modigliani, they did not know each other,

and Germaine Survage has told me how Modigliani introduced them, after he was dead.

Thora

Nov. 29, 1919

Monsieur L'Artiste-Peintre Modigliani
Rue de la Grande Chaumière 8
Paris

Beautiful memories from Algiers. Here there is sun and it is hot. I don't miss Paris—what I lack is you. I hope you understand my French. A thousand compliments to your wife [sic].

Thora Klinckowström

She was actually Baroness Klinckowström. Did *baroness* gild the rose? She is today Countess Hamilton. One cannot know. There is an almost entirely unknown Modigliani drawing, of the right period, that carries what really appears to be Thora's head upon a nude body; and she herself sent me, in 1974, a photostat of the *London Daily Telegraph* account of a sale at Christie's of Impressionists in July, 1971 at which *Portrait of Thora Klinckowström* attained the world record (*sic!*) price of £110,250 (a Picasso achieved £18,900, a Chagall found no taker at £18,900, a Degas, who *was* an Impressionist in name, £31,500)—and the article contained the ambiguous: "By all accounts anyone who came into the orbit of Modigliani became more than a personal friend." She sent me it; but that is not conclusive.

For Lunia Czechowska, I had prepared two sentences: *Je sais que Modigliani vous a aimée, et depuis que je vous ai vue j'en ai été sûr./Je sais qu'il l'a trompée constamment. Je ne crois pas à la version officielle.**—but I did not utter them.

When, with Giovanna, the above-quoted postcard was unearthed from the mass of papers kept from the atelier after the death, she said: "Yet another!" She said this because her father had been very faithless to her mother Jeanne Hébuterne. "Chantal Quenneville told me," she told me, " 'I slept with your father and

* "I know that Modigliani loved you, and since seeing you I am sure of it. / I know he deceived her [Jeanne Hébuterne]. I don't believe the official version."

now when I think of your poor mother—' " No account has linked
Chantal Quenneville to Modigliani amorously, but simply listed
her as one of the two *croquemorts* who watched the night over
Jeanne Hébuterne's body at 8 Grande-Chaumière, to keep the rats
from eating it. To Lunia Czechowska Giovanna attributed the
strange remark: "Just think! If I had given in to him you would
be my daughter."

❧

7-5-1925

> *Mammicchia cara* [his mother]
> Send me the article *immediately*. I will reply once and for
> all (with dignity, be sure). And that the response be *irrefutable*
> get together the financial data. How much and when you sent him
> money. How much and when I sent him money. And send Zbo-
> rowski's address; I have written him several times without reply.
> *Pasciti!*
>
> Menè

13-6-1925

> [To his mother]
> Racist I am. Hebrew in the animal sense. I see great black-
> ness ahead . . .
>
> Menè

(Amedeo repulsed the idea of racism—though he knew a
Sephardi was superior, and if you had psychological insight it
was a sign that you were a Jew.)

10-1-1926

> *Mammicchia*
> Don't ask payment from the biographer [unknown] for re-
> production of photographs. They must pay *in Paris*. If they don't,
> I don't want to demand payment precisely from the one who
> would keep alive the memory of Him.
> We went to Via Quadronno. Excellent reception from one
> very separated from the world, but who wished us well.*
>
> Menè

* 11 Via Quadronno, Milan, home of Modigliani's brother Umberto; today of
Umberto's daughter Nora.

[To his mother, undated]

I wrote Umberto. I think I wrote well. Has he answered? Will he answer? Never did I so desire an answer! Ah, the shut-up souls! If they knew what they refuse, and refuse themselves—senselessly!

[Undated but in 1928 to Margherita—"Piticche"]

You are a hothead! If Zborowski says that in defending his own rights he defends also Nannoli's [Giovanna] he is simply speaking the truth, because in getting what's due him he collects Nannoli's percentage also. And why should we not recognize that if the work was His, the post mortem launching was Zborowski's? Why be surprised that he wants to live from his own work as promoter? Sentiment is fine, but reasonableness has its place. And Zborowski (unmarried I'm sure) has now a child [daughter by Paulette Jourdain, who was then twenty-three]. He too therefore has sentimental reasons for hanging onto money. Look in the mirror and ask yourself if the disdain for money objectively makes for greater happiness than attachment to it—if not too exaggerated!

But maybe it's better to do it your way! Your

Menè

[To Piticche in 1928]

And what he was, and what he has become [Flaminio, the father]. *He*, a Roman and a Jew of a noble line! Rancor? Veneration, dear one, dear one, dear one, my adored Piticche. Thus speaks Menè on his knees.

Menè

1945, *Rome*

Dear Aunt Lo [Laure]

I have here under my eye yours of 10-5 and of 30-6 and have decided to answer because I don't want you to think we—both of us—are more impossible than we in fact are.

Vera is working like a negress to get together her book—*In Exile*.

We're roosting, so far, in a hotel like a pair of migratory birds.

Direct word from Margherita, who is no longer accessible to the advice of her illustrious brother. Nannoli is twenty-six and has gone to live in Paris.

We're glad our old Aunt Lo is still on her legs, which are probably a lot firmer than ours.

Menè

12-5-1925

Dear Mother,

I suffer from persecution mania, but don't mock me!

In P's letter, nothing and nothing.

And we can do nothing and nothing, even about Coquiot's *
biography. I think I met him; and I think I told him *some things*.
Anyhow he knows Zborowski and I suppose he knows the truth.

Piticche omitted the truth. Little or much that we did, we did *everything*, not being those *rich Modiglianis* they write about.

And not to speak of the final rejection of Him, which makes me laugh!

I want this thing finished up.

I warmly embrace you.

Menè

Modigliani biography has argued, and still argues, the question of the abandonment of Modigliani by his family and his poverty in Paris. The question can be argued no longer. That they supported Dedo as their means permitted is irrefutable in view of Menè's letters. That their means progressively diminished to real poverty by the 1920s is evident. That Dedo wasted the means he received seems certain. The contention of some lesser writers that Menè did not admire his brother's painting is completely false.

From Thora Klinckowström:

Smedsbacksgatan, Stockholm
1974

I met Modigliani at the Café Rotonde in October 1919. He was a longtime habitué with his friends Abdul, Kisling, Ortiz, Foujita, Zadkine and many others. I had just met my future husband Nils de Dardel. By way of courting me, Modi drew me on notepaper of the café. He sweetly offered me the drawing, but I found myself very ugly.

Modigliani was badly kept up, dressed in black velvet and with a red silk scarf. I didn't think he looked young, but he was

* Gustave Coquiot, an early Modigliani biographer.

very handsome and romantic. Nils told me that before the war Modigliani had magnificent beauty, but that now he was reduced by debauchery and alcohol yet still very dangerous for women. He was excessively vivid, and always more or less drunk. He talked, sang, laughed.

We went in a group to Rosalie's, a big Italian woman who had a little restaurant in Rue Campagne-Première and was almost a mother to Modigliani. But toward the end of the meal he was thrown out by her and by his friends because he was terribly drunk and annoyed everyone. I took his part and found the others very bad, but he had disappeared.

At the Rotonde he had asked permission to paint my portrait and it was agreed that I would go to his atelier. He made a kind of visiting card of the back of a cigarette box, marking down the address and arranged hour.

I did not ever go to Modigliani's alone. A young Swedish girl, met at the Rotonde, Annie Bjarne, accompanied me. She knew, if possible, less French than I. It was therefore difficult to converse with Modigliani. In the atelier, which was very empty and plain, he introduced me to "his wife" who was visibly pregnant and who looked very young—a little meagre and somewhat disquieted by my presence. She was very pale with thick light-brown braids pinned in a crown about her head. She retired quickly after having said bonjour. Modi said that he already had a daughter by the little Jeanne, and that she was at a nursery in the country.

The floor was covered with a thick layer of crushed coal and burnt matches, cigarette butts, and so on. I asked his permission to sweep it up, but he at once became angry. He coughed constantly, and drank rum without stopping—saying it was for the cough.

Painting, he worked fast and with great intensity. I posed, I think, twice for the portrait. I know one of the days was November 8th. Immediately after me, he began a portrait of Annie Bjarne. I was there reading, all of the time. He finished Annie the 11th, I think.

It didn't occur to us that Modigliani was seriously ill. We thought he had a cold, and that perhaps the coal dust aggravated his cough.

At the end of November 1919, I went to Algeria and came back to Montparnasse in January 1920. From Abdul and Simone

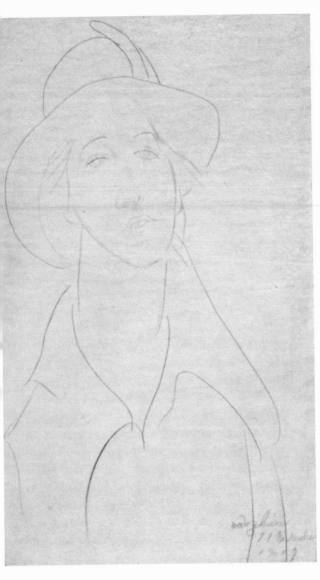

*Drawing of Thora Klin-
ckowström* by Modigliani,
1919

Thiroux, who had had a son by Modigliani, I learned that he was
very ill at the Charité Hospital, seriously tubercular. Two or
three days later I heard that he was dead, and was told also the
tragic end of Jeanne Hébuterne.

The twenty-seventh, I wrote a letter from the Rotonde to my
sister in Sweden saying that it was the day of the burial of Mo-
digliani. But I didn't go.

Subsequently, I often saw Simone, who was very decent,

honest and modest. She had been mad about Modigliani, and one night when he was drunk she took him home with her. It was known throughout Montparnasse. Modigliani never recognized the child. I believe Jeanne was pregnant at about the same time. Simone had placed her son with a nurse outside Paris. She talked to me a great deal about Modigliani; and wanted to change the child's name from Gérard to Amedeo. One day toward autumn 1920, coughing hard, she told me she had the same disease as Modigliani and that she was going to die. She begged me to take care of her son when she would be no longer there. I promised. A few weeks later, Simone had a terrible vomiting of blood and was taken to the Cochin Hospital where she then died. I went to see her on her last day. She again forced me to renew my promise to take care of the boy. What should I do, however, with a poor little boy little more than two? A Swedish friend more experienced than I, also a friend of Simone Thiroux, went to fetch the child so that its mother could see it a last time. It was a fair-haired little boy with brown eyes, resembling its mother, but her eyes were blue. To begin, I sent money to the nurse. My mother was horrified at the idea that I should return to Sweden with a child, that all the world would think mine. Simone was of a bourgeois family; although I heard nothing of her mother or father, her aunt asked me to come to see her. Then she explained that a couple wanted to adopt the child, but on the condition he would never be told his true origin. I was 21, my future was uncertain, and I lived in a hotel room. With a heavy heart, I was forced to let the boy go to them.

Long afterward, in 1960, or even 1962, I met Lunia Czechowska, who seemed to have a species of monopoly of Modigliani. She told me that Simone's son was absolutely not Modigliani's. I am absolutely persuaded to the contrary. Simone was a serious woman; I believe the affair with Modigliani was the great love of her life.

In 1922, I met Beatrice Hastings, who was having a love affair with the young Radiguet. She was a woman of a completely different kind from Simone, but she too told me that she had had a child by Modi, a little girl who died at birth or soon after.

Abdul—Djilani Abdul-Wahab—was the great friend of Modigliani, much closer than many who claimed the position later. He was exceedingly fine, cultivated, sensitive, and of rare delicacy.

I did not have the impression that Modigliani was exceedingly poor. One said that he had a contract with Zborowski, and hadn't the right to sell to others.

Thora Klinckowström (Countess Dardel Hamilton)

Jeanne

A word on Modigliani's method. He first sketched, rested a while, then painted. He sometimes laughed aloud, and sometimes declaimed Dante, Verlaine or Rimbaud (*sic*) throughout a whole session, according to Zborowska. He liked close-grained canvas, said Giovanna, and sometimes employed canvases already painted on, like Soutine. (Soutine would sometimes come in howling because of his stomach cramps. Paulette told me he had all his life the stomach trouble that eventually killed him but he would not go to a doctor owing to terror. The torment shows in his paintings, but that is why they are bought.) It is said the Modigliani woman never existed in life, but Jacob Epstein saw one with Modigliani himself at the Gaîté Montparnasse, and I, it being 1973 and my head full of Lunias, Hankas, Elviras, came to with a terrible start in the Paris métro—there right in front of me was an actual "Modigliani."

He gave pallor to his whites with varnish. His black is blue imposed on green. He never erred when drawing very rapidly, never erased—thus an arabesque was flung out like a coil of mariner's line into which we fit by a bodily movement, feeling it like sex. He drew in pencil; except between 1909 and 1919 he used blue crayon or charcoal. He was too modest, in art, to brunt on one. Malice, blocked tenderness, disenchantment speak as if they were the feelings of others. Painting, he became so engrossed that sometimes, attested Lunia, he talked to her in Italian, a language she did not know. He sometimes placed two chairs opposite each other—sat on one, and propped the canvas on the seat of the other. "Are you," Survage asked him, "an alcoholic?" "Shit. I drink when I want to work, and can stop when I want to." Alcohol secluded him. At the end—painting the children— he painted the sadness natural to the world of innocence. He was,

for most, a disreputable lush. Two plaques stand on the portal of 8 Grande-Chaumière, France commemorating the tenancy there of two immoral men, shunned in their time. Gauguin, Modigliani. The first exaggerator of Modigliani was Modigliani, there followed his family, and a whole world of inky men.

Jeanne Hébuterne was born on April 6, 1898, and when she met Modigliani in July, 1917, she was nineteen. She was a student in the Colarossi art academy in Rue de la Grande-Chaumière and, as it proved out, an excellent artist. Asked to authenticate a Modigliani, Germaine Labaye could not do this because she had seen Jeanne Hébuterne paint it. Her brother, André, was a painter, and approaching eighty has continued to show, a reclusive man, however, academic, who has never been in the stream. It is said he was two years younger than his sister—he was four years older —and Giovanna told me that his relations with her mother and his sister must have approached incest. His wife told me, in Rue de Seine, he was "painting in the country." He paints landscapes. She did not want to say they are separated and no longer live together. André Hébuterne is a straight-haired, even-featured man. Mme Hébuterne, his wife, believes she understands Modigliani clearly. "He was a man who drank and he killed himself with it." More complex, "overprecocious psychically," she said, she did not understand Jeanne Hébuterne so readily. "Why did she do it? Who can know why she did it? André was not there. Oh, it is made very complicated but I am Mme Hébuterne and of course I know. He was away at war. Ah, the war. That caused everything" (until it ended in 1918 fourteen months before Modigliani's death and Jeanne's suicide). Except by Germaine Labaye, André is disliked by everyone, few of whom can ever have met him. "I have long wondered why Uncle André has steadfastly refused to see me."—Giovanna.

Savinkov wanted to discuss politics, perhaps out of a sense of obligation to his profession, which was that of political assassin. No. When Modigliani discussed politics it was with Rappoport, but Modigliani was apolitical. He was remarkably fixed on his goal: which was to make beauty in a world that had outgrown

it. With Rappoport, he went so far as to oppose Brook Farm. He knew nothing about Brook Farm, but Rappoport was pro, Modigliani therefore con, and Eugenia had loved Emerson. Be it said to his credit that had Emerson written better than Nietzsche, he would have favored the idealist over the great, the very great, German, but this was not the case, and far from it. He saw Cendrars, who was working at the Gaumont picture studio— until Cendrars, noting that he was broke, offered him 1,000 francs. He had hated to beg; but it sometimes happens with humiliated persons that they humiliate their humiliation—and beg the more. But he had passed beyond that. He walked abruptly away.

The glory of imprecision moved Modigliani; but *precision* stimulated his rebuttal, and added a mystic aspect which has given greatness to his middle works. Sad attenuation; upon it impinged Cézanne. But he had passed beyond that, and was now painting his masterpieces. Except for three models (and a fourth), nothing but masterpieces. Look! self-destruction cannot cause art but it can suppress, finally erode, the censor.

Jeanne Hébuterne was a virgin, Germaine Labaye, her best friend at the Colarossi, said. I guess she was. She became mute as a crucified creature, a kind of nun of vicious practices, white, presented to the king each night for the abuse which silenced her speaking lips. For some reason, she now fell into a kind of null gazing, beholding obscenities of beauty as though they were right there in front of her, dreadful things she shrank from and could not wait through the day to get to, so that the day was a mucous sea and always much too long, as if she saw depravities of sex suspended in the air in front of her eyes. And her friends Germaine, Jacine, Chana Orloff felt that they could interpret this.

She had a peculiar leukemia of the spirit, for she was not unintelligent, rather the contrary. The two cords of her braids descended to her knees; that this is not so in the portraits is because with Modigliani she graduated from her virginity and cut her hair. Afterward—it was chestnut, a little more than shoulder length—she often wound it in braids set like a bird's nest upon her head.

Achille, her father, was a relapsed atheist. A consequence

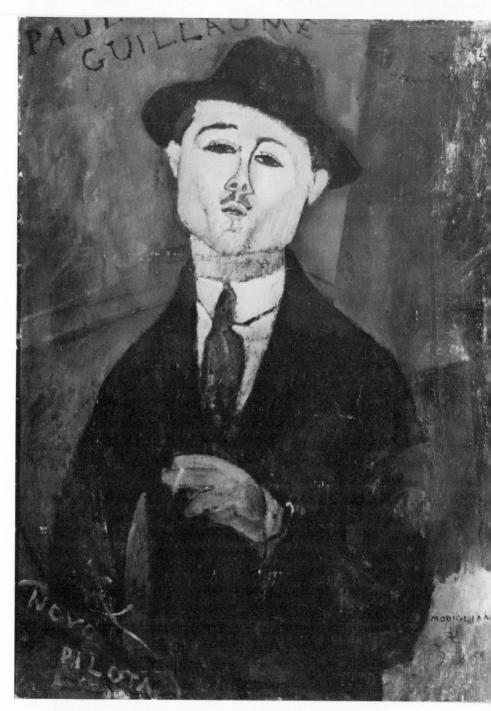

Portrait of Paul Guillaume by Modigliani, 1915
LOUVRE, JEU DE PAUME, PARIS

of this was that Jeanne had had to hear Pascal read aloud, while she was washing the dishes. And had acquired a dislike for him. She preferred Plato. It is not known what she and Modigliani said about this but if she wanted to provoke what they were considered to do, she had only to cite Plato. No Nietzschean could then do less than lower her drawers and tyrannize her pubis.

One of the most tragic pictures in art—a photograph of outrage—shows painter and dealer, on the Promenade des Anglais. It was probably taken impromptu by a street photographer. Paulette told me that, like Picasso, Modigliani always drew himself up when he knew he was going to be photographed, as is indeed apparent from the photos. The Promenade des Anglais photo is one of the most hurting in art. You see the dapper, brisk Guillaume, rolled-brim fedora, a sheaf of business papers under his arm, and you see the artist, coat loose over shoulders, shabby, his shirt-neck loose and his neck scrawny in it, wide-brimmed worn hat crushed onto his head, face anguished, bitumen pits of eyes.

What caused him to adhere to Lautréamont?

Maldoror passed with his bulldog. He saw a young girl asleep in the shade of a plane tree, and he mistook her at first for a rose. One cannot know which erected first in his spirit, whether the sight of the child or the resolution which immediately followed. He undressed swiftly, like a man who knows what he is going to do. Nude as a stone, he threw himself on the child and lifted her skirt to attempt her modesty—in the clarity of the sun! That didn't bother; forward! Never mind the lewd details. Blue, he dressed again hastily, threw a prudent look up and down the dusty road, where no one was to be seen, and then ordered his bulldog to strangle the bleeding child with his jaws. He indicated the place from whence pulsed the screams of the child and in through which she drew breath, and then stepped chastely away in order not to observe the entrance of the yellowed teeth into the rosy veins. The order seemed strange to the bulldog; and he believed himself commanded to do what had just been done, and he contented himself, wolf with monstrous muzzle, with commencing to violate in his turn the virginity of the deli-

255

cate girl. Her groin ripped up, the blood ran anew down the length of her legs and off upon the grass. Her moans joined with the yelps of the animal. She tried to give it the cross of gold that adorned her throat, that it spare her; she had not dared offer it up to the ferocious eyes of him who first thought to advantage himself of the defenseless weakness of her young age. But the dog did not forget what awaited him if he disobeyed: a knife shot out of a sleeve opening his guts without the slightest warning. Maldoror (how the name [my own] disgusts one to speak it!), hearing the extended agonizing, felt surprised that life should be so tenacious, and not yet extinguished. He returned, observed the bulldog confided to the low slope, which lifted its head from over the girl's body, as a drowning person does his from the rushing waves. He cut out one of its eyes. The dog, maddened, fled away, dragging with it, for a space too long however short, the body of the girl suspended, for they became disengaged only owing to the violent movements of flight; but he was afraid to attack his master, who would not see him again. The latter took from his pocket a jackknife of ten or a dozen blades destined for various uses. He opened the angular arms of the steel hydra, and, furnished thus with a sort of scalpel, and observing that the grass could still be noticed through such a flood of blood, he prepared, without paling, courageously to excavate the vagina of the unfortunate child. The aperture once enlarged, he extracted through it the internal organs, the bowels, the lungs, the liver, at last the heart itself, uprooted from their foundations and brought out into the light of day through the hated gap. He perceived that the young girl, now like a cleaned chicken, had sometime since died, and, discontinuing his efforts, let her sleep once again in the shade of the plane tree.

His mind had been steeped in the generous alum of Baudelaire, in the *truth* (Nietzsche); and in Villon. And he elected Lautréamont first.

In these days, he painted Elvira, twice seated, once nude to just under the breasts, once nude to the loins—terribly Elvira. She was an Italian girl brought up in France: eighteen. He gently gave her a preliminary drawing; the pictures he owed Zborowski.

But it did not conform to her idea of herself and she tore it up. And she says she cannot forgive herself for having torn it up.

Eudoxie, Jeanne's mother, accompanied the lovers to Nice. She was there on Friday, November 29, 1918, when Giovanna was born. Some told me the mother didn't go with them but only much later, but Delhay's letter (while not accurate on every point) refutes this. Some told me that she wanted to stand by her daughter in her pregnancy; but the departure from Paris was in March. At that time, if she even yet knew she was, Jeanne cannot have been a month pregnant. Survage says that Modigliani never spoke of Jeanne. Lunia Czechowska: "He responded eagerly to a little attention. It is not true he didn't talk. He talked of his mother, Livorno, Giovanna" (not, incidentally, Jeanne). In April, 1919, Modigliani wrote: "I am here near Nice." (*i.e.*, at Cagnes) A month later a police pass was issued him at Osterlind's villa in Cagnes. It is dated May 27, 1919, four days before he returned to Paris, without Jeanne. Osterlind died of cancer and not old age and was perfectly lucid in spirit till the end. He told Giovanna that Modigliani had stayed with him quite a while and that he was astonished to learn later he had a wife and child in Nice. He had never mentioned them.

10 December 1973
Paris

Survage and the baroness [Hélène d'Oettingen] were together at Nice in the years 1918–1919. Some of the time Serge Férat, and also Modigliani, but he did not live with them. I did not know Leopold [Survage] in Nice, though I was there too, with Pierre Bertin and my sister Marcelle Meyer (Mme Pierre Bertin). Leopold met the baroness through Archipenko. He received a Judas kiss from her when she had dropped in at Archipenko's Paris studio.

I passed through the room—at Nice—in a sky-blue blouse when Modigliani was there visiting Pierre Bertin. He wanted to paint me, and it was arranged. He had me play the piano—and suddenly after ten minutes he said: "That's fine. Let's begin." And with incredible rapidity and deftness he sketched me in a

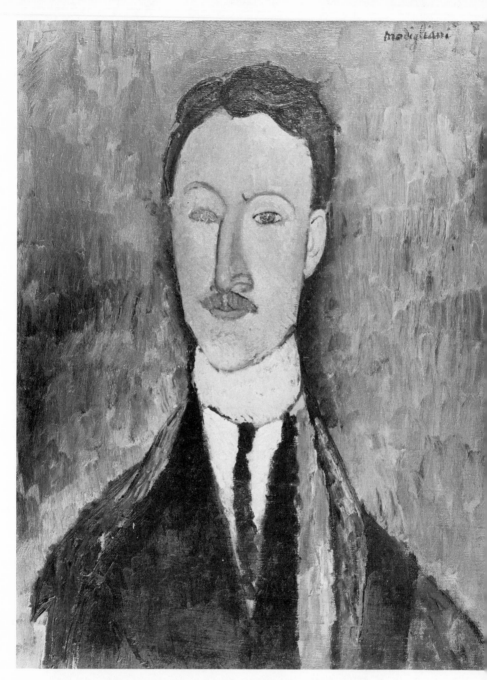

Portrait of the artist Léopold Survage by Modigliani, 1918
ART MUSEUM OF THE ATHENEUM, HELSINKI

matter of minutes. The entire picture took one session, or two. A second portrait was begun but interrupted because I caught influenza. He said he was incapable of resuming a picture, and it was abandoned, and he began anew. That was the portrait in the black dress [usually called *Germaine Survage With Earrings*]. I was a veritable aging virgin, twenty-nine, having thought to devote my life to music.

In 1921, Leopold, of course deeply involved in piano too, came by the house in connection with the piano of my sister, and chanced to speak of Modigliani. I recalled the portrait I had thrust away negligently in a drawer. "Why! Modigliani painted my portrait," I said. Saying Modigliani had been his greatest friend, he forgot all about the piano and entreated me to let him see the picture. And we were drawn together, and six months later we married.

Modigliani and Survage drank together enormously in Nice, though I never saw Modigliani drunk. And of course not Leopold, whom I had never met. Survage, however, was of the type of Stravinsky, with whom he was associated in the second year after Modigliani's death, and became a nondrinker, rather keenly ambitious.

<div align="right">Germaine Survage</div>

Baroness d'Oettingen and Survage had commenced spending part of each year on the Riviera in 1914. She wrote under the name of Roche Grey. She was cut somewhat to the style of Beatrice Hastings. Serge Jastrebzoff, her brother, called himself Férat owing to the unpronounceability of his name; they had taken over *Soirées de Paris* and shortly after his release from Santé Prison confided its editorship to Apollinaire—whose name they in part made. Marcelle, Germaine's sister, became a celebrated concert pianist associated with Cocteau and The Six, and Germaine herself gave piano lessons so that Survage would be freed to paint. She told me, on Rue des Plantes in Paris, that she sold her Modigliani for the same reason, feeling Survage's painting more important than Modigliani's. But she spoke of Modigliani quite lovingly. *Worth noting:* the warmth in the description given by women—Lunia, Germaine, Anna Akhmatova, Paulette Jourdain. We sat under the towering paintings of Survage, still on easels. Modigliani was five foot five

inches tall and had, she said, "your eyes" (my eyes are brown). He carried himself so magnificently, was so proud—always in his checkered shirt in small checks white and blue perfectly clean, his only shirt. Friends offered him clothes to replace his worn velvet, but he always refused. He did not seem ill—she had observed no sign. He spoke a faultless, literary French; had nothing Jewish about him. He and Lunia (her close friend), she declared, were never lovers. Sent on an errand to him in Rue de France, she found him amid family (whereas Giovanna has them separate owing to the dispute of Modigliani and Jeanne's mother). He ran after girls, she said, but not after Jeanne came into his life. He loved her too much for that. He loved Jeanne; she knelt to him in adoration, according to Germaine.

In the painting of Survage lurks a little man, wearing a bowler. Now he is small, now he is large, now there is half of him, or he is threefold. He is a silhouette. He may be a quarter edged out beyond a lintel, as though he were a detective. He may be diminutive down a long corridor as if diminished in a tunnel of dream. He is receding, or approaching, or immobile—forever. And yet, except for the size of him, he never changes at all. He inhabits constructed cities—Villefranche, Nice. And he alone. He populates them with emptiness by his presence, here and there, or huge. The wedding-bouquet cities, of walls, windows, vine leaves, fishes and curtains reintegrated what had been disintegrated from 1908, by the improbability of proximities. The man was a constructivist, and nevertheless had mathematics at the service of poetry, as, in Modigliani's view, a woman should be at the service of painting. To Survage, Nice: "The best gift you can give a woman is a kid. But stop there. They mustn't upset art, but serve it. Up to us to watch out." In Survage, five years Modigliani's elder, but immensely more mature, Modigliani found something like a father; the last gaiety of his life was spent with Survage in Nice, then whiffed out. To Survage, Nice, the end: "Thanks for being a good friend. Au revoir peut-être. This is a good place to recuperate. But now back to the hell of Paris, that stimulates my work." He couldn't any longer work except as a reaction to habitual toxics.

VITA NUOVA

Letters to Zborowski:

[New Year's Eve 1918–1919]

My dear friend
I embrace you as I would have if I had been able to the day you
left. [The Zborowskis shuttled back and forth between Paris and
Nice.]
Having a ball with Survage at the Cocq [*sic*] d'or.
Send the money quick.
Champagne by the bucketful.
We wish you, you and your dear wife, the best of the new year.
Resurrection of life!

Modigliani

My dear friend
Something serious has happened. I was rolled for 600 francs.
It seems to be a Nice specialty. Up to you if I'm annoyed.
Naturally I'm flat. Or almost. Idiot, that's understood. Only
it's neither to your interest or mine that I am hung up so here's
what I propose: telegraph 500 francs to the address of Sturzwage.*
And I'll reimburse you 100 a month out of the stipend. One way
or another, I'll meet the debt. Money aside, the question of the
documents † annoys me enormously.
It needed only this at the moment when I might have been
a little tranquil—finally. In spite of everything this isn't going to
hurt anything essential, I hope. Believe, my dear, in my loyalty
and friendship and with the best wishes I send your wife I extend
you the reach of my hand.

Modigliani

My dear Zbo
Voilà la question. To be or not to be. That is the question.
[In English in the original] Voir Hamlet. That the sinner and
cunt is myself is obvious, I recognize my fault (if fault there is)
and my debt (if debt there be) but now the question is this:
if I am not absolutely flat I am badly sunk. You sent 200 of
which 100 I had to pay back Survage who kept me from being
absolutely sunk and now . . .
Save me, and I will recognize the debt and push on.

* Real name of Survage.
† His papers had been stolen.

MODIGLIANI

If not, I will be strapped like Gulliver—and to whose interest is that?

There are four paintings. I saw Guillaume. I hope he will help with the documents. Everything would have gone well if it hadn't been for that cursed accident. Why not repair it immediately, in order not to stop something that's on the way?

But answer. It's urgent. Time is running away.

Modigliani

I will get back to work. As explanation (you can't explain anything in letters), there was a gap.

My dear friend

I was sincerely touched by your letter. It's for me to thank you.

As for promotion, I leave that to you . . . if it's indispensable. Your affairs are mine, and if I don't lean toward publicity, in principle first of all and because I don't think I'm yet ripe, I don't despise "vile money." But since we're in agreement . . .

Here are date and place of birth: Amedeo Modigliani born 12 July 1884, Livorno.

My identity card is at the commissariat in rue Camp. Première. The thing shouldn't be so difficult to arrange.

Another thing. You speak of coming back at the end of April. I think I won't depart till you come.

My daughter develops amazingly. I see there a consolation and a push that can only favor the aggrandizement of the future.

Thanks for the toys. A little premature.

It remains only to utter with you the great cry *Ça ira!* * for men and for the peoples, knowing that a man is a world worth worlds and that the most ardent ambitions are those that have the pride of Self-Concealment.

Modigliani

Let's give things time to grow and expand.

I loafed a little. Fecundating laziness. The only real work.

As for Survage: the pig.

Are you coming in April? The documents are now arranged through my brother the great Deputy. I can therefore leave when I wish.

* Battle cry of the French Revolution.

Write if you have time and greet Mme Zborowsky for me.

I grasp your hand.

Modigliani

Child is well.

Questioned later as to why Modigliani should have called him a pig or swine, Survage said it was because they both courted the same girl and he got her. When I asked Giovanna who the girl was, she said it was Lunia Czechowska. A curious thing occurred. When, of Lunia and a friend, I asked about Survage and Modigliani competing for a woman whom Survage got, I was told: "Oh, some girl here on the Riviera no doubt. It would be natural. A passing thing." And *just then* was volunteered: "There is a queer story about Modigliani writing 'petit cochon' [little pig] on a drawing of Mondzain. It was said Mondzain had seduced Lunia and that was why. Nothing to it of course. Painters always address their friends, those they respect, in this derogatory way." There is of course no such thing written on the Mondzain portrait, which he showed me. Merely a dedication à Mandzain.

Lunia

Deceived by the rending of Poland, the Polish intellectuals became revolutionary. Paderewski, eventually premier in 1919, gave piano concerts throughout the world to gain funds for the revolution that would restore the existence of Poland. A friend of Pilsudski, subsequently president of Poland 1918–1920, the intellectual Makowski, consented to become a clandestine dynamiter for the revolutionary cause. He dynamited in Russian and Austrian Poland, and having professorial mentality and Polish gallantry became a feared unknown man, fox of the underground swell toward the liberation of Poland. In 1902, he was caught, identified, and condemned to death. Only his eight-year-old daughter was allowed to visit him in prison, but the child brought him bonbons in one of which was a message from the revolutionary command. Believing him executed, Makowska, for she was the daughter of Makowski, returned to the prison and circled and circled its

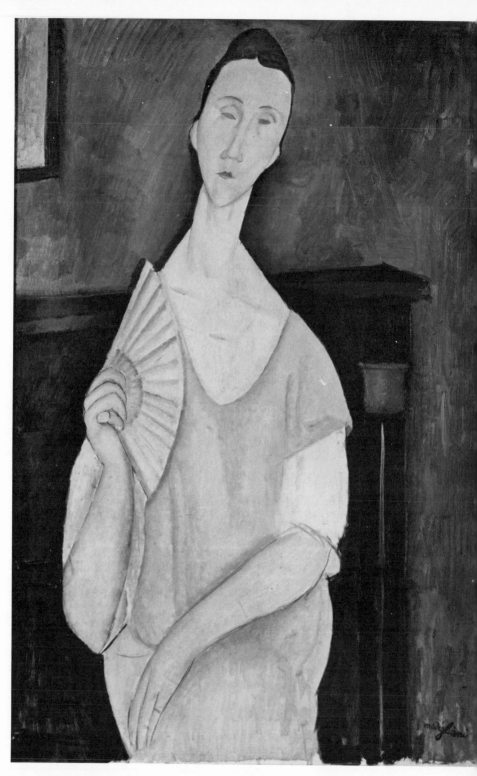

Lunia Czechowska with a Fan by Modigliani, 1919
MUSÉE NATIONAL D'ART MODERNE, PARIS

walls in sorrow. Suddenly he jumped down from a wall saying—
"Don't talk to me. Tell your mother I am alive."—and ran off. An
edict was issued that he could be shot at sight, without trial, with-
out questions. By 1911, having in his lifetime as dynamiter run the
Cossack gauntlet, had limbs broken, and been shot several times,
he considered himself prematurely old and destroyed, and feeling
that there was no future for his daughter in what might have been
Poland he sent her out of Poland in her seventeenth year.

When Pilsudski became marshal of Poland, himself not a mili-
tary man but in order to build a Polish army, he offered a post to
his old friend, who had been hidden behind the guise of a small
worker in art frames, a cabinetmaker. But he considered himself
too broken. It was all over with him. So Pilsudski had him kept in
comfort, and in a year he died.

In Paris, his daughter married the youthful Polish poet and
revolutionary Casimir Czechowski, a true poet though never pub-
lished, and working as a pastrycook at Rumpelmayer's. She must
often in those day have directed upon him the light of love from
her peculiarly pale blue eyes, turning toward him her Sienese head.

When the Russian Revolution broke out, he immediately left
to join the Red Army. He had a Russian passport, being from Rus-
sian Poland. In 1918, while he was in a hospital wounded, his
cohorts found out he was a Polish revolutionary, and they removed
him from bed, stood him against a wall, and shot him.

When he left Paris, he confided his wife to his best friend
and fellow Polish poet Zborowski. Zborowski felt that she was not
to be touched.

Giovanna believes that if Lunia did not give herself to Modi-
gliani it was because of the *petit cochon* affair: she had already
given herself to his best friend. The distance from Nice to Paris
was no obstruction, for Survage could easily have gone to Paris
and returned.

Eudoxie Hébuterne was caustic and critical. The Hébuternes
did not like "the Jew," but had to put up with him as their daugh-
ter was passionate. Modigliani apparently lived with Jeanne and
her mother in the Hôtel Torelli, now disappeared, at 5 rue de

France in Nice, and then moved away from the ménage à trois to what was then 13 rue de France and is now 15. The rhapsodists of Modigliani say that this was a whorehouse and have the girls gaily posing for the impoverished glorious man gratis, or perhaps not, but payment at any rate not in cash—until their pimps turned up. This is unlikely. But though she probably did not have to put up with that, it is difficult to see how Eudoxie could have put up with Modigliani for any long time or he with her—each was intolerant in his different way. It is difficult to see how Modigliani and Jeanne could have put up with the mother's presence at all, for an apparent nine or ten months. An explanation presents itself, where Modigliani is concerned, in such a fact as that he never so much as spoke of Jeanne to Anders and Rachèle Osterlind when he lived with them two months, or perhaps three, at Cagnes. In short, that he did not care for her and kept wide of the mother and daughter. Jeanne and Modigliani *were* sometimes seen together in the streets of Nice, according to Germaine Survage, at the time Germaine Meyer. If she did live at 5 rue de France, nothing would have prevented Jeanne from going to 13, since pregnant girls, if they are in love, are very willing to try again.

In February, 1919, Modigliani was at 13 rue de France, in April he was with the Osterlinds in Cagnes. He went there therefore in March or April.

The place is up the winding, climbing Chemin des Collettes, then called the Route de la Gaude, ascending from the public washing place, Le Beal, amid the palms, eucalypti, mimosa and the great cedars of the coast. The insipid rains spring thick jasmine upon the air; it is not a place one should be sent for one's health. Yet there Rachèle Osterlind was, a condemned tubercular, as indeed shows in Modigliani's portrait of her: the portrait, with the *Frans Hellens,* a poet, most show the *evacuation* of Modigliani's inner spirit at this time. And health is one of the reasons biographically given for Modigliani's being sent there—by Zborowski. Indeed Zborowski, though in Paris, arranged it—for reasons to be shown.

Indeed there are the dialectical collettes, "little hills," three of them dropping down in fat billows like receding waves from the very edge of the place Modigliani actually lived (which is not

where it is said he lived) to the sea and Port Abri, from which it is eight miles along the shore to Nice. But the old inhabitants still call the Chemin des Collettes the ancienne Route de la Gaude because it went on, and still does, to the tiny village of Gaude; and it acquired the name Les Collettes because that was what Renoir called the house he built there in the Les Collettes district of Cagnes and which has become so famous, and which was and is the house immediately next above the house in which Modigliani lived.

From Renoir's wide porch is a clear view over the plumed trees to the château of Old Cagnes, as the inhabitants say. The Barbary pirates used to come to these shores in search of girls. This was the watch place. And that is why Cagnes is called Cagnes, from *cane,* watchdog of the coast. The tocsin rang and the girls who did not want to be taken, not all, fled into the château.

The Osterlinds were teetotalers and the wineshop where Modigliani hung out was, according to Foujita, in front of the château. But it is a very long and hard walk, about three-quarters of an hour, down into the declivity of the stream La Cagne and up again on the other side, from where Modigliani lived to Haut de Cagnes and the château. Usually he is sent higher up along the Chemin des Collettes (*sic*) to a café where—it is 1919—he found the Pernod absinthe sign "the most wonderful work of art in the world." As for the existence of the sign, absinthe was outlawed in 1915.

On the Chemin des Collettes, then at that time the Route de la Gaude, is the villa "La Riante." It is a modern house, with a very menacing dog; and it poses a riddle for which there seems to be no solution. Biography says Modigliani lived at "La Riante" on the Chemin des Collettes in Cagnes. But Monsieur Litzler, who lives in it, built the house ten years ago—and himself named it La Riante. Until then there was no La Riante in the area. Nor did he —mad supposition!—name La Riante after its citation in biography; I checked that.

The entire property below that of Renoir in 1919 was La Quieta; at the top of it, across the Route de la Gaude from the site of the then nonexistent La Riante, at the time an uninhabitable barn, was the oldest house of "Les Collettes," about a century older than Renoir's, which was built in 1907. It is still there. It is where Modigliani lived. It was surrounded by a garden of olive

and orange trees. Some of the garden is there still, bamboo in it. It is a square mustard-colored house of two stories, faded, regretful, peeling, with wooden shutters, the garden overgrown and with the rusty look characteristic of the coast.

Just inside the central door a narrow staircase, edged with an iron railing, bends once in an elbow back upon itself, and arrives on the upper floor. Until very recently, the upper floor was a single large room—it is the room described by Osterlind as immaculate with white-painted walls, up which Modigliani, whom the Osterlinds lodged there, cast his spittle to see how high he could, and then it would string down the wall in ugly, gluey sperm threads.

He had been sent there by Zborowski to get Renoirs cheap, whatever else is said—that he came out of young admiration for the old master, that Zborowski wanted to get him away from the temptations of Nice. He simply appeared in the garden one day "beautiful as a Renaissance prince, tired, dirty as a dockworker" (Osterlind). He painted Rachèle. A deathwatch picture. A prophecy out of the black room. It must have scared them.

Two hundred yards above, Renoir was in his seventy-eighth year. He had been crippled by rheumatism for a long time and his hands were pinched-up claws, the knuckles arthritic knobs, the hands bandaged in straps to keep the fingernails from growing into the palms. He would summon aid by a school bell, which he could take between both hands, as if they were stumps. He could not wipe his own nose. He was carried about outdoors in a sedan chair having collapsible carry arms, which, when folded down, became four legs; and indoors was propelled in a wheeled chair, not a wheelchair but an ungainly sitting chair with wheels on it. And when he wanted to paint a helper would insert or remove brushes into or from his claw, and the binding would hold them in place, and he would paint with a movement of his whole arm. He wore a cap indoors and out, had sunken, staring eyes, and a white beard. When gnats were at him, he wore a mosquito veil from the brim of his hat, as if he were a beekeeper.

Something about him must have revolted Modigliani.

"And you, too, paint, young man?"

Modigliani abruptly nodded his head. Osterlind has recorded the scene.

Hunched under a shawl, at end of day, having painted, Renoir received them in the end or seaward room, before the gilt-edged huge mirror, and the marble mantel, a medallion of the head of the "Renoir girl" set into it, and the quarter-paneled, then tapestried walls, plaincloth ostentation—the established painter, from whom immortality could not be taken, whatever else. He had been painting two nudes, his last, for he was a half year from the intervention of death, forty-eight days before Modigliani. And he wanted them to see them.

A salon is crossed, with elegant French doors, a few steps down, and then the humble atelier, kept as it always was.

Modigliani did not want to go back; Osterlind had to struggle with him.

There the monster sat, awaiting approval. Modigliani could not get it up his throat. He had forgotten his mission surely, for it included buttering Renoir.

Renoir broke the silence tiredly. "You must stroke buttocks with your brush, young man, caress them as you would with your hand."

Suddenly Modigliani muttered: "This stifles me," and got up and left.

The Zborowskis returned to the coast; Modigliani had his documents—and on May 31, 1919, alone, he went to Paris. The Zborowskis had left their place at 3 Joseph-Bara in the care of Lunia Czechowska and she was alone in it.

He fell into a mechanical mannerism at the last. He did. But only when painting Hanka, Lunia and Jeanne. And one other. He had some sort of transparency about him. He is imprinted. He produced illusions of the optic nerve, but illusions, not reports, in the long run matter, because they are human. I think the forming picture displaced a sensed void, and as it concretized it became the reality. Hanka can probably easily be explained. She probably disliked him, actually, and he was sensitive enough to reciprocate. So that he has painted her in a very mannerist way except *Zborowska with White Collar,* at Rome. A sense of exhaus-

tion invades the mannerist pictures; it would seem the slow collapse of his inward physical being is staying his hand, but it is not so, for some of his best paintings, the dear children of the Riviera for instance, *Elvira*, are painted at the same time. There are no self-portrait drawings by Modigliani; the best of them, *Self-Portrait 1918*, in which he looks very rakish, is by Jeanne Hébuterne, and it is comical that when Elmyr de Hory forged it, his most famous Modigliani forgery, he was forging Jeanne Hébuterne.

The one person he painted badly in addition to the three women is, alas, himself. The painted *Self-Portrait* is by Modigliani. It is everywhere said to be his last painting, or last but one, and he looks self-pitying and dreadful enough for this to be true, but it is certainly not true. The *Varvogli*, *Paulette*, and almost certainly *Thora* and *Annie Bjarne*, postdate it; Paulette remembers it as earlier than 1919. It is said he copied it from a Derain of him; but he did not: he simply painted it looking into a mirror.

He did not, at least in the depths of him, much like Jeanne Hébuterne either. He has made her attractive only in three portraits, obviously all of the same girl, and Lanthemann says the model is not Hébuterne. Jean Cocteau, in fact, told me Modigliani painted Mme Hébuterne, the mother, and when a young girl Hébuterne (challenged by Lanthemann) is placed alongside a mannerist Hébuterne you can almost believe it. A further point: Modigliani went far beyond and within exterior reality but he was quite faithful to exterior detail. His *Zborowski* in 1916—one of the tenderest portraits in art, painted with such love, the empty eyes full of sightless seeing as with the penetrating sightlessness of Elvira nude—is so like a photograph of Zborowski that you would think the picture painted from it, a thing he never did. In all Hébuternes except the three Lanthemann says are not Hébuterne, the eyes are green-blue, as Jeanne's were; in the three dark brown. If Lanthemann is right, there are no lovingly seen *Hébuternes*.

When I showed Germaine Labaye the portrait usually called *Haricot Rouge* and in the Lanthemann catalogue *Germaine Labaye*, she said it was positively not she—she had worn quite another dress when Modigliani painted her, and had never worn her hair in that style but all her life as she wears it now in a crown

of coiled braids on her head, just like Jeanne Hébuterne. I showed her the redhaired nude often called *Haricot Rouge.* "I never posed nude in my life!" she exclaimed. It was a pity, for the face that looks up at you, even today, is the face of that girl painted fifty-seven years ago.

There are no 1918 Lunia Czechowskas; all 1918 Lunia Czechowskas are misdated. She did not go to the Riviera. The 1917 Lunias are caricatural. She was the Sphinx for him, one is told. He did not understand her. He drew her, on one occasion signing *hommage à Madame Chakoska*—with his magnificent gift for spelling. Again he drew her distortedly, and down at the bottom wrote *male*—that is the usual interpretation. Could it be *malo*, which at least is Italian? The gender is wrong of course for the final letter is certainly not an *a* (and just as certainly not an *e*); but such things Modigliani scarcely ever got right. If *mala* it would mean "You've been a naughty girl" or "You're a devil and bedevil my life"—depending on the inflection. The 1919 Lunias are very different; the sky has cleared in some fashion. In one, *Lunia Czechowska with Beret,* she is recognizably the woman of today; but another, *Lunia Czechowska in Profile,* is the most beautiful portrait he ever made of a grown female clothed. All were made after his return to Paris at the beginning of June, 1919.

Her hair was done in the same manner, that of *Lunia Czechowska in Profile;* it was gray-marked but not white. "I speak what I call 'my French'—as I always have." It hasn't accent—she has been sixty-three years in France—but it has a curious originality of placement, almost quaint: the words make sense, but not in the way expected, and sometimes make more than sense—as when an intelligent, perceptive person uses a language he knows extremely well but which is not his and to which he has not been dulled by habituation—and sometimes make somewhat less. She spoke mostly about art dealers: "Compared to theirs, burglary is an honest profession. They have their cars, châteaux, but are of *no* value." This was a universal complaint: I met no one in the art world who thought other, including the most successful painters in the world. Germaine Survage: "*No* major picture is bought except *exclusively*

in terms of its resale value." "They forget," said Lunia, her pale blue eyes flashing, "that I am a Pole!" She was speaking of those who try to bribe her to authenticate fake Lunias. She was chic. I had not thought it possible to be stirred by a woman twenty years older than myself (she was seventy-nine). "If Modigliani did not love this woman," I thought, "he was an imbecile." She said: "I refuse to talk about him. Everyone has deformed the story, and *stolen* here, stolen there. I am usually thought dead or decrepit. A Modigliani 'expert' confronted with a refutation stemming recently from me said: 'That is utterly false. If she were alive she'd be a hundred fifteen.' And twenty-six years older than Modigliani! No, my lips are locked. I shall not again open my mouth about Modigliani." Then, a fortnight later when I had been to Capri and returned, she spoke of him.

Lunia says Modigliani did not know of Makowski, her father, or what Czechowski, her husband, was really doing—he probably would not have understood if he had; heroic patriotic devotion was not in his scheme of reality. He thought she was merely a soldier's wife who resisted him, her husband at the Front. That was of course all very well, but wives in fact did not do this. And he was Modigliani. He was baffled, named her Sphinx, and his fascination was whetted. She was a fascinating creature, and is. Desire appeased, too quickly slaked, leads to contempt, or indifference. Desire held off puts down roots, and if the woman is a Czechowska can become love. She told me, when I asked, that she did not tell him of her father and her husband's true role because it would not have been "discreet." Her father was a clandestine revolutionary, her husband was a Polish revolutionary fighting for the Bolshevik Revolution against the Czar, but a revolutionary foremost for the reintegration of Poland which meant taking a piece of it from Russia. She vaunts things that are probably not wholly true; if she did not resist Modigliani then she says she did because it is the imaginative thing to say about it: to have slept with the great man would merely have been a banal way-giving to the unfailing seducer, no originality in it—and yet she says nothing about the true drama, even now. No one who knew her knew the tale of Makowski, and it is in no book. Modigliani

could, with consternation even, have watched the beanstalk grow-
ing in his heart, up to the land of Giants where he had never been,
and the love not of children (not his own) or a friend, or a nude,
but a real inexplicable and resistant woman. Jeanne? She did not
intervene in his self-absorption.

Here were some of Mondzain's premises as he relates them.
He came into art when it was on the pivot, paintings appearing
which Apollinaire aptly said were of the head not the heart—pre-
figuring the lovingkindness of the computer. And Mondzain did
not like them. He felt, insanely enough, that the business of the
artist was to communicate. He considered that the artist should
make lovely images, the recipient taken into account, as others pro-
vided the artist good beer or bread—a matter of reciprocity. He
thought that the evil of this century—which shows itself in the
rejection of values, the annihilation of hierarchies, the disappear-
ance of discipline, the crumbling of social structures, the ruination
of theories and the collapse of schools, the rupture between the
artist and the public so great that each stands on the opposite side
of a crevasse and the work of art is alien to those supposed to con-
sume it—resulted from the break with the deep humanity of the
chain without end. And he said that Modigliani agreed with him;
except he did not have the recipient in view much. Mondzain ac-
tually saw him cough blood: it was about two months before the
end. He said Modigliani seemed rather proud of the stain on his
handkerchief. At least, it provoked a sort of mirth. A measure of
the consequence of Jeanne is that, telling this, which happened at
Rosalie's a few steps from his studio in Campagne-Première then
and now, Mondzain insisted Modigliani's companion was Beatrice
Hastings, in 1919 long since gone from Paris. He said he thought
Modigliani was afraid of alcohol—and so drank it. That arrested
my mind.

In 1919 Lunia learned Czechowski was not coming back, but
only in 1921 did she have definite news of his execution. Late in
1919, she went to Algeria with a musician. When she returned half
a year after Modigliani's death . . . "I asked Zborowski: 'That

Italian who painted me? And the pictures of mine of me? What
has happened to him, and them?' 'Oh,' he said, 'he went back to
Italy. He's in Rome.' Not to prevent my 'self-destruction at the
truth,' as you read in the biographies, but because he had sold my
paintings and didn't want to have to account for them." She di-
rected a perfume shop in Nice for a time. Eventually she married
Baron Chorosco, who assembled dispersed Polish art and sent it
back to the museums of Poland. When Paulette's illegitimate child
by Zborowski was born, Zborowska went off, and for a certain time
she and Lunia shared a small château in the countryside of France.
There has been a certain division into camps, with consequent
understandable divergencies of fact, watered over half a century,
when otherwise all would have gone cold, by the ever-increasing
rain upon the "Modigliani industry" of *filussi*, or *il malito*, or "t,"
into a despicably unstoppable gold deluge. There has, further, na-
turally been a considerable jostling for place in the life of him who,
like Byron, became famous overnight—but did not wake up to
know it. And that has to be taken into account, too.

"I remember that afternoon of high summer heavy with heat
and difficulties," Lunia told Ambrogio Ceroni * (but since Lunia
told me of Ceroni that he too "failed to reproduce" what she said,
I have to be careful about Ceroni).

Lunia and Modigliani worked in the empty Joseph-Bara apart-
ment and he painted his great pictures of her. After work they
would go to the Closerie des Lilas, eat in a bistro, stroll in the
Jardin du Luxembourg under "the warm summer rains of Paris."
He lived at hotels "here and there," she told me, in the Port-Royal
Quarter. Once they went to a fair and there they saw the bloated,
swollen La Goulue in a cage with Russian wolves and a mangy
lion. This was Louise Weber whom Toulouse-Lautrec made famous
at the Moulin Rouge, "the glutton"—La Goulue—of his posters, a
girl of the people, of the sidewalks, fresh, young, who replaced
dancing by a kind of wild bounding, biting the atmosphere, show-
ing her plump legs black-stockinged up to knee garter and above

* Ambrogio Ceroni, *Amedeo Modigliani: Followed by the Recollections of Lunia
Czechowska*, Edizioni del Milione, Milan, 1958.

bare, partnered with T-L's grave, stippled-gray Valentin-the-Bone-less (Valentin-le-Désossé) who in his tall stovepipe hat made himself look "seven feet tall." They were the wonders of a gay Montmartre.

"His real friends," Lunia told me, "were Utrillo, Survage, Soutine."

[24 June 1919]

LACK MONEY TRIP TELEGRAPH 170 FRANCS PLUS 30 FOR NURSE
LETTER FOLLOWS ARRIVE SATURDAY 8:00 PM RAPID ADVISE NURSE

Jeanne

Then, and not earlier (Giovanna puts it July, 1917, Lanthemann 1918 in the *Catalogue Raisonné*), the Grande-Chaumière studio was taken. "Ortiz wanted the Grande-Chaumière studio but Zborowski sent me there and I procured it for Modigliani. It was quite a livable place."—Lunia.

Giovanna admits the morbidity of her mother, for it is confirmed by her daughter, who has it too. "Lunia hated Jeanne," she said, "for having Modigliani. You will see that she is attractive; but does one see through her?" And vice versa: "Jeanne was insanely jealous" (Paulette Jourdain).

La Vita Nuova

It is now a winter's tale. He was drunk, unshaven, which is significant, dirty, which is more significant still. There was a dark presence within the gates, but he did not know that. The fragility, terror, anguish, morbidity of life penetrated the film he had made of his skin. How was he to feel when Vlaminck, Léger, Lipchitz, Archipenko were being hailed as artists? Was the ball of mud worth inhabiting?—considering the sheep-eyed, more and more, that crawled on it?

O mammicchia,
Thank you for your good letter. I had you sent a revue L'Eventail with an article about me. I will show with others in London. I

275

will send you the cuttings from the papers. Sandro Mondolfi is
in London and is going to come through Paris on his way back to
Italy. I had to bring my daughter from Nice and I have installed
her near here in the country. I am sorry I have no photo. I am
so sad not to have my daughter—she is in the country, in a nur-
sery. It seems that Uberto Mondolfi is going into politics—may
God and he himself help him. I hug you hard.

<div align="right">Dedo</div>

The show opened August 1, 1919, at the Mansard Gallery in
London. It was arranged by Zborowski through Osbert Sitwell.
Hung were Picasso, Matisse, Derain, Modigliani, Utrillo, Zadkine,
Archipenko, Survage, Valadon, Ortiz, Kisling, Soutine. It was then
that Arnold Bennett bought *Lunia Czechowska*. Modigliani's
young enthusiasm flushed up. "We are saved!" he said. There was
much love in him, but it was strangulated. He telegraphed Zborow-
ski back and asked him if in view of this success Zborowski could
buy him a pair of shoes, said Lunia. Survage was a fellow success
of the show. But in the same year he joined the Section d'Or, tak-
ing construction as the theme and subject of his paintings, not their
mere fettered technique. Now Survage was gone. But he still had
Ortiz.

Modigliani *had* plane geometry—*The Two Little Girls* where
perspective is caused by putting the smaller one superimposed on
the other in white, while the other is in black, so that distance is
created between them though they are of course on the same sur-
face—but he was not geometric. You have to get the result obtained
by mathematics without passing through mathematics, he deeply
felt. You had to trust yourself upon the slope. Had he fear? One
hoped one had the courage to overcome it. Loneliness.

As he felt death coming on, he went up upon Montmartre.
Does anyone know for whom he was looking? Modigliani? The
stripped acacias were on the Place du Tertre, as before. But the
Bouscarat had become the Hôtel de la Marine. Did he notice the
changes?—the pissed-on walls, gone; the cracked plaster ceilings,
part of one of which fell on him, gone; Bouscarat, gone. He did
not seek out Utrillo. He found Valadon and Utter eating at a table
at Guérin. He simply sat in silence beside Valadon, close-pressed

to her. Slowly he began to sing in a low voice the Kaddish, which he thought was exclusively the Jewish lament for the dead, Giovanna tells, and was all the ritual the irreligious Garsin knew. Then he put his head on Valadon's shoulder and began to weep.

The second child had been conceived in May, 1919. He must have gone to Nice. For Jeanne never went to Cagnes. It was insidious. You simply slipped on the slime walls, treacherously drawn in—and then nine months later you were saddled with intolerable responsibilities.

"I want to return to Livorno to regenerate my body," he said toward the end. "I want to see my mother."

Giovanna was, on her and her mother's return from Nice, placed in a nursery in the Département of Loiret, seventy miles south of Paris, a quite considerable distance. Jeanne went there once a week. Modigliani went just once, at the end of 1919.

The death mask, ultimately salvaged by Lipchitz from the shards, was badly obtained by Kisling and Moricand. They brought off pieces of the noble face, strips of the cheek, rags of skin; so that it is said Jeanne could not kiss adieu the splendid face, all wounded. The latter of the two who failed, Kisling and Moricand, himself died miserably, destitute, surrounded by suitcases of writings and horoscopes which went unpublished, that he had actually lugged through No-Man's-Land between the lines in the war (this is from Henry Miller)—in the Swiss retreat for the old in Avenue de St. Mandé in Paris, actually founded by his parents. From the window of his cell he had a full view of the plaque commemorating the founding by his mother and by his brother Ivan Moricand, the doctor.

Paulette:

"He suffered an *attack*. He was sweet, sunny, at least with a child. He was painting. He suggested he paint me again with a bouquet—would I like that? Then in two weeks he was gone. For two or three days perhaps Jeanne simply sat there. She was incapable of doing anything—always was incapable, disequilibrated, morbid—never *did* anything. Ortiz and Kisling went to look for him, and found him almost dead—Ortiz had come to Kisling and said:

'Hadn't we better look in on Modigliani?' He was taken to the hospital in an ambulance on the order of the doctor of the quarter. I tried to see him but wasn't let in as I was an unaccompanied minor; Lipchitz tried to see him but then he was dead. Jeanne was grief-stricken. She was put by friends into the Hôtel de Nice in Boulevard du Montparnasse because it was heated and clean but she was *alone*. Next morning Kisling said they'd better fetch her to Rue Joseph-Bara. She kept clinging to me saying: 'Don't leave me. Don't leave me.' A razor was found under her pillow at the Hôtel de Nice. Kisling thought it good she go with her parents—this seemed natural—and she did in the afternoon. But they were a poor lot, including Jeanne. It seems they put her to sleep in an attic room *alone*. She was found dead on the sidewalk by workers when they came to work in the dark of six o'clock the following January morning. It was impossible to keep the child in the atelier—it was too cold—but they went to visit her on the train. I don't think the child and the coming baby made any difference to Jeanne. ["She had no maternal instinct"—Giovanna.] Modigliani was proud of his daughter—à la Italian. I only saw him as good. But of course I was fourteen. The Hébuterne were limited, perhaps defective, perhaps Jeanne Hébuterne was defective. I am sure she had gone through some sort of crisis alone with Modigliani before they were found. She seemed somehow wrong. She must have had some crisis of depression. There may have been a suicide pact, but if Jeanne had not been confided to her family she would not have done it. She was somehow 'wrong'; and that provided the final shock. André, younger than Jeanne, was a dreadful person. Bad character. Jeanne Hébuterne was discouraged, somehow, from the first. Incompetent, incapable of doing anything. She had no effect on Modigliani. He was romantic, grandiose, Italian—but sweet and considerate. He'd keep relatively sober if he had the occasion to work, and afterward drink at the Rotonde, often into the next morning. Or he might be drunk for a spell of eight days."

It is everywhere written that Jeanne passed the night of Modigliani's death in a hotel in the Rue de Seine, a confusion provoked perhaps by the fact that later Zborowski had his gallery in the Rue de Seine.

VITA NUOVA

I have Abdul's drawing of the studio, third floor rear, at 8 Grande-Chaumière, and Zavado tells me that it had not been changed at all. 1923, the Abdul drawing is dated, three years after the death. It was, as said, a double studio, ant-body form. There is a pot coke stove, a blue coal box, a brown wooden chest, a brown board floor, a maroon door with a glass inset in the top of it, white walls with broad pink washes with irregular edges over them that were used for backgrounds, a large table for painting tools, an easel, little more. When Zavado and Nina Hamnett took over the studio after the deaths they found a hundred-franc note between the pages of one of the books, Jeanne's feeble attempt to hold out at least a little something. 8 Grande-Chaumière is wooden, and in a year or so a fire inspector came. And a rope ladder with pole steps had to be made and flung out the window, and the friends loved coming and scampering down madly like monkeys from the room where Modigliani had agonized, and hilariously rushing all the way around the building and back in through the court and up the stairs, in order to do it all over again.

On a night, probably in January, 1920, he was drunk, eyes wild, quarrelsome, abusive, wouldn't listen to anyone. He would not go home to 8 rue de la Grande-Chaumière where Jeanne awaited him. He staggered off alone in his blue blouse, dragging his coat after him. Some of the painters started off to go to Benito's, the stretcher, in the Rue de la Tombe-Issoire near Alésia, a good twenty-five or thirty minute walk away, and Modigliani appeared out of the night and joined them. He galled and blamed them; nothing could induce him to put on his jacket, though the night was glacial. He met it simply in the sleeves of his shirt. They begged him to go in; but he cursed Benito and said nothing could induce him to go into the man's house. His friends said they would go in without him and he abruptly turned away. When they came out in nearly three-quarters of an hour he was sitting across the street on a bench up against the iron fencing of the parish church, still in his shirtsleeves. He said to them blissfully that this was the most beautiful site on earth and that they should come and join him. As they were protesting, a woman stopped to look on. Suddenly she went over and sitting beside him put her arms around

279

the shivering man in his shirtsleeves. He pulled back from her, looked at her as if something about her terrified him—and then got up and went to rejoin his friends.

Modigliani spent the first night of 1920 drinking with Greek friends in a café in Rue Joseph-Bara. Mario Varvogli, a Greek musician, was the last person he painted. When Zavado entered the atelier to clean up, the painting was still on the easel, not yet dry. Modigliani drew Varvogli on January first, and on the drawing gaily wrote: "The New Year! Here begins a new life."

On the eighteenth of January Modigliani was stricken by a kidney ailment; it was painful, but not considered serious. He went to bed; shortly Zborowski himself became ill and could not visit him. Ortiz, who had been bringing coal each week, and generally looking in, had gone away on an eight-day trip. But a dark phantom was moving up through Modigliani's body. His head began to ache. "Headache roameth over the desert, blowing like the wind. This man it has struck. He is broken." This was the ancient Babylonian description of one of the first symptoms of what is now known as tubercular meningitis—a disease of stealth, for it does not speak before its work is nearly done.

He felt a stiffening of the neck as though his head were rigidly encased in a collar of pride, and he must have heard the roaring of the world in his ears. Laughter and sudden unmotivated weeping inevitably and abruptly alternated, but that may not have seemed strange in him to Jeanne. She simply sat there, and did nothing. She did not even summon a doctor. She opened a tin of sardines from time to time, or handed him the bottle. He grew very hot, then froze. Hanka was sent to him—and hurried back to her husband horrified: "He has spat blood. He coughs up blood." Then on the fourth day Kisling and Ortiz came in. Ortiz now carried him in his immense arms down the steps which he had so often carried him up, equally semiconscious. "I have only a fragment of brain left," he murmured to him in the ambulance.

He shortly became unconscious in the hospital, or was injected —accounts vary. This was the Hospital of Charity at the corner of

Rue des Saints Pères and Rue Jacob. It is not there now, replaced by the great School of Medicine. At 8:45 on Saturday evening, the twenty-fourth of January, he died. Jeanne had seen him just before, from a distance. She had gone with Hanka and Ortiz, but had not gone in. "I know he is dead," she said [he was not yet quite, but only unconscious], "but he will soon be alive again." From this remark has arisen the belief in a suicide pact.

"Jeanne went to her death voluntarily, not through despair," said her daughter. "She hesitated quite a while; it was not easy for her to take the step. There was a dagger under her pillow [it was a razor] *which she did not use.* She was in the ninth month. While she obviously had no maternal instinct, that is a period of physical well-being when one does not readily quit life."

Sunday, the twenty-fifth, Jeanne was taken to see the body. She simply looked on—it is true or is not that she was not allowed to embrace him because she was in her ninth month and the lacerations on his face caused by Kisling and Moricand were already beginning to infect—and then she backed off, as if she would hold him in her eyes forever.

To Giovanna, undated:

Jeanne Hébuterne was sent to her parents, Catholics offended by her union with the Jew. Two or three days passed before I met André Delhay and asked: And Jeanne? He threw me an evil look. She had that morning thrown herself from the window of the fifth floor of her parents' house. The broken body was gathered from the court by a worker who carried it up to the landing of the fifth floor, where the parents slammed the door in his face. The body was then taken by the same worker, on a cart, to Grande-Chaumière, where the concierge refused it entrance, saying—she was not a tenant. And the worker, unknown but who deserves a medal, went to the commissariat, where he was told to take the body—on order of the police—to Rue de la Grande-Chaumière. The body remained there, abandoned, all the morning.

Jeanne Léger with me, we went immediately to the atelier where the sight of that young girl, so gifted, so absolute in her

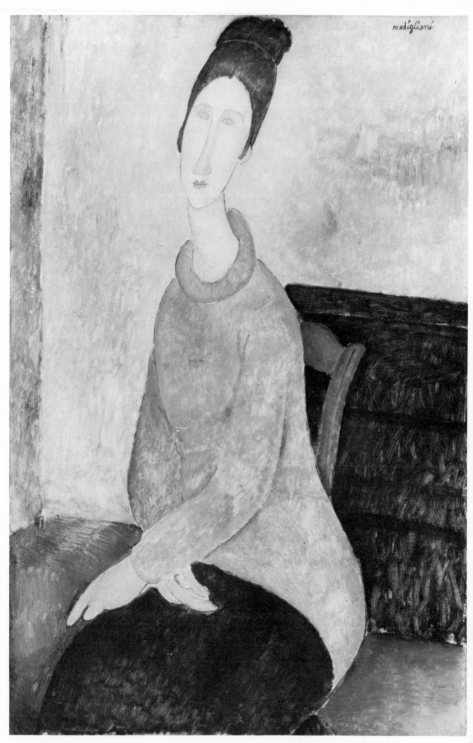

Yellow Sweater: Jeanne Hébuterne by Modigliani, 1919

love for Modigliani, grieved us infinitely. She was my dear friend.* Jeanne Léger went to look for a nurse to dress the corpse. I remained alone with the dreadful drama. Her pregnant belly made a mound under the sheet. A leg seemingly had been broken in the fall and jutted in the wrong sense.

I tidied a little, swept the studio, full of sardine cans and coal. In the other half, almost everywhere, there were empty bottles. On the easel was a beautiful portrait of a man, unfinished. I found drawings by Jeanne in which she depicts herself in her manner [Modigliani's] with her long braids in the act of piercing her breast with a long dagger. Did she guess the end?

<div align="right">Chantal Quenneville †</div>

Rue Amyot is a block long. The center of one side of it is a building with a deep court. Opposite is the house where the Hébuternes lived on the fourth floor, up a corkscrew stairs, and above them a single bedroom on the fifth, with a thigh-high iron balcony above an especially narrow sidewalk. She went off that balcony backward, in order not to have to look, as the position of the body showed. André had guarded her as carefully as he could; he somehow felt wary. About five in the morning, he dozed, and she jumped. The body fell upon the sidewalk—not court. He rushed down and found a worker about to bring the body in, but begged him to take it to Grande-Chaumière because he feared the sight would kill his mother.

At the first word of Modigliani's collapse, Libaude, the merchant of Utrillo and Valadon, rushed about Paris buying Modiglianis, especially from those who had not yet heard the news, and when Modigliani died he shouted for joy. Indeed he did well, for he made an immense profit.

Modigliani was seen into the earth by Jacob, Kisling, Salmon, Soutine, Brancusi, Ortiz, Severini, Survage, Derain, Lipchitz, Picasso, Léger, Utter, Valadon, Vlaminck, Zborowski, Foujita, Zavado. Rivera did not come as this would have interrupted his morning's work. The grandiose funeral procession is said to have been

* She had cuckolded her with Modigliani.
† A minor artist of the quarter.

the beginning of the promotion but Menè paid for it, and Kisling arranged it. At Père-Lachaise, there was a short rabbinical ceremony over the grave, and then he remained alone until 1925, not 1928 as always written ("Finally they sleep together," May 8, 1925, Menè). The tombstone falsifies the Modigliani story for it says: Jeanne Hébuterne 6 April 1898–25 January 1920. She died on January 26.

That was the twenty-seventh, the burial of Modigliani. The next morning at eight, so that no one would be there, Jeanne was fetched down out of 8 Grande-Chaumière and taken off to be buried in an ignoble little cemetery on the route to Bagneux. This was done by her father and brother. But this was caught sight of and they were followed at a distance by two taxis—Kisling, Zborowski, Chana Orloff, Salmon. And there she remained in the Cimetière de Bagneux until at length Menè prevailed upon her parents to let her be buried with the Jew.

Appendix I

The mechanos unquestionably rejected Amedeo. And yet— *Paris-Match*, at the time of Picasso's death. Dr. Pierre Bernal, heart specialist who arrived two hours before 11:45 A.M., Sunday, April 8, 1973, when he died:

> "He joked with me when I came in, to welcome me in the Spanish manner, as usual. His eye was bright. He smiled and didn't seem to suffer. But when his breath failed him, I couldn't understand all he said. He talked, he had confused dreams. Half sleeping, he seemed to wander in his immense past. Apollinaire, Modigliani were the names that came to him most often."

MODIGLIANI

Renato Natali—February 1, 1974:

"*Modigliani, grand peintre!* Modigliani was a good companion, very cultivated, very informed. They sent him sufficient
money but he spent it. He was at home in museums, not school—
and knew everything. He did not agree with modern painting
trends. He was a good painter, he had money, but he drank. Oh—
all those things have been made up by writers. Exaggerated. The
truth has been completely deformed. Above all, women loved
him: that contributed to his end. Writers have chosen not to deal
with what occurred, it has been easier to deal with the legend."
I thought that essentially true. "But artists aren't like other people;
they don't manufacture to specification, it all comes from that."
He spoke of the very many fake Modiglianis, most awed of all at
the fact that these commanded a fortune.

Modigliani

He who, on the terrace of that Rotonde destroyed like our dreams, mysteriously told the lines of our faces.

He who, not selling his drawings, gave them with the gesture of a prince.

He who, under the curls of a model of the Piazza di Spagna at Rome [special meaning for Cocteau: hangout of the homosexuals], pawed the ground till dawn, with the ire of a child who refuses to go to bed.

He who loved us and lent us his elegance.

He whose evanescing ghost a Spaniard * came to retrieve, face to face with my own across a table as we dined at Kisling's.

He who drank incredibly, without baseness.

He who, rooted before the Balzac Statue by Rodin, bent in the posture of an oak before the storm, the bow fletching its arrow.

He who, no more than we, believed a public for art existed.

He who would be stupefied to know he has been betrayed by absurd legends—having fabricated his own by hand, as one weaves straw that can blaze up.

<div style="text-align: right">Jean Cocteau</div>

Zborowski:

"He sometimes laughed like a child; he discussed philosophy and art. He was courteous, naturally erudite; translating Dante he made him fascinating. When drunk, he was crazily irritable and hypersensitive for reasons he did not seem to know."

Franco Russoli, Director, Brera Gallery, Milan:

"From these works [late Mannerist] in which the typical formula often prevails over the obstinate search for characterization, derives that aspect of Modigliani's graphic *oeuvre* that makes his last period, undeservedly, the best known and the most appreciated by the public."

Giovanna (Jeanne Modigliani, March, 1973):

"He must have been uneasy about a certain facility of line he possessed, and himself believed he could not have been satisfied with, for example, some of the very mannerist Jeanne Hébuternes. He was déçu. It would be awkward were I to be known to say Modigliani was a *raté*."

To the author, 1973:

Nina Hamnett had written to me "collect ten pounds and come to Paris!" I knew Nina very well, in London just before, I then being a young art student at the Slade. So Augustus John lent me £10 which I never paid back and I went to Paris and stayed there "forever."

I was taken to 8 rue de la Grande-Chaumière the very night I arrived and also introduced to Abdul whom I married later. The studio was really two (both long and narrow, one leading into the other).

Nina was charming and very amusingly vivacious but no judge of people—absolutely no idea! Extremely superficial. That is to say she liked anybody who amused her but was snobbish in a silly way—I mean she had no idea of *quality*. Liked all sorts of awful Americans who happened to amuse her for the time being and loved people with titles—the English young aristocrats (I must say some of them were very charming)—or anybody who was famous, with *no* discrimination. That is why she said "the Pole," as not being to her *important*, and on the contrary talks about the Princess Murat (Violette Murat) and a lot of other nonentities with all their names. Nina had affairs with all sorts of awful people but didn't appreciate Zawado really or anybody else.

Modigliani as you probably know had affairs with other women—not only Jeanne Hébuterne. Round about the same time as the birth of the daughter someone else gave birth to a son—Thérèse something or other.

If you don't know all about Ch. Albert Cingria I will tell you all about him. Swiss, but on and off always in Paris. It is he who influenced Max Jacob not the contrary. I simply haven't read *any* of the books on Modigliani and I imagine most of his friends didn't either. Abdul was always furious with the ones he came across. Complete lies!

About Aleister Crowley—I saw him a few times in London, probably at the Café Royal and probably with Nina. It was when he was trying to persuade people to go with him to Sicily. I was terribly young at the time but I was not very impressed, as I have never been taken in by these people who like to flabbergast

one. I thought he was a hoax which of course he. was—he was always talking about Black Masses and such things. Then I saw him again in Paris (this time on the way to Sicily for his Rabelaisian "abbaye"). I went to his hotel with Nina and he got up and pee'd in the lavabo so that has poisoned hotel lavabos for me forever as I always (now) think perhaps other people do the same. The wretch! Also he read my hand (with great pretension) and said I should have three children but never be married. So I imagine he must have been equally off with the sex and Black Masses.

M———'s really *intimate* friends whom he saw continually were drinkers—*e.g.* Ch. Albert Cingria, Abdul and Nils de Dardel. It is Nils who introduced Thora to everybody and Nils was *charming*—quite exceptional—as also Cingria. Zawado has never been a drinker—he was the great friend of *Zborowski*. One of the reasons I think Picasso can never have been an intimate friend of M——— is that he didn't drink and wasn't good at talking (hence his jealousy of M———).

All those years of the bande Pascin, Zawado was occupied with Tamara who was separated or about to separate from her Mexican diplomat husband and even we hardly saw him. For a few years he disappeared with Tamara—partly Boul. Raspail and partly, I imagine, Aix.

We, on the contrary, were all mixed up with Pascin's death— Lucy came to ask us if we knew where Pascin was and if he had gone on a trip, and he was only found a few days later when Lucy had the door broken open. It may be true that Kisling accompanied her as she was fairly friendly with Kisling but Pascin wasn't. We went to Boulevard Clichy but I refused to go in— Abdul came out weeping and saying "ses pauvres petites mains" (Pascin had *very* small sensitive hands—very pretty ones). Thora and Nils were there (Thora left after some time)—and Nils I don't know when. But Abdul and Mitrani, the Rumanian, were there *all night* until the funeral started—they were all drinking red wine (of course!), and not having slept all night were of course somewhat disheveled and slightly tipsy. And that wretch Kisling came all spruced up to the funeral, having slept all night, and said how shameful that some of the mourners (meaning Abdul and Mitrani and I suppose Papazoff) were drunk!

Pascin's suicide is accounted for by the following:

1) The autopsy said that he had the beginning of cirrhosis of the liver and he probably knew this.

2) He had "mucho olfato" and he smelt the crisis that was approaching rapidly (when *nobody* could sell a picture 1931– 1932) and he had created *enormous* money obligations (the harem of models), Hermine (not much)—Lucy who was very "expensive" and God knows what Pascin would have done with no money as he always spent everything (lived from day to day).*

3) Lucy was very difficult—there were always quarrels and she was always going off and leaving him and then coming back—a hell of a life.

<div style="text-align: right">Beppo [widow of Abdul-Wahab]</div>

* The depression years following 1929 are referred to.

Appendix II

Modigliani's only surviving poems (translated by the author):

summons . . . tumult . . .
vast mute tumult
in the midnight of the soul,
 o soundless cries!
hound-bayings, calls for help
 —melodies
high near the sun

voluptuous

deafening

severings

rhythms

<div align="right">Modigliani</div>

GODDESS

summons to nomads
all nomads far-flung
 the trumpets of silence
 ship of peace
 make me sleep
 cradle me
 till the new morning

<div align="right">Modigliani</div>

MODIGLIANI

from the height of the sable mountain the king,
he elected to reign, to command,
 weeps for them their tears
 of those who cannot reach the stars;
and from the somber cloud-ring crown
 fall gouts and pearls
 into the choking heat of the night
 Modigliani

 dances and cries of swallows
 over the mediterranean
 o livorno!

 this crown of cries this crown of sound

 I offer you
 o goat-headed poet!
 Modigliani

Appendix III

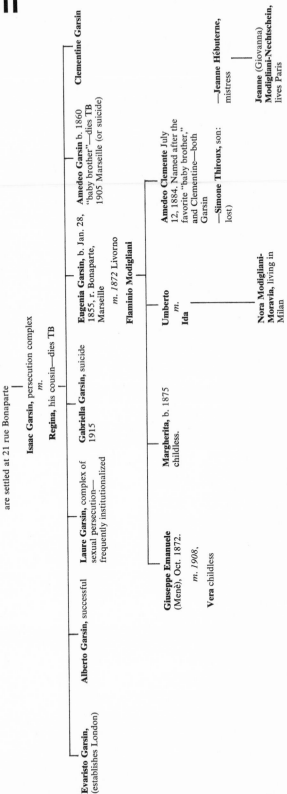

GARSIN

Solomon Garsin
Sephardi. Trader. Originaire of Tunis; quits Tunis late in 18th century for Livorno

m.

Regina Spinoza
Sephardi. Possibly of the family of the great philosopher; also Sephardim, but not a direct descendant as Spinoza died childless

Giuseppe Garsin (José), b. Livorno 1793; the "Blind Patriarch" In 1835, at forty-two, to Marseille, 21 rue Bonaparte, His son Isaac in 1849 marries Regina, his cousin; by 1852 they are settled at 21 rue Bonaparte

Isaac Garsin, persecution complex
m.
Regina, his cousin—dies TB

Evaristo Garsin, (establishes London)

Alberto Garsin, successful

Laure Garsin, complex of sexual persecution—frequently institutionalized

Gabriella Garsin, suicide 1915

Eugenia Garsin, b. Jan. 28, 1855, r. Bonaparte, Marseille
m. 1872 Livorno
Flaminio Modigliani

Amedeo Garsin b. 1860 "baby brother"—dies TB 1905 Marseille (or suicide)

Clementine Garsin

Giuseppe Emanuele (Menè), Oct. 1872.
m. 1908,
Vera childless

Margherita, b. 1875 childless.

Umberto
m.
Ida

Amedeo Clemente July 12, 1884. Named after the favorite "baby brother," and Clementine—both Garsin

—**Simone Thiroux**, son: lost)

—**Jeanne Hébuterne**, mistress

Nora Modigliani-Moravia, living in Milan

Jeanne (Giovanna) **Modigliani-Nechtschein**, lives Paris

MODIGLIANI

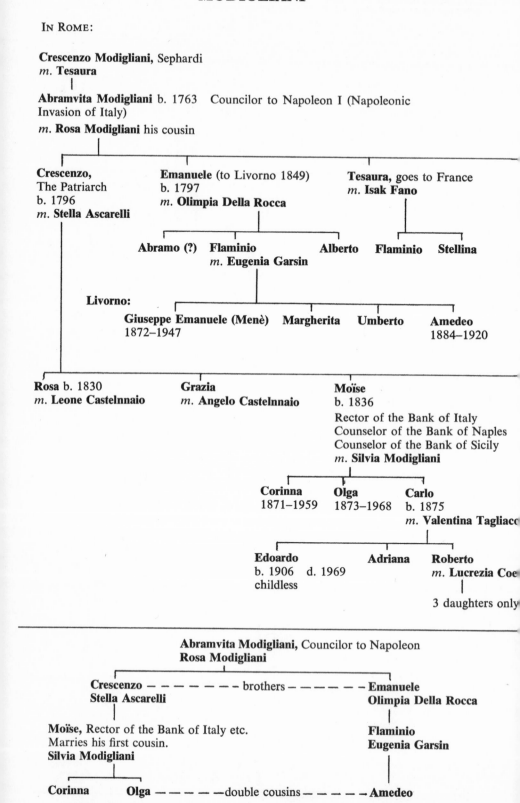

IN ROME:

Crescenzo Modigliani, Sephardi
m. **Tesaura**

Abramvita Modigliani b. 1763 Councilor to Napoleon I (Napoleonic Invasion of Italy)
m. **Rosa Modigliani** his cousin

Crescenzo,
The Patriarch
b. 1796
m. **Stella Ascarelli**

Emanuele (to Livorno 1849)
b. 1797
m. **Olimpia Della Rocca**

Tesaura, goes to France
m. **Isak Fano**

Abramo (?) **Flaminio**
m. **Eugenia Garsin**

Alberto **Flaminio** **Stellina**

Livorno:

Giuseppe Emanuele (Menè)
1872–1947

Margherita **Umberto** **Amedeo**
1884–1920

Rosa b. 1830
m. **Leone Castelnnaio**

Grazia
m. **Angelo Castelnnaio**

Moïse
b. 1836
Rector of the Bank of Italy
Counselor of the Bank of Naples
Counselor of the Bank of Sicily
m. **Silvia Modigliani**

Corinna
1871–1959

Olga
1873–1968

Carlo
b. 1875
m. **Valentina Tagliaco**

Edoardo
b. 1906 d. 1969
childless

Adriana **Roberto**
m. **Lucrezia Coe**

3 daughters only

Abramvita Modigliani, Councilor to Napoleon
Rosa Modigliani

Crescenzo — — — — — — brothers — — — — — **Emanuele**
Stella Ascarelli **Olimpia Della Rocca**

Moïse, Rector of the Bank of Italy etc.
Marries his first cousin.
Silvia Modigliani

Flaminio
Eugenia Garsin

Corinna **Olga** — — — — —double cousins — — — — — **Amedeo**

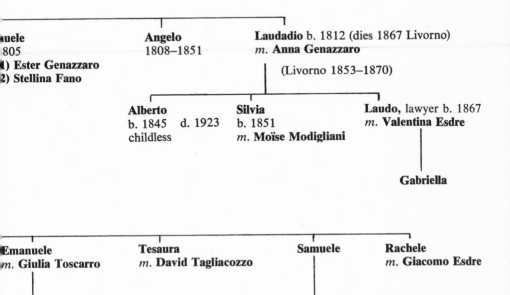

uele
805
1) **Ester Genazzaro**
2) **Stellina Fano**

Angelo
1808–1851

Laudadio b. 1812 (dies 1867 Livorno)
m. **Anna Genazzaro**

(Livorno 1853–1870)

Alberto
b. 1845 d. 1923
childless

Silvia
b. 1851
m. **Moïse Modigliani**

Laudo, lawyer b. 1867
m. **Valentina Esdre**

Gabriella

Emanuele
m. **Giulia Toscarro**

Tesaura
m. **David Tagliacozzo**

Samuele

Rachele
m. **Giacomo Esdre**

Ettore

Alfredo

Arturo

Marcella

*Modigliana is on the eastern slope of the Apennines 30 miles inland from Ravenna.
Legend cites it as the source of the name. The Modigliani came from Spain but it is
possible that, a frequent practice, early members purchased the right to the name.*

*The Modigliani line perishes in the present generation. All living direct descendants
(save the vanished son of Simone Thiroux) are female.*

Appendix IV

Palace of St. Cloud, 4 June 1811

NAPOLEON EMPEROR OF THE FRENCH, KING OF ITALY,
MEDIATOR OF THE SWISS CONFEDERACY &c. &c. &c.

I have decreed and hereby decree:

Article I
Leon di Leone
Giuseppe Samuel Benigno
Vitale di Tivoli
Abram Vita Modigliani *
Sabato Alatri
Are named members of the Israelite Consistory of Rome
The first in his condition of Grand Rabbi;
the second in his condition of Rabbi
And the three latter as Lay Members of the Consistory:
under the condition of swearing before the
Civil Governor of Rome the oath prescribed in
Our decree of 19 October 1808.

Article II
Our Ministry of Cults is charged with the execution
of the present decree.

NAPOLEON

* Emphasis added.

MODIGLIANI

Secretary of State
 Count Daru
Minister of Cults
 Count Bigot de Preameneau
Civil Governor of Rome
 Piranesi

Appendix V

Chronology

July 12, 1884	Modigliani is born in Livorno.
1886	Maternal grandfather Isaac Garsin, persecution mania, moves in with the family.
May 4, 1898	Menè arrested as an anarchist.
August 1, 1898	Modigliani enters Micheli's art school in Livorno.
1898	From age fourteen, Modigliani reads Nietzsche, Bergson, Baudelaire, D'Annunzio, Kropotkin, Lautréamont.
1898	Modigliani's friend of eight years, Uberto Mondolfi, turns from him to Menè, embracing Socialism.
1901	Modigliani undertakes sculpture as his primary art, Pietrasanta.
1901	Aspires to friendship with Gino Romiti.
1901	Modigliani travels to Capri, Rome, Naples, Venice, Misurina. Friendship with Oscar Ghiglia. Letters to Ghiglia.
1902	Modigliani enters Fattori's School of Nude Art, Florence, living with Ghiglia. Ghiglia leaves him to marry.
1903–1906	Modigliani in art school, Venice. Fellow student Umberto Boccioni, future painter of Futurism. Guido Cadorin witnesses Modigliani's introduction to hashish, occultism.

MODIGLIANI

1906	Modigliani arrives as bourgeois on the Right Bank, Paris.
1906	Modigliani moves to Montmartre, adopts bohemian garb, rents a shack in the maquis, avoids the Picasso *bande*. October: friendship with Gino Severini, eventual Futurist. Variety of sexual encounters—Gaby, Mado, Quiqué. Drinks with Utrillo and they are frequently arrested, beaten by the police.
Christmas 1908	Modigliani smashes his friend Drouard's sculpture, slashes his friend Doucet's paintings. (New Year's Eve) Setting bowl of punch afire, dances in front of it, chanting from Nietzsche, D'Annunzio.
1909–1910	Modigliani abandons Montmartre for Montparnasse. Severini asks him to sign Futurist Manifesto and he refuses. Modigliani sculpts with Brancusi in Rue du Montparnasse; at Cité Falguière, neighbored by Soutine and Foujita. Exhibits six paintings at Salon des Indépendants including *The Violoncellist* heavily influenced by Cézanne.
1911	Modigliani visits Yport with Aunt Laure.
1911	Modigliani exhibits suite of linked sculptured heads in studio of Souza Cardosa and the following year at Salon d'Automne.
1912	Modigliani returns to Livorno. Dumps sculpture into the Reale Canal.
May/June 1914	Modigliani meets Beatrice Hastings.
August 3, 1914	World War I.
1914	Modigliani abandons sculpture for painting.
1915	Modigliani's beloved Aunt Gabriella Garsin commits suicide in Rome.
1915	Aunt Laure committed temporarily to insane asylum.
1915	Modigliani paints for Chéron, Paul Guillaume.
End 1915	Modigliani abandoned by Beatrice.

June 1916	Zborowski takes up Modigliani.
July 1917	Modigliani meets Jeanne Hébuterne.
1917	Birth of Gérard, son of Modigliani and Simone Thiroux.
December 3, 1917	Modigliani Exposition at Berthe Weill Art Gallery fails.
March 1918	Zborowski sends Modigliani to Nice (with Soutine, Foujita, Jeanne Hébuterne, Jeanne's mother).
November 29, 1918	Birth of Giovanna, Nice.
April–May 1919	Cagnes-sur-Mer. Meeting with Renoir.
May 31, 1919	Modigliani travels to Paris alone and there meets Lunia Czechowska who is alone in the Zborowski apartment.
End June 1919	Jeanne Hébuterne returns to Paris.
October 1919	Modigliani meets Thora Klinckowström.
December 20, 1919/ January 5, 1920	Paints Paulette Jourdain, his last portrait of the female.
January 18, 1920	Modigliani sickens with nephritis.
January 24, 1920	Modigliani dies of tubercular meningitis.
January 26, 1920	Suicide of Jeanne Hébuterne.

Acknowledgments

In addition to those cited at the beginning of the book, and who in their various ways participated in the life, the author wishes to express his deep indebtedness to Joseph Lanthemann, author of the *Catalogue Raisonné* of Modigliani; his thanks to Vera Durbé, curator of the Fattori Museum in Livorno; to Guy Dornand, oldest art critic of Paris ("my memory is a mini-cemetery haunted by visions of the Great: Derain, Léger, Foujita, Per Krohg, Pascin, Cocteau, Picasso, Utrillo"); to Ferdinand Finne, pupil of Per Krohg at the State Academy of Art in Oslo; Félix Lévy, tenant of the Osterlind villa in Cagnes-sur-Mer; and, curiously enough, to Elmyr de Hory the art forger, for at the outset he thought it useful to go to one who had more than one time been Modigliani. The debt to Marevna Vorobëv, Rivera's mistress, author of *Life in Two Worlds* (the two worlds: Czarist Russia and Paris), is evident.

304

Index